PROCEEDINGS OF

THE
ARISTOTELIAN
SOCIETY

New Series—Vol. LXXVI

CONTAINING THE
PAPERS READ BEFORE
THE SOCIETY DURING
THE NINETY-SEVENTH
SESSION 1975/76

Published by
Compton Russell Ltd.
in association with The Aristotelian Society

First published 1976 by
Compton Russell Ltd.,
The Old Brewery,
Tisbury, Wilts.

ISBN 0 85955 042 7

Printed in England by
The Compton Press Ltd.,
The Old Brewery,
Tisbury, Wilts.

CONTENTS

ERRATA

PAPERS READ BEFORE THE SOCIETY
97th SESSION 1975-76

I* —*The Presidential Address*

SOCIAL OBJECTS

by Anthony Quinton

1. *What is a social object?*

By a social object I mean a group or institution which contains
or involves a number of individual human beings, such as a
people, a nation, a class, a community, an association, a
society, even, perhaps, Society itself. There are other kinds of
social entity, involving a plurality of people, besides what I
am calling social objects. First, there are large-scale historical
events: the Thirty Years' War, the French Revolution, the
economic depression of the 1930s. Secondly, there are social
forces or movements, such as the French Enlightenment,
romanticism, the liberal tradition, even, possibly, the
Zeitgeist.

I shall confine my attention to social objects proper as I
have described them, since I think it is reasonable to assume
that all statements about the other kinds of social entity can
be recast as statements about social objects, that is, groups or
institutions. To say that the war of 1939 was the real cure for
the depression of the 1930s is to say that the countries that
had been economically depressed in the 1930s recovered
when and because many of them started to go to war with
each other. Similarly to say that the French Enlightenment
drew its inspiration from Locke is to say that the progressive
thinkers of eighteenth century France derived their leading
ideas from the writings of Locke.

It would be convenient if this assumption were correct since

*Meeting of the Aristotelian Society at 5/7, Tavistock Place, London,
W.C.1, on Monday, 13th October, 1975 at 7.30 p.m.

we have a firmer logical grasp of objects than of events and processes. We have a clearer notion of the criteria for individuation and identification of the former than we do of the latter. I am not assuming that events and processes in general are reducible to objects in this way, only that events and processes of a social or historical kind are. Nor have I any very precise criterion for distinguishing social entities that are objects from those that are not. A rough and ready verbal or grammatical test is available Objects can be naturally and properly said to exist and to come into or go out of existence. Events and processes, on the other hand, occur, happen or take place. On this basis the name of a social entity such as 'the French Enlightenment', can be the name either of an object or of a process. When we say that the French Enlightenment ceased to exist with the advent of Napoleon, we are talking about a social object, a particular human group. But when we say that the French Enlightenment came to an end with the advent of Napoleon we are talking about a process, the intellectual activity characteristic of that group of people.

Social objects are the theoretical entities of history and social science. They are, I suggest, the form of generality that is proper to history, as contrasted with laws, the form of generality proper to science. They are, furthermore, what distinguishes history proper from chronicle, although even in the latter some mention is likely to be made of such obvious and, at least intermittently, visible groups or institutions as the Witan or the host. The names of social objects are the characteristic subject-terms of the laws of social science: classes and reference-groups in sociology; governments, parliaments and parties in politics; firms and industries in economics. In so far as individual people are mentioned in the laws of social science it will be as the occupiers of particular social rôles, and to occupy a rôle is to stand in a certain relation to other people within a group or institution.

On the whole, the natural sciences of man treat him in isolation, for example, physiology. Where, as in evolutionary biology, these sciences treat man in relation to other people, the relations involved are natural relations of biological parenthood or competition for food supply. What is characteristic of the relations studied by the social sciences is that

they involve consciousness of each other by the people related. Two men can be in biological competition for food if one gets to it first, unaware of the fact that the other was planning to eat it. If they start fighting over it or try to outwit each other in securing it the relation becomes social. There is, of course, no precise demarcation between natural and social relations between people (or other animals).

2. Collectivism and individualism

Two broad kinds of interpretation have been given of the nature of social objects. The individualist view is that there is no more to a group or institution than the individuals who compose it and the collectivist view is that there is more. These are, in the first instance, ontological doctrines which can be expressed in the idiom of philosophical analysis as the theses that statements about social objects can or cannot be reduced, are or are not logically equivalent to, statements about the individuals who are the members of the groups or institutions in question.

What I have described as ontological individualism and collectivism are ordinarily called methodological individualism and collectivism. The aim of this qualification is entirely virtuous. It is to mark off the point at issue from that in dispute between ethical individualists, who take the ultimate good to be the good of individuals, and ethical collectivists, who hold that the needs and interests of the group ought to prevail over those of its members. It is these ethical positions that are commonly described as individualism and collectivism *tout court*. The ethical versions of these doctrines are usually associated with the non-ethical versions and it seems generally to be supposed that some relation of implication holds between them, an implication that can hold only if its two terms are conceived as distinct.

I believe that there is also a distinction on the non-ethical side between ontological individualism and collectivism and methodological individualism and collectivism properly so called. The ontological theses concern the reducibility of objects or the definability of terms. The methodological theses, on the other hand, concern the derivability of laws. It is, *prima facie*, one thing to say that statements referring to

social objects can or cannot be translated into statements referring to individual people, another to say that all laws in which social objects are mentioned can be derived from laws in which only individual persons are mentioned. In view of this I shall reserve the term 'methodological' for the doctrines about explanation or the derivability of laws and describe what I take to be the more fundamental issue of the reducibility of social objects as ontological. (The distinction between ontological and methodological forms of the opposition between individualists and collectivists has been recognised by Nagel, in *The Structure of Science*, who marks it with the terms 'connectibility' and 'derivability', and by Popper, in *The Open Society*, who distinguishes the dispute between ontological individualism and collectivism from that between 'psychologism' and 'sociologism' and goes on to support individualism as an ontological thesis about reducibility while supporting collectivism as a methodological thesis about explanation.)

The ontological problems of social objects is closely analogous to the problem of the status of theoretical entities in natural science. The latter, things like atoms, molecules, cells and viruses, are at once the main items referred to in the laws of natural science and also share with social objects the property of being theoretical, that is to say, in some way or other, unobservable. The two main theories about the nature of theoretical entities in the physical world are realism, which takes them to be distinct from straightforwardly observable common objects, and instrumentalism or positivism, which maintains that statements about them are reducible to statements about common objects.

Realism about physical things can be affirmed in two different ways. More moderately it can take theoretical entities to be the literal parts of common objects. More radically it takes such theoretical entities to be the real constituents of the physical world while the common objects of everyday observation are more or less illusory appearances. The more radical kind of physical realism infers its Lockean conclusion from the greater scope and precision of physical theory in comparison with the findings of ordinary observation and from the inconsistencies it discerns between such findings and

those of physical theory. What common observation finds to be coloured, continuous and stable, physical theory, it is held, shows to be really colourless, discontinuous and in rapid motion.

The version of ontological collectivism about social objects put forward by Hegelian idealism is comparably radical in maintaining that social objects are somehow more real than the individual human beings involved in them. This principle is ordinarily derived from a very strong interpretation of the thesis that man is essentially a social being. It is often associated, furthermore, with the idea that a social object, a group or institution, is itself a mind or person, of a higher, more 'objective' sort than an individual mind or person.

Moderate ontological collectivism about social objects need amount to no more than the negative thesis that they are not analysable in terms of the individuals who compose them. In that form, like its physical analogue, it need not hold that individual people are any less real than the social objects of which they are members.

Physical reductionism usually takes theoretical entities to be *less* real than the common objects to which statements about such entities ultimately refer. It regards them as logical constructions or abstractions, as useful *façons de parler* or symbolic conveniences. Its social analogue, ontological individualism, adopts the same attitude to social objects.

I shall expound and defend a position about the nature of social objects which is intermediate between the extremes of holding them to be more or less real than individual people. I am an ontological individualist in believing statements about social objects to be statements about individuals, interrelated in certain ways. But I do not take the relation of a social object to its human constituents to be that of a logical construction to its elements. It is, rather, that of a whole to its parts, both of which are equally real and objective.

To reconcile these two positions I shall aim to show that although social objects are in a way constructed out of people, the mode of construction is not one that carries any ontological implications. It is, I shall argue, a categorical construction, like that involved in arriving at the conception of the solar

system from observation of the lawfully regular behaviour of its components, and not a hypothetical construction, like the average man, or material things and mental states as understood by phenomenalists and behaviourists.

3. Social objects as concrete universals

The idea that social objects, in particular the state, but also class and family, are more real than their individual members is first explicit in Hegel's theory of objective mind. 'The consciously free substance', Hegel says, 'has actuality as the spirit of a nation. The abstract disruption of this spirit singles it out into *persons,* whose independence it, however, controls and entirely dominates from within.' The state, he goes on, 'is the self-conscious ethical substance' and 'as a living mind the state only is as an organized whole'. Its rational, universal will is opposed by Hegel to the idea of 'a common will as the sum and resultant of atomistic single wills', 'an idea which has on it "the mark of unreality of an abstraction" '. History, in Hegel's view, 'should not concern itself with individuals but with the state, or, which is the same thing, with mind or spirit in history'. 'The self-consciousness of particular nations is a vehicle for the contemporary development of the collective spirit in its actual existence: it is the objective actuality in which that spirit for the time invests its will'.

The state, although the highest, is not the only ethical substance, which may be immediate or natural, as in the family, or relative, as in the estates or classes that make up civil society. In marriage, persons, with their exclusive individualities, 'combine to form a single person'. Civil society is a multiplicity of people engaged in the satisfaction of their wants. Through the division of labour that leads to their allocation to classes or estates. 'As belonging to such a definite and stable sphere', Hegel says, 'men have their actual existence'. The system of estates is politically significant as relating the individual to the state. 'It is not in the inorganic form of mere individuals as such (after the *democratic* fashion of election) but as organic factors, as estates, that men enter upon that participation'. Hegel condemns individualistic notions of liberty and equality for their abstractness.

Hegel's theory of objective mind clearly affirms three pro-

positions mentioned earlier as central to the radical form of ontological collectivism. First, man is essentially social, he is always a member of groups and institutions and is made what he is by that fact. Secondly, the group is more real, more concrete and substantial than its members. Thirdly, groups are themselves minds or persons, they are self-conscious and have minds and wills of their own.

Bosanquet makes the same points more clearly and unequivocally. He praises Rousseau for being the first to see that 'the essence of human society consists in a common self, a life and a mind'. Society, he says, is a 'moral person', not 'an abstraction or fiction of the reflective mind'. It is a mistake to accept 'the absolute and naturally independent existence of the physical individual'. It follows that 'the common self or moral person of a society is more real than the apparent individuals'. The reality of groups and institutions is not the particular people they comprise but 'an identical connection between minds'.

The starting-point of the theory of objective mind is that man is essentially social. Men are truly men, and not mere anthropoid animals, to the extent that they are rational, self-conscious and moral. Rationality, and the language which is its indispensable vehicle, is social. Self-consciousness requires that consciousness of others which is the defining condition of the existence of social rather than natural relations between them. Morality is of its nature a social phenomenon, a concern with the bearings of one's actions on others. There is, it is then inferred, an asymmetrical dependence of individuals on society and the groups and institutions in which it is articulated, a dependence analogous to that of attributes on substances, states of mind on conscious subjects or creatures on God. Society is concrete substance; the individual is abstract attribute. Finally, societies or social objects are themselves self-conscious subjects or persons, with minds, wills and interests.

4. Social objects as logical constructions

The standard empiricist theory of the nature of social objects is that they are logical constructions. This is as often assumed as explicitly argued for, since the state and other social objects

are often called in as paradigm logical constructions in order to explain the application of that concept to more controversial cases such as material things and minds. Thus Ayer, giving an account of contextual definition in general, says 'the English state is a logical construction out of individual people' and Wisdom explains that 'to say that a chair is a logical construction out of appearances of a chair is to say that a chair is related to its appearances . . . as (amongst other things) a family is to its members'.

There is, however, a straightforward argument for the thesis. It is that social objects can be significantly referred to and described but their names are neither ostensively definable nor explicitly definable in terms of ostensively definable expressions that can be uniformly substituted without alteration of meaning for all occurrences of the name in question. The only other way of endowing the names of social objects with meaning is by contextual definition, the provision of rules for replacing statements in which they occur with statements that refer only to unproblematic entities, the significance of whose names gives no trouble.

The names of social objects are not ostensively definable because social objects cannot be observed. I can observe a member, or several members, of the class of unskilled workers, but I cannot observe the class of unskilled workers as such. They are not, in general, explicitly definable since it is very often the case that the predicates ascribed to them either cannot be significantly applied to the unproblematic entities from which they are held to be constructed, or, where they can be significantly applied to them, may well not be true of them although they are true of the social object involved. The German people is numerous but no individual German can be significantly said to be so. The Japanese nation is larger than the Swedish nation, but, on the whole, individual Japanese are smaller than individual Swedes.

It must be admitted that the unobservability of social objects is not very absolute. Relatively small ones—the Cabinet posing for a group photograph, the Jones family at its Christmas gathering, even an army division—are sometimes so arranged as to be straightforwardly observable. But that is the exceptional case. We refer significantly to and

make true or at least justified statements about social objects that have never been observed in that sort of way. Our understanding of the names of, and our knowledge or well-founded beliefs about, the great majority of social objects is not directly observational. These things are linked with observation by way of our perception of the activities of individual people who are members of the social objects in question. If not strictly unobservable, then, social objects are not, on the whole, effectively observed.

The theoretical entities of natural science owe their characteristic unobservability to the fact that they are too small. Those of social science elude observation because they are too large and, even more, too scattered. However, there are some parallels to this in physical science, above all in astronomy. The conception of the solar system is a potentially observational one in that we know what it would look like from a rocket very much further from the earth than any rocket has yet travelled. But this conception has been constructed from observation of particular elements of the solar system of the relations between them. The same is true of social objects like nations and classes.

In some cases, which may be called summative, statements about social objects are equivalent to statements otherwise the same that refer explicitly, if at some level of generality, to individual people. To say that the French middle class is thrifty is to say that most French middle class people are. Quite often to say that the A group is F is to say that all or most or the most influential people who are A are F. But the predicate F is often either not significantly or not truly predicable of A people, although significantly and truly predicable of the A group. The British aristocracy is hierarchically arranged and the Unitarian church is getting smaller but British aristocrats are physically organized much as other men are and individual Unitarians have not shrunk. Carelessness about this can have quaint results. After the General Election of 1964 *The Times* said that the British electorate had been unable to make up its mind. Yet more people voted in 1964 than in the more decisive election of 1966.

Apart from this, predicative, obstacle to explicit definition of the names of social objects, there are many non-summative,

primarily institutional, statements about such objects, for example 'Holland has declared war on Belgium' or 'the Acme Company has laid off half its labour force'. The ultimate reference here is to some identifiable collection of decision-making people, the rulers or management of the institution in question, but, so described, they still constitute a social object and to express the facts in terms of individual people will require more complex and specific predicates than 'declared war' or 'laid off workers'.

The names of many social objects are notably ambiguous, particularly, but not exclusively, those of nation-states. To speak of France may be to speak of all or most Frenchmen *or* of the French government *or* of a portion of the earth's surface. The same variety of reference is possible with 'the Bank of England' or 'the Athenaeum'.

For the reasons given, separately or in combination, it turns out more often than not that the sense of a statement about a social object cannot be conveyed by a statement which differs from the original only in substituting an explicit, if general, reference to some collection of individual people for the name of the social object.

But if the names of social objects cannot be ostensively defined, or, at any rate, are not in practice so defined, and cannot be explicitly defined in ostensive terms, they must, if they are to be endowed with empirical meaning and the statements in which they occur are to be brought under empirical control, be defined contextually. And to say that is to say that social objects are logical constructions.

What that is taken to imply is that social objects are not concrete things but abstractions, convenient devices of abbreviation for thinking about the social actions and relations of individual human beings, even, in the hyperbolic term favoured by Hume and Russell, fictions. The defensible empiricist thesis that social objects are not distinct from the people involved in them, are nothing but their members, appropriately related, is taken to amount to the proposition that they do not really exist in their own right at all. I shall argue that the reducibility of social objects to people does not have such an implication since it is of a different kind from that of the average man to individual men or of the

phenomenalist's material thing to appearances. It is rather that involved in the relation of a whole to its parts, of a wood, for example, to its trees. A wood is nothing but the trees that compose it, suitably arranged, but it is as real and concrete a thing as any of them is. The standard version of ontological individualism seems unable to acknowledge the wood for the trees.

5. Methodological implications

The two ontological doctrines I have set out have methodological implications. Collectivism in its moderate, negative form, where it holds that social objects are irreducible to individuals, seems to imply that observation of the acts and relations of people must be insufficient by itself to establish the truth or falsity of statements about social objects. The radical form of collectivism makes the point more strongly. How can beliefs about what is not real determine the truth or falsity of our beliefs about what is?

One theory of our knowledge of social fact that proceeds from this assumption is that which distinguishes *verstehen* from *erklären,* the empathetic understanding that is proper to the apprehension of facts about social beings from the merely external perception we bring to the constituents of physical nature. A variant of this theory is the Wittgensteinian view that our understanding of human action as done for reasons is something quite distinct from the explanations we give of natural happenings in terms of their causes.

In a less articulate way, what Popper calls 'sociologism' asserts that the laws of social science cannot be derived from laws of individual psychology, the error, as he sees it, of 'psychologism'. Psychologism is the type of general social theory propounded by Hobbes, by Hume and other thinkers of the Scottish Enlightenment, by the classical economists and by Mill in his account of the logic of the moral sciences.

Idealist social theory, stemming from Hegel, is opposed to the element of intuitionism in the doctrine of *verstehen*, but it would agree that psychologism is mistaken, on the ground that it assumes the existence of an abstract, universal and timeless human nature, when in fact human nature is a historical variable. Positively it contends that the understanding

of social fact is confined to abstract appearance if it is no more than the inductive assemblage of observable facts about individual people. A true understanding of social fact may start with the inductive accumulation of such material but it must go on to a philosophical grasp of the inner, rational nature and relations of what is observed.

Ontological individualism simply denies that any special mode of access to social facts is required for knowledge of them to be obtained. Since statements about social objects are equivalent and reducible to statements about individual people, it must follow that every law expressed in social terms is expressible as a law about individuals. For this reason some critics have failed to see how Popper can consistently claim to support what he calls methodological individualism and, at the same time, reject psychologism.

In general, the ontological individualist recognises no fundamental difference of method between physical and social science. Both begin with ordinary perceptual observation, seek to arrive at causal laws and to articulate these causal laws into a theoretical system. Both are at liberty to introduce new theoretical notions, but these notions must be somehow definable in terms of the objects of ordinary observation.

6. *Ethical implications*

As well as these methodological implications about the nature of our knowledge of social fact, the two ontological doctrines also have implications of an ethical kind. Ethical collectivism takes two forms. The first and more important is the view that the interests and well-being of the group are more valuable than those of the individual and ought to override them. In some sense, no doubt, anyone would accept that. If the interests involved are more or less commensurate, the interests of the great majority, it would be agreed, should override the interests of a few. What gives this principle of ethical collectivism its controversial force is the theory that the common good of the group is not simply the sum of the interests of its members. Just as, for the ontological collectivist, the group is not merely the whole or aggregate of its individual members, so, for the ethical collectivist, the welfare of the group is not an aggregate of individual welfares.

For the ethical individualist social objects, groups or institutions, have no intrinsic value that is not constitutive of the welfare of individual people. He sees social objects either as sums of individuals or as institutions and in the latter case any value they possess is purely instrumental. The point was put with memorable vigour by that untypically individualistic idealist McTaggart: 'compared with the worship of the state, zoolatry is rational and dignified. A bull or a crocodile may not have great intrinsic value, but it has some, for it is a conscious being. The state has none. It would be as reasonable to worship a sewage-pipe, which also possesses considerable value as a means.'

The sharp distinction between common and individual good assumed by the first form of ethical collectivism starts from Rousseau's distinction between the private, self-regarding, more or less competitive satisfactions of individuals and the more public-spirited and selfless satisfactions they can enjoy as citizens. But both Rousseau's kinds of satisfaction exist only to the extent that individuals actually experience them. They are, as it were, essentially located in individuals.

But when the idea that the group is more real than the individual is superimposed on the distinction between common and individual good, the ethical collectivist conclusion naturally follows: that the good of the group, as real, is more important than, and should therefore override, the good of its individual members, which is only abstract appearance.

If the further thesis of ontological collectivism, that the group is itself a person, of a higher kind than its component individuals, is embraced, the supremacy of the common good is only further entrenched. If a group really is a person, then the idea that it has a good of its own is more effectively established and, to the extent that it is a superior kind of person to ordinary individuals, it follows that its good is of a higher and more important kind.

A second form of ethical collectivism holds that the group is more authoritative than its members with regard to what is right and, therefore, that the moral convictions of the group are more worthy of acceptance than the deliverances of the individual conscience where the two conflict. This point of view is expressed in Hegel's elevation of *Sittlichkeit*, or social

ethics, above *Moralität,* or the morality of the individual con-
science. True moral wisdom, on this view, consists in the
individual's subordinating his spontaneous moral impulses
to the prevailing prescriptions, and, in particular, the positive
law, of the community of which he is a member.

Ethical individualism simply denies both these proposi-
tions. It takes value to be realised only in the experiences of
individual human beings and takes the common good to be
no more than the sum or aggregate of such experiences, justly
distributed. Furthermore, it takes individuals to be morally
authoritative. Although it can allow that some individual
moral convictions are likely to be better founded than others,
it attaches no special importance to the prevailing moral
sentiments of the community at large.

7. *Critique of the theory of objective mind*

The principle that man is an essentially social being, on which
the theory that groups and institutions are more real and
concrete than the individual people involved in them rests, is
not seriously disputable. What makes human beings human,
or, more precisely, persons, is their rationality and their moral
capacity. There is, indeed, a comparatively trivial mode of
dependence of men on other human beings, their biological
parents, for coming into existence at all and, in all but the
most exceptional cases, for nurture. To become rational
beings men need to become incorporated in a linguistic com-
munity and to become moral agents they need to be brought
up as members of a social system of rights and duties. How-
ever, the most minimal and rudimentary of social groups, the
family, is sufficient for both accomplishments.

There are, of course, true human beings who have with-
drawn from society, hermits and castaways, but they have
first been socially formed. Robinson Crusoe and Ben Gunn
(once his passion for cheese had been satisfied) did not have
to start again from the beginning when they rejoined the
society of their fellow-men. Wolf-children, on the other hand,
nurtured from birth by non-human animals, are not fully
human persons when they come into human society.

But if men are essentially social, societies are even more

essentially human. A memberless society is logically inconceivable, a contradiction in terms. A wholly unsocial man, one who has not passed at least an extended, humanly formative, period in social relations with other human beings, is at most a contingent or empirical impossibility. It is not logically necessary that all human beings should have human parents (indeed it is logically impossible if the human species had a beginning), that they owe their survival to other human beings and not self-preservative instinct, and that they did not invent language for themselves.

This distinction between kinds of impossibility may be questioned. It is widely held that self-consciousness necessarily presupposes consciousness of others and that a private language is not just unactual but inconceivable. For the purpose in hand this can be conceded. All I am trying to show is that there is not an asymmetrical dependence of men on society. For that it is sufficient to establish that there is as much dependence in one direction as in the other.

As a last resort a defender of the original thesis of asymmetry might argue that, although memberless societies are uncommon, they are not impossible since there actually are some. A college might have an archery club all of whose members leave and which, after an interval, is started up again. It could still be said to exist during the interval. It might still be listed in the college handbook, with blanks or the word 'vacant' beside the words 'president' and 'secretary'. This is, at any rate, a pretty fragile sort of existence, an existence by courtesy, based on the fact that it has had members, will probably have members in the future and may have property, archery equipment, say, in the hands of some such ontologically reliable custodian as the college bursar. It would be at least as natural to say that there is no archery club during the interval.

Individuals are, then, certainly no more, and arguably less, dependent on social objects than the latter are on them. Men are essentially social but, since societies must have members, there is no ground for the claim that societies are in some way more real and concrete than the individuals who compose them.

Is there any other ground for this central proposition of the

theory of objective mind? A social object is, in a way, larger and more comprehensive than its human components. But that does not make it more real. The Galaxy is larger and more comprehensive than the solar system. It is no more, and no less real than the groups of heavenly bodies, or particular heavenly bodies, that go to make it up.

The elusive idea that societies are more real than their members is encouraged by three comparisons with supposedly parallel relationships in which one term is held to be more real or concrete than the other. The first of these is the relation of substance and attribute. Substance, conceived in the Aristotelian way as formed matter, and not as bare *substratum*, is certainly the paradigm of concreteness, as attributes, in themselves and uninstantiated, are of abstraction. But individual people cannot seriously be considered to be attributes of social objects. A society will always have attributes, such as vitality, integration or stability, but its human members are not among them. Individuals can, indeed, be shared by different social objects, as attributes are shared by different substances. This differentiates the members of social groups from such proprietary parts of things as limbs, which can be part of only one body at a given time. As capable of sharing members social objects resemble logical classes, although as will be seen there are crucial differences between the two. But classes are taken to be more, not less, abstract than their members. In general, sharing does not relate its terms asymmetrically. A tomato and a carpet may share the attribute of redness; but redness and roundness may also share a tomato that is an instance of both.

The second parallel case of allegedly asymmetrical dependence is that of mental states on a mind or subject of consciousness. Philosophers have usually taken it to be an indubitably self-evident truth that every mental state must be the state of some conscious subject. In their own way mental states are essentially social. But among those who have affirmed this, two of the most influential, Descartes and Berkeley, have asserted the opposite dependence as well, that the mind always thinks, is conscious, is in some mental state or other. Locke, of course, took this to be refuted by 'every drowsy nod'. The Lockean mind is something like the inter-

mittent archery club I mentioned earlier. Sometimes it is active, is characterised by what is, for Descartes, its essential attribute; sometimes it is not. Whatever view is taken of the dependence of minds on mental states the parallel still breaks down. Individuals can, like Robinson Crusoe, withdraw from society. A mental state cannot, according to the original principle of dependence, exist in detachment from a mind at any time. The strictness of the dependence in the mental case is much greater.

Finally, there is a measure of analogy with the relation between God, the *ens realissimum*, and his creatures. In the social case this relation cannot be conceived in the manner of theism, with God as distinct from and prior to what he creates. It must be taken pantheistically, with God being identified with the totality of what exists. But in that case the relation is between a whole and its equally real and concrete parts, whatever else it may be.

If men, then, are essentially dependent on society, social groups are at least as dependent, and arguably more so, on men. There is, therefore, no ground here for the claim that social groups are more real and concrete than the men who compose them.

The comparison of the relation between a society and its members to that between a mind and its states encourages the inference that societies *are* minds, of a higher and more objective kind, an important support for ethical collectivism. We do, of course, speak freely of the mental properties and acts of a group in the way we do of individual people. Groups are said to have beliefs, emotions and attitudes and to take decisions and make promises. But these ways of speaking are plainly metaphorical. To ascribe mental predicates to a group is always an indirect way of ascribing such predicates to its members. With such mental states as beliefs and attitudes the ascriptions are of what I have called a summative kind. To say that the industrial working class is determined to resist anti-trade-union laws is to say that all or most industrial workers are so minded. Where groups are said to decide or promise the statements in question are institutional: the reference is to a person or persons authorised to take decisions or enter into undertakings on behalf of the group.

8. *Critique of the logical construction theory*

Just as I have acknowledged that men are essentially social while rejecting the inference that social objects are on that account more real and concrete than their members, so I agree that social objects are logical constructions while rejecting the inference that they are on that account merely abstractions. Social objects are logical constructions because they are not, in practice, or effectively, observable, so that their names cannot be ostensively defined, and because their names cannot be explicitly defined, by reason of the fact that statements about them either involve institutional reference or contain social predicates that cannot be significantly ascribed to individuals.

Now philosophers who try to show that certain things, usually problematically unobservable things, are logical constructions are very insistent that the relation between a logical construction and its elements is not that between a whole and its parts. Ayer, for example, says that 'when we speak of certain objects b, c, d . . . as being elements of an object e, and of e as being constituted by b, c, d . . ., we are not saying that they form part of e, in the sense in which my arm is part of my body, or a particular set of books on my shelf is part of my collection of books'. Furthermore, it is 'a mistaken assumption' that, in being taken to be a logical construction out of sense-data, 'a material thing is supposed to consist of sense-data, as a patchwork quilt consists of different coloured pieces of cloth'. Carnap insists that a social or cultural object is not literally composed of psychological or physical objects, but that social objects form what he calls an 'autonomous object-sphere', in other words that they are, as it were, on a higher level of abstraction than their constituent elements.

It is clearly true that some logical constructions are not wholes with their elements as parts. The average man is not the totality of men. Similarly a material thing, if it were a logical construction out of sense-data, as phenomenalists believe, would not have sense-data as its parts, but other, smaller material things such as molecules and atoms. A mental state, likewise, if it were a logical construction out of items of behaviour, would not have such items as parts. The parts of

X's anger at Y, to the extent that it can be said to have any, are other mental states: his desire to injure Y and his belief that Y has done something to injure him.

The crucial thing about the philosophically interesting examples, the phenomenalist's material thing and the behaviourist's mental state, is that they are *hypothetical* constructions. In the first case, to say that there is a tree here is to say that, *if* certain conditions are satisfied, certain sense-data will be experienced. In the second, to say that this man is depressed is to say that, *if* such-and-such circumstances arose, he would react in such-and-such ways. Categorical statements about material things and mental states, so interpreted, can be true although no relevant sense-data at all actually occur or no relevant behaviour takes place. Such things and states are conceived as systematic *possibilities* of experience or behaviour. But possibilities cannot be parts of an actual thing.

Carnap, in the only extended treatment of social objects as logical constructions that I know of, maintains that they are latent and manifest themselves, thus imputing the same hypothetical status to them as phenomenalists do to material things and behaviourists to mental states. But the example he relies on does not establish the point. To say that there is a custom of hat-raising is, as he says, to say that individuals have a disposition to raise their hats to one another as a greeting. But the custom is not a social object proper; only the group in which it prevails is. Furthermore, the custom is no more dispositional than its elements. It is, in fact, an aggregate of individual dispositions.

Logical constructions, then, are not as such abstract and in some way less real than their constituent elements. That is arguably true of hypothetical constructions and perhaps of others as well. What I am concerned to show is that something can be a logical construction out of other things and, at the same time, be a whole of which the elements out of which it is constructed are parts. It is in this sense that the solar system is a logical construction out of certain systematically related heavenly bodies and a massive geographical feature like Australia or the Rocky Mountains is a logical construction out of observable bits of terrain or mountain-peaks. Is there any

good reason to reject the view that social objects are related
to the individuals who constitute them in the same way?

9. *Social objects as wholes*

One fact that might have suggested the idea that social objects
are not wholes whose parts are individual people is that their
membership changes through time. But it is plain, in reflec-
tion, that most wholes survive the replacement of their parts,
provided that it is not too drastic. A replacement that is both
sudden and comprehensive, or nearly so, makes the identity of
the whole precarious. The masonry of a mediaeval castle can
be steadily replaced, a small proportion each year, until none
of the original material is left, and it will still be the same
castle. Locke, who favoured identity of parts as a criterion for
the identity of inorganic material things, felt constrained to
abandon the requirement in the case of living bodies.

We do sometimes identify aggregates by way of their com-
ponent parts. When the beach party is over, Anne's clothes are
just those very garments that Anne arrived in and took off in
order to swim. But Anne's clothes, conceived now as the
customary occupants of a particular group of shelves and
wardrobes, will have a temporally variable composition.

This point should be distinguished from the superficially
similar consideration that I can know something about a con-
structed whole without knowing anything much about its
specific individual parts. To know that France is a food-loving
country is to know that most French people care about food.
I can have good reason to believe that, without knowing much
in particular about the majority of Frenchmen who are
indefinitely referred to in my summary statement. This fact
is sometimes, but invalidly, brought up as an objection to the
view that statements about groups can be reduced to state-
ments about individuals. But, even if the reference in the
reducing statement is indefinite, the reduction has still been
accomplished.

A more substantial reason for denying that social objects
are wholes with human parts is that they are, in all but very
exceptional circumstances, scattered and radically discon-
tinuous in space. Many of them, indeed, such as children or

vegetarians or motor-cyclists, who are not the proprietary
occupants of a particular tract of the earth's surface in the way
that nations tend to be, are intermingled in space with the
membership of other social groups. Carnap, in the spirit of
this objection, contrasts a forest with the present vegetation
of central Europe, which he describes as 'a conceptual
assemblage'.

This property of social objects is a good reason for denying
that they are material objects. Material objects are ordinarily
spatially continuous, or, to take account of physical theory,
are at any rate perceived as such, even if only in the way that
a net is, where there is a perceptibly continuous path from
any point in the thing to any other. The reason for this is
that our standard concepts of material objects involve a
characteristic, definitive shape, whose boundaries mark the
object off from others and make possible identification and
counting.

We may prefer, therefore, to call a spatially scattered
entity a collection or aggregate, for example, a library that is
not all in one place, or even a forest. But an aggregate or
collection of objects is still a perfectly good whole of which
those objects are parts, even if we are unwilling to describe it
as a material object itself.

A more striking peculiarity of social objects, which might be
thought to count against their being wholes with people as
parts, is that every human being is at any moment a member
of a great number of distinct groups. These may, indeed,
overlap only in respect of his membership of them. A man
can be the only member common to his family, the local fire-
brigade and a wine-tasting society. Ordinary material objects
can share parts only at different times. A cannot be at a given
moment part of both B and C, unless B itself includes or is
included in C.

An interesting limiting case of member-sharing which
could and perhaps occasionally does occur in the field of social
objects is that in which two groups have exactly the same
membership. It is possible that the parish council of a given
village should have as its members all and only those who are
members of the church bell-ringers of that village. From that
it follows that a social object, even a social class, is not a logical

class, whose membership is the criterion of its identity.

But although simultaneous sharing of parts, and, *a fortiori*, complete identity of parts, is impossible for distinct material objects, that is not true of aggregates or collections. John's books, the books in the thatched house and the paperbacks in this street may have one or many or even all their members in common and yet these book-collections are perfectly good wholes with individual books as their literal parts, held together in these distinct collections by different aggregating relations: ownership, location, physical character.

Wholly distinct material objects cannot simultaneously share parts because in the case of such wholes the aggregating relation is spatial. The strands of wool that make up a sweater in the morning and, when unpicked and reknitted, a scarf in the afternoon have to stand in different and logically incompatible spatial relations in their sweater-forming and scarf-forming rôles. The collection-forming relationships between the parts of the book-collections in the example are, however, logically independent. The same is true of social objects. In the case of the identically-membered parish council and bell-ringers there is no incompatibility between Smith's subordination to Jones as regards parish administration and Jones's subordination to Smith as regards bell-ringing. Smith and Jones are, in a way, in two different social places at the same time. But there is no inconsistency in that. To continue the metaphor: Smith and Jones exist, like other men, in a number of distinct social spaces.

There is, then, no good reason for denying that social objects are wholes with individual people as their literal parts, as real and as concrete as their members. They are, in a way, 'conceptual assemblages', in Carnap's phrase, but only in the sense that that is true of every object of reference. They do not thrust themselves so obtrusively on perception as the generality of ordinary material objects since the aggregating relations that form the collections in question are comparatively elusive and theoretical and do not involve the spatial proximity, joint movement and sharp demarcation from the spatial environment that is typical of material things. But some of these are a bit elusive themselves: the Gulf Stream, the electrical wiring of a house, or a person's cardio-vascular

system. But this kind of perceptual elusiveness does not entail that its possessors are abstractions.

10. *Methodological implications of this theory*

At first glance it seems that if ontological individualism is true the main methodological issue about social objects is easily settled. For if every statement about a social object is equivalent to and can be replaced by a statement in which only individuals are referred to and in which the predicates, whether the same as or different from those of the original statement, are predicates of individuals, then it rather trivially follows that every law about social objects is derivable from a law about individuals since it must implicitly be such a law itself.

Can such a reduction be carried out in fact? Consider an example: in every society the lower middle class is the most patriotic. That implies and would be tested by analogous assertions about particular lower middle classes. In order to establish any such assertion a sample of lower middle class people from a given society would be compared in respect of patriotism with aristocrats and proletarians. Direct reference to individuals would be reached with statements of the form: X is lower middle class and patriotic. Neither of these properties of X is a simple, natural property of an individual. It is a relational property and, in the case of patriotism, at any rate, the other term of the relation is itself a social object. To say that X is patriotic is to say something like 'X is much concerned for the welfare of his country'.

This apparent ineradicability of social terms from the most elementary statements we can make about human beings is emphasised in Mandelbaum's account of 'societal facts', in which he draws attention to the large difference between describing someone as cashing a cheque (with its implicit mention of money, a banking-system and so forth) and as giving someone an oblong piece of paper and receiving some smaller oblong pieces of paper from him. Such implicit reference to social objects enters into our most everyday remarks about the character and activities of individuals, particularly those which are going to serve as the basic empirical evidence for the propositions of history and social science.

Powerful as this consideration is, I think the individu-
alist can meet it. It is true that reference to social objects is
implicitly present in ordinary social judgments about partic-
ular individuals, since social predicates like 'is patriotic' and
'cashes a cheque' express complex relational properties among
whose terms are social objects like nations and banks. But that
does not make such references in principle ineliminable. It
is just that there is seldom any occasion to eliminate it; the
use of the predicates is too familiar. An indirect way of bring-
ing this out is to contrast a child's conception of what cashing
a cheque is, which would amount to little more than the
visible exchange of oblong pieces of paper, with an adult's
grasp of the notion which would involve a conception of the
attitudes and customary practices of the very different kinds
of people involved in a transaction of this kind.

It would be extremely laborious to spell out Mandelbaum's
example in wholly individual terms, but it could be done. In
the case of 'X is patriotic' an approximate translation is fairly
easy. It might run: 'X is one of a nationally related collection
of people and is much concerned for the well-being of that
collection of people, conceived as so related'. Even here we are
not individualistically home and dry if a common government
is held to be essential to nationhood, but that could be coped
with by means of something along the lines of Austin's defini-
tion of sovereignty. It should be noted that a patriot's state
of mind is partly constituted by his possession of the concept
of a particular kind of social object, but that does not imply
the irreducibility of that concept.

In practice our ascription of social predicates to individuals
is unreflective. It is one of the functions of social science to
clarify our social concepts in individual terms and make it pos-
sible for empirically rigorous evidence to be substituted for
unreflective impressions in the making of social judgments.

But even if this reducibility in principle is admitted there
is still an important point to be made by explanatory collec-
tivism, methodological collectivism proper, what Popper calls
'sociologism'. To maintain that laws about social objects are
in principle reducible to laws about individual people is not
to say that there is a single psychology of human beings in
general, a comprehensive theory of human nature, from which

all social laws can be derived. Popper is right to question Mill's remark, 'men are not, when brought together, converted into another kind of substance'. When they are brought together in a national, rather than a tribal or merely familial, way they do become different. In other words, the psychology that Mill thought of as the master social science will, as far as we can tell, be a social psychology. New social objects, new social systems or schemes of social relationship between men, not only make it logically possible for new things to be true of men, for instance patriotism, they also causally promote new states of mind and styles of conduct, for instance thrift or snobbery. There can be, that is to say, emergent properties of people in particular kinds of relationship to each other.

In practice a rigidly psychologistic social science is often unsatisfactory, in Pareto, for example, or Russell's *Power* or the vulgar Marxism, largely avoided by Marx, which emphasises individual acquisitiveness rather than the influence of the social and economic structure. Hobbes's social theory is an impressive example of rigid psychologism. Classical economics is even more impressive but, despite the psychological look of the postulate of utility-maximisation, is not wholly psychologistic. The maximisation postulate allows for indefinite variation between different assessments of utility, as between, for example, income and leisure, which are, no doubt, socially determined. Furthermore it assumes an initial allocation of controlled resources which implies the institution of ownership, and thus some law or custom of property, and also some institutional scheme for the exchange of factors and resources.

I believe, then, that all statements about social objects are statements about individuals, their interests, attitudes, decisions and actions. But the predicates of these statements about individuals will essentially, if only implicitly, mention social objects in a way that is not practically or usefully eliminable, even if it is eliminable in principle. Social objects are involved from the beginning in our every-day characterisations of individuals. To say that Smith owns the house he lives in presupposes a property system, although it can be translated into something like 'Smith is one of a collection of people who recognise the right of certain of their number to protect Smith

from any interference in his use and disposal of the house he lives in.'

It could turn out that the socially determined variations in human nature are themselves explainable in terms of a universal psychology. The idea is analogous to Einstein's belief in a unified theory of gravitational and electromagnetic forces. But it does not follow from ontological individualism. All that does follow is that the social determinants of human variety are themselves no more than observable relationships between individual human beings.

11. *Ethical implications of the theory*

The view that I have defended about the nature of social objects denies, on the one hand, that they are, in Hegel's phrase, the true 'ethical substances' and, at the opposite extreme, that they are mere abstractions. Both denials have ethical implications, which I can treat only very sketchily here.

The idea that social objects are mere abstractions encourages the belief that personal obligations are more important than institutional ones. That belief is expressed with some force in E. M. Forster's remark that if he had a choice between betraying a friend and betraying his country he hoped he would have the courage to betray his country. This is, in fact, to adopt an unreasoned and unreasonable preference for one kind of social object, an intimate and informal one, to another, which is more comprehensive and formal. It is, in a way, a sophisticated version of the kind of moral barbarism which regards fellow-tribesmen as moral beings but looks on everyone else as game in the open season.

No doubt this personalist moral outlook is a reaction called into being by the excesses of its collectivist opposite, that shares the extravagance of its counterpart. For when the collectivist denies that the good of the community is simply the aggregate of the goods of its individual members he is treating that community as a kind of person, or at least as something with a life of its own. If this conception is, as it should be, rejected, it should be acknowledged that what collectivists regard as the overriding common good, the preservation of the power and vitality of a scheme of social

relationships, is of no intrinsic value but has value only through its contribution to the welfare of its individual members. That contribution will be most evident in the form of what may be called convergent, as contrasted with competitive, goods; goods, that is to say, which are available to any only if available to all, like peace or a stable currency or a pure water supply. As the chief provider of convergent goods however, social objects have very great value as means. And they do not have this in quite such a contingent fashion as McTaggart's sewage-pipe. The scheme of social relationships in which a person is placed is not simply a set of mechanical arrangements for the pursuit of individual ends. It is much more intimately involved in an individual's personality than that, above all in his sense of himself. It is the framework of his settled expectations and often the object of his direct affections. The common good is indeed an aggregate of individual goods, but the individuals in question are still essentially social beings.

A comparable middle position is possible with regard to the problem of authoritative moral knowledge, one that falls between the contrary extremes of taking the convictions of the community, conceived either as those of the majority or those of some ruling group, or the convictions of the isolated individual conscience as the final arbiter. Neither the prevailing convictions of the majority of the community nor those of some ruling group within it are immune to individual criticism. On the other hand, the individual's capacity for criticism and innovation, in morality as in science, rests on the foundation of established opinions and, at a higher level, on a method of critical reasoning which the individual has derived from society. The individual can criticise the moral traditions of his community. But he can do so only with the critical weapons with which that tradition has equipped him.

II*—DELIBERATION AND PRACTICAL REASON

by David Wiggins

Consider the following three contentions:

(1) In Book III of the *Nicomachean Ethics* Aristotle treats a restricted and technical notion of deliberation which makes it unnecessary for him to consider anything but technical or so-called productive examples of practical reason. It is not surprising in the context of Book III that deliberation is never of ends but always of means (*cp.* that limited notion of rationality properly accessible to utility theory and decision theory).

(2) When he came to write Books VI and VII of the *Nicomachean Ethics* and *De Anima* III Ch 7, Aristotle analysed a much less restricted notion of deliberation and of choice. This made it necessary for him to give up the view that deliberation and choice were necessarily of *ta pros to telos*, where it is supposed that this phrase means or implies that deliberation is only of means. Thereafter he recognized two irreducibly distinct modes of practical reasoning, *means-end* deliberations and *rule-case* deliberations.[1]

(3) The supposed modification of view between the writing of Book II and Books VI-VII, and the newly introduced (supposed) 'rule-case' syllogism, bring with them a radical change in Aristotle's view of the subject—even something resembling a satisfactory solution to the problems of choice and deliberation. Thus VI-VII do better in this way than vaguely suggest what complexities a life-like account of practical deliberation would have to come to terms with.

Taken singly these doctrines are familiar enough in Aristotelian exegesis. Their conjunction, the overall picture I have given, represents something of a conflation or contamination of what I have read or heard people say.[2]

It is my submission that, both as a whole and in detail, the

* Meeting of the Aristotelian Society at 5/7, Tavistock Place, London, W.C.1, on Monday, 27th October, 1975, at 7.30 p.m.

view constituted by (1) (2) (3) is substantially and damagingly mistaken, and that it obstructs improvement in our understanding of the real philosophical problem of practical reason. The examination of (1) (2) (3) will lead (in Part III below) into some general consideration of that problem and Aristotle's contribution to it.

I shall begin by trying to show that for all its simplicities and over-schematizations, Aristotle's Book III account is in fact straightforwardly continuous with the Book VI account of deliberation, choice and practical reasoning. Both accounts attempt to analyse and describe wide and completely general notions of choice and deliberation. Both accounts are dominated, I think, by Aristotle's obsession with a certain simple situation of the kind described in Book III, 1112b—the geometer who searches for means to construct a given figure with ruler and compass. Aristotle is acutely and increasingly aware of the limitations of this analogy, but (in spite of its redeployment at 1143$^{b1-5}$) he never describes exactly what to put in its place. Twentieth Century philosophy is not yet in a position to condescend to him with regard to these questions. For all its faults, Aristotle's account is informed by a consciousness of the lived actuality of practical reasoning and its background. This is an actuality which present day studies of rationality, morality and public rationality ignore at their cost, and ignore.

1. *Rejection of the First Thesis. Book III of the* Nicomachean Ethics

The supposition that Book III set out to analyse a restricted notion of deliberation[3] or a restricted notion of choice gives rise to some internal difficulties within the book.

One apparent difficulty is this. *Bouleusis* (deliberation) is inextricably linked in Book III to *prohairesis* (choice). 'Is *prohairesis* then simply what has been decided on by previous deliberation?' Aristotle asks at 1112$^{a15}$, later to define it at 1113$^{a10}$ as *deliberative desire of what is in our power*. About choice Aristotle remarks at 111$^{b6-7}$ "choice is thought to be most closely bound up with (*oikeiotaton*) virtue and to discriminate characters better than actions do.' Now this is at least a peculiar remark if deliberation is construed as narrowly

as some have been encouraged by the geometrical example at
1112$^{b20}$ to construe it, and if we construe Aristotle's assertion
that choice and deliberation are of what is towards the end
(*tōn pros to telos*) to mean that choice and deliberation are
concerned only with means. The only straightforward way to
see it as a cardinal or conceptually prominent fact about
choice that it accurately or generally distinguishes good from
bad character, and has a certain constitutive relation to vice or
virtue, is to suppose choice to be a fairly inclusive notion
which relates to different specifications of man's *end*. The
choices of the bad or self-indulgent man, the *mochtheros* or
akolastos, would seem to be supposed by Aristotle to reveal
this man for what he is because they make straightforwardly
apparent his *misconceptions of the end*. The thought ought
not to be that the choices such men make reveal any
incapacity for technical or strictly means-end reasoning to
get what they want—the ends they set themselves. For these
they may achieve—and, in Aristotle's view, miss happiness
thereby. Their mistakes are not means-ends or technical
mistakes. (*Cp.* 1142$^{b17}$ foll. and VI.12 on *deinotēs*)

It may be objected that the thought is neither of these
things, but that by seeing a man's choices one can come to see
what his ends are; and to know what his ends are is to arrive
at a view of his character. But this interpretation, which
scarcely does justice to *oikeiotaton*, must seem a little unlikely
as soon as we imagine such an indirect argument to a man's
ends. Typically, *actions* would have to mediate the argument.
But actions are already mentioned by Aristotle in an un-
favorable contrast. "Choice . . . discriminates characters
better than actions do."

The interpretation of this passage is not perfectly essential
to my argument, however. Let us go on, simply remarking
that the onus of proof must be on the interpretation which
hypothesises that *prohairesis* or *bouleusis* means something
different in Book III and Books VI and VII. The first effort
should be to give it the same sense in all these books. I hope
to show that this is possible as well as desirable, and that if
anything at all gets widened in Book VI it is the *analysis* of
choice and deliberation, not the sense of the word. Each
must be one *analysand* throughout. As so often there has been

confusion in the discussion of this issue because a *wider analysis of notion N* has sometimes been confused with an *analysis of a wider notion N*. 'Wider conception' is well calculated to mask the difference between these fatally similar-looking things. But let us distinguish them.

There are certainly reasons why some scholars have seen the Book III notions of deliberation and choice as technical notions which were superseded by wider notions, and then by wider philosophical analyses of either or both notions. These reasons derive from Aristotle's frequent assertions that, unlike *boulēsis* (wish), choice and deliberation are not *of the end* but of *what is towards the end (pros to telos)*. See 1111^{b26}, 1112^{b11-12}, 1112^{b34-35}, 1113^{a14-15}, 1113^{b3} [4]. If *what is towards the end* in Book III is taken (as it is for instance by Ross in his translation) to be a *means to an end* then that must certainly suggest that, as regards *prohairesis* and *bouleusis*, we have a wider *analysand*, as well as a wider analysis) in Books VI–VII. But I argue that they need not be taken so.

It is a commonplace of Aristotelian exegesis that Aristotle never really paused to analyse the distinction between two quite distinct relations, (A) the relation x bears to *telos* y when x will bring about y, and (B) the relation x bears to y when the existence of x will itself help to constitute y. For self-sufficient reasons we are committed in any case to making this distinction very often on behalf of Aristotle when he writes down the words *heneka* or *charin* (for the sake of). See e.g., Book I 1097^{b1-5}. The expression *towards the end* is vague and perfectly suited to express both conceptions.

The first notion, that of a means or instrument or procedure which is causally efficacious in the production of a specific and settled end, has as its clear cases such things as a cloak as a way of covering the body when one is cold, or some drug as a means to alleviate pain. The second notion which can take shelter under the wide umbrella of *what is towards the end* is that of something whose existence counts in itself as the partial or total realization of the end. This is a constituent of the end cp. *Met* 1032^{b27} (N.B. *meros* there), *Politics* 1325^{b16} and 1338^{b2-4}. Its simple presence need not be logically necessary or logically sufficient for the end. To a very limited extent the achievement of one end may do duty for that of

another. Perhaps there might even be some sort of *eudaimonia* (happiness) without good health, or without much pleasure, or without recognized honour, or without the stable possession of a satisfying occupation. But the presence of a constituent of the end is always logically relevant to happiness. It is a member of a nucleus (or one conjunct, to mention a very simple possibility, in a disjunction of conjunctions) whose coming to be counts as the attainment of that end. Happiness is not identifiable in independence of such constituents (*e.g.*, as a feeling which these elements cause, or as some surplus which can be measured in a man's economic behaviour).

If it commits us to no new interpretive principle to import this distinction into our reading of Book III, and to suppose that both these relations are loosely included within the extension of the phrase *what is towards the end*, then, on this understanding of the phrase, Aristotle is trying in *NE* III (however abstractly and schematically) to treat deliberation about means and deliberation about constituents in the same way. Optimistically, he is hoping that he can use the intelligibilities of the clear means-end situation and its extensions (how to effect the construction of this particular figure) to illuminate the obscurities of the *constituents to end* case. In the latter a man deliberates about what kind of life he wants to lead, or deliberates in a determinate context about which of several possible courses of action would conform most closely to some ideal he holds before himself, or deliberates about what would constitute *eudaimonia* here and now, or (less solemnly) deliberates about what would count as the achievement of the not yet completely specific goal which he has already set himself in the given situation. For purposes of any of these deliberations the means-end paradigm is an inadequate paradigm, as we shall see. But it is not easy to get away from. It can continue to obsess the theorist of action, even while he tries to distance himself from it and searches for something else.

There are two apparent obstacles in Book III to interpreting the passages on choice and deliberation in this way, and to making the crudities of the book continuous with the sophistications of Books VI–VII.

(α) Three times Aristotle says, "We do not deliberate

about *ends* but about *things which are towards ends,"* and the plural may have seemed to anyone who contemplated giving my sort of interpretation to rule out the possibility that any part of the extension of *things which are towards ends, i.e.,* things which are deliberated, should comprise deliberable constituents of *happiness* (singular), *i.e.,* ends in themselves. If we do not deliberate about ends (plural), then it seems we do not deliberate about the constituents of happiness, which are ends, *i.e.,* about things which are good in themselves and help to make up happiness *(tele)*. So, it will be said, 'that which is towards the end' cannot ever comprehend any constituents of happiness—these being according to Aristotle undeliberable. But on my interpretation it may include such constituents. Therefore, it may be said, Ross' translation of *pros* in terms of *means* is to be preferred.

(β) To deliberate about that which is towards happiness in the case where the end directly in question in some practical thinking is happiness might, if *that which is towards happiness* included constituents, involve deliberating happiness. But this Aristotle explicitly excludes.

Reply to (α). The first passage of the three in question, 1112^{b1} reads

"We deliberate *(bouleuometha)* not about ends but about what is towards ends. For a doctor does not deliberate whether he shall heal, nor an orator whether he shall persuade, nor a statesman whether he shall produce law and order, nor does anyone else *deliberate about his end*. They assume the end and consider by what means it is to be attained, and if it seems to be produced by several means they consider by which it is best and most easily produced, while if it is achieved by one only they consider how it will be achieved by this, and by what means that will be achieved till they come to the first cause, which in the order of discovery is last. For the person who deliberates seems to investigate and analyse in the way described as though he were analysing a geometrical construction (not all seeking is deliberation but all deliberation is seeking), and what is last in the order of analysis seems to be first in the order of being brought about."

I submit that the four words I have italicized show that the *bouleuometha* (we deliberate) and the use of the plural *telon* (ends) are to be taken distributively. Each of these three gentlemen, the orator, doctor, or statesman has *one* telos (for present purposes). He is already a doctor, orator or statesman and already at work. That is already fixed (which is not to say that it is absolutely fixed), and to that extent the form of the *eudaimonia* he can achieve is already conditioned by something no longer needing (at least at this moment) to be deliberated. If I am right about this passage then there seems to be no obstacle to construing the other two occurrences of the plural, 1112$^{b34-5}$ and 1113$^{a13-14}$ (both nearby), as echoes of the thought at 1112$^{b11}$, and taking *towards the end* (singular) as the canonical form of the phrase. (*cp.* 1113$^{b3-4}$, 1145$^{a4-5}$ for instance). Provided only that difficulty (β) can be met, this end may (where required) be a man's total end, *viz.*, happiness.

This reply prompts another and supplementary retort to the difficulty. Suppose I were wrong so far and that *that which is towards the end* (singular) had no special claim to be the canonical form of the phrase. Consider then the case where Aristotle is considering deliberations whose direct ends are not identical with happiness. (Presumably the indirect end will always be happiness *cp.* 1094a.) Such ends need not be intrinsically undeliberable ends, but simply ends held constant *for the situation*; *cp.* 1112$^{b11}$ "assuming the end" *themenoi to telos*.

Reply to (β). It is absurd to suppose that a man could not deliberate about whether to be a doctor or not; and very nearly as absurd to suppose that Aristotle, even momentarily while writing Book III, supposed that nobody could deliberate this question. It is so absurd that it is worth asking whether the phrase *deliberating about the end* or *deliberating about happiness* is ambiguous. It is plainly impossible to deliberate about the end if this is to deliberate by asking, 'Shall I pursue the end?' If this end is *eudaimonia*, then *qua* animate and men we have to have some generalized desire for it (a generalized desire whose particular manifestations are desires for things falling under particular specifications of that *telos*). Simply to call *eudaimonia* the *end* leaves nothing to be deliberated about whether it should be realized or not.

That is a sort of truism (cp. 1097$^{b23}$ *homologoumenon ti*), as is
the point that, if the desirability of *eudaimonia* were really
up for debate, then nothing suitable by way of practical or
ethical concern or by way of desire would be left over (outside
the ambit of *eudaimonia* itself) to settle the matter. But this
platitude scarcely demonstrates the impossibility of deliberat-
ing the question 'what practically speaking *is* this end?' or
'what shall *count* for me as an adequate description of the
end of life?' And so far as I can seen nothing Aristotle says in
Book III precludes that kind of deliberation. The only
examples we are given of things which we might conclude
are instrinsically undeliberable are health and happiness.
(1111$^{b26}$). The first is arguably (at least in the philosophy of the
Greeks) an undetachable part of the end for human beings.
The second is identical with the end as a whole (and no more
practically definite an objective than 'the end'). So we are not
given examples of logically detachable constituents of the end
or of debatable specifications of the end to illustrate Aristotle's
thesis in *NE* III. But, on the traditional interpretation of the
undeliberability thesis, these were what was needed. So what
I think he is saying that one cannot deliberate is *whether* to
pursue happiness or health. It is not in any case excluded that
(as described in *NE* VI) a man may seek by deliberation to
make more specific and more practically determinate that
generalized *telos* of *eudaimonia* which is instinct in his human
constitution.

If this is right so far, then I think another step is taken
beyond what is achieved in Allan's discussion to dissociate
Aristotle's whole theory of deliberation from that pseudo-
rationalistic irrationalism, insidiously propagated nowadays
by technocratic persons, which holds that reason has nothing
to do with the ends of human life, its only sphere being the
efficient realization of specific goals in whose determination
or modification argument plays no substantive part.[4]

II. *Rejection of the Second Thesis. The Transition to Book VI.*

On the reading of Book III so far defended the transition
from *NE* III to *NE* VI is fairly smooth.

> "Regarding *practical wisdom* we shall get at the truth by considering who are the persons we credit with it. Now it is thought to be the mark of a man of practical wisdom to be able to deliberate well about what is good and expedient for himself, not in some particular respect, e.g. about what sorts of thing conduce to health or to strength, but about what sorts of things conduce to the good life in general." (*poia pros to eu zēn holōs* 1140[a24-28], Ross' translation—note the *pros*)

And again

> "Practical wisdom on the other hand is concerned with things human and things about which it is possible to deliberate; for we say this is above all the work of a man of practical wisdom, to deliberate well. . . . The man who is without qualification good at deliberating is the man who is capable of aiming in accordance with calculation at the best for man of things attainable by action. Nor is practical wisdom concerned with universals only—it must also recognize particulars. That is why some who do not know, and especially those who have experience, are more practical than others who know." (1141[b9] following, Ross.)

Aristotle is saying here, amongst other things, that practical wisdom in its deliberative manifestations is concerned both with the attainment of particular formed objectives and also with questions of general policy—what specific objectives *to* form. He contrasts the two components and in doing so he commits his investigation to the study of both. (*cp.* 1142[b30]) On my view of *N.E.* III, we ought not to be surprised by this. But there is a philosophical difficulty about this kind of deliberation which becomes plainer and plainer as *N.E.* VI proceeds.

Aristotle had hoped in *N.E.* III to illuminate examples of non-technical deliberation by comparing them with a paradigm drawn from technical deliberation. The trouble with both paradigm and comparison is this. It is absolutely plain what counts as my having adequate covering, or as my having succeeded in drawing a plane figure of the prescribed kind using only ruler and compass. The practical question here is

only what means or measures will work or work best or most
easily to those ends. But the standard problem in a non-
technical deliberation is quite different. In the non-technical
case I shall characteristically have an extremely vague de-
scription of something I want—a good life, a satisfying pro-
fession, an interesting holiday, an amusing evening—and the
problem is not to see what will be causally efficacious in bring-
ing this about, but to see what really *qualifies* as an adequate
and practically realizable specification of what would satisfy
this want. Deliberation is still *zetēsis*, a search, but it is not
primarily a search for means. It is a search for the *best speci-
fication*. Till the specification is available there is no room
for means. When this specification is reached, means-end
deliberation can start, but difficulties which turn up in this
means-end deliberation may send me back a finite number of
times to the problem of a better or more practicable specifi-
cation of the end. And the whole interest and difficulty of the
matter is in the search for adequate specifications, not in the
technical means-end sequel or sequels. It is here that the
analogy with the geometer's search, or the search of the
inadequately clothed man, goes lame.

It is common ground between my interpretation and the
interpretation of those who would accept the three tenets
given at the outset, contentions (1) (2) (3), that Aristotle
sensed *some* such difficulty in his dealings with practical
reason. But, according to the other interpretation (see (2) and
(3)), Aristotle was led at this point to make a distinction be-
tween the situation where the agent has to see his situation as
falling under a rule and the situation where the agent has
simply to find means to encompass a definite objective.

Professor Allan gives the most argued form of this inter-
pretation. Speaking of the practical syllogism he says, 'in some
contexts actions are subsumed by intuition under general
rules, and performed or avoided accordingly. . . . In other
contexts it is said to be a distinctive feature of practical
syllogisms that they start from the announcement of an
end . . . [he then instances *N.E.* 1144$^{a31}$, 1151$^{a15-19}$, and *E.E.*
1227$^{b28-32}$] . . . A particular action is then performed because
it is a means or the first link in a chain of means leading to the
end.' (2) In support of this he claims to find Aristotle making

such a distinction in the syllogisms mentioned at *De Motu Animalium* 701$^{a9}$ *seq.* In Forster's Loeb translation that passage reads as follows:

"The conclusion drawn from the two premises becomes the action. For example, when you conceive that every man ought to walk and you yourself are a man, you immediately walk; or if you conceive that on a particular occasion no man ought to walk, and you yourself are a man, you immediately remain at rest. In both instances action follows unless there is some hindrance or compulsion. Again, I ought to create a good, and a house is a good, I immediately create a house. Again, I need a covering, and a cloak is a covering, I need a cloak. What I need I ought to make; I need a cloak, I ought to make a cloak. And the conclusion 'I ought to make a cloak' is an action. The action results from the beginning of the train of thought. If there is to be a cloak, such and such a thing is necessary, if this thing then something else; and one immediately acts accordingly. That the action is the conclusion is quite clear; but the premises which lead to the doing of something are of two kinds, through the good and through the possible."

Now I think Allan understands this passage in a strange way. For he writes 'Aristotle begins with an example of the former (*sc.* rule-case) type (the walk syllogism) but includes among other examples one of the latter type (the cloak syllogism). And he adds that the premises may be of two forms, since they specify either that something is good, or how it is possible (*hai de protaseis hai poiētikai dia duo eidōn ginontai, dia te tou agathou kai dia tou dunatou*—the premises which lead to the doing of something are of two kinds, concerning the good and the possible)'. This is a strange reading. The walk syllogism like the next syllogism would have to be treated as a dummy syllogism, a mere variable in any case. For even if Allan's distinction between two kinds of syllogism could stand, the syllogism would be an idiotic example of either. No conclusion could safely rest on its 'rule-like' appearance. It would also be difficult to settle which sort the house-syllogism belonged to if any such distinction were intended.

In truth, the sentence about two kinds of premisses seems to be no more than an allusion to the general form often manifestly displayed and always present (I believe) in Aristotelian action-syllogisms. The first or major premiss mentions something of which there could be a desire, *orexis*, transmissible to some practical conclusion (*i.e.*, a desire convertible *via* some available minor premiss into an action). The second premiss pertains to the feasibility in the particular situation to which the syllogism is applied of what must be done if the claim of the major premiss is to be heeded. In the context of these *De Motu* examples nothing could be more natural than to describe the first premiss of a practical syllogism as *pertaining to the good* (the fact that it pertains to some good—either a general good or something which the agent has just resolved is good in this situation—is what beckons to desire); and to describe the second or minor premiss as *pertaining to the possible* (where 'possible' both means feasible given the particular situation of the agent and also suggests the relevance of some aspect of the situation, as described, to the first premiss). I can find no textual support for Allan's attempt to make the distinction into a distinction between different kinds of major premisses. Indeed no syllogism could be truly practical, or be appropriately backed by *orexis*, if its major premiss were simply of the possible.

So much for the alleged presence of the distinction between rule-case and means-end syllogisms in the *De Motu* passage. But even if I were wrong (and even if a distinctive rule-case type of syllogism were found at *N.E.* VII), still contention (3) would founder on other rocks. Allan's distinction of syllogisms is not the right distinction to solve Aristotle's problem, or *the* problem, of practical deliberation. The deliberative situations which challenge philosophical reflection to replace the means-ends description do not involve a kind of problem which anybody would think he could solve by subsuming a case under rules: whereas the comparatively trivial technical problems which are treated by Allan as means-end cases might often be resolved by recourse to rules. Nor can this difficulty be avoided by suggesting that if a policy-question becomes too general or all-embracing then there is no longer any rational deliberation about it. For Aristotle there is. He is convinced

that the discovery and specification of the end is an intel-
lectual problem, among other things, and belongs to practical
wisdom. See 1139$^{a21}$, for instance:

> "If excellence in deliberation, *euboulia*, is one of the
> traits of men of practical wisdom, we may regard this
> excellence as correct perception of that which conduces
> to the end, whereof practical wisdom is a true
> judgement".

It is one of the considerable achievements of Allan's interpre-
tation to have resolved the dispute about this sentence and to
leave it meaning what the ancient tradition took it to mean,
and what it so obviously does mean. The good is the sort of
thing which we wish for *because we think it good*, not some-
thing we think good because it is what we wish for. Thought
and reason *(not without desire*, I must add) are the starting
point.[5]

If all this were not enough to wreck contentions (2) and (3),
then Aristotle's own remarks elsewhere about the character
of general rules and principles would be enough to discredit
the rule-case approach. There *are* no general principles or
rules anyway. "Matters concerned with conduct and questions
of what is good for us have no fixity, any more than matters
of health. The general account [of practical knowledge]
being of this nature, the account of particular cases is yet
more lacking in exactness; for they do not fall under any art
or precept but the agents themselves in each case consider
what is appropriate to the occasion, as happens also in the
art of medicine and navigation" (1104$^{a7}$, compare 1107a28).
From the nature of the case the subject matter of the practical
is indefinite and unforeseeable, and any supposed principle
would have an indefinite number of exceptions. To under-
stand what such exceptions would be and what makes them
exceptions would be to understand something not reducible
to rules or principles. The only metric we can impose on the
subject matter of practice is the metric of the Lesbian rule:

> "In fact this is the reason why not everything is deter-
> mined by law and special and specific decrees are often
> needed. For when the thing is indefinite the measure of

it must be indefinite too like the leaden rule used in making the Lesbian moulding. The rule adapts itself to the shape of the stone and is not rigid, and so too a special decree is adapted to the facts" (1137^{b6} following, cp. *Politics* 1282^{b3}).

I conclude that what Aristotle had in mind in Book VI was nothing remotely resembling what has been ascribed to him by his Kantian and other deontomaniac interpreters. Certainly contention (3) must seem absurdly overstated if the only new material which we can muster on Aristotle's behalf for the hard cases of deliberative specification is the 'rule-case' syllogism.

III. *The Books VI-VII Treatment of Deliberative Specification—a general framework for its interpretation and evaluation*

N.E. VI can be seen in a more interesting light than this. On the interpretation to be presented I admit that the new materials largely consist of sophistications, amendments, and extensions of the means-ends model. Nor is the problem of the 'validity' of the practical syllogism solved. But Aristotle has a number of ideas to offer which, however sketchily and obscurely he expressed them, seem to me to be of more fundamental importance than anything to be found now in utility theory, decision theory, or other rationality studies. That Aristotle's ideas are inchoate, however, is only one part of what is troublesome in establishing this claim. There is also the difficulty of finding a perspective or vantage point, over a philosophical terrain still badly understood, from which to view Aristotle's theory; and the difficulty (in practice rarely overcome) of sustaining philosophic momentum over a prolonged examination of a large number of obscure but relevant passages of the *Ethics* and *De Anima*. Finally there is one more impediment: that in *NE* VII Aristotle allows the problem of incontinence to confuse and disrupt his whole theory of practical reason.

To these difficulties my practical response is to adjourn all discussion of *akrasia* and, proceeding as if Aristotle had avoided the errors of *NE* VII, to give the bare outline (a)–(g)

of a neo-Aristotelian theory of practical reason. After that I shall amplify one cardinal point in this theory by giving an expanded paraphrase of two of the most obscure and most important passages about practical reason in *NE* VI. The only excuse I can offer to scholars, whom this style of interpretation will scandalize, is the Society's limitation of length. Your only defence against prejudicial a method of exposition is to compare the paraphrase with the Ross translation.

(a) There are theories of practical reason according to which the ordinary situation of an agent who deliberates resembles nothing so much as that of a snooker player who has to choose from a large number of possible shots that shot which rates highest when two products are added. The first product is the utility of the shot's success (a utility which in snooker depends upon the colour of the ball to be potted and the expected utility for purposes of the next shot of the resulting position), multiplied by the probability P of this player's potting the ball. The second product is the utility (negative) of his failure multiplied by $(1-P)$. It is neither here nor there that it is not easy to determine the values of some of these elements for purposes of comparing prospects. There is no problem about the end itself, nor about the means, which is maximizing points. What is more, there do exist deliberative situations, apart from snooker, which are a bit like this. But with ordinary deliberation it is quite different. There is nothing which a man is under antecedent sentence to maximize; and probabilities, though difficult and relevant, need not be the one great crux of the matter. A man usually asks himself 'What shall I do?' not with a view to maximizing anything, but only in response to a particular context. This will make particular and contingent demands on his moral and practical perception, but the relevant features of the situation may not all jump to the eye. To see what they are, to prompt the imagination to play upon the question and let it activate in reflection and thought-experiment whatever concerns and passions it should activate, may require a high order of situational appreciation, or as Aristotle would say perception (*aisthēsis*). In this, as we shall see, and in the unfortunate fact that few situations come already inscribed with the names of all the human concerns

which they touch or impinge upon, resides the crucial import-
ance of the minor premiss of the practical syllogism.

(b) When the relevant concerns are provisionally identified
they may still be too unspecific for means-end reasoning to
begin. See the account of 'deliberative specification' in Section
II above. *Pace* the utility and decision theorists, who concern
themselves exclusively with what happens *after* this point,
most of what is interesting and difficult in practical reason
happens here, and under (a).

(c) No theory, if it is to recapitulate or reconstruct practical
reasoning even as well as mathematical logic recapitulates or
reconstructs the actual experience of conducting or exploring
deductive argument, can treat the concerns which an agent
brings to any situation as forming a closed, complete, con-
sistent system. For it is of the essence of these concerns to
make competing and inconsistent claims. (This is a mark not
of irrationality but of *rationality*, see (e) below, in the face of
the plurality of ends.)[6] The weight of the claims represented
by these concerns is not necessarily fixed in advance. Nor need
the concerns be hierarchically ordered. Indeed a man's
reflection on a new situation which confronts him may disrupt
such order and fixity as had previously existed, and bring a
change in his evolving conception of the point (*to hou
heneka*), or the several or many points, of living or acting.

(d) A man may think it is clear to him, in a certain situa-
tion, what is the relevant concern, yet find himself discontent
with every practical syllogism promoting that concern with a
major premiss representing the concern. He may resile from
the concern when he sees what it leads to, or what it costs, and
start all over again. The set of relevant concerns is not there-
fore closed. (The same would have to apply to public ration-
ality, if we had that. In a bureaucracy, where action is not
constantly referred back to what originally motivated it, the
problem is to make room for this stepping back and re-
evaluation. This is one of the conceptual foundations for a
reasoned hatred of bureaucracy, and for the demand for
'public participation' in planning. If one dislikes the last
one should go back to the beginning and re-examine the
ends for which a bureaucracy of such a size was needed, and
also the means chosen to realize them.)

(e) The unfinished or indeterminate character of our ideals and value structure is constitutive both of human freedom and, for finite creatures who face an indefinite or infinite range of contingencies with only finite powers of prediction and imagination (NE 1137b), of practical rationality itself.

(f) The man of highest practical wisdom is the man who brings to bear upon a situation the greatest number of pertinent concerns and relevant considerations commensurate with the importance of the deliberative context. The best practical syllogism is that whose minor premiss arises out of such a man's perceptions, concerns and appreciations. It records what strikes such a man as the, in the situation, most salient feature of the context in which he has to act. This activates a corresponding major premiss which spells out the general import of the concern which makes this feature the salient feature in the situation. The larger the set of considerations which issue in the singling out of the feature, the more compelling the syllogism. But there are no formal criteria by which to compare the claims of competing syllogisms. Inasmuch as the syllogism arises in a determinate context the major premiss is evaluated not for its unconditional acceptability, but for its adequacy to the situation. It will be adequate for the situation if and only if circumstances which could restrict or qualify it and defeat its applicability at a given juncture do not in the practical context of this syllogism obtain. Its evaluation is of its essence dialectical, and all of a piece with the perceptions and reasonings which gave rise to the syllogism in the first place.

(g) Since the goals and concerns which an agent brings to a situation may be diverse and incommensurable, and may not in themselves dictate any decision, they need not constitute the materials for some psychological theory (or any empirical theory above the conceptual level of a theory of matter) to make a prediction of the action.[7] Nor need anything else constitute these materials. There is simply no reason to expect that it will be possible to construct an (however idealized) empirical theory of the rational agent to parallel the predictive power, explanatory non-vacuity and satisfactoriness for its purposes of (say) the economic hypothesis that, under a wide variety of specifiable circumstances,

individual firms will push every line of action open to them to the point where marginal cost and marginal revenue are equal.

My first translation *cum* paraphrase is of 1142[a23] following:

> That practical wisdom is not deductive theoretical knowledge is plain. For practical wisdom is, as I have said, of the ultimate and particular—as is the subject matter of action. In this practical wisdom is the counterpart or dual of theoretical intuition. *Theoretical* intellect or intuition is of the ultimate but in this sense—it is of ultimate universal concepts and axioms which are too primitive or fundamental to admit of further analysis or of justification from without. [At the opposite extreme] practical wisdom [as a counterpart of theoretical reason] also treats of matters which defy justification from without. Practical wisdom is of what is ultimate and particular in the sense of needing to be quite simply perceived. By perception here I do not mean sense perception but the kind of perception or insight one needs to see that a triangle, say, is one of the basic or ultimate components [of a figure which one has to construct with ruler and compass]. [For there is no routine *procedure* for analysing a problem figure into the components by which one may construct it with rule and compasses.] The analysis calls for insight and there is a limit to what one can say about it. But even this sort of insight is more akin to sense perception than practical wisdom is really akin to sense perception.

Comment: On this reading the geometer example turns up again. The method which the geometer discovers to construct the prescribed figure has a property unusual in a technical deliberation and ideal for making the transition to another kind of case, that of being in some sense constitutive of the end in view. It counts as the answer to a question he was asked (and would be proved to count so). *Caution*. Paraphrase and interpretation is not here confined to square-bracketed portions.

The other paraphrase *cum* translation I offer is of *N.E.* 1143[a25]ff:

"... when we speak of judgement and understanding
and practical wisdom and intuitive reason we credit the
same people with possessing judgement and having
reached years of reason and with having practical wisdom
and understanding. For all these faculties deal with ulti-
mates, *i.e.*, with what is particular; and being a man of
understanding and of good or sympathetic judgement
consists in being able to judge about the things with
which practical wisdom is concerned; for the equities
are common to all good men in relation to other men.
Now all action relates to the particular or ultimate; for
not only must the man of practical wisdom know parti-
cular facts, but understanding and judgement are also
concerned with things to be done, and these are ulti-
mates. And intuitive reason is concerned with ultimates
in both directions [*i.e.*, with ultimates in two senses and
respects, in respect of extreme generality and in respect of
extreme specificity.] For intuitive reason [the general
faculty] is of both the most primitive and the most ulti-
mate terms where derivation or independent justification
is impossible. In the case of that species of intuitive reason
which is the theoretical intuition pertaining to demon-
strative proof, its object is the most fundamental concepts
and axioms. In its practical variety on the other hand
intuitive reason concerns the most particular and contin-
gent and specific. This is the typical subject matter of the
minor premise of a practical syllogism [the one which is
'of the possible']. For here, in the the capacity to find
the right feature and form a practical syllogism, resides
the understanding of the reason for performing an action,
its end. For the major premiss, and the generalizable
concern which comes with it, arises from this perception
of the particular. So one must have an appreciation or
perception of the particular, and my name for this is
intuitive reason. [It is the source both of particular
syllogisms and of general principles, concerns, or ideals.]
... we think our powers correspond to our time of life,
and that a particular age brings with it intuitive reason
and judgement; this implies that nature is the cause. ...
Therefore we ought to attend to the undemonstrated

sayings and opinions of experienced and older people or of people of practical wisdom not less than to demonstrations; for because experience has given them an eye they see aright."

Comment. It is the mark of the man of practical wisdom on this account to be able to select from the infinite number of features of a situation those features which bear upon the notion or ideal of human existence which it is his standing aim to make real. This conception of human life does not reside in a set of rules or precepts—useful though Aristotle would allow these to be at a certain stage in the education of the emotions. In no case will there be a rule which a man can simply appeal to to tell him exactly what to do. He may have to invent the answer to the problem. As often as not this, like the frequent accommodations he has to effect between the claims of competing values, may count as a modification or innovation or further determination in the evolution of his view of what a good life is.

Conclusion. Against this theory, as I have explained it, it may be complained that in the end very little is said, because everything which is hard has been permitted to take refuge in the notion of *aisthesis* (or *situational appreciation* as I have paraphrased it). And in *aisthēsis*, as Aristotle says, explanations give out. But if there is no real prospect of an ordinary empirical theory of all of action and deliberation as such, see (g) above, then the thing we should look for may be precisely what Aristotle provides—namely, a conceptual framework which we can apply to particular cases, which articulates the reciprocal relations of an agent's concerns and his perception of how things objectively are in the world; a schema of description which relates the ideal the agent tries to make real to the form which the world impresses, both by way of *opportunity* and by way of *limitation*, upon that ideal. Here as von Wright says, are knitted together "the concepts of wanting an end, understanding a necessity, and setting oneself to act. It is a contribution to the moulding or shaping of these concepts."[8] I entertain the unfriendly suspicion that those who feel they *must* seek more than this want a scientific theory of rationality not so much from a passion for science,

even where there can be no science, but because they hope and desire, by some conceptual alchemy, to turn such a theory into a regulative or normative discipline, or into a system of rules by which to spare themselves some of the agony of thinking and all the torment of feeling that is actually involved in reasoned deliberation.

NOTES

† Parts I and II of this essay have been circulating in typescript since 1962 and as a result I have had the inestimable benefit (from which they will feel I had the time and ought to have had the ability to profit better) of comments from J. L. Ackrill, M. J. Woods, M. F. Burnyeat, R. Sorabji (without the support of whose article *P.A.S.* 1973/4 "Aristotle on the rôle of intellect in virtue" I should have had to postpone publication yet further), J. C. Dybikowski, T. Irwin, M. L. C. Nussbaum and G. E. L. Owen. To the last-named I owe also the invitation to continue Parts I and II into Part III and on to a section on *akrasia* (not given here) as James Loeb visiting fellow in Classical Philosophy at Harvard in Spring 1972.

1 I think that those who employ these or similar terms usually intend the distinction of two kinds of reasoning, and the two distinct kinds of non-theoretical syllogism allegedly recognized by Aristotle, to correspond in some way to Aristotle's distinction of production *poiēsis* and practice *praxis*.

2 (1) (2) (3) is to be sharply distinguished from the (worse mistaken) subjectivist interpretation still in some quarters defended. This enlarges the rôle of moral virtue at the expense of intellect and, so far as possible, assimilates *NE* VI to *NE* III—where *NE* III is read in an exclusively means-end fashion. (1) (2) (3) is closer to the reason-oriented naturalist interpretation I shall commend and, like my interpretation, it owes much to Professor D. J. Allan. See his "Aristotle's Account of the Origin of Moral Principles" *Proceedings of the XIth International Congress of Philosophy*, Volume XII, (hereinafter referred to as Allan (1)) and "The Practical Syllogism" in *Autour d'Aristote: Recueil pour Mgr. Mansion*, (hereinafter referred to as Allan (2)). These publications represent so considerable an advance in clearing away the mass of captious misinterpretation to which Aristotle's praxeology had been previously subjected that I have preferred to consider the composite view given above rather than dwell on Allan's special version of it. But I shall allude frequently to his treatment of single passages.

What principally distinguishes Allan's view from the composite view (1) (2) (3) is that Allan is inclined to say that the changes he postulates between the view of III and the view of VI-VII leave Aristotle's analysis of *deliberation* itself more or less unaffected. Against this, I say either the alleged rule-case reasoning, which is admitted by Allan to be *prohairetic*, can be properly termed deliberative or it cannot. If it can then, if choice needed radical alteration, then so *on Allan's interpretation of it* did the Book III account of deliberation. It could not remain unaffected. For precisely the same considerations then operate on both. If we say it cannot be termed deliberative, however, we contradict 1140a27-8. *Cp.* also 1139a23, 1141b8-15.

3 *Cp.* Allan (1) p. 124 ". . . the good propounded may be (a) distant or (b) general. Thus there is fresh work for practical reason to perform. In the former

case, we have first to calculate the means which will, in due course, achieve the end. In the latter, we have to *subsume the particular case under a general rule*. Both these processes are analysed by Aristotle in a masterly fashion, *in different parts of his work, the former in the third book* of the Ethics, the latter in Books VI and VII and in his psychological writings" (my italics). And *cp.* (2) "His *first* position in the *Ethics* is that all virtuous action involves choice, that all choice follows up a deliberation and *that all deliberation is concerned with the selection of means.*" (my italics.)

⁴ *Cp.*, at random, Jeremy Bray *Decision in Government* (Gollancz, London 1970) page 72 ". . . the individual consumer's own decision processes which are the more complex for not being wholly rational in any economic sense." (Is there really, or should there be, a special sense of "rational" in economics?) Bray goes on to suggest that anyone who thinks there is room for reason in this sphere, or sets much store by the concept of *need*, must wish to deny freedom: "However the concept of minimum need may be used in social security arrangements, it is a poor guide to consumer behaviour whether at the minimum income or other levels, and whether in an advanced or primitive society. The particular purchases made by a family reflect not only their immediate tastes such as a liking for warmth, bright colours, and tinned fruit, but also their spiritual life and fantasy world—the stone fireplace as a safe stronghold in a morally insecure world, the Jaguar car to release frustration or bolster a waning virility, the tingling toothpaste as a ritual purification. Far from being a matter for ridicule, consumer choice is something to nurture, cultivate and protect." In the name of liberty, yes, but not because these ends are really outside the reach of reason or rational appraisal. Lest Bray's seem to be a purely Fabian doctrine, I quote a Chicago School economist Milton Friedman: "Differences about economic policy among disinterested citizens derive predominantly from different predictions . . . rather than from fundamental differences in basic values, differences *about which men can only fight*" (my italics) page 5, *Essays in Positive Economics*. For a protest see Alan Altshuler *The City Planning Process* (*ad init.*)

⁵ See *Politics* 1332b6 and *Metaphysics* 1072a20 "We desire it because it seems good to us, it doesn't seem good to us because we desire it." It is the beginning of wisdom on this matter, both as an issue of interpretation and as a philosophical issue, to see that we do not really have to choose between Aristotle's proposition and its apparent opposite (as at *e.g.*, Spinoza *Ethics* pt. III proposition 9 note). We can desire because it seems good *and* it seem good because we desire it.

⁶ Jonathan Glover speaks at p. 183 of *P.A.S. Supp. Vol.* 1975 of "the aesthetic preference most of us have for economy of principles, the preference for ethical systems in the style of the Bauhaus rather than Baroque." Against this, I say that only a confusion between the practical and the theoretical could even purport to provide reasoned grounds for such a preference. (For the beginnings of the distinction, see Bernard Williams "Consistency and Realism" *P.A.S. Supp. Vol.* XL, 1966.) Why is an axiom system any better foundation for practice than *e.g.*, a long and incomplete or open-ended list of (always at the limit conflicting) *desiderata*? The claims of all true *beliefs* (about how the world is) are reconcilable. Everything true must be consistent with everything else that is true. But not all the claims of all rational concerns or even all moral concerns (that the world *be* thus or so) need be reconcilable. There is no reason to expect they would be; and Aristotle gives at 1137b the reason why we cannot expect to lay down a decision procedure for adjudication in advance between claims, or for prior mediation. By the dragooning of the plurality of goods into

the order of an axiom system I think practice will be almost as rapidly and readily degraded (and almost as unexpectedly perhaps) as modern building, by exploitation of the well-intentioned efforts of the Bauhaus, has been degraded into the single-minded pursuit of profit. The last phase of Walter Gropius' career will repay study by those drawn to Glover's analogy.

[7] See Donald Davidson "Mental Events" in *Experience and Theory* ed. Foster and Swanson, Duckworth, London 1971. Also my "Towards a Reasonable Libertarianism" in *Essays on Freedom and Action* (edited T. Honderich, Routledge 1973) p. 36-41.

[8] *Varieties of Goodness* p. 171. Both for the quotation and in the previous sentence I am indebted to M. L. C. Nussbaum. She writes (in an unpublished edition of *De Motu*):

> "the appeal of this form of explanation for Aristotle may lie in its ability to link an agent's desires and his perceptions of how things are in the world around him, his subjective motivation and the objective limitations of his situation . . . animals are seen as acting in accordance with desire, but within the limits imposed by nature".

III*—ON THINKING OF WHAT ONE FEARS

by J. M. Howarth

I

It is a familiar claim that the difference between certain emotions, for instance between fear and repulsion, regret and remorse, is constituted, at least in part, by a difference in the range of objects towards which the respective emotions can be felt. Kenny[1] writes:

> ". . . each of the emotions is appropriate—logically, and not just morally appropriate—only to certain restricted objects."

If we violate these restrictions, if we speak, for instance, of fear as having an object outside its appropriate range, what we say is incoherent. But how can this be, when given a suitable background of beliefs, thoughts and circumstances, it is surely possible to fear anything? The incoherence, as Kenny goes on to remark, arises rather when an emotion is ascribed against a *background* inappropriate to that emotion. To say, *e.g.*,

> 'John fears something which he believes holds no danger for him'

or,

> 'John is filled with remorse for something he is convinced he did not do'

is to reveal a misunderstanding of the character of fear or remorse. The incompatibility, then, is not between an emotion's being fear and its being directed on certain objects, but between a person's fearing something and his having certain

* Meeting of the Aristotelian Society at 5/7, Tavistock Place, London, W.C.1, on Monday, 10th November, 1975, at 7.30 p.m.

kinds of beliefs or thoughts about it: thoughts to the effect that it is in no way dangerous or threatening.[2]

As a claim about episodes or occurrences of fearing—and it is these, in contrast with dispositions to fear, which I wish to consider—this is both too weak and too strong. It places too weak a condition on fear in that it allows that a man may fear something while having no thought at all concerning the danger of what he fears; yet the condition it imposes is too strong since a man may fear, if only for an instant, what he believes to be no danger if, in that instant, he is struck by a thought of its possible danger. The restriction which fear places on its objects is this: it is a necessary condition of a man's fearing something that he should also have some thoughts concerning its dangers. This allows for the evident possibility that a man, just because he is afraid, might tell himself there is no danger; it also explains why he might do this, and why he does not, by so doing, necessarily succeed in dispelling his fear. The satisfaction of this condition on fearing something would involve the satisfaction of another condition which, in fact, has some plausibility in its own right: the condition, that is, that if one fears something, one must have some beliefs or thoughts about what one fears. The fear and the appropriate thought must, it would seem, be of the very same thing.

This requirement is in apparent tension with another familiar thesis: the thesis that psychological verbs produce non-extensional contexts. According to this thesis, when 'ϕ' is a psychological verb, and 'a' and 'b' singular terms, we cannot conclude from:

$$\text{'X } \phi \text{ } a\text{'}$$
that 'a exists'.

Nor can we conclude from:

$$\text{'X } \phi \text{ } a\text{'}$$
$$\text{and '}a = b\text{'}$$
$$\text{that 'X } \phi \text{ } b\text{'}$$

The problems attached to quantifying into contexts of this sort are familiar.[3] If

'Jones is thinking of the man next door'

can be true when there is no man next door, then we cannot infer from it:

'(Ex) (x is next door and Jones is thinking of x).'

Furthermore, from

$$'(Ex) \ (Fx \ \& \ Gx)'$$
$$\text{and } '(x) \ (Fx \equiv Hx)'$$

we can in general conclude:

$$'(Ex) \ (Hx \ \& \ Gx)'$$

but, since 'to think of' is a psychological verb, from:

'Jones is thinking of the man next door '

and:

'The man next door is Jones' father'

we, supposedly, cannot conclude:

'Jones is thinking of his father.'

We cannot, then, understand quantification into psychological contexts in the way we understand quantification into extensional contexts. These difficulties stand in the way of representing the sentence:

'Jones fears the prowler who he thinks is about to attack him'

as being of the form:

'Jones fears a and Jones thinks a will attack him'

or as implying:

'(Ex) (Jones fears x & Jones thinks x will attack him)'.

The same difficulties stands in the way of representing the noted relation between fear and thought in general as:

'(x) (A fears $x \rightarrow A$ has a belief or a thought about x)'.

The interest of this conflict depends on the independent plausibility of the conflicting theses; accordingly, my discussion will begin with a brief examination of each in turn. Following this, I shall consider how these two theses might be

thought to be compatible. My criticism of this attempted reconciliation lays the foundations for my conclusion which is that the solution of the difficulties lies in the rejection of the second thesis for the psychological contexts in question.

II

The first thesis, as I have interpreted it, says that what distinguishes between certain emotions is a difference in the character of the accompanying thought. I shall not here attempt to argue conclusively for this thesis. For the present discussion, it is sufficient to defend the plausibility of the claim with respect to a particular emotion. Fear is an apt example since it is, save in respect of the *kind* of thought associated with it, particularly closely akin to a range of other mental states: disgust, revulsion, and agitation are just three such kindred states. It is a further characteristic of fear, though not one peculiar to fear, that fear is frequently accompanied by a variety of other states: what we fear, we also exercise the imagination on, run away from, become obsessed by, or seek to avoid. Not only fears and thoughts, but these other states too, have the same object.

That, typically, when we fear, we also think of what we fear and think it dangerous, is surely unexceptionable. A man who confesses to having feared his present journey would normally be taken to be confessing also to some specific thoughts about the dangers of this journey. We regard it as a measure of the intensity of his fear that what a man fears acts as a focus for his thought: 'He can', we say, 'think of nothing else.' At the other end of the spectrum of intensity, we recommend as an antidote to his fear that a man should turn his thoughts away from what he fears; or, failing that, at least from those features of it which he regards as dangerous. But, if such a thought of its danger is to be shown to be a necessary condition of fearing something, then it must be shown to be present in all cases and not just in the central ones. To this the natural objections and apparent counter-examples fall into two broad categories. It might be claimed that one can fear something while having no thought about it whatever. Alternatively, the need for some thought about what one fears

might be acknowledged, but it be denied that the thought must be that the object is dangerous.

It cannot be ignored that people do confess to feelings of fear or dread dissociated from thought, but typically such fear is not object-directed. A sudden loud noise can evoke fear, but the fear so produced may not be fear of the noise, or, indeed, fear of anything. While we lack an independent account of what it is for fear to be object-directed, no clear counter-example can emerge to the thesis that such fear requires an associated thought. Borderline cases will always allow room for manoeuvre; but some manoeuvres may be more plausible than others.

Those who take a parsimonious view of the mental life of animals might allow, for instance, that a dog is capable of fearing the stick with which his master is threatening him, but incapable of thinking it dangerous. The minimal facts are, we may suppose, that the dog is cowering and whimpering in the presence of the stick. How does this differ from the dog's fearing the stick? One difference is surely that the latter requires, while the former does not, that the dog be aware of the stick. But what could a dog do to show that he was aware of the stick which would not also show that he thought the stick was present? If the dog's behaviour justifies our saying he is afraid of the stick, it justifies also our saying that he has a thought of the stick, albeit a very simple thought. The reverse of this, however, does not hold. A dog may cower and whimper in the presence of his master's stick, and be aware of the stick, without fearing the stick; he may be afraid, not of the stick, but of the man behind it; or he may be performing a trick in response to a movement of the stick. We shall show the dog to be afraid of the stick only if we can show that he has certain expectations about it; for example, that he expects it will harm him. But any behaviour of the dog which will show this will surely show equally that he believes the stick is dangerous. It is immaterial for my purposes whether a dog's behaviour could be sufficiently rich or complex to show this. My claim is only that, if it is not, then neither is it sufficiently complex to show that the dog fears the stick. I will venture to remark only that it is no more fanciful to say that a dog believes his master's stick is dangerous than to say

what is so commonly said of members of the canine species, that he trusts his master; for both essentially involve ascribing expectations to the beast.

Can the thesis under review accommodate so easily certain more unusual human fears? Do, *e.g.*, phobias exemplify fear which does not require a thought of what is feared? Some cases, perhaps, do. The first signs that one is claustrophobic may be a general unease or total panic occasioned by being in an enclosed space, but with no thoughts about the enclosed space: the very panic might serve to exclude such thoughts. The discovery that the state was occasioned by the enclosed space in this sort of case would be made inductively, and it would be one which the subject was not specially well placed to make. However, such states seem not to be object-directed, but would more plausibly be viewed on the model of response to a stimulus. The fear which is fear of the enclosed space occurs when the subject, armed with some self-knowledge of his characteristic reactions, recognises that he is, or is about to be in a situation of a kind which makes him panic. He does then have some thoughts of the object of his fear, but does he have thoughts to the effect that it is dangerous? He may, it seems, have no belief of the appropriate kind; or he may have: he might believe, albeit irrationally, that he cannot get out, or that the walls will move in and crush him. It is, however, sufficient that he has certain compelling thoughts or imaginings to this effect about his situation: thoughts, that is, precisely to the effect that his situation is dangerous. One such thought could be just the thought that in such a situation he will panic, for this is in itself a danger. It is characteristic of phobias that those who have them do describe the objects of their fear in terms of standardly recognised dangers. If a person can offer no such description of the object of his mental state, and if we can see no danger in it, then the reasonable conclusion to draw is that what he feels is not fear but, for example, extreme dislike or revulsion.[4] Again, we seem not to have a clear counter-example to the thesis.

This brief discussion has, I hope, gone some way towards showing that the first thesis has sufficient plausibility to render problematic its apparent conflict with the second thesis. It is to this second thesis which I shall now turn.

III

The non-extensionality of psychological contexts is thought to reveal itself in two ways which might be termed briefly 'indifference to existence' and 'non-substitutivity'. These phenomena, introduced in the first section of the paper, must now be considered in a little more detail. It is my aim, in this section, to provide a classification of some familiar examples of indifference to existence and non-substitutivity.

Indifference to existence is said to occur in two distinct ways:

'Jones is thinking of the prowler'

or

'Jones fears the prowler'

can be true when there is no prowler, for Jones might believe that there is someone prowling. But:

'Jones is hitting the prowler'

or

'The prowler is hitting Jones'

cannot be true in these circumstances. We can conclude that the expression 'the prowler' lacks its customary existential import when it occurs as the object expression of these psychological verbs.

'Jones is thinking of Cinderella'

or

'Jones fears The Headless Horseman'

can, similarly be true though neither Cinderella nor The Headless Horseman exists. But it does not follow from this that the expressions 'Cinderella' or 'The Headless Horseman' here lack their customary existential import, since:

'Cinderella lost her shoe at the ball'

and

'The Headless Horseman rides through the ruin at Wyecollar whenever the moon is full'

are also true despite the non-existence of both Cinderella and

this, or indeed, any other headless horseman. We have, then, two rather different kinds of example of indifference to existence. At this stage, I simply note, without further discussion, that there is this difference.

Examples of non-substitutivity also fall into two categories. The substitution for the object-expression of a psychological verb of a different expression with the same reference can, it is said, change the truth value of the whole sentence when the person to whom the mental state is ascribed is ignorant of the identity relation in question. A simple example will serve to illustrate here.

1. Jones fears his neighbour as this ferocious gentleman advances, red-faced to Jones' door. Jones' neighbour is also the captain of the village cricket team. Jones, ignorant of this fact, surely cannot be said to fear the captain of the cricket team. Gripped as he is with fear, his thoughts are all of his neighbour; no thought of the cricket team or its captain enters his head.

Depending on what beliefs Jones actually has, we can distinguish three different grounds for rejecting the substitution in this case. Jones may be wholly unaware that anyone is the captain of the village cricket team; he may not know that the village has a cricket team. How, then, could he be fearing or thinking of the captain of the cricket team? Alternatively, Jones may be aware that there is a captain of the cricket team, having observed him from a distance wielding his bat on the village green; but it has never occurred to Jones to identify this man with his neighbour. Why, then, would Jones now fear or think of that cricketer? Finally, Jones may have false beliefs about who is the captain of the cricket team; he may believe that Brown, whom he knows well, and who is not his neighbour, holds that position. If this were so, then Jones would certainly hotly deny that he fears or is thinking of the captain of the cricket team. In each case it is said to misrepresent the facts to say that Jones is thinking of, thinks dangerous or fears the captain of the cricket team.

But the subject's ignorance of the identity is not the only ground on which substitution is rejected; there are other, perhaps more compelling examples.

2. Out walking in the dark, Jones sees a tall dark figure striding towards him. He is terrified of this person, struck by the thought that it is a thug about to attack him. In fact, it is the local school-mistress. Had Jones known this, he would not be afraid. Not only is Jones not afraid of her, but he holds it as a point of pride that he fears no mere woman.

To say of Jones, in this case, that he fears the school-mistress would be to misrepresent a whole aspect of Jones' character. Jones had no thought of the school-mistress; it would be totally out of character for him to have this thought about her, his thought was about the possible thug who was about to attack him.

In this second example, factors other than the subject's ignorance of the identity come into play. The third example is quite different in that it depends wholly on such other factors.

3. Jones, a raw recruit into the army, is much afraid of his Commanding Officer. All his dealings with him since he joined the force have been of a kind to inspire fear. As Jones sits outside his office awaiting the reprimand he knows will come, he quakes with trepidation. But, the Commanding Officer is, as Jones well knows, also Jones' Uncle Robert: a splendid avuncular figure, provider of youthful treats, always friendly and not in the least feared by Jones. When he thinks of his uncle, his thoughts have an entirely different character from when he thinks of his Commanding Officer. As he awaits his interview, he thinks only of his Commanding Officer; pleasant thoughts of his uncle are far from his mind.

To claim in this case that Jones fears his uncle would be to misrepresent the relationship which he enjoys with his uncle *qua* uncle, one which is quite separate from the very different relationship between the two men in their respective rôles in the Army.

Resistance to substitution is sharper in cases like the last two because here the result of substituting is a sentence which appears to contradict what we know of the situation in which

the original ascription was made. Where the subject is simply ignorant of the identity in question, there need be no such actual conflict.

IV

Having given, I hope, some plausibility to the two theses I claimed are in tension, I shall now outline a family of attempts to show them compatible. The attempted reconciliation is a very strong one in that it claims not only that the two theses are compatible, but that they are interdependent.

The crucial feature of any such account is that it holds that the grammatical form of 'X fears a' masks its logical form. It is a necessary condition of the truth of 'X fears a' that X has thoughts that a is dangerous precisely because 'X fears a' alludes to some such thoughts. Exactly how it does this need not concern us from this general viewpoint; the expression 'a' may be understood to refer to a thought, or, more plausibly, not to refer at all but to be elliptical for a sentence ascribing the thought to X. It is part of the notion of fear that the thought must be concerned with some danger. That it is also a thought of a is (somehow) given by the expression 'a', for that expression represents a part of the thought in question.

Now it is, supposedly, clear that 'X fears a' may be true when there is no a, for we can think of what does not exist. It is also clear that preservation of the customary reference of 'a' need not be sufficient to preserve the truth value of 'X fears a'. Substitution of 'b' for 'a' will preserve truth-value on this account only when the thought 'b is dangerous' is the same thought as the thought 'a is dangerous', or where 'X has the thought that b is dangerous' is true just in case X has the thought that a is dangerous. These conditions are held to be independent of 'a''s having the same customary reference as 'b', just because 'a' and 'b' are governed in these contexts by the psychological verb 'to think'. Thus, we do not, on this account, require a notion of sameness between object of fear and object of thought for the connexion to hold between someone's fearing and his having the appropriate thought. So this particular need for quantifying into psychological contexts is shown to be illusory.

It may seem to be a difficulty for such an account that ordinary discourse does not require the description '*a*' in '*X* fears *a*' to be either the very description occurring in the relevant thought or a synonymous expression. The account might seek to accommodate this practice in the following way. It is not necessary, in order to convey what a thought is, to give the precise 'wording' of the thought: in certain circumstances it is necessary or desirable not to do so. In many contexts, what *X* is thinking can be conveyed equally well or better by substituting '*b*' for '*a*' in '*X* fears *a*' when *a* = *b*. Every schoolboy knows the value of a nickname to disguise his thoughts of his head-master; the boy may think of his master always in terms of the nickname, but he must use some other name or description of the man if he is to convey the fact that he fears him to his uninitiated parents. The truth value of '*X* fears *a*' may remain unaltered by some such substitutions, but not, according to this account, purely because the customary reference of the object expression has been preserved. Not that it is clear in advance exactly what modifications to '*a*' in '*X* fears *a*' are admissible; it is, however, clear that there is one restriction on these modifications. We cannot substitute for '*a*' any expression '*b*' such that *X* has no thought that *b* is dangerous, for this would be inconsistent with his fearing *b*. It would be inconsistent because of the restrictions which fear places on its objects; restrictions which render incoherent the claim that a man fears something though he has no thoughts concerning its dangers.

This would explain why it is that certain examples of non-substitutivity are particularly compelling. In my second example, Jones is described as having the belief that no woman holds any menace for him. Since this belief is, we were to suppose, never far from the front of his mind, and since it so obviously contradicts: 'the school-mistress is dangerous', we cannot sensibly ascribe this latter thought to Jones. But just such a thought is ascribed to him in saying that he fears the school-mistress.

Likewise, in my third example, it was supposed that whenever Jones thinks of his uncle, his thoughts have a quite different 'colouring' from the thoughts he has of his Commanding Officer. The complexion of his thoughts about his

uncle are such that if thoughts of danger were to intrude, we might say he is no longer thinking of him as his uncle. If Jones fears his uncle, he must have just such thoughts of danger: thoughts which in the nature of the case he does not have about his uncle.

On this general sort of account, there is no notion of the object of fear independent of the object of thought. It might, therefore be supposed to avoid the conflict between the non-extensionality of psychological contexts and the need for object-directed fear to be accompanied by a thought of a certain kind. But it is evident that no such account of object-directed fear can be complete in the absence of an account of object-directed thought. What, then, is it to think of something? What do we want to know when we ask what someone is thinking of? What are we told when our question is answered? Anyone who has found himself temporarily baffled by an unfamiliar description of a familiar object will recognise that we do, on occasions, try to discover what other people are thinking of, and we do, on occasions, succeed. It is not only the unfamiliarity of the descriptions which can baffle us: if a man were to say he was thinking of the capital of France and not thinking of Paris, until we knew more we should not be justified in feeling confident that we knew what he was thinking of. We should no doubt assume from his words that he mistakenly believes that Paris is not the capital of France, but to know this is to know very little. Does he believe Paris is not France's capital city? or that the capital of France is not called Paris? or that some other town— Bordeaux perhaps or Rome is the capital of France? We cannot judge between these and indeed a variety of other alternatives; we neither know what his thoughts are, nor can we report them to others. If we knew what he was thinking of, if we knew for instance that it was indeed the capital of France, home of Notre Dame and the Eiffel Tower, that he had in mind, then we could say which of the various errors he was making; but what he is thinking of is precisely what we are trying to find out. In a further effort to divine this man's thoughts, we might set about persuading him that Paris is the capital of France. If he admits that this is so, but continues to insist that he is thinking of the capital of France

and not thinking of Paris, our bafflement turns to incomprehension. What is this man trying to tell us? Certainly not what we want to know. Once again, if we already knew what he was thinking of, then we might take it that he is telling us why he is thinking of it, or what aspect of it he is thinking of; but, given that we do not know what he is thinking of, we are not yet in a position to appreciate any such additional information.

In this sort of case, then, when we wonder what someone is thinking of, what we want in answer is an identification of that thing. Any description which serves to identify it for us will serve equally to satisfy our curiosity about what the man is thinking of. But if this is so, how can substitution of one description of Paris for another change the truth value of a sentence which says of someone simply that he is thinking of Paris? If it can, then we need an account of how it can consistently with our ordinary understanding of such sentences. If it cannot, then we do not have, in the kind of account I outlined at the beginning of this section, an explanation of non-substitutivity in sentences ascribing fear. If, on the other hand, it were thought that what I have said about thinking of something applies also to fearing something, then the earlier account of sentences of the form: 'X fears a' seems needlessly complex.

The attempted reconciliation of our original conflict, I have suggested, involves a misconception of what it is to think of something. I must now show that it is a misconception.

V

If the information I get from the sentence: 'Jones is thinking of Paris' could be given equally well by substituting for 'Paris' any other name or description which would serve to identify Paris to me, then surely what I understand the sentence to be saying is that a certain relation holds between one man and one city. But if Jones can think of something which does not exist, then sentences of the form: 'X thinks of a' cannot be straightforwardly relational. Clearly we cannot allow that they are relational when there is an a, but not when there is no a, for that would be to construe questions of logical form as

determined by contingencies of worldly existence. If these
sentences are ambiguous, some other account of their
ambiguity is needed. But is it even true that they are am-
biguous? Are they perhaps, contrary to some appearances,
never relational? Or are they, contrary to other appearances,
always relational? It is the suggestion of this last question
which I shall now take up and defend.

One part of the question is this: where '*a*' is a singular
term, can: '*X* is thinking of *a*' be true if *a* does not exist?
First, is this a possibility when the customary rôle of '*a*' is
such that *a* must exist if the sentence in which '*a*' occurs is to
be true? Though I cannot eat or set fire to what does not exist,
can I think of what does not exist? If I can, why is it that I
seem unable to obey the command to think of Charles II's
murderer? Is it because it is too difficult for me? If so, what
further skills would enable me to succeed? My response to the
command would be to say that it cannot be done since there
is no such person as Charles II's murderer: Charles II died
a natural death. Not only am I unable to think of Charles
II's murderer, but I shall challenge anyone else who claims
that he is doing so, on the very same grounds. Nor can he
respond to my challenge by appealing to the indifference to
existence of psychological contexts: he cannot sensibly reply:
'I claimed only to be thinking of him, not capturing or
arresting him.'

No one who believes that a singular term '*a*' has no
reference, can sincerely say: 'I am thinking of *a*'. Such an
utterance would be both unjustified and misleading. If I said
to a friend that I was thinking of his wife's lover, he would
naturally assume, and be perfectly justified in assuming, that
I believed his wife had a lover. To believe that one is think-
ing of *a*, requires the belief that *a* exists. *Prima facie*, this sug-
gests merely that the situation here is analogous to the case of
having false beliefs: I can hold false beliefs but not if I be-
lieve them to be false. In similar fashion, it might be thought
that I can think of things which do not exist, but not if I
believe they do not exist. But a little reflection reveals that
the cases are not analogous. If one of my beliefs is discovered
by me to be false, I cease to believe it; but it is still true that I
did believe it. If, in the other case, having sincerely asserted

or believed: 'I am thinking of a', I discover there is and was no a, I must withdraw the claim that I was thinking of a; I cannot go on making past tense claims on the grounds that I then believed that a existed. 'Only last week I was thinking of your wife's lover' is an utterance ill-designed to re-assure the hearer concerning either his wife or my beliefs about her. The belief that a exists or did exist is a belief that the speaker must have at the time *at* which he is speaking, not at the time of which he is speaking. His audience would be justified in ascribing such a belief to him on the basis of his saying now that he was previously thinking of a.

Suppose, now, I were to tell Jones not that I am thinking of his wife's lover, but that Smith is. It is quite consistent with the truth of what I say that Smith knows nothing either of Jones or his philandering wife, or that Smith believes Jones' wife to be above reproach. But, again, Jones or anyone else who heard me would be justified in inferring from my words that I believe Jones' wife has a lover. With third person ascriptions of the form: 'X is thinking of a', it appears that it is the utterer who commits himself to a belief in the existence of the object; and, indeed, the person to whom the ascription is made need have no such belief.

The situation then is this: whoever X is, if X asserts under normal conditions, 'Y is thinking of a', then we are justified in inferring that X believes 'a exists'. But in general, surely, those beliefs which we can ascribe to someone just on the basis of what he says are beliefs in those things which are necessary conditions for the truth of what he says. So if X's assertion that Y is thinking of a entitles us to ascribe to X the belief that a exists, then a's existence is a necessary condition of the truth of 'Y is thinking of a'; which is to say that: 'Y is thinking of a' cannot be true if 'a exists' is false, contrary to the claim that it is indifferent to existence. The general principle I am putting forward is this:

If, for any X, from X's assertion, under normal conditions, of p we are justified in inferring that X believes q, then the truth of q is a necessary condition for the truth of p.

Note that the antecedent of this principle is satisfied only if

the inference can be made for any[5] speaker in any normal circumstances. Inferences based on peculiarities of the speaker, the manner of speaking or the specific context in which he speaks are therefore excluded from its range.

It is in keeping with the spirit of the principle, therefore, that we should so restrict 'p' to exclude sentences in the first person. Without this restriction, we get unwelcome results: if X asserts 'I believe p', we are justified in inferring that X believes p, whereupon the principle yields that p is a necessary condition for the truth of 'I believe p'. The proposed restriction will avoid this; and comparable restrictions would avoid difficulties involving other token reflexives.

A further restriction is required. It is necessary to exclude from the range of the principle, inferences which we might draw on the basis of conversational rules.[6] The general validity of the principle will depend on a defence of the distinction between these inferences and others which can be drawn from someone's making an assertion. However, the application I am making of it, as my earlier arguments have been designed to show, falls on the right side of this distinction. If, believing there is no man next door, someone were to say that he was thinking of the man next door, it is not merely his act of saying it which is at fault; it is the content of what he says which must be withdrawn. Nor is the inference I am concerned with 'cancellable':[7]

'X is thinking of the man next door and there is no man next door'

is an unintelligible utterance. If it is, indeed, the hall-mark of conversational implications that they should be cancellable, then this is surely decisive; but this is not an issue I can pursue here.

If my observations concerning our use and understanding of sentences of the form 'X is thinking of a' are accurate, and if this restricted principle is unobjectionable, it follows that the existence of a is a necessary conditon for the truth of 'X is thinking of a'.

I envisage its being objected to this conclusion that it simply cannot be correct because the content of human thought just is not restricted to actual existents. Such an

objection might be motivated by a belief in first person authority for avowals: surely if I say sincerely that I am thinking of the man next door, I cannot be *completely* wrong. What truth there is in this view does not constitute an objection to my conclusion.

If *a* does not exist, then it is false that *X* is thinking of *a*. But this is not to say that if *a* does not exist, nothing is conveyed by saying '*X* is thinking of *a*'. Given a suitable context, and a desire to understand what is being said, we could be informed that *X* is thinking of *b* which does exist and which the speaker believes to be the same as *a*. Alternatively, if '*a*' is a definite description such as 'the man next door', we might be informed that *X* imagines that there is a man next door. We might glean some information from being told that *X* is thinking of *a*; it would not be the information that *X* is thinking of *a*, but nor should we be forced to conclude that, as far as we can tell, *X*'s mind is completely blank.

It might be, however, that the point of the objection is not this, but rather the apparent possibility of thinking of certain notorious kinds of non-existents, such as fictional characters. No more than the form of an answer to this second set of difficulties can be provided here. Very briefly, it is that in '*X* thinks of *a*', '*a*' has its customary existential import. Whatever analyses are correct for sentences containing apparent reference to fictional objects, future objects, imaginary objects, *etc.*, the same analyses will serve, I should wish to claim, when the apparently referring expressions occur as object expressions of the verb 'to think of'. Since it is by no means clear what analyses are correct for sentences containing such apparently referring expressions, it would be reasonable to leave this issue until further work has been done elsewhere.

Let me, however, say a little more in elaboration. I shall confine my attention to thinking of imaginary objects and thinking of future objects, since these are particularly relevant when we are thinking of what we fear.

The special difficulty concerning thinking of future objects is that a person can, for example, think of his future trip to America while remaining agnostic about whether it will take place; he might be thinking of it precisely with a view to

deciding whether or not to go. If there is to be no trip, how, on my account, is this possible? If we compare this case with cases of thinking of past trips, it is clear that there are differences. The grounds on which we say that someone is thinking of a past trip are significantly different from the grounds on which we say he is thinking of a future trip. These differences emerge most sharply if we ask what would count as two people thinking of the same thing in each case. For two people to be thinking of the same future trip, it would usually be required that they share, to a very large extent, views about the nature of the trip: they must have a common body of descriptions which they regard as describing the trip. But if this is so, this is not a condition we impose on thinking of the same past trip; for if the trip has occurred, then two people may both be thinking of that trip while the descriptions they each believe true of it converge at no point. It is in certain circumstances possible that two people be thinking of the same future trip, though having in mind totally divergent descriptions of it. Suppose, for example, a secret mission is planned. For reasons of security each participant is told no more than his own task. Consequently, the description of the mission which each man has at his disposal is totally different from that of every other man. What makes it true here that they are all thinking of the same mission must surely be that whatever descriptions they have derive from the central plan of the mission. Again, this is not a condition we impose on thinking of a past mission. The move which now suggests itself, but which I shall do no more than suggest, is that in thinking of a future trip one is thinking of an existent object: an abstract object—a possible trip or a planned trip; but in so doing one is not thinking of a trip.

The special problem with imaginary objects is not peculiar to their case but it is particularly vivid; hallucinations are very frightening things, more frightening, perhaps, when we do not realise we are hallucinating. The problem is this: if someone hallucinates pink rats and, unaware that he is hallucinating, thinks of these pink rats, is he not thinking of something which does not exist? For there are no such pink rats. It is clear that the man is making a radical mistake in supposing the hallucinatory rats to be real. He is also making a radical mistake in supposing that he is thinking of these

rats, for it is false that he is. This mistake would reveal itself in the sort of evidence he would look for as evidence that others were thinking of the same rats. He would look for evidence that they had seen the rats; but what would count as their thinking of what he was thinking of would not be this, but their looking to his reports as authoritative, or their having had the same (and not an exactly similar) hallucination,[8] if such is possible. But this is just the mistake we should expect of an hallucinated man; indeed we should take it as evidence that he was hallucinated.

Many problems remain concerning this second kind of indifference to existence. But in the first kind of case, where it is clear what the customary existential import of a singular term is, I have argued that the import is the same when the singular term occurs as the object expression of the verb 'to think of'. Such terms have their customary reference there, but are they purely referential?

Is a possible state of affairs described by the following sentence:

'X is thinking of a & a = b & it is not the case that X is thinking of b'?

I suggested earlier that we find unintelligible someone who tries to tell us what he is thinking of by means of a sentence of that form. Yet, one of the examples I gave of non-substitutivity was apparently of just that kind: Jones, aware that his Commanding Officer was his uncle, was thinking of his C.O. and not thinking of his uncle. But now, we can understand what is meant in this example by 'Jones is thinking of his Commanding Officer, not his uncle' only if it is understood not to be in question that his C.O. is his uncle. If we did not know this, we should naturally understand from these words that the Commanding Officer was not Jones' uncle. Thus, we are in fact being presented with information additional to what Jones is thinking of.

It would be more perspicuous to have said that Jones is thinking of his C.O. as his C.O. and not as his uncle. If we look at this expanded construction, it is clear in broad outline why there is the appearance of non-substitutivity in this example. To think of a painting as the object which covers the damp patch on the wall is precisely not to think of it as

the work of art it also is. More generally, if a man is thinking of a as b, and $b = c$, not only does it not follow that he is thinking of a as c; it seems to follow that he is not thinking of a as c. If this is why we cannot substitute 'uncle' for 'Commanding Officer' in 'Jones is thinking of his Commanding Officer', then clearly that sentence is functioning not to tell us what Jones is thinking of, but rather what he is thinking of it as. These are clearly quite different pieces of information. It is possible to think of something as what it is not, even fully aware that it is not: to think of my car and to think of the car I am using as my car may very well be to think of two different cars. By compressing 'Jones is thinking of his C.O. as his C.O.' into 'Jones is thinking of his C.O.', we have given the expression 'his C.O.' two distinct functions. Functioning in one way, the expression is not in substitutive position; but it is in its other rôle that it serves to say what Jones is thinking of.

We do not, then, have in this case, a counter-example to the claim that one cannot, providing one is concerned simply with what one is thinking of, believe of oneself that one is thinking of a and not b, and also believe that $a = b$. Familiar as I am with the geography of Cambridge, I cannot obey the command to think of Trinity College but not of the college next to St. John's. If someone else claimed to be doing so, I should reject his claim. Nor could he appeal in his defence to the opacity of psychological verbs. One who claimed to be thinking of Trinity and not the college next to St. John's would be taken to believe that they are different, and not just lacking the belief that they are the same, for, if he simply did not know whether Trinity was next to St. John's, he would say he did not know whether he was thinking of the college next to St. John's. It would be misleading of him to say he was not, since someone asking him if he was thinking of the college next to St. John's, knowing him to be thinking of Trinity, might be asking, in effect, precisely whether Trinity was the college next to St. John's. If, then, someone sincerely claims that he is thinking of a and not of b, we are justified in inferring that he believes $a \neq b$, for he cannot consistently believe the conjunction of all three claims.

The possibility arises here, as it did in relation to

indifference to existence, that the case is analogous to the case of having false beliefs. I cannot believe the triad:

I am thinking of a
$a = b$
I am not thinking of b

but it might nonetheless be true. Again, in this case, it is clear that the analogy with belief is crucially inexact. What I say concerning what I have been thinking of reflects the beliefs I have at the time at which I speak, and not at the time at which I had the thoughts I speak of. If I tell someone that last week I was thinking of his wife's lover and not of Smith, he is justified in inferring from my claim that I now believe that Smith is not his wife's lover.

Similarly in the third person case, my saying to Jones that Brown is thinking not of Smith but of Jones' wife's lover, can be taken by Jones as evidence that I believe Smith not to be his wife's lover. It is the identity beliefs of the utterer and not those of the thinker which are reflected in such reports. It appears, then, that the utterance of: 'X is thinking of a and not b' commits the speaker to the belief that $a \neq b$. We are justified in inferring from such an utterance that the speaker believes $a \neq b$.

I am now in a position to invoke the principle I introduced earlier. If, for any X, from X's assertion, in normal circumstances, of p we can infer that X believes q, then q is a necessary condition for the truth of p. So, since whoever X is, if X asserts that Y is thinking of a and not b, we can infer that X believes $a \neq b$, then $a \neq b$ is a necessary condition for the truth of 'Y is thinking of a and not b', contrary to the claim that the triad:

Y is thinking of a
$a = b$
Y is not thinking of b

is consistent; contrary, that is, to the claim of non-substitutivity for such contexts.

I have argued that in sentences of the form 'X is thinking of a', 'a' occurs purely referentially when it serves to tell us what X is thinking of. If this is so, then there is no difficulty

in quantifying into such contexts. My arguments, it seems to me, apply with only minor adjustments to sentences of the form 'X fears a' when these sentences serve to ascribe object-directed fear. This being so, the need for a more elaborate account of the logical form of 'X fears a' is obviated, for the connexion between fearing and thinking which presented the original difficulties can now, since we have a notion of same object of fear and of thought, be represented as:

$$(x) \ (A \text{ fears } x \rightarrow A \text{ thinks of } x).[9]$$

NOTES

[1] *Action Emotion and Will*, p. 192.

[2] I intend 'danger' to be understood very generously here. If there is in consequence a hint of circularity, that is irrelevant to my primary concern which is with the *thought* rather than the danger.

[3] This is not to say that they are all insuperable.

[4] There is here a natural invitation to speak of unconscious fears. Since these might be thought to constitute an important exception to the thesis of this section, some explanation of their omission is in order. The strongest claim that they provide a counter-example would come from one who held unconscious fears, but not unconscious thoughts or beliefs, to be possible. This is a question which must be discussed at length or not at all. Since the space at my disposal is limited, I elect to take the latter course.

[5] Confusion might arise when 'p' is 'X believes q' for from X's assertion of 'X believes q' we are justified in inferring that X believes q, and so the principle might appear to yield that q is a necessary condition of 'X believes q'. But this is a misapplication since the antecedent of the principle is satisfied only if we are also justified in inferring, as we clearly are not, from Y's assertion of 'X believes q' that Y believes q.

[6] *E.g.*, "one should not make a weaker statement rather than a stronger one unless there is a good reason for so doing"; H. P. Grice "The Causal Theory of Perception", *Proc. Arist. Soc., Suppl. Vol. XXXV*, 1961, pp. 121-152.

[7] See H. P. Grice. *loc. cit.*

[8] People speak of mass hallucinations, and of going together on an L.S.D. 'trip'. Whatever they mean, it is not, or not just that they have exactly similar perceptual experiences.

[9] This is not yet to solve the problems of representing the relation in question between fearing and danger; but it is, I believe, to solve some of them.

IV*—PRINCIPLES AND SITUATIONS: THE LIBERAL DILEMMA AND MORAL EDUCATION

by Brenda Cohen

The aim of effecting a compromise between a strict principle and a situational morality is one which has occupied moral philosophers ever since W. D. Ross introduced his famous distinction between duties and *prima facie* duties. It is an enterprise which must commend itself to many a reasonable person, since both the policy of rigidly sticking to pre-accepted principles whatever the circumstances, and the opposing policy of judging each and every new situation entirely on its merits and without recourse to principles, would appear to represent extreme positions in morality. Consequently, it is not unreasonable to assume that the truth, as so often happens, lies somewhere in between.

It is the purpose of this paper, however, to suggest that what reasonable sentiment demands, reason itself, its more austere sister, is unable to supply, and in this case we may indeed be faced with the need to choose between being governed by principles or moulded by situations, insofar as the latter position can be logically contemplated at all.

Before attempting to justify this proposition, however, I want to indicate the extent to which a familiar variety of recent approaches in ethics, which have not necessarily been presented as attempts to reconcile these two positions, can in fact be seen as attempted solutions of this dilemma—a dilemma which afflicts particularly thinkers of liberal persuasion, if these are characterised as having both high moral principles and broad toleration.

W. D. Ross' distinction between duties and *prima facie*

* Meeting of the Aristotelian Society at 5/7, Tavistock Place, London, W.C.1, on Monday, 24th November, 1975, at 7.30 p.m.

duties was perhaps the first instance in the present century
of a proposal which could be interpreted in terms of this
dilemma as a device offering a compromise between absolute
obligations and consideration of circumstances.

Ross's original distinction was between *prima facie* duties:
those which might be held to apply in advance of any con-
sideration of the distinctive features of an actual situation,
and duties, which represented the obligations judged to
actually obtain when *prima facie* duties and external factors
had all been taken into account. *Prima facie* duties, then,
were recognisably associated with abstract moral principles,
arguably indeed, even identifiable with these; duties, on
the other hand, were these principles mediated and adapted
by the situation (particularly, of course, where the situation
was one which engendered conflict between several different
moral principles).

Looking briefly at the details of this approach, Ross started
from a definition of 'right' according to which the expression
'right act' was carefully differentiated from the expression
'act that ought to be done' and also from the expression
'morally good act'. Instead, the sense of 'right' in which Ross
was interested was that sense that can be equated with the
expression 'morally obligatory'. It will be seen that this is the
way in which 'right' is used in reference to *the* right action
rather than to *a* right action, which means that Ross in fact
deliberately chose to ignore one use of right'. Nevertheless,
using 'right' in the sense defined, he asked whether there is a
common characteristic which makes these sort of right acts
right, and if so what that characteristic might be. Dismissing
any hedonistic or utilitarian answer, he argued in effect that
for the plain man, thinking a particular course of action right
(or a duty) is justified retrospectively rather than prospectively
—a promise has been given, for instance, or a debt or other
obligation, incurred. Where probable consequences present
a reason for breaking a promise, Ross suggests that the situa-
tion may genuinely be that other duties do in fact take
precedence:

> "It may be said that besides the duty of fulfilling promise
> I have and recognise a duty of relieving distress, and that

when I think it right to do the latter at the cost of not doing the former, it is not because I think I shall produce more good hereby but because I think it the duty which is in the circumstances more of a duty."

Ross adds in a footnote:

"These are not strictly speaking duties, but things that tend to be our duty, or *prima facie* duties."

He continues:

"When I am in a situation . . . in which more than one of these *prima facie* duties is incumbent on me, what I have to do is to study the situation as fully as I can until I form the considered opinion (it is never more) that in the circumstances one of them is more incumbent than any other; then I am bound to think that to do this *prima facie* duty is my duty *sans phrase* in the situation."[1]

Ross's theory raises its own set of difficulties, not least of them the apparent circularity of an interpretation of 'right' which itself includes such tacit valuations as are implied in phrases like 'more incumbent', 'more of a duty' and, elsewhere, 'more weighty', in explaining the process by which actual duties are yielded from *prima facie* duties and particular sets of circumstances. It is not, however, these difficulties that are at issue here. Instead, what is of interest is the way in which this particular compromise resembles strategies adopted by other more recent writers, especially in relation to discussion of the particular issue of moral education.

This area is touched on by Hare, in his presidential address to the Aristotelian Society, "Principles",[2] in which he reiterates his view thtat prescriptivity and universality are essential defining characteristics of moral principles,[3] but he seeks to defend himself against the charge of consequentialism to which his earlier views appeared to leave him open. One of the critics he is concerned to refute is G. E. M. Anscombe, who had set up against what she took to be Hare's consequentialist position her own view that there are in fact

[1] W. D. Ross, *The Right and The Good*, p. 19, O.U.P. 1930.

[2] *Proc. Arist. Soc.*, 1972-3.

[3] See *The Language of Morals*, O.U.P. 1952 and *Freedom and Reason*, O.U.P. 1963.

principles of 'absolute generality',[4] pointing out that this is the only view consistent with the Hebrew-Christian tradition, within which certain things are forbidden whatever consequences threaten; for example, choosing to kill the innocent for any purpose, vicarious punishment, treachery, idolatry, etc. Prof. Anscombe had claimed that it is not usually recognised how great a departure from this are the views of most modern philosophers, but particularly Hare, in so far as they always allow exceptions in the light of consequences.

In his address to the Aristotelian Society, Hare concedes something to this point of view, and suggests that for certain purposes, such as, for instance, playing a part in moral learning, it may in fact be necessary to abstract some general features from any particular case, and to lay down certain hard and fast rules, which will not be held to be waivable in the light of consequences.

Here it is important to bear in mind the difference between generality, and the other notion which it in some ways resembles, universality. Hare's own way of indicating the distinctness of the two notions is to point out the difference between their opposites: while the opposite of 'general' is 'specific' the opposite of 'universal' is not 'specific' but 'singular'. Hence it follows that universalisability may apply to very complex moral principles, principles which may be both specific and highly detailed, just as much as to short general principles. Thus Hare's earlier position did not commit him to the holding of brief general principles, such as 'Stealing is wrong,' but was quite consistent with the claim that moral life consists, amongst other things, in adding qualifications to the simple moral imperatives in the light of experience, thus building up a body of universalisable principles of any desired degree of detail and complexity.

In "Principles", on the other hand, he appears to recognise that, whatever the intention, and the arguments for such a position have always been humanitarian, the consequence of such a strategy may be to lend support to immoralism by in fact inducing moral scepticism. Whilst still rejecting the brief and rigid principles favoured by those of Prof.

[4] G. E. M. Anscombe, "Modern Moral Philosophy", *Philosophy*, 1958.

Anscombe's persuasion, as inevitably generating 'hard cases', Hare sees as a new and important problem the question how is one to bring up one's children. For this purpose, he feels obliged to concede that the inculcation of simple moral principles is in fact to be preferred to the situational or consequentialist ethics which he earlier appeared to be endorsing. This leads Hare to put forward a new and surprising suggestion. Essentially, this is that we should draw a line between two kinds of people: those (and this category would obviously include children) who have not had the time, or lack the ability, to make judgments about the kind of principles that ought to be followed, and those who have this ability, and have also devoted time and energy to the task. Whilst the former need relatively straightforward moral principles, a more 'situational' approach might be appropriate for the latter, and it would be the function of the second group to think about principles and propound a 'body of fairly simple teachable principles' for the first group. Hare makes the point that principles of more than a certain degree of specificity could not be taught. He calls the system in which principles of the required degree of specificity could be expressed 'specific rule-utilitarianism', and claims that a type of specific rule-utilitarianism could be found which would be consistent with his universal-prescriptivist theory of moral argument. Hare defines the required degree of specificity as "sufficiently general for the ordinary man to build them into his character and those of his children in such a way that they will not be in doubt as to what they should do in the moral situations that they are likely to meet with, unless they are rather unfortunate".[5]

Of this solution, which offers instead of different types of principles, different types of people, it must first be remarked that the notion of one approach for the philosopher, the well-informed and trained intellect, and another for the ordinary person, seems distastefully Platonic and paternalistic in a democratic age. But apart from this, it is equally, in spite of Hare's own optimism, extremely difficult to reconcile with the universalistic position which Hare has previously

[5] *Op. cit.* p. 16.

represented. Universalism, by definition, cannot function on two levels. We are left unsure which set of universalisable principles are in fact being prescribed, but with a suspicion that both cannot be. The universalisability principle at least entails that what is right for one group or individual is right for another, unless indeed the criteria mentioned for distinguishing between the two types of people are held to be morally relevant in the sense needed to justify differing moral obligations.

Hare has however, raised the practical issue of moral education, as the testing-ground for the theoretical conclusions of moral philosophers, and it is interesting to turn to the work of philosophers more directly concerned with the issue of moral education, and to note the extent to which the situationalist assumptions which Hare takes to be unsuitable for such a purpose, are in fact widely implied in their writings.

Probably the best-known philosophical approach to moral education of the past few years is that of John Wilson in connexion with the Farmington Trust research on this subject.[6] Broadly, Wilson's conclusion is that moral education does not consist, as Hare in "Principles" almost seems to be suggesting, in the inculcation of first-order principles, such as 'Stealing is wrong', nor of an either more or less general form of this type of principle, but rather in the development and encouragement of specific moral abilities, such as the power to see situations from another person's point of view, imaginative sympathy, impartiality, fairness, *etc.* The implication of this approach, whether intentional or not, is that given these qualities, a person (or child) must and should expect to evaluate each new situation on its merits. Wilson sees this, in contrast to the first method, as the imparting of *second-order* principles, of which an example would be, he suggests, the principle of justice. It is his case that morality consists in principles for conduct based on rational consideration of other people's interest, allied with the Kantian principle of impartiality: that distinctions between persons shall not be made on irrelevant grounds. These two criteria

6 Wilson, Williams, Sugarman, *An Introduction to Moral Education*, Penguin, 1967.

are very similar, if not identical to the principles described by R. S. Peters as respect for persons and fairness or impartiality.[7] From this it follows, on Wilson's view, that to be morally educated, a person must be trained to make independent judgments and decisions, following rules in a rational and discriminatory fashion, rather than being trained to obey without question first-order norms.

It is clear, however, that by including such qualities as impartiality and fairness in their list of essential qualities, writers of Wilson's persuasion are in fact demonstrating how difficult it is to provide a coherent approach to morality which ignores Kant, since through such notions as these they in effect attempt to reinstate, within a situationalist setting, something very similar to the Kantian notion of universalisability, and with it the crucial notion of moral principles as essentially applicable to all similar situations.

There is, indeed, an assumption that the child brought up by this method of moral education and versed in situational ethics, will through the notion of impartiality or fairness, come to recognise the need not to make an exception of himself. What this amounts to is the belief that he will, in fact, implicitly accept that any conclusion that he comes to on any particular situation must be frameable as a general principle of some sort, applicable to himself as well as to others, neither over-general nor over-specific.

It is impossible to avoid the feeling that there is a basic confusion here, since if the formation of principles and not merely the ability to appraise individual situations, was agreed to be the aim of Wilson's type of moral education, then moral education in the real world situation could be greatly simplified if these principles could be isolated, perhaps by Hare's special category of individuals, identified and then directly imparted, at the beginning, instead of the end, of the process. Indeed, some self-deception is needed in order to convince oneself that this is not in fact what happens in the case of children. A determined desire to avoid the verbal enunciation of principles, as in the case of some progressive educators and parents, only results in a desperate attempt to

[7] R. S. Peters, *Ethics and Education,* chs. 4 and 8.

impart these principles non-verbally by a string of unconscious and unrecognised devices, unrecognised, that is, by the actors in the drama, but very much visible to the outside observer. What else is to be expected, indeed, if as Peters suggested in "Reason and habit: the Paradox of Moral Education",[8] Piaget has shown experimentally that children cannot understand rules or general principles before the age of seven? For, since children must in general interact with the world before that date, they will necessarily have been shown in some way or other what positives and negatives apply in regard to this interaction.

This is what makes the two-level terminology of the moral education theorists disturbingly misleading, though in a different respect. What they undoubtedly attempt to say, in the guise of a distinction between imparting principles and encouraging attitudes, is that children should not be told, *e.g.*, that stealing is wrong (this is a first-order principle) but they must be told, or otherwise brought to see, that consideration or respect for persons is right, a second-order principle from which it may or may not follow that stealing is wrong. They must not be taught to tell the truth or avoid cheating in examinations (these are first-order principles) but they must be taught to value truth, and to weigh evidence impartially, objectively and with an open mind—from which the practice of truthfulness may or may not follow.

The reason for avoiding instruction in the first-level principles is largely a desire to avoid authoritarianism, (sometimes called indoctrination) to some extent for psychological reasons, but mainly, it would seem, for sceptical reasons. For some reason, however, these are not thought to apply at the second-order level, where commitment on the part of the older person is expected and indeed recognised as unavoidable.

It follows that, from the point of view of the learner, scepticism must apply, not as seems generally assumed, to the validity of first-order principles as such—the doubts are not *moral* doubts after all—but rather to the logical and factual

[8] In W. R. Niblett, (ed.), *Moral Education in a Changing Society*, Faber, 1963.

questions concerning precisely *which* first-order principles follow from the second-order principles. It is possible, then, to see this aspect of the moral education debate, as a return to the question raised by Hare as to what level of generality is the most appropriate one for the formation of sound *universal* moral opinions. It does not, after all, establish a genuine distinction between different types or levels of *moral* principles. It follows, then, that the attempt to construct a position halfway between situationalism and acceptance and imparting of moral principles of universal applicability has been and must be unsuccessful. Neither the recognition of two kinds of people, nor the positing of two levels of principles, successfully achieves this compromise.

It might be argued that, where fairness and impartiality are mentioned as second-order principles, the intention is in fact to install the principle of universality as itself a moral principle, but one of special status and importance. If this is indeed the aim, then it is, of course, misconceived, since the status of the principle of universality is not that of a supremely important moral principle; on the contrary its strength lies in the fact that if it has any validity at all, this is as a principle of a different order entirely; logical rather than moral.[9]

Reviewing the course of the argument so far, then: it has been suggested that a number of well-known recent approaches in moral philosophy and reflections on the practical problems of moral education can be construed as attempts to escape from a dilemma—a dilemma which belongs peculiarly to this century because it is only with the widespread adoption of more liberal and humane ideals that the problem could impose itself on the philosophical consciousness; at earlier periods, 'hard cases' would invoke no more than a passing sigh. The problem is the one that first exercised Ross: how to hold a firm set of useful and reasonably brief moral principles, and yet how to be flexible enough to abandon or be deflected from these principles in the light of circumstances. Ross' own solution was predominantly linguistic,

[9] For an argument in support of this statement, see my "An Ethical Paradox", *Mind*, 1967.

whilst subsequent more recent solutions have tended to attire the sort of distinctions Ross made in more respectable logical garb, through reference to principles of a different order, or at a different level, or adapted to the needs of different people.

It has been argued that none of these solutions provides an escape from this particular dilemma, although they may indeed be illuminating and useful in other ways, which it is freely conceded may be closer to their author's intentions.

It is, however, as possible solutions to this dilemma that they have been considered here, and something must now be said about the dilemma itself. It has been referred to as a liberal dilemma, and whilst not attempting a full definition of liberalism, some indication must be given of the reasons for this label. What, in fact, characterises the liberal position in morality?

First, I would suggest, a liberal position is itself a position of principle. By this I mean that the liberal cannot be held to be indifferent to moral issues, and he must not be open to accusations of pragmatism or expediency on these issues; therefore a level of consistency is expected of him. He must also, and this is equally important, be willing to express moral condemnation of positions with which he disagrees strongly, such as fascism and racism.

Secondly, however, the liberal position is essentially one of toleration. Looking back to his nineteenth century roots, and the classic statement of the liberal position by John Stuart Mill, the liberal must endeavour to incorporate the principle of *laissez-faire* into morality. This entails that to some extent he will eschew judgmental positions and will concede to every other man his right to be his own moral arbiter. In adopting this approach he must necessarily abandon the idea of conventional moral codes as briefly-statable general principles, which are both objective and binding since, although he may choose to subscribe to these himself, he will not wish to interfere with the freedom of others to make different moral decisions. In general, then, although he *may* wish to adopt a strict and briefly general moral code, it is unlikely that he will in fact do so, since the point of general principles is greatly diminished if there is only one person following them. His inclinations, then, will tend to the form of morality in which

judgments are modified by particular circumstances, in other words, situational ethics. Certainly, in judging the actions of other people, he will be particularly alive to the circumstances within which any particular moral decision was made.

It begins to be apparent, then, what is the liberal's dilemma. How is he to place those things about which he has deep and unshakeable moral convictions out of reach of the toleration and situationalism to which his position appears to commit him? Lying may be wrong for him and right for somebody else—he demands that the other person make his own moral decision, and he will tolerate and endeavour to understand that decision—but can he allow that his principles equally allow that person to decide to be a racist? As soon as Hare's practical testing-ground is approached, that of moral education, whether of one's own children or of others' in school, the theoretical difficulty becomes an acutely felt practical problem, and one on which the intentions of liberal devisers of teaching-packs on issues like sex or racism have foundered.

"There is no need whatsoever to teach children how to behave", wrote A. S. Neill,[10] "A child will learn what is right and what is wrong in good time—provided he is not pressured". But what if the views they form about right and wrong violate their teacher's convictions, *in things that really matter*? The teacher may, for instance, be willing, even anxious, to concede that shop-lifting is part of the value-system of the children he teaches, and therefore not for him to condemn, but he may be less willing to view mugging in the same sympathetic light.

In order to avoid the implication that morality, then, is a matter of degree—that the principle of toleration can in the end only apply to things that do not matter, the liberal may be tempted to seek refuge in Mill's self-regarding/other-regarding distinction.[11] Mugging, or racism affects other individuals adversely and very directly in a way in which shop-lifting does not. However, it is clear that this distinction is

[10] A. S. Neill, *Summerhill*, p. 254, Gollancz, 1966.
[11] J. S. Mill, *On Liberty*, ch. 4, O.U.P. 1971.

itself so much one of degree that it cannot fulfil its purpose
—the price of shop-lifting is reflected in the price of goods in
the shops, and in the end everything the individual does
affects others, at least by affecting and changing the prevailing
identikit of society. Sexual freedom, that most appropriate
area for applying Mill's test, is itself an example of the way in
which changing patterns of behaviour create a different 'feel'
of society which affects even the uninvolved, the very young
and the very old. (To go no further, Aunt Ada's visits to the
theatre may well be circumscribed!)

Hence the appeal of those solutions which appear to retain
fixed principles at one level, whilst supplying the desired
flexibility at another; and which claim to be able to justify
this strategy by drawing a logical distinction between these
levels. Ross' *prima facie* duties are unvarying, and their
validity is not undermined by the fact that in practice it is
principles of another and more adaptable kind, tailored to
the circumstances, that determine what he actually does.

For Hare, at least in his recent guise, firm principles will be
adhered to by the many, while principles of a more flexible
variety will be worked out by the few. And for the moral edu-
cation theorists, a few highly general ideals at one level will
be expected to form the basis from which a range of variable
and adaptable principles of a different order entirely may be
derived.

But can this type of solution work? Some initial plausi-
bility might be held to derive from the fact that it is true
that moral principles may be more or less general in nature,
and one might possibly therefore speak of principles of first or
second order. And it is true that the degree of generality
affects the likelihood of the principles being held to apply
without exception. However, this difference operates in pre-
cisely the reverse order to that which applies in the cases
cited. For instance, when one considers levels in this way,
then the more general the principle, the more likely it is to
require exceptions.

 E.g., 'Lying is wrong'

is more likely to suggest grounds for exceptions than

 'Lying to trusting friend in order to do him an injury'.

In the case of the moral education theorists, however, it is the narrower type of judgment that is held to be more open to dispute, whilst the 'second-order' principles, justice, etc. are general in the extreme, and it is these that are assumed to be beyond exception. Similarly, in the case of Ross' two kinds of principles, the simple *prima facie* principles were not open to dispute, but the complex judgment arising from a particular situation might be.

It would seem, then, that while it is certainly the case that principles may be of a different level in respect of being more or less general, this does not supply a difference of level in the sense required. That is to say, it does not supply a higher sacrosanct level of moral principles, together with a second, situationalist level.

It is in fact necessary to accept a unified approach to principles, and it is this necessity that makes liberalism an inherently unstable position. The liberal cannot retain both his principles and his flexible response to situations. He must therefore abandon either his judgmental morality, which manifests itself in a near reflex response to certain moral positions, or he must abandon the moral toleration (though not necessarily the *practical* toleration) which engenders his situationalist ethics. Having done this he will at least have cleared the ground for a coherent and logically sound approach to the question, how are we to bring up our children?

Principles, then, have become unfashionable, but their usefulness makes it impossible to abandon them completely. Nevertheless, it has been argued here that the half-hearted attempt to reject and retain them at the same time is no more than an expression of indecision, and a form of compromise which cannot work, in whatever field the attempt is made. In the field of moral education it is, however, peculiarly inapposite.

V*—SOME VICTIMS OF MORALITY

by Barrie Paskins

I

Jonathan Glover recently issued a challenge. Noting that to "many people . . . it will seem wrong that the question of working on chemical warfare, or of selling arms to South Africa, should be decided by calculating consequences" and rejecting philosophical reliance on long and *ad hoc* lists of absolute prohibitions, he writes:

> "An alternative is to produce a coherent system of manageable size, where there is a small number of prohibitions stated in very general terms, together with priority rules where prohibitions conflict. Prohibitions would no longer refer to chemical warfare, but to some such act as indiscriminate killing. In recent philosophy such a system is sometimes gestured at, especially in discussions of war or abortion, where the prohibition on killing the innocent is mentioned. But we have not been presented with even the outline of a properly worked out system. For this reason, we are still justified in any scepticism we feel. In the absence of a whole system . . . we still do not know what disasters such systems might make inescapable."[1]

The challenge, I take it, is to talk philosophical sense about the non-consequentialist resistance to certain controversial public measures and involvements.

Current philosophical controversy over non-utilitarian scruples about utilitarianism, non-consequentialist scruples about consequentialism[2] takes its shape from the general structure of utilitarianism. Miss Anscombe and Thomas

Nagel among others have made plain their moral abhorrence
of much that passes for utilitarianism.[3] The question is, can
we point to anything that demonstrably has moral force yet
will not fit the utilitarian mould? Utilitarianism is a species
of teleological system that takes the fundamental questions
in ethics to be questions about what to do[4] and answers these
questions in terms of the production of states of affairs. As
such, it entails a doctrine of negative responsibility. These
structural features make possible a wide variety of critique.
One might focus on negative responsibility, but I shall not do
so here. One could question the model of morality as produc-
tion of states of affairs. This might be done *e.g.*, by trying to
make sense of the refusal to lynch one man in order to quieten
the fury of a rampaging mob who will otherwise kill many
innocent people;[5] or by teasing out the implications of the fact
that in Kant's view it is no part of the moral law that I should
tell a lie to procure less lying by other people.[6] Such enquiries
invite the utilitarian riposte that appearances can be saved by
some special weighting of utilities. In addition to technical
debate, this reply engenders the criticism that such a ploy is
objectionably artificial. And it cannot rule out arguments
which call in question the very idea of a universal and manda-
tory decision-procedure in morality.[7] I shall return to the
production-line model of morality, to artificial reconstruction
and to the search for a decision-procedure. But I want to
begin with a third type of critique, which involves a closer
look than is usual at the assumption that the fundamental
questions in ethics are (all of them) about what to do.

Glover demands "priority rules where prohibitions con-
flict". How is this to be understood? I see it as one way of
making the point that any interesting response to his chal-
lenge will have something to say about what happens when
moral claims conflict (more primly: what is proper when
moral claims conflict). It lays the usual utilitarian stress on
the question of what to do in the conflict situation and makes
the familiar utilitarian assumption that this is the only
possible stress. To provide a context for my main argument,
I want to indicate in outline why I think the assumption
wrong and the stress at least questionable.

Consider some well-known remarks by Sir David Ross:

"If . . . it is sometimes right to tell a lie or to break a promise, it must be maintained that there is a difference between *prima facie* duty and actual or absolute duty. When we think ourselves justified in breaking, or indeed morally obliged to break, a promise in order to relieve some one's distress, we do not for a moment cease to recognise a *prima facie* duty to keep our promise, and this leads us to feel, not indeed shame or repentance, but certainly compunction, for behaving as we do; we recognise, further, that it is our duty to make up somehow to the promisee for the breaking of the promise."[8]

We promise the children a day at the seaside, Granny falls ill. All things considered we must stay and look after her but we feel bad about the children and try to make it up to them. This tells us something about what happens (what is proper) when moral claims conflict.

Consider, too, the plight of Agamemnon as presented by Aeschylus.[9] Agamemnon finds himself called on to sacrifice his daughter Iphigenia to appease the goddess Artemis. Having reflected on his responsibilities as a commander, the many people involved, the considerations of honour, *etc.*, he comes to the conclusion that he is duty-bound to sacrifice her. Bernard Williams uses the example to suggest that the structure of the moral conflict facing Agamemnon is "connected directly" with his "regret".[10] The word 'regret' repays closer scrutiny. The speech attributed to Agamemnon ends

" 'For them to urge such sacrifice of innocent blood angrily, for their wrath is great—it is right. May all be well yet' "

which might be thought expressive of regret. The chorus at once proceeds to report something altogether more agitated, however. Richmond Lattimore renders the disputed and perhaps intentionally incoherent lines thus:

"But when necessity's yoke was put upon him
he changed, and from the heart the breath came bitter
and sacrilegious, utterly infidel".[11]

Is the philosopher to regard this as adding something of merely psychological interest? I think not: the differences and similarities between our 'compunction' on disappointing the children and Agamemnon's 'feelings' are too compellingly in need of philosophical attention.

One evident common feature is that in both cases a moral decision goes against somebody (the children, Iphigenia). Let us provisionally dub the person(s) against whom the decision goes in moral conflict 'the victim'. In moral philosophy, as in law and jurisprudence until recently, little attention seems to have been paid to the victim. Perhaps connected with this is "a fundamental criticism of many ethical theories", namely:

> "that their accounts of moral conflict and its resolution do not do justice to the facts of regret and related considerations: basically because they eliminate from the scene the *ought* that is not acted upon."[12]

It is a trite but neglected fact that when this ought is eliminated there is very often a victim who has not been reduced to inexistence. So what attitude is proper to the victim and on the victim's part?

To call the children 'victim' is to take an altogether too tragic view: the children may see their disappointment in this desperate way but an important part of their growing up will be the realisation of how childish they were being in doing so. A good parent will enter sympathetically into their upset and enable them to see that he does. But if he views their world only from their viewpoint, or gives the impression that he does, then he is spoiling them (a moral concept that deserves close scrutiny). This indicates that Ross has under-described what happens when a promise has to give way: if the promisees are children, an obligation to educate is inescapable. If the promisee is an adult there will usually not be this obligation but then something else *takes its place*. In the simplest instance the adult simply sees that his claim has been overridden: so that *e.g.*, there can be no question of his easing things by releasing us from our promise. There is no tension to be eased, nothing in force for him to release us from.[13] The adult's understanding being present, the obligation to

educate is necessarily absent. A manageably small number of non-standard cases also require mention. One is the childish adult: depending on detail, there might be the obligation to try and educate him or some remarks might be needed from the theory of comedy, including something on how the ludicrous can occasionally be tragic. All other non-standard instances seem to fall under the general heading of situations in which, because of communication problems, the victim cannot understand the overriding of his claim and thereby accept things. Two specially interesting types here: as a child I made a promise to my father to avenge some old wrong. I come to see that other claims outweigh the consequent obligation—perhaps come to think that revenge is wicked—but there is no language in which I can explain myself to my father. This seems to touch the realm of the tragic. Second: the victim is able to accept even where he cannot understand because he has towards the agent the trust that asks no questions. A to him incomprehensible decision provides no ammunition for the destruction of his trust, whereas relationships between people who respect one another morally as fallible moral agents do require some sort of understanding. I take it that moral philosophy, with its interest in rationality, should regard the trust that asks no questions as requiring special study.

The understanding that cannot explain itself and the trust that asks no questions bring us, in a way, pretty close to the situation sketched by Aeschylus. For the language and experience needed of a victim who could comprehend are not available to Iphigenia. But I am also and more struck by a disanalogy. The demand made on Agamemnon is an outrage and one cannot say that he is taking an excessively tragic view of things. He is not a child or childish. A radical discontinuity between his sense of outrage and that of the disappointed child and indulgent parent must be preserved if we are to make any philosophical sense of tragedy. I cannot here attempt to analyse the tragic but it would seem obvious that a necessary condition of any non-reductionist account is that it should preclude the possibility of conflating childish and tragic desperation.

This has bleak implications for utilitarianism, which

cannot give much weight to the distinction between the tragic and the childish. The sharpest contrast it can draw is between saying on the one hand that a well-brought-up person will feel awful about having to do what Agamemnon must, on the other hand that the child is still being brought up and that the childish adult has been brought up badly. But does one not want to say more, namely, that Agamemnon has been brought into encounter with a rather general feature of the world, its tragic quality, and that someone who did not see this would be deficient in the tragic sense of life? Utilitarianism forces on us an external view of Agamemnon's sense of outrage, requiring us to separate it from morality as at most an instrument for getting good states of affairs produced. It is unclear why we should give in to this forcing unless we are already convinced utilitarians and unclear how anyone with a tragic sense of life can be persuaded rationally into utilitarianism. What rational ground can he have to repudiate his awareness of what the world is like? One wonders what the utilitarian thinks he is doing. He has the look of a man in the grip of a philosophical picture.

As a weakness in utilitarianism this is unexcitingly similar in shape to many other criticisms that have been made. But I am more concerned to commend an alternative than to enforce still further the agreeably widespread dissatisfaction with utilitarianism; and for my purpose the example is important. It shows that a deep-seated implausibility about utilitarianism quickly comes into focus when we begin to develop the obvious but neglected theory of victims. In consequence, it shows that difficulties this theory might pose for the utilitarian are not to be removed by the fine-tuning of re-weighted moral goals. For it is objectionably arbitrary to try and save the appearances of an implausible theory and utilitarianism has been shown to be implausible. We need not try to decide here whether traditional deontology is rendered implausible by similar reasoning.

So far I have complained that moral philosophy pays little attention to the victims of moral conflict. A perfunctory look at a few examples suggests that one can generalise about two types of victim. Consideration of examples in which 'victim' hardly seems the right word indicates the need for revision of

the theory of *prima facie* obligations to account for a complexity inadequately grasped by talk of 'compunction' and reparation. A look at the victim in tragedy leads one to sceptical doubts about what the utilitarian is trying to do. If all this is roughly right it shows that the utilitarian stress on being told what to do in moral conflict situations is at least questionable. And the familiar assumption that it is the only possible response to the question of what happens when moral claims conflict is plainly false.

It is now possible to indicate what I hope to do in the present paper by way of response to Jonathan Glover's challenge. Sometimes when one has to make a moral decision, a possible victim is oneself. Occasionally, this poses a special problem that I want to identify and discuss. The difficulty I have in mind has to do with integrity. And whereas my examples so far have mainly been of victims who (morally) must be made to suffer, I shall now be in search of a possible victim who arguably must be spared, for reasons that are not amenable to analysis in terms of the production-line model of morality. Among the controversial issues I hope to throw light on are work in chemical warfare and the sale of arms to South Africa.

II

Jim: Latin America. An army captain, Pedro, has 20 Indians tied up against a wall. He is about to shoot them when Jim, an English botanist, happens along. Pedro offers Jim a choice: you shoot one of the Indians or I shoot them all. What should Jim do?

Bernard Williams uses this example as a reminder that we are not all single-minded utilitarians, for the question of what Jim should do gives (some of) us pause whereas for a utilitarian the answer is easy and obvious.[14] For my purpose, a more specific question must be raised: what are the sources of our non-consequentialist scruple over (to use a question-begging phrase) giving in to Pedro?

Notice that the shooting problem is one of a variety that Pedro could have set for Jim. Two examples. *The choice problem*: Pedro says, "I was going to kill all 20 but in your

honour I am prepared to kill only one and release the rest. You have only to say the word, the choice is yours." *The torture problem*: Pedro says "I was going to torture them all horribly but if you will torture one horribly then I will let the others go." Many people find the choice problem easier than the shooting problem and the torture problem hardest of all; but is there any ground for such discrimination? The utilitarian will not think so, but consider Kant's principle "Always treat humanity as an end, never merely as a means". Pedro is obviously in breach of it: he is presumably not treating the Indians' humanity as an end and—more important for my argument though not for the characterisation of the situation from a participant's point-of-view—he is also treating Jim merely as a means. He may be deriving considerable pleasure from Jim's discomfort; in all three situations he is using Jim to decide how many shall die—he could have used dice instead; and in the shooting/torture case he is using Jim in place of his own trigger finger/torturer's hands. It seems to be these facts that make it right to describe Jim's acceptance of Pedro's offer as 'giving in to Pedro'. But from Pedro's violation of Kant's principle it does not follow that Jim, if he gives in, will be treating either the Indians' or his own humanity as a means.

A feature of the situation that Bernard Williams makes clear without stressing it is that none of the unlucky 20 knows who the victim will be if Jim accepts Pedro's offer. Very sensibly, they all beg Jim to accept. As a consequence, Jim cannot be regarded as trampling on anyone's rights in shooting one of the Indians. (The Indian who is unlucky cannot blame Jim since he has already consented in the most explicit manner to what is now going to happen.) The situation would be significantly altered if Pedro said "I will release all these men if you will shoot"—seizing another innocent out of the bush—"this man". If the new victim pleads for his own life as against the lives of the 20 Jim faces a nasty conflict of rights that does not arise in the cases we are considering which, I take it, are meant to help us towards a clearer understanding of conflict of rights problems. (The situation would be altered in a different way that I do not pretend to fathom if some of the 20, not knowing who the victim will be, beg Jim not to

give in to Pedro. It might be important to see the terms of their pleading: *e.g.*, whether they speak of not giving in or stress their refusal of consent to something whose only justification can be in terms of their and the rest of the 20's interests.) In the case described by Williams, it is as clear as Kant that Jim will not be treating any of the Indians merely as a means if he 'gives in' to Pedro.

Would he be treating himself merely as a means? I am not yet in a position to answer this, more examples are needed. But one thing can be said at once. In the circumstances described by Williams and the choice and torture variations on it, what Jim is trying to do is evident. He is trying to save as many Indians as possible. If we have been given all the morally salient facts then there can be no doubt at any stage of the process that this is what Jim is doing. In this regard at least, Jim is luckier than

George: George is very much in need of a job, as much for his family's sake as his own, but the only work available is at a laboratory engaged in chemical and biological warfare (CBW) research. If George does not take it, someone else will and he knows that the person in question is a sinister character no man of good will would wish to see in the post. What should George do?[15] Philosophical discussion, if this is the right word, of CBW work seems to proceed in ignorance of the rather impressive arguments in its favour. One such argument: other governments are proceeding with CBW research and the fruits of this might fall into the hands of irregular military forces who will not hesitate to employ CBW against civilian targets. Question: is it not at least arguable that we, living in a relatively just society, should proceed with CBW research aimed at enabling us to cope with the problems that might follow such theft? If not, would one wish to argue by parity of reasoning that Einstein *et al.* were wrong to urge the US and UK governments to develop an atom bomb lest Hitler get it first? Philosophers' references to CBW seem calculated to produce a *frisson* in those who are unaware of such arguments. Because the arguments have force, George's problem needs specifying more closely. One could focus on the possibility that George's judgment is that nobody should do the job. This has complications in at least two

directions: what should George do, judging that no one ought
to do the job, knowing that someone will, and under strong
moral pressure to let that someone be himself? and what
should we, not necessarily sharing and perhaps opposing
George's judgment, say about his doing something to which
he has conscientious objection? For a reason which will
emerge shortly, I prefer another approach.

Someone who agrees to work in a CBW establishment
might (or might not!) be faced with a special but familiar
enough difficulty. If he takes the job, it might come to be the
case that someone or something is using him in some wicked
activity: he knows it but there is nothing he is in a position
to do which corresponds to Jim's effort at saving the Indians.
Four examples. *Bad luck*: It seemed that there might be a
chance of doing something worth while or at least mitigating
disaster but it turns out that nothing can be done, as was
always on the cards. Nor is it possible to get out now: if I
try to resign they will shoot me. The only alternative to going
on with the work is suicide, which in this context is no sort of
moral solution but an expression of total moral defeat. *Value
trap*: I committed myself to the enterprise on the strength
of certain values which made it seem right to take the risk.
These values now rule out anything that could count as a pro-
ject on my part, distinct from the enterprise of the evil person
or agency using me. *Loss of moral sense*: My grip on moral
distinctions was always precarious and in trying to mitigate
disaster by joining the enemy I allowed myself to be drawn
into circles in which my moral sense is so eroded that I can
do nothing worth while. If I still see what is right and wrong,
my will has been so weakened that I cannot act on my percep-
tions. Or I no longer really see what is right and wrong:
maybe I can still draw the old distinctions, but they mean
nothing to me. *New loyalties*: I always knew that loyalty to
those with whom one is working can be influential in people's
actions. But no one could determine in advance the extent
to which I should be drawn into loyalty to those with whom
I am working on CBW, and I now find myself (morally) un-
able to perform the acts of betrayal that would be necessary to
avert the disasters I took the job to head off.

In each of these situations it might become increasingly

clear that I cannot escape: I am being used and that is all there is to it. There is nothing one can point to which is my project as distinct from what the person or thing using me is doing. And looking back I can see that there was no point at which I was in position to recognise what was happening and able to say 'I have gone thus far but I will go no further'. Let us call this process of which complete moral impotence is the end-point 'the trap'. A trap involves a one-way door, a downward gradient, and a bottom where all moral agency is lost. George's problem with the CBW job may be that although he cannot be sure about what he is letting himself in for in taking the job, he knows that there is an appreciable risk that he will be falling into the trap. If it is the trap George is facing, he is at one with some who scruple at military service in all or in some wars, and with some who agonised over whether to serve under Hitler in the hope of saving some lives.

I am going to suggest that there is a special kind of moral difficulty about the trap but before we proceed it is convenient to re-consider five questions that I have left hanging in the air. (1) What if anything is a good ground for finding Jim's shooting problem easier than his torture problem and harder than his choice problem? The choice problem obviously involves no risk of the trap. The shooting problem also involves no risk of the trap but it requires thought to establish this. The torture problem probably involves no risk of the trap, although this should give one pause since in agreeing to carry out torture Jim is signing a somewhat blank cheque. And as we have seen, all three problems can be described as giving in to Pedro. Accordingly, I suggest that all three give us pause for reasons that find expression in Kant's principle "Always treat humanity as an end". The different difficulty of the cases can be grounded in the different degrees of difficulty they involve of seeing that there is no risk of the trap. I put this forward as good reason for scruple rather than as the psychological or sociological residue that remains if it emerges that there are no good reasons. I shall have supported this suggestion if I can show that there is special moral difficulty in risking the trap. (2) Would Jim be using himself if he gave in to Pedro? I have given reason to think not.

(3) What should Jim do? I have given reason to think that a *prima facie* case for refusing to give in proves untenable on closer examination. Unless I have overlooked something, therefore, it is open to us to agree with the utilitarian about what to do, though not for his reasons. (4) What should we, not necessarily sharing and perhaps opposing George's judgment on CBW, say about his doing something to which he has conscientious objection? I feel very uneasy about the great generality of such questions. I can best indicate my problem by glancing at a comment Bernard Williams makes on the relation between Jim, George and utilitarianism. He is discussing the idea that a non-consequentialist response to the shooting and CBW problems is mere squeamishness:

> "The reason why the squeamishness appeal can be very unsettling is not that we are utilitarians who are uncertain what utilitarian value to attach to our moral feelings, but that we are partially at least not utilitarians, and cannot regard our moral feelings as objects of utilitarian value. Because our moral relation to the world is partly given by such feelings, and by a sense of what we can and cannot "live with", to come to regard these feelings from a purely utilitarian point of view, that is to say, as happenings outside one's moral self, is to lose a sense of one's moral identity; to lose, in the most literal way, one's integrity."[16]

This passage contains an argument to the conclusion that utilitarianism is very unsettling. One of the premisses has something to do with alienation from the moral self, loss of integrity.[17] Among possible readings of the premiss are (i) alienation from the moral self is always a bad state of affairs and (ii) in at least one case, I cannot but regard alienation from the moral self as deeply unsettling. I do not accept (i) since it seems to me that people are often imprisoned in false values. Alienation from his moral self is fairly frequently the best thing that can happen to a person. But I do accept (ii). For example, I am able to recognise judgments about the trap of a non-utilitarian kind which are my own, or which I respect. These may be the moral judgments Jim and George make if they take a non-consequentialist line. The general

distinction underlying that between (i) and (ii) is rather fundamental in moral and political philosophy. To mention just three cases immediately relevant to the argument of this paper: Bernard Williams' argument carries the uncancelled implication that there is something called 'alienation from the moral self' or 'integrity' that requires the same treatment in ethics regardless of whether the values in question are false or worthy of the highest respect. Conscientious objection (George's, the pacifist's, *etc.*) is very often discussed without reference to the moral and intellectual viability of the objector's ground for objection. And in trying to establish the kind of difficulty that there is with the trap I find myself having to trace things back to something which is at least worthy of respect.

If I am right about the moral significance of the trap then the objectionably general question about a person's doing things to which he is conscientiously opposed can—for the case we are considering—be replaced by a more determinate and manageable question: namely, what should we say about George's doing something which he finds morally problematic on account of the trap? I shall not return to this question but my argument will have obvious implications for it. Similarly, for the very general question (5) what should George do, judging that no one should do the job, knowing that someone will, and under strong moral pressure to let that someone be himself? we can substitute a more determinate question referring explicity to the trap.

III

To see what the problem is with the trap, let us begin by looking at someone who has reached the end-point by reference to which I defined it. What is unacceptable about being so placed that someone or something is using me in some wicked activity and there is nothing I can do which could be regarded as a project of my own, some quest for the good, distinct from the activity of the evil agency? I am interested not in reflections about how I came to be in this sorry state but in determining what if anything, apart from

all remorse, makes this a sorry state to be in. Nothing of a non-moral kind is relevant: non-moral pain or unhappiness may accompany this state but relate to it only externally, contingently. And if ought implies can, and there is nothing of a virtuous kind that I can do then my misery cannot consist in doing what I ought not to. Perhaps all that can be said is that mine is an intrinsically wretched state to be in.

But I think something else is to be said: (a) a person who has fallen to the bottom of the trap has necessarily lost something and (b) the view which has to be taken of what he has lost involves seeing the loss as a misfortune. I argue first for (a). It is part of being in the trap that one is a centre of moral agency. If one were not one would not figure in the specification of those participating in the wicked activity. A mere cog in a machine does not participate, even a thinking cog. Now: to count as a moral agent a person must have virtuous action open to him at some time, or the claim that he is a moral agent is vacuous. But there is nothing of the sort now open to the person at the end of the trap. Hence he has lost something. This establishes (a). If I can now show that what he has lost is something valuable or valued by him then (b) will be proved. Consider the trap from the standpoint of someone contemplating it from afar and wondering whether to risk it. Is it open to such a person to say "The power to act morally is not valuable"? or "I don't value it"? If it were then it would be open to him to stop looking at his present moral problem in a moral way, or to take of it a moral view that did not require action of him where action was possible and morally required; but this is not open to him. Nor can he say "I now value the power to act morally now but not the power to act morally later" since there is nothing he could point to in explanation of this distinction. Hence he must regard the loss implicit in the trap as a bad thing and there is no way for us to question the value of that which the person in the trap has lost without opening the general and not here very pressing question of the value of the moral.

The necessity of regarding the loss of moral agency as a bad thing does not in itself prove much. Morality that does not involve at least the possibility of heavy cost to the moral agent has little philosophical interest. To show that the trap

poses some special problem I must point to something special in this cost. I shall not argue that the trap is an especially bad state of affairs to produce but rather that there is a special obstacle in the way of risking the trap, something not to be construed in terms of the production-line model of morality.

This brings me to what will probably seem the strangest part of my argument. It does not seem to be noticed very often that morality poses its own problem of evil for the religious and non-religious alike. The problem might be expressed thus: how can I continue with a practice that demands such victims? The emotional force of this question can be readily grasped if we imagine it in the mouth of some Agamemnon who has no gods, only morality, and reflects on that which is forcing him to kill his daughter.

If the question can have emotional force, what of its intellectual content? It is a special case of a more general question: namely, how can I accept something while at the same time I continue to regard it as bad (or evil, or bad for me, *etc.*)? How is the rejection of a thing as bad (*etc.*) to be combined without inconsistency or incoherence with the thing's acceptance? For the utilitarian this question is not very serious, since it can be formulated only externally: roughly speaking, in consequentialism a person's acceptance of the cost or risk of what he is doing matters only insofar as it makes him likelier to do the right thing or is to be counted in the sum total of happiness. But the problem looks quite different from the standpoint of someone for whom it is real, someone who asks himself "How *can* I accept this?" He is asking a practical question. What is and is not open to him depends on the answer. I want to suggest than anyone who asks himself this question should find the trap impossible. I take it that the point will be enforced sufficiently if I can show that there are insuperable obstacles to risking the trap in each of the four examples that I sketched earlier.

My argument proceeds on three assumptions. First, that *sometimes people are right to be troubled by morality's evil.* A person who is wondering whether to risk the trap will be (at least) worthy of respect if he asks himself the practical question "How *can* I accept that?" The utilitarian's external attitude to his problem is unsettling in a way that moral

philosophy should take seriously. The hesitation is not to be shrugged off as mere squeamishness.

Second, *acceptance is something we do.* Acting in the knowledge that a cost or risk is involved is one thing, acting with acceptance of that cost or risk is a further thing. For example, it is one thing to act in the knowledge that the cost is death, a further thing if I act with the acceptance of death. There is of course no logical guarantee that there is one thing, the same in all cases, that makes the difference between acting with mere knowledge and acting with acceptance. But it seems to me that as a matter of fact what makes the difference is always something the agent is doing: acceptance is something we do.

Third, *if it is true that I am carrying out some project of mine then some description of what I am doing is available to me throughout and this description relates my project to my interest in my project.* For example, if I spend several months building a garage for the car then some description of the work is available to me throughout which relates the building of the garage to the pleasure I take in the work (!) or to the fact that I want to protect the car from the weather, please you, improve the value of our house, *etc.* No doubt a shifting pattern of emotions will alter my attitudes to this description as I lay brick on brick with pleasure, patience, weariness, impatience, rage, unspeakable boredom, *etc.*, but if it is still the same project of mine that I am carrying out then I am always able to recognise what I am doing, and see it as something I want. Hence the constant availability of the one description. Clearly, my second and third assumptions are closely linked.

My four examples of the trap fall into two pairs. Where George has bad luck or his arm twisted by a value trap, there is no change in George. Where he undergoes loss of moral sense or acquires new loyalties, he does change. The first pair are closely related to my second assumption; the second pair to my third assumption.

Bad luck: in virtue of what could George be said to accept the trap? The obvious reply is to point out that George could say 'It was just bad luck'. If my first assumption is correct, it will not be enough for him to *say* this. He must be doing something which entitles us to claim that he means it. But he

is in a situation in which he has lost all moral agency. There is therefore nothing he can do which can count as that in virtue of which he can say "I was unlucky" and mean what he says. Acceptance of the trap as bad luck is not open to him. *Value trap*: the obvious thing for George to do here as a way of accepting the trap is to refer to the values that make the trap inescapable for him. But can he do this? Of course he can if he is a utilitarian, but then he does not need to, since the problem is not serious for him in the first place. If George is to find the question "How *can* I accept this?" serious then his subscription to the values that entrap him must be at most ambivalent. And if his adherence is ambivalent, he cannot refer to the values that trap him in order to accept the trap. If he is value-trapped, he cannot accept the trap.

Loss of moral sense: the extent of George's moral decay is variable but let us suppose that it is extreme enough for him to become untroubled by the question "How *can* I accept this?" One might then suggest that George's moral 'development' was the thing in virtue of which he could be said to have accepted the trap. This suggestion is open to several criticisms. It does not cover all cases of loss of moral sense and drives an arbitrary-looking wedge among them. And it might be thought that George's 'development' could be a candidate for acceptance only if it were something that happened to him rather than something he willed. But what interests me most is another point. George got into the trap through some moral concern. If there is to be something he is doing, some project of his in virtue of which he can be said to have accepted the trap then a description must be available to him throughout which captures this moral concern. This description must both draw the requisite moral distinctions and capture his moral interest in the action. But by the hypothesis of his moral decay such a description is not available to him; so he cannot *accept* the trap. *New loyalties*: the difficulty here is closely related to that with loss of moral sense. If George is to accept the trap, some description of a moral project must be available to him which will specify his overriding concern with whatever it was that got him into the trap. But no such description is now available to him since his concern has been overridden.

Thus, in each of the four cases that I sketched to introduce the notion of the trap, anyone who is troubled by the question 'How can I accept this?' faces an insuperable difficulty. It is at least as understandable as utilitarianism that such a person should find it impossible to risk the trap.

According this quasi-absolute status[18] to trap-avoidance invites the question of, in Glover's words, what disasters such a prohibition might make inevitable. A plausible example of disaster as distinct from an arbitrary construct is remarkably hard to find because any situation in which a person is under strong moral pressure to risk the trap is one in which his power to produce good or evil is and will remain for the foreseeable future very limited. The kind of moral conflict that is likely to arise between utilitarian calculations and avoidance of the trap as a deontological necessity will not be on the pattern 'Let justice be done though the heavens fall' but one in which something that could well look insignificant on a consequentialist calculus is bound to look more important when one analyses, from a perfectly familiar view of the world, the relation between an agent and his projects.

The next question one faces, presumably, is this. Consider any moral decision that goes against somebody. How *can* one make that decision? How is the rejection of the person's suffering the decision as bad to be reconciled without inconsistency or incoherence with acceptance? I find it rather gratifying that this is obviously a central question in the theory of victims and do not feel called upon to try and answer it here.

I am now at least in a position to respond explicitly to Jonathan Glover's challenge to talk philosophical sense about the non-consequentialist resistance to certain public measures and involvements. Any interesting response was going to tell us something about what happens when moral claims conflict and I urged the merits of the theory of moral victims for the study of that question. The demand was for at least an outline and I can certainly offer nothing more in this paper. In outline, then: consideration of one special problem in the theory of victims renders at least as understandable as utilitarianism an absolute prohibition on risking the trap. The example leads one to question utilitarianism's model of morality as the

production of good states of affairs and search for a mandatory universal decision-procedure. Other examples in the theory of victims make utilitarianism look singularly implausible and so preclude any attempt to save the appearances by means of sophisticated re-weighting of utilities. There has been no need to say anything about negative responsibility or the idea that an important place in ethics must be found for unobjectionable ethical inconsistency. These conclusions have been arrived at through an examination of one thing that might be involved in work on CBW research, which was one of the controversial public involvements to which Glover drew attention.

What of his other example, selling arms to South Africa? Many of the most influential considerations on that issue are not discussable in the extremely limited terms of this paper. But one point can be made. It is often argued in defence of arms sales and transfers that they give the supplier a chance of influencing the recipient for the good. This is very dubious where the recipient has more than one possible source of supply, but suppose a state acts on it. Suppose there really is a chance of achieving something worth while. What are we to think of a state that, in thus seeking the good, is totally unimpressed by the fact that it faces another possibility also— something very like the risk of the trap?[19]

NOTES

[1] Jonathan Glover "It makes no difference whether I do it or not" *PASS Vol. XLIX* (1975), pp. 183-4.
[2] For brevity I make no further reference to consequentialism as distinct from utilitarianism.
[3] Nagel not very consistently in "War and Massacre" *War and Moral Responsibility* (eds.) Marshall Cohen, Thomas Nagel and Thomas Scanlon, Princeton UP 1974, p. 6; repr. from *Philosophy and Public Affairs* I no. 2 (Winter 1972).
[4] Am I implying that the utilitarian is unaware of such ethical problems as freewill and moral objectivity? No: merely that he construes these very restrictively as the problems of free action, objectivity of judgments about right action, good state of affairs.
[5] Example from Robert Nozick *Anarchy, State, and Utopia*, Blackwell Oxford 1974, pp. 28-9.
[6] Fact pointed out by Bernard Williams: J. J. C. Smart and Bernard Williams *Utilitarianism For and Against* CUP 1973, p. 89.
[7] Most impressive of the latter perhaps Peter Winch "The Universalizability

of Moral Judgments" *Ethics and Action* Routledge 1972; repr. from *Monist*
Vol. 49 (1965).

[8] W. D. Ross *The Right and the Good* OUP 1930, p. 28.

[9] *Agamemnon* 205-21.

[10] Bernard Williams "Ethical Consistency" *Problems of the Self* CUP 1973,
p. 173; repr. from *PASS Vol. XXXIX* (1965).

[11] *Oresteia* U. of Chicago P. 1953, p. 41.

[12] Williams "Ethical Consistency" *loc. cit.*, p. 175.

[13] So why is there still the need to make amends to which Ross directs atten-
tion? There is not space to discuss this here.

[14] Smart and Williams pp. 98-9.

[15] *Id.* pp. 97-8.

[16] *Id.* pp. 103-4.

[17] For brevity I make no further reference to integrity, which seems to play
no independent part in the argument quoted.

[18] *Quasi*-absolute because I am not committed to saying that trap-risking is
absolutely wrong.

[19] I am very grateful to Bernard Williams for discussion of an earlier and
much worse draft of this paper.

VI*—FREEDOM, AUTONOMY AND THE CONCEPT OF A PERSON

by S. I. Benn[1]

A. THE FREEDOM OF PERSONS

1. *The principle of non-interference stated*

Claims that a person is/was free, or is/was not free to act occur characteristically in speech-acts like expressions of grievance or resentment, giving or seeking justifications, making or rebutting excuses, fixing or denying responsibility.[2] Such talk, in short, is normative talk, invoking what I shall call *the principle of non-interference*, the minimal or formal principle that no one may legitimately frustrate a person's acting without some reason. In calling it a *formal* principle I mean that it determines neither what a person ought to be free to do, nor what is to count as a reason for interfering. Instead, it locates the onus of justification: when an agent Alf announces his intention to do X and Ian announces *his* intention to interfere to prevent him, it is for Ian, not Alf, to make out a case, and if he cannot, to desist. Of course, in many instances reasons for interfering will not be hard to find. Alf's wanting to torture his cat is not a reason for letting him do it; but in that case the specification of the act supplies the reason for preventing it. Nor does Alf's *wanting* to do it constitute a counter-reason. But we do not ask Alf to begin the justificatory exchange: unless Ian can supply some reason why Alf should be stopped, Alf is free to go ahead. He doesn't have to have a reason. Consider the following dialogue:

> *Ian*: I am going to stop Alf.
> *Enquirer*: Alf! I've no idea what you are doing, but is there any reason why Ian shouldn't stop your doing it?

The Enquirer's response is so odd that one is led to think up *ad hoc* hypotheses to account for the displacement of the

* Meeting of the Aristotelian Society at 5/7, Tavistock Place, London, W.C.1, on Monday, 12th January, 1976 at 7.30 p.m.

normal onus of justification: perhaps Alf is a child who is notoriously up to mischief who may therefore be supposed, by inductive inference, to be up to no good now.

Admittedly, there will be cases of frustration where the onus is unclear, and others where no occasion for justification arises. Alf may announce his intention to do X and Ian *his* intention to do Y, X and Y being, as a matter of fact though not by intentional description, non-compossible, so that at least one must end up by frustrating the other; yet neither may need to justify what he is doing; each is at liberty to try. H. L. A. Hart's example of the two men each exercising his natural liberty to try for the dollar lying on the sidewalk, is of this kind.[3] The principle of non-interference could now be invoked if either prevented the other from trying. And there are games—or competitive business relations—in which frustration is sanctioned by the game. But then the rule of the game already provides the justifying reason for interference.

The principle of non-interference applies paradigmatically to the case where Ian's *intention* is to prevent Alf's X-ing, when there can be no agreed settlement without a change of primary intent; for the intent to frustrate is not then an incidental consequence of an intention to achieve some other end that might be sought in some more accommodating way. For this case at least there must be a rule settling the onus of justification.

'Frustrating' includes creating conditions in which, as in deterrence situations, Alf is supplied with a reason he did not have before for not doing what he might otherwise have done; it does not include informing him of what reasons there already are. For to tell Alf what he *cannot* do is not to prevent his doing it. And if the information does not show that he *cannot* do it, but only that the course is less attractive than he thought, then he is still at liberty to do it if he wishes. Warning does not impair Alf's freedom to act, if it extends his knowledge of his situation without changing it.

2. *The standard choice-situation and modes of interference*

The standard instances of unfreedom to act in moral and political discourse are those in which an agent is under

physical constraint or in which he is liable to penal sanctions
or subject to exploitation or duress. Apart possibly from
physical constraint, all these presuppose an agent in a
standard choice- or decision-situation.

This has four components:

(a) he has a determinate set of resources at his disposal;
(b) he is confronted with a set of opportunity costs: if
he pursues x he must forgo y;
(c) he has goals forming an ordered preference set, in
the light of which he makes choices;
(d) he has a set of beliefs about (a), (b), and (c), *e.g.*,
about the relation of resources, as means, to his
goals.

I shall refer to conditions (a) and (b), which are states of
the world confronting the agent, as objective choice condi-
tions. I shall refer to (c) and (d), which are states of the agent
himself, as subjective choice conditions.

Standard cases of being made unfree to act involve inter-
ference to alter one or more of these four conditions. Or by
an extension, Alf may be unfree because Ian has failed to alter
his position when it is below some accepted or presupposed
baseline or standard, this being taken to be Ian's responsi-
bility. Thus Alf may be unfree as much because Ian has not
unlocked the door, as because he has locked it. And by yet
a further extension, if Alf is perceived as constrained by un-
reasonable social and economic conditions maintained by
people with the power to change them, then these conditions
too would be said to make Alf unfree, whether by restricting
his resources, weighting his opportunity costs, distorting his
preferences, keeping him ignorant of his opportunities, or
perhaps by all four.

The model can be extended to embrace physical constraint
by treating the agent's mobility as a resource. By locking him
in a room or by tying his hands, one limits what he can choose
to do, just as one denies a mountaineer freedom to climb by
confiscating his ropes. So these can both count as instances of
limiting a person's options by rigging (a). Duress and ex-
ploitation are instances of adversely rigging (b), attaching
costs to certain forms of action that they would not otherwise
carry. But one may deceive the agent into believing that some

options actually available are not available; or one may deny him access, *e.g.*, by censorship, to information that would correct his false beliefs. By so manipulating his beliefs (*i.e.*, by manipulating the (d) conditions), one may control his choices while leaving (a) and (b) untouched.

This choice model ascribes to the agent as chooser a minimal rationality. Duress makes him unfree because he knows that additional costs are attached to certain options; there would be no point in threatening to exact the costs were he incapable of deciding and acting on a cost-benefit analysis based on an ordered set of preferences. Similarly there is no point in deception and censorship unless the subject can be expected to form his beliefs on evidence, and to act on them; otherwise providing false evidence would not be a way of controlling action. So the model decision-situation presupposed by talk of freedom to act ascribes to the chooser a degree of both practical and epistemic (or cognitive) rationality.

The classical liberal concern for freedom was principally for non-interference with the objective choice conditions. The state of the chooser himself, *i.e.*, the subjective conditions (c) and (d), was rarely considered, save in connexion with information flow and censorship. Except in the wider philosophical context of determinist theories (which, of course, denied that any wanting could be free), little attention was given to whether someone could be unfree in forming and ordering his preferences. Recent critics of traditional liberalism have drawn attention to goal-shaping by advertising and mass-information agencies, stressing the Marxian insight that an individual's preferences reflect the values maintained by his society. If social conditions might be otherwise, and if some class of people is held responsible for their *not* being otherwise, then it is plausible to regard the agents as unfree in what they do, even when they do what they want, more especially if it is also supposed that were they given the opportunity to look critically at what they want, they would not want it.[4]

3. *The model of the chooser and respect for autarchy*

The condition of being a chooser, presupposed by the

standard choice-situation, I shall call *autarchy*—a self-governing condition—distinguishing it both from conditions that fall short of it, which I shall call *being impelled*, and from an ideal that transcends it, which I shall call *autonomy*. I shall explore the nature of autonomy more fully in the second half of this paper.

Autarchy is normal, both in the statistical sense and in the sense that human beings who fail to qualify are held to be in some measure defective as persons. So one can grasp the norm by understanding the kind of neurotic and psychotic states that disqualify someone as a chooser. These may be classified under three heads: defects of practical rationality, of epistemic rationality, and of psychic continuity whether as believer or as agent.

(a) Various kinds of compulsive behaviour qualify as defects of practical rationality, including cases in which action is unaffected either by anterior decisions or by changes of belief. Kleptomaniacs do not decide to steal; indeed, they may decide not to, but steal all the same. Reminding a compulsive handwasher that he washed his hands only moments ago will not stop him washing them again. Reasons that he acknowledges as relevant and sufficient to make his action inappropriate are nevertheless ineffective. He does not choose —he is impelled by inner drives.

Psychopaths display a different kind of practical irrationality. They seem incapable of treating any but the most immediate consequences of action as relevant considerations for decision-making, and consequently of formulating and carrying through projects requiring deferment of gratification. Here again it seems appropriate to talk of someone's being impelled (or perhaps drawn) towards his goals, rather than deciding. Of course it would be wrong to describe his actions as if they were automatic reflexes; he is drawn to one course rather than another, but under a certain description. In appreciating the nature of the alternatives he may exhibit quite a high degree of epistemic rationality. But he will be attracted to one rather than another only by the expectation of greater immediate gratification. Though he may grasp that disastrous results will certainly follow, this does not move him. He has, it is true, a kind of preference for

not being in trouble, and when he is he may resolve with apparent sincerity to avoid it in the future. But the preference is strictly theoretical; faced with an immediately attractive course he turns to it with no kind of struggle. His preference for staying out of trouble, though not a hypocritical pretence, nevertheless cannot motivate him. So it would not be correct to say that he succumbs to temptation, for one is not strictly speaking tempted unless one has some disposition, however feeble, not to go for the immediately gratifying outcome, a disposition the psychopath seems to lack.

(b) Defects of epistemic rationality are exemplified in the paranoiac, whose belief structure is so disordered that his choices are made from mere phantasy-options, in a world of his own fabrication, fortified against refutation. Unable to take account of evidence upsetting his delusions, he invents *ad hoc* hypotheses to absorb it into the phantasy.

It may be objected that this description of a paranoiac does not distinguish someone of defective rationality from someone committed to an ideology or belief-structure we just happen to find unacceptable. What it is rational to believe may depend in great measure on the pre-existent belief structure into which the new material has to be absorbed. Precisely how to evaluate an occurrence in the Middle East will no doubt depend on whether one sets it against a Marxist, a Zionist, or an Arab nationalist background. Each provides basic theses which constitute canons of interpretation. It may be very difficult to say what an objective description of the evidence would amount to. For all that, each set of canons makes possible an interpersonal assessment of evidence within that ideological system, and to that extent each system remains a public world, in which the conceptual distinction between reality and phantasy retains its meaning. By contrast, the paranoiac's world is essentially private. He allows no one's testimony to count as evidence against his strange beliefs, even though forced to impugn the honesty of everyone he meets, and to believe them all in league against him. So he is committed to withdrawing into a private world, to an 'ideology' in which it is impossible to test his perceptions and inferences against *anyone* else's, since disagreement on the very point at issue and on that alone would always count as a

sufficient reason for dismissing the other's testimony on that point as inauthentic. Prompted by his anxieties, the paranoiac adopts cognitive strategies that isolate him from counter-evidence, and so deprives himself of the distinction between phantasy and reality. Nor can one say, as one might of a scientist doggedly carrying on with a theory despite counter-instances, that it would be irrational to abandon a theory that is still fruitful when no better one is in sight. For the paranoid's phantasy is not fruitful—it does nothing to solve his problem. His anxiety state is made more miserable rather than relieved by it. Moreover, his very ingenuity in saving his 'theory' stands in the way of his overhauling his total conception of the world without which there can be no relief. The paranoid psychotic is non-autarchic because his goals and his beliefs are alike generated by his anxieties, so there can be no rational matching of means to ends.

(c) The third class of defect is yet more radical. One instance is the schizophrenic lacking consciousness of himself as originating changes in the world, conceiving himself instead as process or as something to which things happen. In advanced cases the subject may act out this self-conception in catatonic paralysis, becoming for the world, too, the mere thing he believes himself to be. A different case, but equally disqualifying from autarchy on the ground of psychic discontinuity, is dissociation, where facets of a subject's personality split in multiple consciousness. The subject's conflicts may be so intolerable that surrendering continuity of self-awareness may be an unconscious strategy for evading responsibility not only for what he feels driven to do but also for what he cannot help believing. With the more Protean of such subjects it is virtually impossible to identify any single sustained personal agent with all the behaviour attributed to the single physical body; indeed the subject will talk as though there are different persons inhabiting and quarrelling over his body. Precisely because there is no one person to whom beliefs and actions can be attributed the subject may be said to have disqualified himself both as chooser and as believer.

Overwhelming disabilities such as the last ones described may indeed totally disqualify someone as a chooser. But not

all need be as crippling as that. A compulsive neurosis may affect only a segment of a person's behaviour; outside that, his capacity for rational choice may be unimpaired. Conversely, someone may be temporarily deprived of autarchy by unusually taxing conditions: a starving man or one sexually tormented may be so 'driven' that he is quite incapable of counting the cost of what he does. Excuses of 'irresistible temptation' and 'provocation' amount to pleas of temporary loss of autarchy.

The following requirements for autarchy now emerge:

(a) it must be possible to identify a single person corresponding over time to a single physically acting subject;

(b) he must recognise canons for evidence and inferences warranting changes in his beliefs;

(c) he must have the capacity for making decisions when confronted by options, and for acting on them;

(d) changes of belief must be capable of making appropriate differences to decisions and policies;

(e) he must be capable of deciding in the light of preferences;

(f) he must be capable of formulating a project or a policy so that a decision can be taken now for the sake of a preferred future state.

I call someone incapacitated in any of these ways *inner-impelled* because in one way or another he behaves like an automaton, set in motion perhaps by signals, abnormally unadaptable in his responses, going through a kind of programmed performance rather than correcting or adjusting as his perception of the situation changes. I call him *inner-*impelled to distinguish him from a heterarchic agent, also impelled and equally disqualified as a chooser, responding equally uncomprehendingly to drives or attractions, but according to a programme implanted by someone else. Subjects acting under hypnosis, or brain-washed,[5] or unable to contemplate disobeying an authoritarian parent, are all instances. Their normal functioning as choosers is not merely defective but has been impaired or crippled by someone else. But the principle infringed in their case is not the principle

of non-interference with someone's doing what he chooses; for what is now in question is whether the manipulated man can strictly be said to choose at all.[6] The principle invoked in protesting against such treatment is that a person's capacity to formulate and pursue his own projects is a source of considerations in dealing with him that do not arise, for instance, in dealing with sheep or chickens; manipulating his actions by means that short-circuit his decision-making capacity do him wrong, unless overriding justification can be found. I shall call this *the principle of respect for autarchy*.

4. *Justifying the principles*

So far I have made no attempt to justify the principles of non-interference and respect for autarchy; I have claimed only that common forms of our moral discourse presuppose them. I shall now try to remedy this. I shall argue that for someone who has a normal conception of himself as a natural person in a world of natural persons, the conceptual sacrifice to which he would be committed by denying the principle of non-interference would be extremely punishing.

(a) *The conceptual commitments of natural persons and the principle of non-interference.* To be a natural person is to have a certain kind of awareness of oneself; to distinguish oneself from the *things* in the world which are simply the subjects of happenings, carried along by the tide of events. I am aware of myself as an initiator of events which will go differently, sometimes at least, if I decide to do this rather than that. Not that a natural person must reject determinism; he is required only to perceive that among the elements in the causal sequences that account for the actions of natural persons, his own included, are reflective appreciations of situations in the light of the agent's preference sets (which include his principles and value-attitudes generally); that these appreciations are necessary and not merely epiphenomenal constituents of the sequences; and that nothing corresponding to them is discernible in the behaviour of other entities from which he distinguishes natural persons. So though he might say of some non-personal entity too that what it did made a difference to the way the world went— as one might say of a wind that it made a tree fall down—it

would not mean that it made that difference because the wind preferred that it should. Its causal agency would not be of the required kind, that includes an evaluation of the situation.

Again, though a natural person may know with virtual certainty what he will decide on an issue to-morrow, or, indeed, what he would decide under hypothetical conditions, this is different from saying, as a clear-sighted compulsive neurotic might, that he knew what he would do *whatever* he decided. The normal chooser knows what he will (or would) choose because he knows his own preferences, character, and beliefs, and expects to act on his decision. It might even be said that in forming a belief about what he will choose, he has already chosen, for the inferential part of choosing would be incapsulated in the predictive inference. Moreover, anyone who knew him well enough could be as certain as he is—but only by taking account of his rational capacity for decision, that is, of his autarchy.

Now I do not say that everyone knows himself as a natural person. Autistic children do not seem to arrive at self-differentiation at all. A certain kind of schizoid seems to have only a very weak grasp of his own identity as a person. Seeing himself only as determined by happenings, and not at all as determining happenings by his decisions, he may never learn the concept of a person, or having learnt it, may not believe himself to be an instance. What I have to say would get no grip, therefore, on *his* self-awareness. But for anyone with what I take to be a more normal consciousness of self, it makes sense for him to think of his decisions as making a difference, and so to entertain goals, make projects, engage in enterprises. And having goals, he will have the notions of success, achievement, and failure, and he will distinguish conditions and events as important or unimportant in the light of these assessments.

Now it is at least conceivable that a natural person could fail to extend this concept of being a person to anyone in the world save himself. If he distinguished himself as a person from the other, impersonal objects, he would certainly have the concept of a person; and he would therefore be bound to entertain the *possibility* of others like him in the world. But

there might be nothing in his experience that would *compel* him to accept other human beings as persons. His uniqueness would simply be a contingent fact about the world. John Plamenatz believed this to be an impossibility. Following Hegel, he claimed[7] that "self-knowledge in man is not prior to knowledge of other persons, but is acquired in the course of the same practice and process of learning as knowledge of a world that is external to the knower and includes other persons besides himself." And this view is supported by Piaget's account of 'reversibility' and 'decentering' as elements in the development of rationality.[8] Nevertheless, there seems no logical barrier to one's *having* the notion, even if there might be difficulties in *coming* to have it. Suppose someone concluded that he had been mistaken all along in thinking of other human beings as natural persons like himself, that they were instead complex automata. If he managed to reconstruct his view of himself in the world along these lines he would certainly have purged it of any rational commitment to non-interference in respect of any actual being, whatever its implications for possible ones. The cost, however, would be enormous. There would be so much of human behaviour to explain away; and such a strategy would, in any case, be rather like the paranoid, forcing the subject back into a private world.

Suppose, then, that our person accepts that others, too, are persons, with enterprises important for them as his are for himself. This would still not be enough to commit him to an appreciation of their enterprises as reasons for action or forbearance for him too. For this might still be a Hobbesian state of nature, a psychopathic world. Each could be aware of the others as having distinctive points of view, which he would take account of as facts of life to which he had to accommodate. Provided each stood to gain, and none could simply take possession of another's contribution, they might even contrive to collaborate in a limited sort of way, given that no one was ever required to commit anything to the enterprise before others had done likewise, and provided everyone expected the conditions favouring collaboration to remain unaltered until the task was completed and the outcome enjoyed. Mostly, however, they would find themselves in a succession

of Prisoners' Dilemmas, wrestling with the problems of free-riders wherever no selective incentives could operate.[9] But nothing in their ruggedly individualist consciousnesses would warrant a sense of unfair treatment or injury; at most their mutual impacts, however infuriating, would have to be accepted as natural hazards to be endured.

Persons so related would not be able to experience what Strawson has called 'reactive feelings and attitudes that belong to involvement or participation with others in interpersonal human relationships'.[10] There could be no love or friendship between them as equals, since none would acknowledge the goals and values which gave point to the conduct of others as capable of generating any reasons for action for him. More strictly, it is conceivable that one might come to identify himself with the well-being of another, encapsulating the fulfilment of that one's projects among his own. But someone who experienced another's enterprises only in this way could hardly grasp the importance which they had for the other as *his*. Just so do hungry and possessive parents and lovers, lacking respect for the loved one, smother what they claim to love.

But of course, as between lovers lacking the notion of mutual respect, the one devoured would hardly know what to complain of. For a complaint—or, indeed, any expression of resentment or indignation, as distinct from simple rage or distress—cannot be formulated unless the complainant already supposes that some respect or consideration is *owed* to him. One could not feel resentment in such a situation unless one believed that every natural person, being conceptually equipped to grasp what it is to have and to value projects of one's own, were thereby committed to respect the standing of every other as an originator of projects—that is, to exercise a minimal forbearance from interfering with his projects. For what ground could Alf have for resenting Ian's taking over his project that would not be as good a ground, *mutatis mutandis*, for Ian's resenting Alf's taking over his? Seeing ourselves as natural persons, or makers of projects, in a world with other persons, we have developed a conception of ourselves as *moral* persons too, entitled to a degree of forbearance from any other natural person conceptually capable of grasp-

ing the nature of our self-perception. Claiming respect—moral personality—on the grounds of natural personality, we are then committed to extending it to anyone else satisfying the same conditions.

There may be Spartan or tribal cultures in which the notion of a natural person, of an independent project-maker, is poorly developed; in which, perhaps, everyone identifies pretty thoroughly with his tribal rôle. But modern men, with their strongly developed sense of personal agency, could hardly live together at all without making the conceptual link between natural and moral personality. A psychopath can exist as a deviant in a modern society; but to consider a psychopath's perception of himself and his world as anything but defective and impoverished would be to treat as an acceptable option a kind of conceptualisation which, if standard, would be incompatible with the continued existence of the world it sought to capture. The history and the poorly developed structure of the international society of states suggests that natural persons who generally perceived one another as natural hazards even during their limited alliances and collaborations could neither create nor sustain a complex modern society.[11] Amoralism could be canvassed as a rational option only by someone prepared to exchange a social order for the war of each against all.

Part of what I understand, therefore, by showing respect for persons is also what is required by the principle that if what I propose to do will thwart someone or reduce his options in some way, then it is not enough that I *want* to do it; his enterprise counts as a defeasible reason for my not doing it, and requires therefore some further reason for my going ahead. At the least, I must show that my action is of some importance to me, being related to some enterprise of my own that *he* could reasonably be expected to see as of importance too. And this amounts to the principle of non-interference, the first of the two principles I set out to justify.

(b) *The conceptual commitments of natural persons and respect for autarchy.*

The second principle, of respect for autarchy, can be justified in a roughly analogous way. Suppose someone with the self-consciousness of a natural person came to believe that he was

not a chooser at all, but a heterarchic man, the states of affairs he valued and for the sake of which he acted being those which he had been manipulated into valuing by someone else. If he found it hard to escape control and to restructure his values, his behaviour would remain oriented to the same ends as before. But instead of seeing himself as a natural person, as originating action, as making decisions for the sake of ends, he would now see himself only as behaving in ways apt to bring about determinable outcomes. What he formally conceived as the importance to him of his ends would now seem only a kind of mechanical attraction drawing him towards realising certain states of affairs, no longer a manifestation of his own creative agency. Mistrusting the inclinations that moved him, seeing them as alien, he would have a kind of dissociated schizoid view of himself, as from the outside, always determined, never determining.

To take seriously one's conception of oneself as a chooser is to assign a kind of higher-level importance to being the kind of agent capable of arranging his conduct according to the importance he attaches to states of affairs. To find that his choices were manipulated would amount to finding he did not choose at all. Thereafter nothing could count for him as important at the lower level; he would be left with a conception of himself as a set of dispositions to behave, but to none of them could he sensibly attach importance. But the higher-level importance of being a chooser would not be similarly dissolved. It would manifest itself in a sense of lost identity, of having been deprived of that element in one's self-perception that had given its particular kind of coherence to all the rest.

Now someone oppressed by the weight of moral responsibility for his decisions might conceivably accept such a change with a deep sense of relief. If autarchy is a burden, to know that one is no more than process may come as a deliverance. But for someone of more robust moral constitution, such an assault on the very core of his personality, on his perception of his own ontological status, must generate deep resentment, that a person having the same kind of self-perception as he had had could have devised such an attack. This would be an expression of a universal principle, that persons owe respect to one another's autarchic natures.

B. PERSONAL AUTONOMY

1. *Autonomy as an ideal*

I have used the term 'autarchy' rather than the more usual 'autonomy' because I want to distinguish the former, as the characteristic of a normal chooser, from a particular personality ideal which by no means all choosers instantiate. I have associated autarchy with two moral principles governing the moral relations between natural persons. I distinguish principles and ideals in the following way: At the most general level, a principle is a rule of procedure for deliberation or argument, doing little more than settle the burden of justification. The so-called formal principle of justice, 'treat equals equally . . .' is of this type. At a rather more substantial level, a principle can limit the kinds of reasons able to defeat presumptions embodied in more general principles: 'to each according to his needs' is a principle like this. Rather different and more specific are principles laying down general rules for acting appropriately in a particular class of situation, *e.g.*, 'pay your debts', 'tell the truth'. Such a principle can be interpreted in two ways: it may be invoked in deliberating before acting or it may provide the grounds invoked in justifications, recriminations, *etc.*; or it may be understood to inform a person's actions without his ever articulating it, *e.g.*, a person's conduct will be informed by the truth-telling principle if whenever he is questioned he replies truthfully *believing that response to be the appropriate one* for the occasion. An ideal, by contrast, is a state of affairs it would be valuable to bring about. Consequently, it can generate reasons for quite specific actions and policies, as well as fairly general principles, too, that constitute general strategies for bringing about the valued state of affairs. Thus the ideal of a classless society may generate the general principle of action: 'act so as to sharpen the class struggle.'

Now I take autonomy to be an ideal in this sense. To be a chooser is not enough for autonomy, for a competent chooser may still be a slave to convention, choosing by standards he has accepted quite uncritically from his milieu. He assesses situations, adapts means to ends, and so on, but always by norms of propriety and success absorbed unreflectively from parents, teachers, or workmates. It is not that he is incapacitated from

making independent judgments, like the heterarchic man; it is only that he has little inclination for making them and rarely does so. Such a person is *heteronomous*: unlike the heterarchic man, he governs himself, but by a *nomos* or set of standards taken over from others.

Or someone may make no attempt to live consistently, acting on impulse not because he is impelled but because he acknowledges nothing as a reason for doing otherwise. Caring about nothing, he sees no point in controlling the inclination of the moment. This is the *anomic* chooser. Under stress his autarchy would probably break down into heterarchy or psychosis, since he has no firm conception of himself as a personality of a particular kind with its characteristic principle of integration: but until the pressure is on, he is recognizably autarchic, but not autonomous.[12]

2. *Characterization of autonomy*

The difference between autarchy and autonomy lies precisely in the *nomos*. The autonomous man is the one who, in Rousseau's phrase, "is obedient to a law that he prescribes to himself", whose life has a consistency that derives from a coherent set of beliefs, values, and principles, by which his actions are governed. Moreover, these are not supplied to him ready-made as are those of the heteronomous man: they are *his*, because the outcome of a still-continuing process of criticism and re-evaluation. The autonomous man is not merely *capable* of deciding for himself, he does so; he is not merely capable of considering reasons, he does consider them, and he acts on them. He is therefore the man who realizes what the autarchic man has merely in potentiality. The remainder of this paper will maintain the thesis that anyone who attaches importance to his ontological status as a person will have a reason for accepting autonomy as an ideal.

It is a feature of the active life of a person that he is conscious of himself as an author of changes in the world. Admittedly, the man who has a place on an assembly line, so far as concerns this rôle alone, is *not* likely to see himself in this way. The total product is remote from his performance, and he is unlikely to feel much personal responsibility for it—to feel that he is, even in small measure its author. But of

course his whole life is not like that. If he fries an egg for breakfast, he can recognize that this at least is *his* work, and he can judge whether he has done it well or ill.

A man's consciousness of himself as author is essential to his conception of himself as a person. Moreover, though his life may be directed to projects outside himself, like making good pots or the workers' revolution, still, the process can be represented at the same time as a process of *self*-perfection, even though this may not be at all how the person himself is primarily aware of it. For when the potter judges his own pots, knowing them to be his own, there is something about the judging that is inescapably absent from any judgment he makes of someone else's pots.

I do not mean that to be a person one must engage in a rather objectionable self-contemplation, whether self-admiring or self-abasing, obtruding between oneself and the activity that is one's proper object. Narcissim is an exaggerated pathological preoccupation, a *distortion* of that mode of self-awareness which is nonetheless necessarily a dimension of any conscious personal activity. The potter who dedicates his life selflessly to making pots will need to monitor his progress and achievements and therefore himself as a person by the standards appropriate to the craft. For inasmuch as being a potter is an important constituent of his way of life, he will earn his own respect according to his skill and integrity. In praising *anyone's* pots he is by implication of course praising the potter too. But recognizing his pots as his *own* handiwork, his own responsibility, his appraisal is inevitably practical, associated with resolutions, hopes, and projects for his future performance, over which he has a kind of control such as he has over the work of no one else. The very dissatisfaction he experiences in spotting imperfections and mistakes can motivate him to try harder and do better because they are ways of being dissatisfied with himself as the responsible creative agent. And this characterization of personal agency applies not only to the artist or craftsman; it can be just as true of a man as banker or revolutionary, father or friend. For each of these rôle-descriptions there is a set of standards by which he will assess his performance, and therefore—and unavoidably —himself.

A person cannot be indifferent to success and failure by the standards that he himself endorses. Failing in some rôle that he does not care about at all—like a conscript who cannot internalize the army's standards—may leave him unmoved because good soldiers are not for him admirable. But he cannot be indifferent to how he shows up in a rôle with which he identifies. For many people, of course, whether they endorse a standard or accept a rôle depends on whether others do so. These are the heteronomous ones. Still, heteronomous or autonomous, in assessing his performance in a rôle he accepts, a person assesses by implication himself.

But how does one distinguish the autonomous from the heteronomous? Are we not all governed by the basic presuppositions of a society which has provided the very conceptual structure of our world, the traditions into which we have been inducted, the demands of rôles we have internalized? One's range of options is as much circumscribed by such mental furnishings as the highest speed at which one can travel is governed by the state of its technology. But none of this affects my distinction, which is between character types *all* of which are subject to these conditions. Indeed, it is necessary for his autonomy that a person be capable of rational choice, and for that he needs criteria and a conceptual scheme for grasping the issues. How could he come by them unless he learnt them in the first instance from the people about him? Someone not so equipped would not be free, able to make *anything* of himself; he would be able to make nothing of himself, hardly a person at all. To be autonomous one must have reasons for acting, and be capable of second thoughts in the light of new reasons; it is not to have a capacity for conjuring criteria out of nowhere.

Within this conception of a socialized individual, there is room to distinguish one who simply accepts the rôles society thrusts on him, uncritically internalizing the received *mores*, from someone committed to a critical and creative conscious search for coherence. The autonomous man does not rest on the unexamined if fashionable conventions of his sub-culture when they lead to palpable inconsistencies. He will appraise one aspect of his tradition by critical canons derived from another. As the artist or the scientist must draw on the

resources of a tradition to contribute creatively to its development, so an autarchical man must construe it for himself to become autonomous.

To say choice and rational criticism are necessary for autonomy is not to suggest, then, that we choose, or would choose, our principles as we choose our hats and ties. It is rather that we discover our principles changing as we discover reasons for setting old ones aside as empty that once we thought serious and weighty. The critical junctures in our lives occur when we discover that a principle or attitude that we had taken to be constitutive of our characters, as making certain kinds of action 'unthinkable', has been eroded by our acceptance alongside it of others that now seem basic. We discover experientially what considerations really matter to us, or, what amounts to the same thing, who we really are. Such discoveries are possible only to the extent that we are autonomous. The heteronomous man looks in his uncertainty to others for cues, or he clings to the habitual, because unwilling or afraid to recast his view of himself, or because he is conscious of the social pressure to conform. But because his conflict is repudiated rather than resolved, he fails to discover who he really is.

I do not suggest that an autonomous man would make a conscious decision before every action. Someone like that would be an existentialist gone mad or would be suffering from a neurotic anxiety about doing the wrong thing. Most of the autonomous man's actions would be appropriate but non-deliberate responses to situations falling into fairly standard, readily recognizable categories. Living according to principle does not demand continuous ratiocination. Though in perplexity we may need to articulate our principles to ponder what we really stand for, they have an inarticulate existence, too, as ways of identifying situations, picking out what is relevant to them, and intimating the judgment or action appropriate. Men in tribal societies know well enough what is to be done, but rarely need to articulate principles. This is not because they do not have them or act on them: just because tribal life exhibits a very high degree of coherence of principle, the need to articulate them rarely arises. For this reason, however, tribesmen would not qualify

as autonomous: their massive personality integration is
entirely socialized, not arising from rational, critical reso-
lutions of conflict. For autonomy, *two* conditions must be
satisfied, one of coherence, the other of process.

Because I have formulated the concept of autonomy in
terms of criticism internal to a tradition, I do not need to
decide whether there are *ultimate* principles. Suppose it to
be a logical truth that there would be no way of demonstrat-
ing to someone reared in a tradition that took little account
of some very general principle, such as the value of human
life or truth, that he ought to adopt it. There would then be
principles that even the autonomous man could not question
—but only because *ex hypothesi* there is no way of question-
ing them, not because he is somehow glued up by a socializa-
tion process that prevents his questioning them. In an im-
portant sense they would then be defining elements of his
character—he would be the kind of person that has those
principles, and there would be other kinds who have others.
Sociological explanations of their differences would not entail
that no one qualified as autonomous; for the autonomous
man is not necessarily one who can give reasons for *all* his
principles and values—it is necessary only that he be alive to,
and disposed to resolve by rational reflection and decision,
incoherences in the complex tradition he has internalized.
Such criticism would always be internal: the reasons on
which he could draw would always be, in that sense, within
himself. Though he is open to persuasion by others, they can
succeed only by invoking principles and beliefs to which he
is already committed at least as much as to those under attack.
For that reason, autonomy is an ideal available only to a
plural tradition. However massive the personality integra-
tion and principled coherence of tribesmen and some reli-
gious sectarians, they cannot qualify as autonomous if they
cannot claim to have actively made the *nomos* their own. And
this may simply not be open to them as individuals.

3. *Justifying autonomy as an ideal*

I began with the apparently undemanding conception of a
person who cares about his ontological status as a chooser, and
has projects that structure his activities and his perceptions

not only of his world but of himself too. With growing under-standing of his activities he learns to appraise not only his performance, but also the very standards he uses for the appraisal. And this applies not only to the standards for appraising deeds and artefacts, but to his standards for appraising himself too. For he now emerges as the author of his own personality, conceiving his own ego-ideal, modifying it in the light of his successes and failures, much as the potter learns by experience the potentialities as well as the limitations of his material.

And beyond all the standards by which a person judges his performances in particular activities, there are higher order standards governing what things are worth doing, by which he rates the relative importance of successes and failures in his particular projects to the success of his total enterprise, the making of himself.

Now someone who cared nothing for his ontological status as a natural person—if such a person could be—need have no particular concern for autonomy. But someone who did care about it must acknowledge that the autonomous person has realized the potentialities of his autarchic status to a higher degree than someone who merely falls in with the projects of others and assesses his performance by standards thrust on him by his environment. For the heteronomous man's per-ception of himself as the author of changes is in part self-deceiving. The *nomoi* that govern him affect his decisions as alien restraining causes. By contrast, the principles by which the autonomous man governs his life make his decisions con-sistent and intelligible to him as his own; for they *constitute* the personality he recognizes as the one he has made his own. His actions, in instantiating his principles, thus express his own moral nature. So if our consciousness of our own natural personality is the source of our respect for other persons and for autarchy, it also commits us to admire—at least in respect of his autonomy—the person who is his own cause, his own handiwork.

Of course, autonomy is not an exhaustive characterization of a personality. Concentrating on process and modes of con-sciousness, I have necessarily left out of account the content of the autonomous man's principles and ideals. There is no

reason why an autonomous man should not be deeply con-
cerned about social justice and community—but I have said
nothing to suggest he will be. If Cesare Borgia turned out to
have been no less autonomous than Socrates, one would still
be hard put to it to share Machiavelli's unqualified
admiration. Autonomy may not be an all-embracing
excellence, redeeming all the rest.

NOTES

1 I gratefully acknowledge the generous help I have received in clarifying
my ideas generally, and this paper in particular, from many colleagues, but
notably from W. L. Weinstein, R. S. Peters, G. W. Mortimore, my wife J. M.
Benn, M. Schioler, Q. Skinner, B. A. O. Williams and M. Hollis, all of
whom have been very patient with me.

2 For a justification of this analysis of 'freedom to act' see S. I. Benn and
W. L. Weinstein, "Being free to act and being a free man", *Mind*, vol. 80,
1971, pp. 194–211, and "Freedom as the non-restriction of options—
a rejoinder", *Mind*, vol. 83, 1974, pp. 435–8.

3 "Are there any natural rights?", *Philosophical Review*, vol. 64, 1955,
pp. 175–191.

4 *Cf.* my "Freedom and persuasion", *Australasian Journal of Philosophy*,
vol. 45, 1967, pp, 259–275.

5 See R. J. Lifton: *Thought Reform and the Psychology of Totalism*,
Harmondsworth, 1967, for the sense of 'brain-washed' intended. Looser usages
may extend even to normal socialization procedures, which would not,
in my view, deprive one of autarchy.

6 Delimiting heterarchy is problematic. There will be disputes about
whether the subject could reasonably be thought capable of resisting, guard-
ing against, or correcting if he chose, some particular type of influence. Are
TV commercials manipulative or just persuasive—do they make us, or our
children, heterarchic? (See my "Freedom and persuasion", *loc. cit.*) This
may be a case of a kind of concept fashionably but dubiously termed
'essentially contested'.

7 In "Persons as moral beings" presented posthumously to the World
Congress on Freedom and Equality, St. Louis, 1975 (not yet published).

8 J. Piaget: *Six Psychological Studies*, London, 1968.

9 *Cf.* Mancur Olson Jr.: *The Logic of Collective Action*, Cambridge, Mass.,
1965, for a demonstration that in a society of individuals with this kind of
self-awareness, the level of collective goods will be sub-optimal.

10 P. F. Strawson, "Freedom and resentment" in *Freedom and Resentment
and other essays*, London, 1974.

11 The idea of mutual respect owed to one another by natural persons,
which I see as at least causally necessary for a society of natural persons, is
partially supplied, in Hobbes, by the fifth law of nature enjoining
'complaisance'.

12 *Cf.* Bruno Bettelheim: *The Informed Heart*, London, 1970, for a
sensitive study of what happens to heteronomous and anomic personalities
under conditions of stress, *e.g.*, in S.S. concentration camps. Note that what
Bettelheim, following the usage of ego-psychologists, calls 'autonomous', I
call 'integrated'.

VII*—PROPOSITIONS AND DAVIDSON'S ACCOUNT OF INDIRECT DISCOURSE

by I. G. McFetridge

Consider the following dialogue:

A: The earth moves.
B: Galileo said that.
A: The earth moves.
B: That's *another* thing Galileo said.

This dialogue, which could continue indefinitely in the same vein, is, I take it, absurd. More precisely, the use of 'another' in *B*'s second remark is mistaken. Yet on Davidson's account of indirect discourse, as we shall see, *B*'s comment would be perfectly in order. Davidson, I shall argue, has given a mistaken account of *things said*, and I shall suggest an alternative. But first the question arises: are there such things as things said?

I

(1) Galileo said that the earth moves. Hence
(2) Galileo said something *i.e.*, there is something which Galileo said.

We produce and seemingly understand sentences such as (2) and infer them from sentences like (1). The theorist of natural language, as opposed perhaps to the constructor of a regimented idiom for certain scientific purposes must, it would seem, allow that there are things said, stated, asserted and so on. More generally that there are things propounded, in various modes. Uncommitted as yet to any account of their nature, he must allow that there are propositions.[1] If his account of our linguistic resources is to proceed by providing, for each sentence of our language, a formal representation amenable to inclusion in a finite theory of truth, then such a

* Meeting of the Aristotelian Society at 5/7, Tavistock Place, London, W.C.1, on Monday, 26th January, 1976 at 7.30 p.m.

representation of (2) must, it would seem, contain a bound variable ranging over things said. While to account for the entailment of (2) by (1) the representation of (1) must contain after the verb of saying a position accessible to such a variable, hence a position accessible to a singular term referring to something said.

Two objections may be raised at this early stage. Both agree that (2) is to be represented using a variable bound by an existential quantifier. The first denies that this requires a domain of objects—things said—to serve as values of such a variable. The account is Prior's.[2] Represent (2) as (3)

(3) $(\exists p)$ (Galileo said that p)

and explain such a form by saying that it is true if there is a true sentence obtainable by dropping the initial existential quantifier and replacing the variable thereby left free by a sentence. But this substitutionalist account is, at best, incomplete. It makes free use of the notion of the truth of sentences obtained by placing arbitrary sentences in such contexts as 'Galileo said that . . .'. Until we are shown that an account of *this* is available which does not reintroduce the notion of things said, the objection is quite worthless. In any case, if the objection to things said is, as it seems to be in Prior, an essentially nominalist one, then little has been achieved by the substitutionalist account. We are not, I presume, to take it that substitution is an operation performed on concrete objects, on sentence-*tokens*.

The second objection would be to point out that we cannot make the simple connection suggested above between the English expressions 'something', 'there is something which' and the category of singular terms. In English as we have it, such expressions can be used to express quantification into positions accessible to predicates and sentences containing them can formally be represented by second-order quantification. This objection is correct and shows two things. First that it is unnatural to attempt a formal account of the linguistic resources we actually possess within a purely first-order language. Secondly, that the existential generalisation test we in effect used to identify first-order quantification in (2) and the occurrence of a singular term in (1) needs supplementation. We need at least criteria for distinguishing idiomatic

first- and second-order quantification. Such tests can be devised[3] and I here merely report that, as might be expected, they reveal the quantification in (2) as clearly first-order. Hence, I suggest, a straightforward account of (1) will locate therein a singular term whose referent is something said— a proposition—and an account of (2) will require a variable ranging over such things.

To see (1) and (2) thus is, *ipso facto*, to see them as containing an expression 'Galileo said' which would be represented as a predicate, true or false of things said, and hence, plausibly to locating an at least two-place predicate, 'said' relating persons and things said.

II

Objections to propositions spring from at least two sources: (a) that they are intensional objects (b) that they are abstract objects.

I shall first look briefly at (a). On the traditional view of the matter, the singular term I claimed we ought to find in (1) would be the complex expression 'that the earth moves'. This might certainly be called an *intensional singular term* where this means: substitution within this term of co-extensional expressions may change the reference of the whole term. For example, substitution for 'the earth' of a different singular term with the same reference may change the reference of the 'that' clause. And the ground for this claim, of course, is that such substitution may alter the truth-value of (1). To see (1) as containing the predicate 'Galileo said' true or false of propositions is to commit ourselves to see changes in the truth-value of (1) under substitution within the alleged singular term as explicable only on the supposition that the proposition referred to has shifted. Thus, on the tradional view, such expressions as 'that the earth moves' are intensional singular terms the referents of which are propositions.

But while we can thus classify singular terms as, in this sense, intensional, it is difficult to see how we can move from this to a classification of their referents as intensional, difficult to find a property which *objects* must possess if and only if they are intensional.[4] Such a classification could be derived from the notion of an intensional singular term in only two

ways it would seem. We could say either (i) an object is intensional if ever singular term referring to it is intensional or (ii) an object is intensional if there is at least one intensional singular term referring to it.

No entities meet the condition in (i). Thus, cleaving to the present case of propositions, if there ever are singular terms referring to propositions then, in sentences such as 'John said what Mary said yesterday' 'Galileo asserted the theory of Copernicus' there are extensional singular terms referring to propositions.

If substitution of co-referring singular terms can ever change the truth-value of a sentence in which they occur (and it was only this possibility which could force us to treat any singular terms as intensional) then any entity for which we possess a singular term meets the condition in (ii). Let '$C(\)$' be a context completable by a singular term to yield a sentence which can change from true to false under substitution, for the contained singular term, of a co-referring one. Suppose 't' be a term such that '$C(t)$' is true. Let a be an arbitrary object for which we possess a singular term 'a', and 'b' a singular term for an object b, where $a \neq b$. Then the following, (4), is an intensional singular term for a.

(4) $(\imath x)((C(t) \supset x = a)\ \&\ (\text{not} - (C(t)) \supset x = b))$

All this is merely to say, what is in any case obvious, that problems about intensionality are merely problems about, among other things, ways of referring, not particularly about the objects allegedly referred to. That objections to so-called intensional objects are often simply objections to, among other things, intensional singular terms. I shall not rehearse such objections.

Now a necessary condition of a singular term's being, in the above sense, intensional is that it contain semantically significant parts. We defined the intensional character of a singular term *via* the notion of substitution within it of expressions having the semantic property of extension or reference. Thus a sufficient, and rather radical, condition of avoiding intensional singular terms for things said is to see singular reference to propositions as being standardly made by means of expressions which lack semantically significant parts. But singular terms for propositions have a potential

infinity of distinct referents. Thus if the semantic properties of singular terms for propositions were themselves sufficient to determine their referents they would needs possess a potential infinity of distinct semantic features which, under the present assumption, they would not derive from their possession of parts with semantically significant properties. But, as Davidson has repeatedly argued, no learnable language, and no language amenable to a finite theory of truth (which may not be the same thing) could contain expressions meeting this specification.[5] Thus on the present hypothesis the referent of a term picking out a proposition must be determined by something more than the semantic properties of the term alone. And the only plausible candidate for that which, in addition to the semantic properties of a term, can determine its referent is, speaking broadly, the context of its utterance. If we call a singular term, the referent of which on an occasion of utterance is thus in part determined, a demonstrative singular term, then, on the present hypothesis, things said will standardly be referred to by means of demonstrative singular terms. This is, of course, Davidson's proposal.

III

To say that the referent of a demonstrative singular term *is determined by* some feature of the context in which it is uttered is not to say that its referent, on a particular occasion, *is* some feature of that context, some object, for example, present in that context. I shall argue that by moving from something like the former to the latter, Davidson has given an absurd account of things said, one which, within a framework broadly like his, can only be avoided by maintaining the second allegedly undesirable feature of propositions *viz.,* that they are abstract objects.

Davidson's proposal concerning the logical form of sentences such as (1) should by now be familiar. It is that

". . . sentences in indirect discourse . . . consist of an expression referring to a speaker, the two-place predicate 'said', and a demonstrative referring to an utterance. Period. What follows gives the content of the subject's saying, but has no logical or semantic connection with the original attribution of a saying."[6]

Thus in his and our favoured example, *viz.*, (1), the expression 'that' has the logical rôle of a demonstrative singular term standardly used to perform an act of demonstration to the ensuing utterance of 'the earth moves'. Given that it has such a rôle, the position it occupies is open to first-order quantification. A sentence such as (5)

(5) (∃ x) (Galileo said x)

is thus quite legitimate on Davidson's account and may seem to provide a reading for 'Galileo said something' *i.e.*, for (2). Moreover, as Davidson notes[7] if, in uttering 'Galileo said that' the speaker does succeed in referring, by means of the demonstrative, to an utterance, then one can deduce that Galileo said something. We thus find an explanation of the plausibility of the inference from (1) to (2).

Davidson does, then, locate in (1) and (2) respectively singular reference to, and quantification over, things said *i.e.*, propositions in the minimal sense. They are utterances.

It is to be noted, though, that the things said, on Davidson's account, by Galileo are not (or at least not necessarily) *his* utterances but utterances of mine, yours or possibly anybody's. And it certainly seems odd to say that among the things said by Galileo is an utterance of mine. While odd, it is difficult to see in this fact an actual error.

Nevertheless the theory does have a consequence which is, surely, a mistake. Suppose we ask: *how many* things did Galileo say (possibly on some particular occasion which interests us)? The answer must be given: as many distinct things as he came, by his utterance on that occasion to stand to in the saying relation. But if the things to which he stands in that relation are utterances, possibly of anybody's, this number can be indefinitely extended. For example, each appropriate utterance of 'The earth moves' is a distinct thing to which Galileo stands in the saying relation *i.e.*, a distinct thing said by Galileo. Producing more and more such utterances we can multiply at will the number of things said by Galileo, which is absurd. This, of course, is just the absurdity graphically illustrated in our opening dialogue.

It has frequently been urged that there is, intrinsically, no answer to the question 'How many distinct things did a man say on an occasion?' For some, this alleged fact is, of itself,

sufficient reason to give up the notion of things said. But, as I argued, no account of our actual linguistic resources can do that.[8] The grounds for saying that there is no determinate answer to this question have typically been that there is no unique or determinate standard of correctness in the reporting of another's speech. Tightening the match required between reporting and reported speaking will yield more stringent conditions on the identity of things said, whatever they are, and thus multiply the number of distinct things said, on an occasion, by a speaker. Variation in our interests in, hence in our standards of, speech attribution, may thus vary the degree of match required. Hence there may be no determinate answer to the question 'How many things were said?' My objection to Davidson can ignore such points. Even if we could fix on a determinate degree of match between reported and reporting utterance, the number of things said cannot depend on *how many* subsequent matching utterances are made. On Davidson's account it does so depend.

Another problem for Davidson's account, and hints towards a solution, emerge by considering sentences of a sort we had occasion to mention briefly before; *e.g.*, 'Galileo asserted Copernicus' theory.' If verbs of saying typically relate speakers to utterances then Copernicus' theory is an utterance. But this is absurd. If Copernicus' theory were an utterance then there would be an utterance which Copernicus' theory was (identical with). And clearly there is no utterance of which we can say that it (and hence it alone) is identical with Copernicus' theory. What is not absurd is to say, of many distinct utterances, that they are each *of* Copernicus' theory. Thus we should regard the referent of 'Copernicus' theory' as being the sort of entity that different utterances can be of. Similarly, if we wish to see a sentence such as 'Copernicus' theory is that the earth moves' as an identity judgment containing a demonstrative 'that', then likewise we should see the referent of 'that' not as the ensuing utterance but as something which it, and other utterances can be of.

Given that expressions such as 'Copernicus' theory' can occur after verbs of saying, such entities *viz.*, those with utterances can be of, can be the second terms of those two-place relations which, on Davidson's account, verbs of saying

express. Uniformity would better be served, then, by seeing such entities as, in general, the second terms of such relations, hence by seeing the demonstrative 'that' which Davidson has located in standard attributions of sayings as referring not to the ensuing utterance, but to something which it, and other utterances can be of. Likewise the variable in '(∃ x) (Galileo said x)' ought to be seen as ranging over such things and not over utterances themselves.

Such a move would solve the counting problem mooted above. The number of distinct things said by Galileo on an occasion would not depend on the number of distinct utterances to which he stood in the original saying relation but on how many distinct things these utterances were of. Old-fashioned writings remind us to distinguish sayings, and what is said, utterances, and what they are of. The counting problem within a programme committed to locating things said would seem to provide a telling reason for such a distinction.

IV

Things said, then, must be things utterances can be of, not utterances themselves. To give an account of such entities within a broadly Davidsonian framework we shall find it necessary to look not merely at his account of the logical form of (1) but at the analysis proposal which it abbreviates. This runs:
The earth moves.
(6) (∃ x) (Galileo's utterance x and my last utterance make us samesayers)
(6) is the analysis of (7).
(7) Galileo said that.
The analysis introduces a primitive predicate 'make . . . same-sayers'—a four-place predicate relating two speakers and two utterances. Implicit in the use of the predicate is the idea that utterances a,b, can only make speakers p,q, samesayers when a,b, are utterances made by, respectively p and q. Given that two utterances a,b, are by speakers p,q, what more is required for a,b, to make p,q, samesayers? Simply that a certain relation R, as yet unspecified, hold between the utterances in question.

Now the first thought here, *viz.*, that the utterances in

question must be by the relevant speakers, implicit in the notion of *making-samesayers* is, elsewhere in the analysis, made explicit—namely in the allusion to *Galileo's* utterance, and to *my* last utterance. So this first thought is, needlessly, caught twice over. We can drop its implicit occurrence in the notion of *making-samesayers*, replacing this four-place predicate by what then remains of it, *viz.*, a two-place predicate holding between utterances. Davidson himself makes such a move in his analysis of 'Jones asserted that Entebbe is equatorial' where a two-place relation between utterances is introduced by the expression 'has the content of'.[9]

The syntax of 'has the content of' is a little suggestive for our purposes. For one thing, it suggests rather strongly that the relation is symmetrical. (If *a* has the content of *b* must not *b* have the content of *a*?) It would be rash to assume this. If we wish an expression for the relation, other than the aseptic '*R*', then I shall use 'reports'. This will be a relation which an utterance *a* must have to an utterance *b* in order that *a* could be used to report *b*, a relation which can hold between *a* and *b*, in the usage I shall adopt, even when *a* is not, in fact, being so used. Nothing I say should be taken to imply that we are here dealing with a single relation, or with something which may not vary with our interests, standards of fairness, judiciousness and so on. As I said above, even if all these were fixed, the present counting problem would still arise.

Embodying our two-place predicate 'reports' (or rather its converse) into the analysis as it stands yields:

(8) ($\exists x$) (Galileo's utterance x is reported by my last utterance).

An oddity of this is that the bare demonstrative 'that' in the logical form proposal has yielded to the much more explicit demonstrative 'my last utterance'. All that is essential to Davidson's account is that reference be made demonstratively to an utterance (or, of course, also to an inscription) and Davidson himself begins his paper with a case where demonstrative reference is allegedly made to an utterance of one other than the speaker.[10] So we can best capture the spirit of Davidson's account by retaining the demonstrative 'that' and merely making it clear that it is intended to refer to an utterance. Thus by something like:

(9) ($\exists x$) (Galileo's utterance x is reported by that utterance). The counting problem then is that if we derive a reading for 'Galileo said something' from (9) by existential generalisation with respect to the demonstrative singular term, construed as it there is, distinct utterances reporting Galileo's utterance will be distinct things said by Galileo.

I suggested that we ought to find, rather, for things said, entities which distinct utterances could be of *viz.*, propositions, and that these should be the referents of the demonstrative 'that' and the values of the variables in the representation of 'Galileo said something'. Thus (9) should yield to something like (10):

(10) ($\exists x$) (Galileo's utterance x is of that proposition).

Within the present framework the most plausible candidate for propositions will be classes of utterances *i.e.*, a certain sort of abstract object. To say that an utterance of Galileo's is *of* a proposition will be to say that it is a member of it.

Some writers, *e.g.*, Dummett, have seen it as typical of at least some abstract objects that they are not possible objects of ostension hence, presumably, not of demonstrative reference.[11] Nevertheless, whatever the deeper roots of this doctrine, abstract objects can be introduced into discourse, and singular terms for them explained via what Quine has called *deferred ostension*.[12] I point to a concrete inscription and say 'That is alpha'. Relative to our standard grammatical apparatus subsequent utterances of 'alpha' can make it clear that 'alpha' is to be construed as a singular term. It was to just such apparatus, in particular the accessibility of certain positions to first-order quantification which led us to seek singular terms after verbs of saying. In the case of 'alpha', appeal to our apparatus of individuation, in particular to our notion of identity, can make it clear that 'alpha' (and hence the demonstrative used in its introduction) is not to be construed as referring to the concrete inscription in the presence of which the demonstrative utterance was produced. Different utterances of 'That is alpha', in the presence of different concrete inscriptions, are to be taken as involving reference to the same thing *viz.*, alpha—a letter which different inscriptions can be of. Likewise, it was such an appeal to our apparatus of individuation, embodied in such devices as the expres-

sion 'another' and in counting, which showed that the demonstrative reference located by Davidson in utterances of 'Galileo said that the earth moves' could not be to the particular utterances of 'the earth moves' therein produced, but to a single thing, a proposition, which these distinct utterances could be utterances of.

As Quine notes, it is plausible to regard a letter as the class of its incriptions *i.e.*, a set of inscriptions ". . . variously situated in space-time but . . . classed together by virtue of a certain similarity of shape."[13] Aiming to pick out such a class, then, we perform an act of demonstration in the presence of one of its members. While the presence of the inscription aids in determining the referent of the demonstrative, it itself is not the referent.

Analogously, then, could we not see such deferred ostension occuring in attributions of saying, regarding the thing said, thereby picked out, as the class of its utterances? Not quite analogously. We said, following Quine, that a letter was a class of inscriptions like in shape, meaning—like in shape to each other. This requires that *like in shape* be an equivalence relation. But there is no reason to think that the corresponding relation 'reports' which we might use to construct propositions along similar lines is an equivalence relation.[14] Indeed there is good reason to think that it is not. In the first place, we can often correctly report another's utterance by means of an utterance of a sentence which is logically weaker than that which he uttered, but not conversely. Thus I could report the Galileo utterance in question by means of an utterance of 'A planet moves' *i.e.*, I could say that Galileo said that a planet moves. But his stronger utterance might well not be usable to report mine. Thus the relation *reports* is not symmetrical.[15] Secondly, if *reports* were an equivalence relation, then propositions would be equivalence classes of utterances, hence disjoint classes. Thus each utterance, if it was of any proposition at all, would be of exactly *one* proposition. Each saying would be a saying of exactly one thing. And this seems just wrong.

Propositions, then, cannot be classes of utterances which report each other. Rather, I think, we must say that a proposition is a class of utterances sufficiently alike for there to be at

least one utterance which reports all and only the members of the class. Such an utterance binds the utterances it reports into a unity, so I shall call it a *binder* of the proposition. Now it seems plausible to maintain that if an utterance reports any utterance then it reports itself *i.e.*, the relation *reports* is reflexive. Thus the binders of propositions will be members of the propositions they bind.

My claim, then, is that the demonstrative 'that' in attributions of sayings is characteristically uttered in the presence of an ensuing utterance, but that its referent is not that utterance but the set of utterances bound by that utterance, a set of which that utterance will be a member. Note therefore that each attribution of a saying will have the same truth conditions as those given by Davidson. In attributing a saying we shall be stating that the reported utterance is a member of the class of utterances bound by the ensuing utterance. But the reported utterance will be a member of this class if and only if it is reported by (*i.e.*, matches in content) the ensuing utterance, which is just what Davidson said.

But our proposal, unlike Davidson's, avoids the counting problem. Distinct utterances of the demonstrative 'that', in the presence of distinct ensuing utterances, need not usher in distinct things said. At least this will be so if distinct utterances can bind the same proposition. It is easy to state the conditions necessary for distinct utterances so to do. If a,b, bind the same proposition P, then a is a member of a set all and only the members of which are reported by b, and *vice versa i.e.*, a,b, report each other. And while we agreed that *reports* is not in general symmetrical, there is no reason to think this situation never occurs. If it never occurred, then, for example in our initial dialogue the two utterances of A would not report each other. And if this were so then, on the present account as on Davidson's, it would have been incorrect for B to have said, after A's first utterance, 'You are just about to say that again', and to have said, after A's second utterance 'You said that a moment ago.' And both these remarks seem perfectly in order.

Whether the fact that a,b, report each other is a *sufficient* condition for them to bind the same proposition, hence to be usable to introduce by deferred ostension the same proposi-

tion, is not to me clear. It would require that whenever *a* reports *b*, and *vice versa*, that *a,b* report, in general, exactly the same utterances. I have no proof that this must be so, hence no general account of what is sufficient for deferred ostension in the presence of distinct utterances *not* to be used to ascribe distinct things said to the speaker whose speech we are reporting. But surely, again, it would be implausible to think that distinct utterances which report each other can *never* report exactly the same utterances. Again, returning to our original dialogue, if the mutually reporting utterances of *A* did not in general report exactly the same utterances, then it must be possible to find something of the form 'X said that' which *B* could truly utter after *A*'s first utterance and falsely utter after A's second utterance. And I can find no plausible example of this.

V

I end with what might seem an obvious objection. On the current view, a proposition is a set of utterances such that there is an utterance which reports all and only the members of the set. Given that 'reports' is reflexive such an utterance will be a member of such a set. There are thus no unuttered propositions. More precisely: for any proposition *P* there is an utterance of *P*.

But I do not find this consequence in the least objectionable. Certainly we can say: there are things which might have been said but haven't and won't. Equally we can say: there are things which might have happened but haven't and won't. Perhaps a construal of such sentences will require an ontology of things which might have been said, things which might have happened. But things which might have been said are no more things said (*i.e.*, propositions) than things which might have happened are happenings (*i.e.*, events). Perhaps we do need an account of things which might have been said, or things which might have happened *i.e.*, of possible propositions and possible events, perhaps even of possible *F*'s in general. But if we need such a theory, then this need must surely be met by a general doctrine of possible objects, not piecemeal. It is no criticism of a theory of what *F*'s are that it

does not, by itself, constitute a theory of what possible F's are.

This objection, though, may be pursued in a more interesting way by pointing to the fact that things said can be identical with things believed. And that some things believed may never be said. But the present theory leaves no room for such believed but unuttered propositions.

This thought certainly points to a real gap in the theory, but one which I think, in principle, could be filled. The present account of reports of speech requires an ontology of particular events—utterances—which can stand in certain relations to other such particulars, and be members of the propositions which they are utterances of. Its extension to, say, belief, would require an ontology of particular believings (which might be states rather than events) which could stand in analagous relations to each other, to utterances, and be members of the propositions they were beliefs in. I shall not here embark on an attempt to show that such an ontology is required, and for purposes other than preservation of the theory under consideration.

NOTES

[1] *The Shorter Oxford Dictionary* "Proposition . . . that which is propounded." The entry, of course, gives other senses of 'proposition'. This though is the one which interests me. It can be treated, if one wishes, as mere shorthand for 'that which is said, asserted *etc.*'

[2] A. N. Prior, *Objects of Thought* (Oxford 1971) Chapters 2, 3, esp. pp. 35–6.

[3] See Michael Dummett, *Frege: The Philosophy of Language* (London 1973) Ch. 4.

[4] For arguments against moving from grammatical features of sentences ascribing mental states to alleged properties of mental states see Roger Scruton "Intensional and Intentional Objects" *P.A.S.* 1970–71.

[5] For the beginnings in Davidson of this argument see D. Davidson "Theories of Meaning and Learnable Languages" in Y. Bar-Hillel (ed.) *Logic, Methodology and the Philosophy of Science* (Amsterdam 1965) pp. 383–394.

[6] Davidson "On Saying That" *Synthese* 19 (1968–9) p. 142.

[7] *Id.* p. 144.

[8] Indeed doctrines of this sort have been held about entities other than things said. See, for example, D. Wiggins *Identity and Spatio-Temporal Continuity* (Oxford 1967) pp. 39–40 on oily waves and crowns. Such doctrines may just be that *we* cannot give an answer to the question 'How many F's?'

But the move from this to the view that there *is* no answer to the question requires hard work. If we retain the predicate 'F' and standard quantification theory with identity then we can formulate, for each finite number *n*, a sentence stating that there are exactly *n* F's. Under a realist semantics each of these sentences will be determinately true or false, and at most one true. Perhaps then the doctrine is, at least, that all are false. But then we need a way of distinguishing the cases where the ground for this is that there is a determinate, but non-finite number of F's, from the present alleged sort of case.

[9] *Loc. cit*, p. 143.

[10] *Id.* p. 130 where Wilde allegedly refers to an utterance of Whistler's.

[11] Dummett *op. cit.* Chapter 14, esp. p. 481.

[12] W. V. O. Quine *Ontological Relativity and Other Essays* (New York and London 1969) pp. 40ff.

[13] The quotation is actually a proffered account of expressions in general, one rejected by Quine basically on the ground that some distinct expressions, lacking instances, would be identically the empty class. But he does accept the account for *letters*.

[14] A point made by Mr. John McDowell in a talk he gave at Birkbeck College.

[15] An example suggested by Mark Platts. I am indebted to him, and to Roger Scruton, for discussion of these matters.

VIII*—LOVE

by Gabriele Taylor

I

There[1] is a class of emotions the members of which share the following characteristics:

1. If a man x feels one of these emotions then it will always be possible for him to specify, however vaguely, what the emotion is 'about'. What it is about, the 'object' of the emotion, will normally be the thing, person, event or situation indicated by the grammatical object-phrase in sentence-forms of the kind 'x ϕs y', 'x is ϕ with/of/about y'. This very loose characterization of 'object' is simply meant to exclude from consideration those cases where such an object phrase is not in place, or where 'y' can be replaced by 'everything' or 'nothing in particular'; as for example if 'ϕ' stands for 'feeling depressed', 'feeling happy', or 'experiencing nameless fears'.

2. If x feels the emotion, and if y is the object, then x will believe y to have a specific property or set of properties. Depending on which emotion he feels he will believe $e.g.$, that y is dangerous, that y has done him an injury or a good turn. Put more formally, this requirement reads: for any member of this class of the emotions there is a quality or set of qualities ϕ such that for all x and all y, if x feels the emotion towards y then x believes y to be ϕ:

$$[(\exists \phi)(x)(y)(Exy \rightarrow Bx\phi y)].^{2}$$

The quality ϕ cannot, of course, tell us much about the object y, or much about how y appears to x. As the same quality is supposed to belong to any object of fear, or any

* Meeting of the Aristotelian Society at 5/7, Tavistock Place, London, W.C.1, on Monday, 9th February, 1976, at 7.30 p.m.

1 I should like to thank the many people who have made helpful suggestions, in particular Kathleen Lennon and Anthony Savile.

2 I deliberately abstract from the notorious difficulties of quantifying into intentional contents. They are not relevant here. My two formulae are not meant to display logical form; they are merely offered as visual aids.

object of anger or gratitude, it can hardly give us much information, and I shall call such qualities 'determinable qualities'.

Evidently, it may be in virtue of very many different determinate qualities that a man may believe y to be dangerous or to be an injury or a good to him.

3. x will therefore also believe, and normally be able to articulate, that y has certain determinate qualities ψ, and further he will believe that it has the determinable quality ϕ because it has the determinate quality ψ: the thing is dangerous, say, because it is aggressive and has sharp claws, or again because it is malicious and powerful. So we have the further requirement, that if x feels the emotion in question towards some object y then x believes y to have some determinate quality, which normally but not necessarily he will be able to specify:

$$[(x)(y)(\exists\,\psi)(\text{E}xy \to \text{B}x\,\psi\,y)].$$

But although the determinate quality which x believes y to have may vary widely from case to case, it is clear that some restraint must be put on x's belief if he is to feel a particular emotion. He cannot fear y, be angry with or grateful to y in virtue of *any* quality he cares to mention. The necessary constraints are, however, not far to seek, for they are given by the relevant determinable quality: if x e.g., fears y, then the determinate qualities of y he picks out must be such that they explain why x believes y to be dangerous. The relation between the two requirements is therefore that the first requirement, concerning determinable qualities, entails the second requirement concerning determinate qualities: if x believes that y is dangerous then he must believe that y is dangerous because it has certain determinate characteristics, even if he is not able to name these. The second requirement does not entail the first; x may believe that y is powerful and malicious and yet not believe that y is dangerous. But if x is to count as feeling the emotion in question towards y, then it must be possible for him to see the determinate qualities as falling under the relevant determinable one. So what we substitute for ϕ in the first formula will impose limiting conditions on what is substituted for ψ in the second.

4. The features set out under 1 to 3 are offered as necessary conditions for feeling one of the emotions belonging to the class under discussion. They are not, of course, meant to be sufficient. It is at least one further necessary condition that x will have certain wants and consequently tendencies to behave in certain ways towards y: he may want to run away from y, to hit y, or do him a good turn. He will have these wants just because, at least in his view, y has certain qualities. If then he is to count as experiencing a specific emotion such as fear it must be possible to explain his wants as a response to his belief that the situation is dangerous, so that again the determinable quality imposes constraints: just as x cannot cite any determinate quality of y's in explanation of his fear so he cannot produce any want he likes as relevant. To be so relevant, it must be causally related to his view of the situation, or at least by him believed to be so related. This is of course not a complete characterization of wants involved in fear, for x when confronted by a dangerous situation may have other wants which, though causally related to it, have nothing to do with fear.

With these conditions in hand we have a basis on which to decide whether experiencing some emotion on this or that occasion is justified or not: x may or may not be justified in believing that y is ψ, or that given y is ψ it is also ϕ. If either or both of these beliefs are irrational then x can hardly be justified in experiencing an emotional reaction based on them. The converse of this proposition may however appear to be more doubtful, for surely it is possible for a man's beliefs to be perfectly well-founded and yet it might be better if he had not felt the emotion at all. So for instance it could be argued that however rational the beliefs involved in a man's envy, jealousy or hatred, such emotions are highly undesirable, and if so it would be odd to regard their occurrence as ever justified.[3] So there appears to be a lack of symmetry here: while it is sufficient for an emotional reaction to be unjustified if the beliefs involved are irrational, the rationality of such beliefs is not enough for the occurrence of the emotion to be justified.

[3] It is of course a different matter whether or not it would be prudent to *express* the emotion.

But this objection ignores the complexity of the relevant beliefs. They all involve an assessment of the situation which will often rely on an appeal to norms of various kinds or to previously formed moral views, so that in judging them true or false, rational or irrational, we have to take these views into account as well. It is therefore quite possible to hold that the beliefs involved in some of the emotions are based on views which themselves are irrational, or at least unjustifiable in the sense that no good reason can be given for them. For example, if x envies y then he believes (roughly) that y possesses some good which he wants for himself, that y is an unworthy possessor of it whereas x would not be, and that consequently the good should be removed from y, or at any rate to restore the balance some harm should befall y. On some occasions x may of course be mistaken in believing that y possesses such a good at all, or indeed that he is unworthy of it. But even if these beliefs are correct it may be possible to argue that these cannot by themselves be grounds for justifying the further belief that therefore y is harm-deserving. The view that they are such grounds may well involve quite unfounded beliefs concerning one's own rôle in life as opposed to that of one's neighbour. Fully justifying the feeling of this or other emotions on some occasion will therefore often be a difficult and troublesome undertaking as it is likely to include a defence of one's moral values. How complex this may be can only be shown by an investigation of individual emotions when the relevant beliefs are spelt out. If it is correct to say that appeal to norms, standards and values is often involved then it is not surprising to find that whether a man does or does not have a particular emotional response on some occasion may tell us something about his moral views. Emotional reactions may then be based on defensible or indefensible beliefs of various kinds, and so may the lack of such reactions. In particular, it is possible to show that if on some occasion where a man would be justified in experiencing a certain emotion but he does not do so this may be due to an attitude of his which we should regard as morally objectionable in some way. Obvious and extreme examples would be a man who does not feel pity because he never spends enough thought on others to realise

that they may find themselves in a painful situation, or one
who does not feel remorse because he cannot conceive of
himself as ever doing wrong.[4]

With so much said by way of preamble, I can now turn to
the main business of this paper.

II

The question I want to discuss here is whether love belongs
to the class of emotions characterized by the conditions set
out above and can therefore be judged to be on occasion justi-
fied or otherwise. We tend to think of love as so great a good
that it seems sacrilegious to raise the possibility of it being
unjustified under some circumstances, but on my account
love being always justified would entail that the beliefs in-
volved in it are always well-founded, and that would be a
very strange state of affairs. But of course love may turn out
to be so different from other emotions that the various moves
appropriate to them simply do not apply.

There is at least no trouble at all about the preliminary
step, *viz.*, that if love is to fit the scheme at all it has to have
an object. One always loves something or somebody, and if
there is any embarrassment here then it is that the objects
of love can be of such limitless variety. One can love very
many different sorts of things without being thought con-
ceptually muddled, though one may of course be thought to
be very eccentric. Many of such objects can be ignored for
present purposes, and I shall concentrate solely on that love
which has another person as its object. I also need the further
restriction, that the other person not be the object merely of
a man's 'practical love'.[5] In Kant's sense of this term anybody
qualifies for this sort of love, and what one's own particular
feelings are towards this neighbour is neither here nor there;
it is sufficient that he is one's neighbour. It can therefore
hardly qualify as an emotion at all, and this is indeed Kant's
point when he distinguishes it from 'pathological love'.

We are left, then, with personal love, and even this may

[4] For a more detailed account of this see my paper "Justifying the
Emotions" in *Mind* July 1975.

[5] Kant: *Grundlegung zur Metaphysik der Sitten*, Ch. 1.

well be thought to be more than should be brought under one common denominator which will have to suit among others romantic love, passionate love, a mother's or a friend's love. But I hope that given a general starting-point the necessary additions and qualifications can be introduced in order to distinguish between different kinds of love.

If x loves y, can it be said that x believes y to have a determinable quality ϕ comparable to 'dangerous' in the case of fear or 'caused an injury' in that of anger? The most suitable candidate would seem to be 'lovable' (or perhaps 'attractive') so that if x loves y then x believes y to be lovable. But this will hardly do. There are after all criteria for settling, at least in the paradigm cases, whether or not a person is lovable, just as there are criteria for settling by and large what sorts of situations are dangerous. If this were not so it would be impossible to decide whether a man's belief that a situation has certain particular features can be related to his belief that it is dangerous and whether the belief is well-founded or not. It is of course true that what is a danger to one man need not be one to another, or again what seems dangerous to some may not seem so to others. Taking a lovable person to be one who is outgoing, friendly and open to affection, then similarly apparently unlovable people may not be so to the lover, or not to him appear to be so. But there is no reason to suppose that this must always be the case; there seems to be no contradiction in saying that x loves y although he does not believe y to be lovable in the accepted sense, as there is a contradiction in saying that x fears y and yet does not believe y to be dangerous in some respect. If this is so, and if a no more suitable candidate than 'lovable' (or 'attractive') can be found, then we have here no determinable quality as we do in the case of the other emotions. We therefore lack a guide as to what sorts of determinate qualities we are to look for in the object of love and so what substance to give to the love-beliefs. This is of course reflected in our occasional inability to deny that x loves y in spite of our total failure to understand why he does. Maybe x can still be said to *find* y lovable. This description, unlike the one in terms of beliefs, applies to matters of taste and does not imply that x believes y to have some recognizably attractive characteristics. But if all that can be said is that if x loves y he finds y lovable,

then although this may tell us something about x and his tastes it can tell us nothing whatever about what qualities to look for in y, and in this sense love could be said to be more subjective than other emotions. No wonder then that this formulation is more vacuous than that applying to other emotions, and no wonder that it cannot be used to put constraints upon the ψ qualities which x may believe y to have.

We are left with two possibilities: either something analogous to ϕ qualities will have to be found to which beliefs that y is ψ can be related and so shown to be beliefs relevant to love; or love does not lend itself at all to treatment in terms of belief. No doubt there are cases where all that can be said of x is that he just finds y attractive or lovable. But on the other hand, it seems true and even trivial that very often at least if x loves y then he does so in virtue of certain determinate qualities which he believes y to have, even though such qualities may vary greatly for different persons, and even though the lover may find it difficult to be articulate about them. But though choice and variety may be great, not just any description of such beliefs will do if x is to love y. Some constraints upon them can perhaps be derived from the original restriction, that the love in question be of a particular person; this allows us to rule out such features as are universally possessed by any normal person. But this is hardly good enough. Additional constraints can however be found when we consider that a man experiencing an emotion will have wants as wells as beliefs. The beliefs and wants are interrelated in that a man will have certain wants because he has certain beliefs, so that an explanation of why he has such-and-such a want will refer to his beliefs. Conversely, given his wants, some beliefs will account for them, others will not. If therefore we can find a set of wants which are typically involved in the case where x loves y then this will put a constraint upon the beliefs concerning particular qualities in virtue of which x can love y, and allow us to dismiss those which can in no way be seen as explanatory of the wants in question.

We view love as a give-and-take relationship, so the essential wants will have to reflect this feature. If x loves y we have on the one hand x's wants to benefit and cherish y, on the

other his wants to be with y, to communicate with y, to have y take an interest in him, to be benefited and cherished by y. Such wants allow us to impose constraints on x's beliefs in that only those are now relevant which can explain his wants. This, quite properly, leaves a wide choice of ψ properties at x's disposal in virtue of which he may have these wants. It is indeed difficult to give an example of an irrelevant belief, for we can hardly say *a priori* of any quality ψ that it could not feature in a sufficiently complex causal story which could quite plausibly explain that x loves y because he believes y has just this ψ. Presumably, though, there are some descriptions of x's belief which x himself cannot subscribe to, as for example 'y is such a *deadly* bore'.

The description I have given of the wants involved in love is a rough and ready one and will need qualifications and refinements. One of these arises out of the possibility mentioned earlier that after all beliefs may not be central to love at all, that the wants enumerated can perhaps be sufficiently accounted for by the simple fact that x finds y attractive. Whatever form a further description may take, it need not be in terms of x's beliefs. This possibility is not, I think, a threat to an account of love in terms of beliefs as well as wants; it does on the contrary enable us to draw a worth while distinction between what is to count as love and what as mere infatuation, a phenomenon sometimes identified with love and sometimes contrasted with it. Lack of clarity in this area is natural enough, for infatuated x and loving x may well have the same wants in the sense of wanting the same sorts of things. If so, then *what* x wants offers no clue for a distinction. But it may still be the case that such wants are differently based in that love proper requires certain beliefs and infatuation does not. This at any rate would conform to our view of infatuation as a state which we do not even attempt to link with anything that is accessible to rational, or for that matter, moral evaluation. It is otherwise with love, which has traditionally been regarded as capable of being rational and as admitting of degrees of moral excellence.[6]

[6] The moral status of love is of course much discussed by philosophers, poets and novelists. Its intellectual standing is less often explicitly mentioned, but *e.g.*, Aquinas speaks of some of its manifestations as 'intellectual

Such considerations are not enough to justify the proposed distinction between love and infatuation, but they are hints which can be exploited and given a theoretical backing if we accept that there are (at least) two very different kinds of want.[7] The crucial difference between these is that wants of one kind do and of the other do not involve some form of evaluation of what is wanted. If a man wants to have or do a in the former sense then he believes it is worth while to do or have it, although he may not believe it to be the most worth while thing to do or have, given the alternatives. But he cannot regard doing or having a as being of no value whatever, for his wanting a is based on the thought that a is of some value to do or have. If on the other hand he simply desires a, *i.e.*, has a want of the second kind, then there are a number of possibilities: he may not evaluate a at all; or he may think that no value or even that a dis-value attaches to doing or having a; and finally he may think it worth while to do or have a, but if so then not because a as such is worth doing or having, but because he thinks it worth while to satisfy his desires, either on this occasion or as a general policy.

My tentative suggestion is that while infatuated x and loving x may have the same wants in the sense of wanting the same sorts of things, their wants are different in the sense just indicated. If x loves y then at least some of his wants will be based on the thought that it is worth while *e.g.*, to be with and cherish y, while the wants of his infatuation have no such base. Such a distinction is a highly theoretical one, and not only because in practice the two types of wants are no doubt untidily mixed up, or because what started as infatuation may turn into love, and the other way about. In many cases it would seem impossible for either x himself or anyone else to decide which of the two states applies to him: does he attach value to, say, y as a companion or merely to the satisfaction of his desire to be with y? It may be somewhat easier to settle

and rational' (*Summa Theologica, Prima Secundae*, Question 26, Article 1) and Dante's love for Beatrice is ruled by the 'faithful council of reason'. (*La Vita Nuova*, II.)

[7] The distinction is made and defended in Gary Watson's paper "Free Agency", *Journal of Philosophy*, April 1975.

the question if x does not value y's company at all and perhaps even deliberately sets out to satisfy his want to be with y as a step towards eliminating it. But again in practice this may not always be clearly distinguishable from the case where x, while believing it worth while to be in y's company, nevertheless rates it low in his hierarchy of values. For these reasons it is also difficult to produce a clear-cut example of infatuation as opposed to love. A possibly uncontroversial case is Count Muffat's passion for Nana, which so conflicts with his values as a man of religious convictions.[8] By contrast, Swann's complex thoughts about Odette and his 'appreciation of her based on the sure foundation of his aesthetic principles' make his feeling for her a more likely candidate for love.[9] Practical difficulties of this sort do not, however undermine the distinction; it rather helps to explain why we have such troubles in this area. Moreover, infatuation, being thought of as a blind passion, is very suitably linked with a type of desire which may lead a man to act against his better judgment, while the type of want ascribed to love accounts for the view that the lover tends to value what he loves. Such an assessment on the lover's part would hardly be possible if he did not believe that y had certain characteristics in virtue of which it would be worth while to have his wants satisfied, indeed he will think this if what he values is being with y, cherishing y etc., and not just the satisfaction of his desires. So a distinction between love and infatuation in terms of different kinds of wants leads back to the point that if x is to love y, x must believe y to have certain properties in virtue of which x has the wants specified.

The infatuated man may want to use the satisfaction of his wants as a means towards a further end, viz., to eliminate desires which are a source of discomfort to him. This at least seems a clear case of x's not loving y, and one which can be used to introduce a more general restriction: if x loves y then the satisfaction of the relevant wants taken collectively cannot by x be seen as a means towards some other end. So x cannot be said to love y if he regards benefiting and being

[8] Zola: *Nana*, esp. Ch. 13.

[9] Proust: *Remembrance of things past. Swann's Way*, II p. 8, Chatto and Windus. But Vlastos takes a different view of this case: "Love in Plato" p. 7 and p. 30 (*Platonic Studies*, Princeton University Press).

with y solely as a means towards, say, obtaining social status and wealth.

To summarize: if x loves y then x wants to benefit and be with y etc., and he has these wants (or at least some of them) because he believes y has some determinate characteristics ψ in virtue of which he thinks it worth while to benefit and be with y. He regards satisfaction of these wants as an end and not as a means towards some other end.

Given these ingredients it is possible, as in the case of other emotions, to assess a man's love favourably or unfavourably on the basis of a number of considerations:

i. First and most obviously, the belief that y is ψ may be well- or ill-founded.

ii. Another type of belief is involved if we accept that one distinction between wants and mere idle wishes is that necessarily, if a man wants something and not just wishes for it then he believes there is a real possibility that he can obtain whatever it may be. He may then have more or less good grounds for the belief that his wants can be satisfied, or even cling to it in the face of contrary evidence.

iii. Finally there is also the possibility of a man's being mistaken in attaching the value he does to what he wants. This of course is not only more difficult to assess than the justification of the other beliefs mentioned, but also raises the question of what is here to count as the criterion. The happiness or unhappiness of the lover can be no more than an indication, for happiness may be blind and unhappiness due to different sources, so that the problem of a criterion re-appears when we try to eliminate irrelevant types of un-happiness. Maybe it can be said that a man is mistaken in valuing, or in valuing so greatly, what he wants if the satis-faction of this want frustrates the satisfaction of some other more important want. But how then is one to settle the relative importance of different wants? I am not sure that anything generally useful can be said on this point, except perhaps that we should doubtlessly count as at least among the most important wants those arising out of human needs. The most basic and universal needs are presumably those which have to be met if a man is to stay alive, and among the wants that arise out of these is the want to avoid that

which threatens his existence or capacity to exercise a certain amount of control over the situations in which he finds himself. Perhaps no more controversial is the human need for contact with other human beings and social inter-relationships. The want to be with *y etc.*, may interfere with wants stemming from such basic needs and from that point of view one may think the value the lover attaches to what he wants mistaken. But the criterion is a crude one and will hardly do as it stands, for in the event of a clash between wants arising from need and from love respectively we should not always and necessarily wish to say that a man was mistaken in putting the latter first. But where a third person may be uncertain and suspend judgment it is at least possible for the lover himself to see or come to see that something has gone wrong with his evaluations.

Cases of love irrationally based in any of these ways are of course plentiful in literature. George Eliot's Dorothea, for example, is an extreme case of a person's wants to be with *y* and to benefit *y* being based on quite irrational beliefs, for Casaubon does not possess the characteristics she ascribes to him, and she would not have ascribed them to him had she applied a little more commonsense to the situation.[10] Misguided beliefs of the third type are naturally a popular theme as they are almost inevitably fatal to the lover. In the ballad we have Lord Randal explaining to his mother that he has just been with his true love and then promptly dying of the poison his true love has administered to him. Venus, in Wagner's *Tannhäuser,* harms her lover not quite so drastically but poisons him by draining his energy so that he no longer has the will to lead an active life. If one can speak of a person's need for some freedom of action and a certain degree of richness in his life then she is fatal to this particular need. Proust allots a similar rôle to Odette in her relation to Swann. His life is emptier in many ways than it would have been had he not loved her, and he is indeed aware of this:

> "he realised, too, that Odette's qualities were not such as to justify his setting so high a value on the hours he

[10] George Eliot: *Middlemarch*, esp. Books I and III.

spent in her company. And often, when the cold govern-
ment of reason stood unchallenged, he would readily
have ceased to sacrifice so many of his intellectual and
social interests to this imaginary pleasure.'"[11]

Not only does the attempt to satisfy some of his wants inter-
fere with the satisfaction of perhaps more fundamental ones,
but Swann can also be said to have unjustified beliefs of the
second type. Odette herself is quite incapable of loving or
giving anything, and Swann should have realised that even
his rather low-pitched expectations were unlikely to be satis-
fied. The three types of ill-founded beliefs are naturally de-
pendent on each other in that both a mistaken evaluation and
the unjustified belief that one's wants can be satisfied are
very likely based on misguided views about the nature of the
object loved. So Swann's mistakes at least partly stem from
his rather Berkeleyan conception of Odette as existing only
when perceived by him.[12]

In these ways, then, love may involve ill-founded beliefs.
But more than that may go wrong, for love has a dimension
which to a large extent at least other emotions lack. This
complicating factor may be called the 'nature' of a man's love;
it consists of the form taken by the individual beliefs and
various wants, and their relation to each other. What x sees
as satisfying his want for y's company will of course vary in
different cases, as will what he understands by 'benefiting y',
which may range from the simple and mundane to such a
complex one as making y aware of being valued as the person
he is. Again, the wants in the two groups may vary very much
in intensity, so x's want to have y take an interest in him may
be much stronger than his want to benefit y, or the other way

[11] *Swann's Way*, Pt. II p. 26, Chatto & Windus.

[12] It may be thought that these conditions ignore those cases where it is a
feature of the love in question that the object is unattainable, as *e.g.*,
described in some of the poetry of *amour courtois*. On my account the
'courtly lover' is not irrational as he holds no unfounded beliefs about the
satisfiability of certain wants. He may be worshipping an ideal and so not
count as exemplifying personal love. Where the love is personal it is thought
to be ennobling and so a means of narrowing the gulf between lover and
beloved. Here the lover has wants which may be well- or ill-founded, though
it may be that my descriptions of the wants will need some qualification to
meet his case.

about. He may also put a higher value on the satisfaction of one set of wants than on the other, irrespective of their intensity. The sorts of beliefs he holds here as well as the focus and intensity of his wants will indicate the kind of love he feels, whether it is relatively disinterested or possessive, sentimental or passionate.

I do not intend to offer conditions under which the various elements of the nature of love come out 'right' and are properly balanced. But something can be done with the conditions already available: what is seen by the lover as satisfying his various wants will often be connected with his belief that y has certain characteristics, his evaluation of these, and his estimate of his success. If these latter beliefs are irrational then very likely something will be wrong with the former ones as well. So for example, as a consequence of ill-founded beliefs about Casaubon's character, Dorothea's notion of how to benefit him is quite mistaken and certainly does not meet with his approval. Similarly, Helmer, in Ibsen's *A Doll's House*, benefits and cherishes his wife Nora according to his lights, but he is concerned with her desires as a charming plaything, not at all with her needs as a person. His knowledge of Nora is defective, but his case is different from that of Dorothea in that he does not ascribe characteristics to her which she does not possess: Nora is, as he believes, gay, affectionate and eager to please. His fault is rather that he regards only these qualities as important and ignores any others she may possess. His expectations of how he himself will benefit by their relationship are therefore not as unfounded as Dorothea's corresponding beliefs, but they are totally lop-sided and tailored to fit his ideal of domestic life. Helmer's way of benefiting Nora in the way he does seems, therefore, a means towards obtaining from her just the kinds of benefits he requires, *viz.*, those bestowed by his 'feather-brain', as he sometimes calls her, and not those which a responsible person like Nora is capable of giving. Where x's view of what constitutes a benefit to y is so entirely coloured by considerations of his own interests, his wants concerning y will be correspondingly 'unbalanced' in that he is more concerned with taking than giving, and the demands he makes on y will tend to be unreasonable.

III

I made two claims for the emotions described in section I of this paper:

1. There are two sets of conditions, the first to be satisfied if *x* is to feel the relevant emotion at all, and the second to be satisfied if *x* is justified in feeling the emotion in question.

2. As the beliefs very often include what might roughly be described as 'moral beliefs' the justification conditions are more substantial and complex than may at first appear. For where the experiencing of an emotion on some occasion is based on an ill-founded belief of this type, or conversely where the lack of emotional response on some occasion is due to an ill-founded belief, then either the emotional experience or the lack of it may indicate some failing or short-coming in the agent.

In the case of love I have tried to set out both sets of conditions. Here, too, we have beliefs which may or may not be well-founded, and so it seems that we have reason to think of it, too, as justified or otherwise. But to speak of an emotion as being on this or that occasion unjustified implies that it would have been better not to have felt it, and we tend to think of love as such a good in itself that it may be better to have loved irrationally than not to have loved at all. Although we may agree that love may indeed be defective, 'unjustified' seems hardly an appropriate term. Such reluctance on our part may of course be no more than romantic prejudice, but some of the features of love itself go some way towards explaining the difficulty we have in moving from the irrational to the unjustified:

1. Unlike other emotions, love is not 'occasional': while it is appropriate to speak of an occasion for being angry, afraid, grateful *etc.*, we can hardly talk in this way of love. This is partly so because to link love with particular occasions would leave open the possibility of its being very short-lived indeed, and this we are not prepared to do. More importantly, the beliefs and wants involved are too varied to be tied to one particular occasion. The emotional states in virtue of which we say that *x* loves *y* may, when each is taken in isolation,

lack that complexity which is a feature of love itself. While particular experiences of fear and anger will differ from each other merely in degree of intensity, particular experiences of love may differ also in kind. Not only may x on some occasion have just this or that desire involved in love, but more than any other emotion it may be responsible for his finding himself in almost any emotional state we can think of, covering the whole range from bliss to despair, or hope to jealousy. This feature makes love far more difficult to assess than other emotions, and if there are no particular occasions for feeling love then of corse we cannot ask whether a man is justified or not in feeling love on this or that occasion.

2. But it is not only the lack of occasions which makes this question such a strange one; the nature of love further complicates the matter. For a man's anger or fear to be unjustified it is sufficient that his beliefs about the situation are irrational, but in the case of love we should also want to know what sort of love he is offering. It is after all only very likely but by no means necessary that if x's beliefs about y are ill-founded then the nature of his love is in some way defective; his want to benefit may be wholly generous and indeed result in benefiting y. So the nature of x's love may well compensate for any mistaken beliefs about y. Even if his view that such-and-such would benefit y is quite unfounded we may still not want to judge the love adversely. We may for example still admire the feeling of the mother which prompts her to part with her son in the belief that this is in his best interest, although we think her quite wrong-headed in taking this to be the best course for the child.

The complexity of the matter is therefore such that it may well prevent us from speaking of love as unjustified. But that is not all there is to it. Love is thought of as somehow enriching to the lover as well as the person loved, and there seems something sad or even sinister about the man who never loves at all. Given the various wants and beliefs involved in love it is of course not difficult to enumerate possible failings and shortcomings of the man who does not love at all: most obviously, he may be so utterly preoccupied with his own concerns that no other interest can compete, and so he may never want to benefit and cherish another, or

may want to do so only with an eye to the return. If not too self-absorbed he may be too mean ever to think of giving anything, or he may be too arrogant to think that other people can possibly possess characteristics in virtue of which it would be worth his while to seek their company and take an interest in them. Or again he may be too indolent to take the trouble involved in caring for another person, or to make the effort to get to know him. So sloth may be at the root of his lack of love. Equally, it may be cowardice: the want to be with and communicate with y, and to be to y an object of interest and attention commits x to wanting some form of intimacy with y, and he may not have such wants because he lacks the courage to face the risks involved. He may wish to avoid not only being hurt through or by a person loved, but also letting himself be known by y, which he could hardly avoid if there is to be some intimacy between them. He may dislike to reveal his weaknesses or just be afraid of what there may be to reveal. Casaubon largely fails in love because he cannot afford to let Dorothea know what he is really like. He cannot afford this not only because he would run the risk of losing her respect when, after all, her rôle was specifically that of the admiring wife, but particularly also because such revelation might force him to look at himself and so perhaps for him destroy the fiction that he is a creative man of immaculate integrity.

Selfishness, avarice, arrogance, sloth and cowardice are at any rate among the major failings a man may possess if he lacks this or that belief or want essential to the lover. But it cannot be said without further ado that he man who loves will lack these failings, or that he will have the corresponding virtues. It seems that this can be said only of the 'good' lover whose beliefs are well-based and whose wants well-balanced. So there lurks the Aristotelian thought that only the good man can offer a love which is not defective. The bad lover, on the other hand, may have much the same defects as the non-lover. Maybe it can be said that he cannot have these to quite the same degree, for there must at least be some involvement with another person. And perhaps here we come to the crux of the matter. It may be the case that the good lover must have many virtues, but on the other hand a man may

have many virtues and not love at all. Like Kant's man of moral worth he may do much for others from a sense of duty, and he may indeed be very admirable. On many occasions his treatment of his neighbour may do very well: in our various rôles we do not on the whole expect more than is 'due' to us. But such rôles, we think, are not exhaustive. What we value about love is no doubt the spontaneous appreciation of another person, and maybe it can be said that even in its most defective form it involves a trust in another which is spontaneous in that it is not backed by any rights or conventions. From that point of view x's wants to be with y etc., are as important as his wants to benefit etc. y; not because such wants indicate any kind of virtue in him, but because they express appreciation of the other person, for whatever reason. Maybe this is why we do not like to commit ourselves to the unqualified judgment that it would have been better if x had not loved y at all.

My question was whether love in its structure is sufficiently like other emotions to be thought of as justified or unjustified. My answer is that there is no structure common to all the emotions, but love is not so unlike paradigmatic emotions that the question of justification does not arise: in the form of questions of deficiency and of propriety it does. This may not be a conclusion to please the tidy-minded, but untidiness is unavoidable where it reflects the complexity of the phenomena involved.

IX*—*DISTINCTIONES RATIONIS,* OR THE CHESHIRE CAT WHICH LEFT ITS SMILE BEHIND IT

by Ronald J. Butler

The primary point to be emphasized in elaborating Hume's 'compleat system of the sciences' is the centrality to his thought of the *distinctio rationis*. Small wonder this centrality has gone unrecognized, for Hume announces and illustrates the distinction almost as an afterthought in the penultimate and final paragraphs of the essay "Of abstract ideas". He was by no means the first to invoke the *distinctio rationis*, but nobody else had attempted "to explain that *distinction of reason*, which is so much talk'd of, and is so little understood, in the schools" (T 24).[1] Hume not only offers an explanation of the distinction, but makes it the kingpin of his system.

His explanation is that we are able to distinguish ideas which are different but nevertheless inseparable by comparing contrasting comparisons. We can compare a globe of white marble with a globe of black marble and a cube of white, "and find two separate resemblances, in what formerly seem'd, and really is, perfectly inseparable" (T 25). Thus we make distinctions between figure and colour, between figure and body figured, between motion and shape, between motion and body moved, between a lake and its reflection, between a mirror and its reflection, between Cézanne's poplars and the light falling upon them, between an expression on a face and the face which has that expression. It is precisely this ability to distinguish what really is inseparable which gives point to Charles Dodgson's joke about the Cheshire cat which left its smile behind it.

Hume's science concerning the principles of human nature

* This paper is an enlarged version of Prof. Butler's supplementary remarks when presenting his Inaugural Address "T and Sympathy" to the Joint Session of the Aristotelian Society and the Mind Association (*Arist. Soc., Suppl. Vol.* XLIX, 1975, pp. 1–20) at the University of Kent at Canterbury on the 18th July, 1975, and is here published at the request of members.

is founded "on observation and experience" (T xx). When Hume uses the word 'experience' he nearly always means 'experiment', and he is well aware that what we are able to observe may itself be conditioned by our experiments. To take one of his examples, "this invisible and intangible distance is also found *by experience* to contain a capacity of receiving body, or of becoming visible and tangible" (T 63). Before the experiment the distance between the two bodies is invisible and intangible, but after a third body, perhaps no thicker than a piece of rice paper, has been slipped between the two bodies, the distance which *was* invisible and intangible *is* visible and tangible. There is a tendency to think of the experiment as the act of slipping the third body between the other two, but for Hume the experiment (or experience) lies in the comparison between the two original bodies before and after this act is performed. Similarly with distinctions of reason, in comparing contrasting comparisons we are engaged in an experiment, we are finding out by experience, that two inseparable ideas are distinguishable.

In a most interesting context late in the *Treatise* Hume recalls one of his prime examples of a distinction of reason, that between body and body moved:

> Human nature being compos'd of two principal parts, which are requisite in all its actions, the affections and understanding; 'tis certain, that the blind motions of the former, without the direction of the latter, incapacitate men for society: And it may be allow'd us to consider separately the effects, that result from the separate operations of these two component parts of the mind. The same liberty may be permitted to moral, which is allow'd to natural philosophers; and 'tis very usual with the latter to consider any motion as compounded and consisting of two parts separate from each other, tho' at the same time they acknowledge it to be in itself uncompounded and inseparable (T 493).

In other words, just as a natural philosopher can write one book on physical bodies and quite another on velocity, even although motion and body moved are inseparable, so Hume the moral philosopher can write one book on the passions

and quite another on the understanding: between the subject-matters of Books I and II of the *Treatise* there is only a distinction of reason. Several passages support this conclusion. Perhaps the most important is that contained in the section "Experiments to confirm this system", where he offers "a clear proof, that these two faculties of the passions and the imagination are connected together, and that the relations of ideas have an influence upon the affections" (T 340).

And this makes all the difference. That the blind motions of the affections without the direction of the understanding incapacitate men for society is allied to Hume's claim, so often misunderstood, that "reason is, and ought only to be the slave of the passions, and can never pretend to any other office than to serve and obey them" (T 415). Hume does not use 'reason' to refer to that which is rational, but rather to those principles of the mind which enable us to form ideas and make judgments. In discussing these principles in Book I he is emphatic that if we were to rely entirely upon them (which is out of the question because these principles cannot operate independently of the passions) then reason would entirely subvert itself (T 187). It is the principles-of-the-mind-which-enable-us-to-form-ideas-and-make-judgments which are and ought to be the slave of the passions. Hume is saying that *vis-à-vis* the passions reason has an informative rôle to play, for every passion is accompanied by, or founded upon, a supposition from which it is inseparable. If that supposition is false then the passion is 'unreasonable'; but even then, Hume hastens to add, it is "not the passion, properly speaking, which is unreasonable, but the judgment" (T 416). Hume was precisely correct in saying that it is not contrary to reason in this sense to prefer the destruction of the whole world to the scratching of my finger. He could still say what he surely would have said that although it is not contrary to reason it is contrary to common sense. Although reason is and ought only to be the slave of the passions, "the moment we perceive the falsehood of any supposition, or the insufficiency of any means, our passions yield to our reason without any opposition" (T 416): reason and the passions are counterbalanced. The purpose of this contentious passage is to establish the impossibility "that reason

and passion can ever oppose each other, or dispute for the government of the will and actions." Reason informs the passions: the passions in turn are completely dependent upon and inseparable from reason.

If there is only a distinction of reason between the subject-matter of the first two books of the *Treatise*, there is also only a distinction of reason between that which is particular and that which is general. Doubtless Hume's homage to Berkeley at the beginning of the essay "Of abstract ideas" is responsible for the view that he merely re-presented Berkeley's theory. In fact Hume made two contributions which took him far beyond anything Berkeley had said. His proposition summing up Berkeley's account was "that all general ideas are nothing but particular ones, annexed to a certain term, which gives them a more extensive signification, and makes them recall upon occasion other individuals, which are similar to them" (T 17). Hume's primary contribution was to catalogue the capacities of the mind which it is necessary to assume if one accepts this theory. This Berkeley has not done. His secondary contribution was to draw the consequence that there is only a distinction of reason between the abstract and the particular. This too Berkeley has not done; and nor did Hume explicitly in the essay "Of abstract ideas". Nevertheless it follows as a natural consequence of his theory, and on the very next occasion he mentions the distinction between abstract and particular ideas he uses his customary idiom concerning distinctions of reason: "All abstract ideas are really nothing but particular ones, consider'd in a certain light" (T 34). He could equally well have said that all particular ideas are nothing but abstract ones seen in a certain light. In Hume's system the distinction between particular and abstract lies only in the set of different connexions, relations and durations which we attribute to the idea. Viewed with one set the idea is particular along with other particulars. Viewed with quite a different set the idea is abstract, applying to all ideas of that kind. We are able to compare the contrasting comparisons between the idea considered as particular and the idea considered as abstract, and in this way *we* make the distinction between abstract and particular.

In this connexion, note the remark about resemblance

which Hume appends to the opening statement of his theory. The opening statement is, "When we have found a resemblance among several objects, that often occur to us, we apply the same name to all of them, whatever differences we may observe in the degrees of quantity and quality, and whatever other differences may appear among them" (T 20). On a first reading this might be a restatement of Locke's theory of ratiocination which Hume, with his highly dispositional account, was concerned to avoid. On a close reading this difficulty disappears, for Hume in the footnote carefully points out that even "different simple ideas may have a similarity or resemblance to each other" without having any "point or circumstance of resemblance" which is "distinct and separable from that in which they differ." Hence *blue* and *green* are more resembling than *blue* and *scarlet*. In Hume's system, "finding a resemblance" is not a matter of finding a property in common, but is rather a matter of noting unwitting transitions of the mind when for example we say that two things are more alike or less alike than two other things. Such transitions may occur even between two simple ideas, which "resemble each other in their simplicity" (T 637). Noticing *this* resemblance we form the very abstract idea of a simple idea. But this is not a temporal sequence. In becoming aware of the transition of the mind we have already formed the abstract idea of a simple idea. In allowing *any* simple idea to do duty for the abstract idea, we are allowing that *that* simple idea may be seen in two quite different lights. As a particular idea *it* may be related by resemblance, by contiguity or by causation to other particular ideas. As an abstract idea *it* resembles other members of a class of particular ideas. In this as in all other cases of the *distinctio rationis* we make the distinction between abstract and particular by comparing contrasting comparisons.[2]

So far I have advanced three theses:

1. that Hume gives a precise account of distinctions of reason as experiments in which we compare contrasting comparisons;

2. that he claims that there is only a distinction of reason between the understanding and the affections;

3. that his theory of abstract ideas entails that there is only

a distinction of reason between an idea considered as particular and the same idea considered as abstract.

I now wish to advance a fourth thesis which I have argued at greater length elsewhere:

4. that within every perception there is a distinction, in Hume's words, between thinking and feeling.[3]

In introducing the distinction between impressions and ideas Hume says

> I believe it will not be necessary to employ many words in explaining this distinction. Every one of himself will readily perceive the difference betwixt feeling and thinking (T 2).

It has become customary to assume that Hume was aligning impressions with feeling and ideas with thinking, an interpretation I find thoroughly implausible because if it were correct Hume's first principle *"That all our simple ideas in their first appearance are deriv'd from simple impressions, which are correspondent to them, and which they exactly represent"* (T 4) would entail that all simple thoughts are exact copies of simple feelings. What could this possibly mean? Far more plausible is the assumption that just as figure and colour are different aspects of the globe of white marble, so feeling and thinking are different aspects of perceptions. Two perceptions may convey the same thought while differing in feeling. This difference in feeling, or feeling-tone as I prefer to call it, is merely one of degree, an impression being more dominant in this respect than its correspondent idea. This being so, we are able to compare perceptions conveying the same thought but differing in feeling-tone with perceptions differing in thought but having precisely the same degree of feeling-tone, and thereby make a distinction of reason, in Hume's words, between thinking and feeling.

'Feeling' is Hume's generic word for an aspect of perceptions which he found difficult to express. In giving it expression he produced a rich variety of epithets which has tantalized commentators: 'force', 'liveliness', 'vivacity', 'vigour', 'firmness', 'strength', 'solidity', 'steadiness', 'intensity', 'vividness', 'influence' and their correlatives 'faintness' and 'weakness'. The distinctions made in terms of

this battery are that between impressions and ideas, that between belief and simple conception, and that between ideas of the memory and ideas of the imagination. In each case Hume is referring to a single quality *of the mind* in having a perception. Thus belief gives ideas

> more force and influence; makes them appear of greater importance; infixes them in the mind; and renders them the governing principles of all our actions (T 629).

In his discussion of causation Hume links belief in the causal connexion with the transference of the force and liveliness of an impression to a related idea. Given the impression we *anticipate* the idea. The impression influences us to behave in a certain way. One might say that the resulting belief in the causal connexion *is* our ability to anticipate. But this leaves out an important feature in Hume's account: our immediate awareness of the act of anticipating. All perceptions have this characteristic, that we are aware to a greater or lesser extent of their possible connexions. This awareness may be pleasureable or painful, may excite contentment or anxiety, may rest the mind or throw it into a state of agitation. Every perception has its pleasure-value.

In this respect impressions are stronger than their correspondent ideas on account of the multiplicity of connexions which are open to them when they first appear. In becoming ideas many of these connexions cease to be possible, and the feeling-tone wanes accordingly. My fifth thesis is

5. that the feeling of a perception is an awareness of its possible connexions with other perceptions.

If my interpretation is correct it must above all accord with what Hume has to say about sympathy. One is inclined to say that by sympathy Hume means fellow-feeling, but this will not do for the *Treatise* because Hume there allows that in sympathy I may have the contrary of another's passion, *e.g.*, the response to another's love may be hate (T 340). Hume has, as usual, taken the nearest word in the language and given it a technical use. His account of sympathy in Book II begins with "that propensity we have to sympathize with others, and to receive by communication their inclinations and sentiments, however different from, or even contrary to

our own" (T 316), and ends with "'Tis evident, that *sympathy*, or the communication of passions, takes place among animals, no less than among men. Fear, anger, courage and other affections are frequently communicated from one animal to another, without their knowledge of that cause, which produc'd the original passion" (T 398). In short, sympathy is nothing but the communication of passions from one person to another, or from one animal to another.

How does this communication take place? Here we have Hume's most bewildering doctrine, that the idea of another's passion may be converted into an impression of one's own. It is only within a system in which every perception may do duty both as an abstract idea and as a particular idea that it makes sense to talk about converting a simple idea into an impression. This conversion is achieved by giving the perception a different set of relations, connexions and durations. When in sympathy I convert my simple idea of your love for somebody into an impression of my own, the abstract idea of the self "as it concerns the passions and the concern we take in ourselves" is already contained in the simple idea of *your* love.This abstract idea of the self and the abstract idea of love are distinguished only by a distinction of reason. In converting the idea into an impression the idea of the self is instanced anew. Throughout Hume's system there recurs the suggestion that by an act of the mind a perception may be seen in quite a different light: on occasion *we* attribute to the perception different relations, connexions and durations (T 68). The doctrine that

> the minds of men are mirrors to one another, not only because they reflect each others emotions, but also because those rays of passions, sentiments and opinions may be often reverberated, and may decay away by insensible degrees (T 365)

is central to Hume's thesis in its emphasis upon the immediacy of this kind of communication and the consequent dependence of men's minds upon each other.

The sixth thesis is

6. that the minds of men are interdependent, there being no private perceptions.

That there are no private perceptions entails no more than

that there are no thoughts which cannot be shared. The tradition that Hume commits himself to a world of private experience arises from two misconceptions. The first is that by feeling Hume means sensing, *feel* with a direct object as contrasted with *feeling that*. The second is that Hume aligns feelings (or sensings) with impressions and thinking with ideas. Both misconceptions vanish once it is realized that Hume is making a distinction of reason between *feeling that* and *thinking that*, and that this distinction is appropriate at any point on the impression-idea continuum.

It has been suggested that to read privacy out of Hume is to read Wittgenstein in, and that the interpretation I am offering is therefore anachronistic. On the contrary, the problems to which Wittgenstein addressed himself were in a large measure those of James, Russell and Moore: they by no means coincide with those which concerned Hume. Hume is *not* concerned with the privacy of sense-data, a problem which does not arise in his system, and *ipso facto* he is not concerned with Wittgenstein's problem of private languages. If the case rested upon the metaphors at T 365 quoted above, it would indeed be a difficult case to argue against the stalwarts of the Reid-Green-Passmore tradition. As it happens Hume addresses himself directly to the question of privacy which does arise in his system in the preceding section, "Of the love of relations", when he applauds the thesis that man is altogether insufficient to support himself:

> To this method of thinking I so far agree, that I own the mind to be insufficient, of itself, to its own entertainment, and that it naturally seeks after foreign objects, which may produce a lively sensation, and agitate the spirits. On the appearance of such an object it awakes, as it were, from a dream: The blood flows with a new tide: The heart is elevated: And the whole man acquires a vigour, which he cannot command in his solitary and calm moments. Hence company is naturally so rejoicing, as presenting the liveliest of all objects, *viz.* a rational and thinking Being like ourselves, who communicates to us all the actions of his mind; makes us privy to his inmost sentiments and affections; and lets us see, in the very instant of their production, all the emotions, which are caus'd by any object (T 352–3).

Nothing could be more explicit. Furthermore not a single
sentence in the whole of the *Treatise* conflicts with this state-
ment. Significantly in the very next sentence Hume alludes
to the conversion of the idea of a passion into an impression,
upon which rests his thesis than the minds of men are
interdependent:

> Every lively idea is agreeable, but especially that of a
> passion, because such an idea becomes a kind of passion,
> and gives a more sensible agitation to the mind, than
> any other image or conception.

<div align="center">* * *</div>

It has also been suggested that Hume abandoned his
doctrine of sympathy in *An Enquiry Concerning the
Principles of Morals*: it seems appropriate to speak to this
suggestion in an epilogue. In the second *Enquiry* Hume
certainly abandons the technical use of the word 'sympathy',
but he does not abandon the theory of sympathy contained
in the *Treatise*: on the contrary most if not all of the points
relevant to the *Enquiry* recur therein. There is indeed a
change of emphasis from our sympathy with another person
to our sympathy with the public interest reflected in two
corrections—we now know they were Hume's—contained
in a copy of the *Treatise* in the British Library.[4] The first
occurs in the same section in which Hume says that the blind
motions of the affections without the direction of the under-
standing incapacitate men for society. Here he says that men
lay themselves under the constraint of general rules after they

> have found by experience, that their selfishness and
> confin'd generosity, acting at their liberty, totally
> incapacitate them for society; and at the same time have
> observ'd, that society, is necessary to the satisfaction of
> those very passions (T 498–499).

At the end of this passage Hume had written

> *Thus self-interest is the original motive to the* establish-
> ment *of justice: but a* sympathy *with public interest is
> the source of the* moral approbation, *which attends that
> virtue* (T 499–500).

To this Hume later added in the margin—we know not when
—the sentence: "This latter principle of sympathy is too
weak to control our passions; but has sufficient force to
influence our taste and give us the sentiments of approbation
and blame". It might be thought that "sympathy with the
public interest" is a different use of 'sympathy' from that
which concerns the communication of the passions, but this is
a mistake. In talking about sympathy with the public interest
Hume is talking about our sympathy with others regulated by
general rules, which is precisely what one would expect him
to talk about in *An Enquiry Concerning the Principles of
Morals* as contrasted with the much broader canvass of the
Treatise. For this reason he says in the *Enquiry*

> Sympathy, we shall allow, is much fainter than our con-
> cern for ourselves, and sympathy with persons remote
> from us much fainter than that with persons near and
> contiguous; but for this very reason it is necessary for
> us, in our calm judgements and discourse concerning
> the characters of men, to neglect all these differences,
> and render or sentiments more public and social (E 229).

In the second correction the words italicized in the following
quotation

> But tho' a present interest may thus blind us with regard
> to our own actions, it takes no place with regard to those
> of others; nor hinders them from appearing in their true
> colours, as highly prejudicial to *public interest, and to
> our own in particular* (T 545, my italics)

are replaced by "our own interest, or at least that of the
public, which we partake of by *sympathy*".
 In his Index to the *Enquiries* Selby-Bigge devotes a whole
page to Sympathy. In some entries the word 'sympathy' does
not appear; but Selby-Bigge is quite right to draw attention
to them because in every case there is a parallel passage in the
Treatise in which Hume explicitly mentions sympathy. All of
the considerations concerning sympathy relevant to an en-
quiry concerning the principles of morals are contained in
both the *Treatise* and the second *Enquiry*. That other con-
siderations concerning sympathy are not mentioned in the

second *Enquiry*, which is far more limited in scope, neither establishes nor disestablishes that Hume had abandoned his account of sympathy as the communication of the passions. The only valid conclusion of an argument from silence is silence.

NOTES

¹ D. Hume, *A Treatise of Human Nature*, ed. L. A. Selby-Bigge (Oxford, 1888). This edition of the *Treatise* is cited in the text by 'T' followed by the page number. Hume's *Enquiries Concerning the Human Understanding and Concerning the Principles of Morals*, ed. L. A. Selby-Bigge (Oxford, 2nd ed., 1902) is cited in the text by 'E' followed by the page number.

² A very different account of T 637 is given by J. A. Passmore in *Hume's Intentions* (London, 2nd ed., 1968), pp. 109–110.

³ Theses 4 and 5 are argued at greater length in "Hume's Impressions", read to the Royal Institute of Philosophy on 14th February, 1975, to appear in *Impressions of Empiricism*, ed. G. N. A. Vesey. I should like to thank Professor Vesey for permission to draw upon this article.

⁴ *Cp*. E. C. Mossner, *The Life of David Hume*, (Oxford, 1954), p. 137n.

X*—WHAT IS "REALISM"?

by Hilary Putnam

While it is undoubtedly a good thing that "ism" words have gone out of fashion in philosophy, *some* "ism" words seem remarkably resistant to being banned. One such word is "realism". More and more philosophers are talking about realism these days; but very little is said about what realism *is*. This paper will not answer that very large question; but I hope to contribute a portion of an answer.

Whatever else realists say, they typically say that they believe in a Correspondence Theory of Truth.

When they argue *for* their position, realists typically argue *against* some version of Idealism—in our time, this would be Positivism or Operationalism. (This is not in itself surprising —all philosophers attempt to shift the burden of proof to their opponents. And if one's opponent has the burden of proof, to dispose of his arguments seems a sufficient defence of one's own position.) And the typical realist argument against Idealism is that it makes the success of science a *miracle*. Berkeley needed God just to account for the success of beliefs about tables and chairs (and trees in the Quad); but the appeal to God has gone out of fashion in philosophy, and, in any case, Berkeley's use of God is very odd from the point of view of most theists. And the modern positivist has to leave it without explanation (the realist charges) that "electron calculi" and "space-time calculi" and "DNA calculi" correctly predict observable phenomena if, in reality, there are no electrons, no curved space-time, and no DNA molecules. If there are such things, then a natural explanation of the success of these theories is that they are *partially true accounts* of how they behave. And a natural account of the way in which scientific theories succeed each other—say, the way in which Einstein's Relativity succeeded Newton's Universal Gravitation—is that a partially correct/partially

* Meeting of the Aristotelian Society at 5/7, Tavistock Place, London, W.C.1, on Monday, 23rd February 1976, at 7.30 p.m.

incorrect account of a theoretical object—say, the gravita-
tional field, or the metric structure of space-time, or both—
is replaced by a *better* account of the same object or objects.
But if these objects don't really exist at all, then it is a *miracle*
that a theory which speaks of gravitational action at a distance
successfully predicts phenomena; it is a *miracle* that a theory
which speaks of curved space-time successfully predicts
phenomena; and the fact that the laws of the former theory
are derivable "in the limit" from the laws of the latter theory
has no explained methodological significance.

I am not claiming that the positivist (or whatever) has no
rejoinder to make to this sort of argument. He has a number :
reductionist theories of the *meaning* of theoretical terms,
theories of explanation, *etc.* Right now, my interest is rather
in the following fact : the realist's argument turns on the
success of science, or, in an earlier day, the success of common
sense material object theory. But what does the success of
science have to do with the Correspondence Theory of
Truth?—or *any* theory of truth, for that matter?

That science succeeds in making many true predictions,
devising better ways of controlling nature, *etc.*, is an un-
doubted empirical fact. If realism is an *explanation* of this
fact, realism must itself be an over-arching scientific
hypothesis. And realists have often embraced this idea, and
proclaimed that realism *is* an empirical hypothesis. But then
it is left obscure what realism has to do with theory of *truth*.
In the present paper, I shall try to bring out what the con-
nexion between these two concerns of the realist is—what
the connexion is between explaining the success of knowledge
and the theory of truth.

1. *The "convergence" of scientific knowledge*

What I am calling "realism" is often called "scientific
realism" by its proponents. If I avoid that term here, it is
because "scientific realist", as a label, carries a certain
ideological *tone*—a tone faintly reminiscent of 19th century
materialism, or, to be blunt about it, village atheism. Indeed,
if a "scientific realist" is one who believes, *inter alia*, that *all*
knowledge worthy of the name is part of "science", then I am
not a "scientific realist". But scientific knowledge is certainly
an impressive part of our knowledge, and its nature and

significance have concerned all the great philosophers interested in epistemology at all. So it is not surprising that both realists and idealists should claim to be "philosophers of science", in *two* senses of "of". And if I focus on scientific knowledge in what follows, it is because the discussion has focused on it, and not out of a personal commitment to scientism.

To begin with, let me say that I think there *is* something to the idea of *convergence* in scientific knowledge. *What* there is is best explained, in my opinion, in an unpublished essay by Richard Boyd.[1] Boyd points out that all that follows from standard (positivist) philosophy of science is that later theories in a science, if they are to be *better* than the theories they succeed, must imply many of the *observation sentences* of the earlier theories (especially the *true* observation sentences implied by the earlier theories). It does not follow that the later theories must imply *the approximate truth of the theoretical laws of the earlier theories in certain circumstances*—which they typically do. In fact, preserving the *mechanisms* of the earlier theory as often as possible, which is what scientists try to do (or to show that they are "limiting cases" of new mechanisms)—is often the *hardest* way to get a theory which keeps the old observational predictions, where they were correct, and simultaneously incorporates the new observational data. That scientists try to do this—*e.g.*, *preserve* conservation of energy, if they can, rather than postulate violations—is a fact, and that this strategy has led to important discoveries (from the discovery of Neptune to the discovery of the positron) is also a fact.

Boyd tries to spell out Realism as an empirical hypothesis by means of two principles:

(1) Terms in a mature science typically *refer*.
(2) The laws of a theory belonging to a mature science are typically approximately true.

What he attempts to show in his essay is that scientists act as they do because they *believe* (1) and (2) and that their strategy works because (1) and (2) are *true*.

One of the most interesting things about this argument is that, if it is correct, the notions of "truth" and "reference" have a causal-explanatory rôle in epistemology. (1) and (2)

are premisses in an *explanation* of the behaviour of scientists and the success of science—and they essentially contain concepts from referential semantics. Replacing "true", in premiss (2) (of course, Boyd's argument needs many more premisses than *just* (1) and (2)) by some Operationalist "substitute"— e.g., "is simple and leads to true predictions"—will not preserve the explanation.

Let us pause to see why. Suppose T_1 is the received theory in some central branch of physics (*physics* surely counts as a "mature" science if any science does), and I am a scientist trying to find a theory T_2 to replace T_1. (Perhaps I even know of areas in which T_1 leads to false predictions.) If I believe principles (1) and (2), then I know that the laws of T_1 are (probably) approximately true. So T_2 must have a certain property—the property that the laws of T_1 are "approximately true" *when we judge from the standpoint of T_2*—or T_2 will (probably) have no chance of being true. Since I want theories that are not *just* "approximately true", but theories that have a chance of being *true*, I will only consider theories, as candidates for being T_2, which have this property—theories which contain the laws of T_1 as a limiting case. But this is just the feature of the scientific method we discussed. (Boyd also discusses a great many other features of the scientific method—not just this aspect of "convergence"; but I do not need to go into these other features here.) In fine, my knowledge of the truth of (1) and (2) enables me to restrict the class of candidate-theories I have to consider, and thereby increases my chance of success.

Now, if all I know is that T_1 leads to (mainly) true predictions in some observational vocabulary (a notion I have criticized elsewhere[2]), then all I know about T_2 is that it should imply most of the "observation sentences" implied by T_1. But it does *not* follow that it must imply the truth of the *laws* of T_1 in some limit. There are many other ways of constructing T_2 so that it will imply the truth of most of the observation sentences of T_1; and making T_2 imply the "approximate truth" of the *laws* of T_1 is often the *hardest* way. Nor is there any reason why T_2 should have the property that we can assign *referents* to the terms of T_1 from the standpoint of T_2. Yet it is a fact that we can assign a referent to "gravitational field" in Newtonian theory *from the stand-*

point of Relativity theory (though not to "ether" or "phlogiston"); a referent to Mendel's "gene" from the standpoint of present-day molecular biology; and a referent to Dalton's "atom" from the standpoint of quantum mechanics. These retrospective reference assignments depend on a principle that has been called the "Principle of Charity" or the "Principle of Benefit of the Doubt";[3] but not on *unreasonable* "charity". Surely the "gene" discussed in molecular biology is the gene (or rather "factor") Mendel *intended* to talk about; it is certainly what he should have intended to talk about! —Again, if one believes that the terms of T_1 do have referents (and one's semantic theory incorporates the Principle of Benefit of the Doubt), then it will be a *constraint* on T_2, it will narrow the class of candidate-theories, that T_2 must have this property, the property that *from its standpoint* one can assign referents to the terms of T_1. And again, if I do not use the notions of truth and reference in philosophy of science, if all I use are "global" properties of the order of "simplicity" and "leads to true predictions", then I will have no analogue of this constraint, I will not be able to narrow the class of candidate-theories in this way.

2. *What if there were no "convergence" in scientific knowledge?*

Let me now approach these problems from the other end, from the problem of "truth". How would our notions of *truth* and *reference* be affected if we decide *there is no* convergence in knowledge?

This is already the situation according to someone like Kuhn, who is sceptical about convergence and who writes (at least in *The Structure of Scientific Revolutions*) as if the same term cannot have the same referent in different paradigms (theories belonging to or generating different paradigms correspond to different "worlds", he says), and even more so from Feyerabend's standpoint.

Let us suppose they are right, and that "electron" in Bohr's theory (the Bohr-Rutherford theory of the early 1900s) does not refer to what we *now* call electrons. Then it doesn't refer to *anything* we recognize in present theory, and, moreover, it doesn't refer to anything *from the standpoint of* present theory (speaking from that standpoint, the only thing Bohr

could have been referring to were electrons, and if he wasn't referring to electrons he wasn't referring to anything). So if we use present theory to answer the question "was Bohr referring when he used the term 'electron'?", the answer has to be "no", according to Kuhn and Feyerabend. And what other theory can *we* use but our own present theory? (Kant's predicament, one might call this, although Quine is very fond of it too.) Kuhn talks as if each theory does refer—namely, to *its own* "world" of entities—but that isn't true according to *any* (scientific) theory.

Feyerabend arrives at his position by the following reasoning (which Kuhn does not at all agree with; any similarity in their views on cross-theoretical reference does not come from a shared analysis of science): the introducer of a scientific term, or the experts who use it, accept certain laws as virtually necessary truths about the putative referent. Feyerabend treats these laws, or the theoretical description of the referent based on these laws, as, in effect, a *definition* of the referent (in effect, an *analytic* definition). So if we ever decide that nothing fits *that exact description*, then we must say that there was "no such thing". If nothing fits the exact Bohr-Rutherford description of an electron, then "electron" *in the sense in which Bohr-Rutherford used it* does not refer. Moreover, if the theoretical description of an electron is different in two theories, then the term "electron" has a different *sense* (since it is synonymous with different descriptions—Feyerabend does not say this explicitly, but if this isn't his argument he doesn't have any) in the two theories. In general, Feyerabend concludes, such a term can have neither a shared referent nor a shared sense in different theories (the "incommensurability of theories").

This line of reasoning can be blocked by arguing (as I have in various places, and as Saul Kripke has) that scientific terms are not synonymous with descriptions. Moreover, it is an essential principle of semantic methodology that when speakers specify a referent for a term they use by a *description* and, because of mistaken factual beliefs that these speakers have, that description fails to refer, we should assume that they would accept reasonable reformulations of their description (in cases where it is clear, given our knowledge, how their description should be reformulated so as to refer, and there

is no ambiguity about how to do it in the practical context).
(This is, roughly, the Principle of Benefit of the Doubt
alluded to above.)

To give an example: there is nothing in the world which
exactly fits the Bohr-Rutherford description of an electron.
But there are particles which *approximately* fit Bohr's de-
scription: they have the right charge, the right mass, and
they are responsible for key effects which Bohr-Rutherford
explained in terms of "electrons"; for example, electric
current in a wire is flow of these particles. The Principle
of Benefit of the Doubt dictates that we treat Bohr as
referring to these particles.

Incidentally, if Bohr had not been according the Benefit of
the Doubt to his earlier (Bohr-Rutherford period) self, he
would not have *continued to use* the term "electron" (without
even a gloss!) when he participated in the invention of
(1930s) quantum mechanics.

Coming back to Kuhn, however: we can answer Kuhn by
saying there *are* entities—in fact, just the entities we now call
"electrons"—which behave like Bohr's "electrons" in many
ways (one to each hydrogen atom; negative unit charge;
appropriate mass; *etc*). And (this is, of course, just answering
Kuhn exactly as we answered Feyerabend) the Principle of
Benefit of the Doubt dictates that we should, in these circum-
stances, take Bohr to have been referring to what we call
"electrons". We should just say we have a different theory of
the *same* entities Bohr called "electrons" back then; his term
did refer.

But we can only take this line because present theory does
assert the existence of entities which fill many of the *rôles*
Bohr's "electrons" were supposed to fill, even if these entities
have other, very strange, properties, such as the Comple-
mentarity of Position and Momentum, that Bohr-Rutherford
"electrons" were not supposed to have. But what if we accept
a theory from the standpoint of which electrons are like
phlogiston?

Then we will have to say electrons don't really exist. What
if this keeps happening? What if *all* the theoretical entities
postulated by one generation (molecules, genes, *etc.*, as well
as electrons) invariably "don't exist" from the standpoint of
later science?—this is, of course, a form of the old sceptical

"argument from error"—how do you know you aren't in error *now*? But it is the form in which the argument from error is a *serious* worry for many people today, and not just a "philosophical doubt".

One reason this is a serious worry is that eventually the following meta-induction becomes overwhelmingly compelling: *just as no term used in the science of more than 50* (or whatever) *years ago referred, so it will turn out that no term used now* (except maybe observation terms, if there are such) *refers.*

It must obviously be a desideratum for the Theory of Reference that this meta-induction be blocked; that is one justification for the Principle of Benefit of the Doubt. But Benefit of the Doubt can be *unreasonable*; we don't carry it so far as to say that *phlogiston* referred. If there is no convergence, if later scientific theories cease having earlier theories as "limiting cases", if Boyd's principles (1) and (2) are clearly false from the point of view of future science, then Benefit of the Doubt will always turn out to be unreasonable—there will not be a reasonable *modification* of the theoretical descriptions of various entities given by earlier theories which makes those descriptions refer to entities with somewhat the same rôles which do exist from the standpoint of the later theory. Reference will collapse.

But what happens to the notion of *truth* in theoretical science if none of the descriptive terms refer? Perhaps all theoretical sentences are "false"; or some convention of narrowest scope or widest scope, *etc.*, for assigning truth-values when predicates don't refer takes over. In any case, the notion of "truth-value" becomes uninteresting for sentences containing theoretical terms. So truth will collapse too.

Now, dear reader, I want to argue that the foregoing *isn't* quite what would happen. But this will turn on rather subtle logical considerations.

3. *Mathematical Intuitionism—an application to empirical knowledge*

On the assumption that the reader has not studied Mathematical Intuitionism (the school of mathematical philosophy developed by Brouwer, Heyting, *etc.*), let me mention a few facts that I will use in what follows.

A key idea of the Intuitionists is to use the logical con-
nectives in a "non-classical" sense. (Of course, Intuitionists do
this because they regard the "classical" sense as inapplicable
to reasoning about infinite or potentially infinite domains.)
They explain this sense—that is, they explain *their* meanings
for the logical connectives—in terms of constructive
provability rather than (classical) *truth*.

Thus:

(1) Asserting p is asserting p *is provable*.

("$p \cdot {}^{\ulcorner}p$ is not provable${}^{\urcorner}$" is a *contradiction* for the
Intuitionists.)

(2) "$\neg p$" (\neg is the intuitionist symbol for negation) means
it is provable that a proof of p *would imply the provability of*
$1 = 0$ (or any other patent absurdity). In other words, $\neg p$
asserts the *absurdity of* p's *provability* (and not the classical
"falsity" of p).

(3) "$p \cdot q$ means p *is provable and* q *is provable*.

(4) "$p \lor q$" *means there is a proof of* p *or a proof of* q *and
one can tell which*.

(5) "$p \supset q$" means *there is a method which applied to any
proof of* p *yields a proof of* q *(and a proof that the method
does this)*.

These meanings are clearly different from the classical
ones. For example, $p \lor \neg p$ (which asserts the decidability of
every proposition) is not a theorem of Intuitionist proposi-
tional calculus.

Now, let us *reinterpret* the *classical* connectives as follows:

(1) \sim is identical with \neg.

(2) \cdot (classical) is identified with \cdot (Intuitionist).

(3) $p \lor q$ (classical) is identified with $\neg(\neg p \cdot \neg q)$.

(4) $p \supset q$ (classical) is identified with $\neg(\neg\neg p \cdot \neg q)$.

Then, with this interpretation, the theorems of *classical*
propositional calculus become theorems of Intuitionist pro-
positional calculus! In other words, this is a *translation* of
classical propositional calculus *into* Intuitionist propositional

calculus—not, of course, in the sense of giving the classical *meanings* of the connectives in terms of Intuitionist notions, but in the sense of giving the classical theorems. (It is not the only such "translation", by the way.) The meanings are still not classical, if the classical connectives are reinterpreted in this way, because these meanings are explained in terms of *provability* and not *truth and falsity*.

To illustrate: classically $p \vee \sim p$ asserts that every proposition is true or false. Under the above "conjunction-negation translation" into Intuitionist logic, $p \vee \sim p$ asserts $\neg(\neg p \cdot \neg \neg p)$, which says that it is absurd that the negation of a proposition and its double negation are both absurd— NOTHING ABOUT BEING TRUE OR FALSE!

One can extend all this to the quantifiers—I omit details.

> *One thing this shows is that, contrary to what a number of philosophers—including, surprisingly, Quine —have asserted, such inference rules as $p \cdot q / \therefore p$; $p \cdot q / \therefore q$; $p / p \vee q$; $q / \therefore p \vee q$; $\sim p, \sim q / \therefore \sim (p \vee q)$ do not fix the "meanings" of the logical connectives. Someone could accept all of these rules (and all classical tautologies, as well) and still be using the logical connectives in the non-classical sense just described—a sense which is not truth-functional.*

Suppose, now, we apply *this* interpretation of the logical connectives (the interpretation given by the "conjunction-negation translation" above) to empirical science (this idea was suggested to me by reading Dummett on Truth, although he should not be held responsible for it) in the following way: replace *constructive provability* (in the sense of Intuitionist mathematics) by *provability from* (some suitable consistent reconstruction of) *the postulates of the empirical science accepted at the time* (or, if one wishes to be a realist about "observation statements", those together with the set of true observation statements. If the empirical science accepted at the time is itself *inconsistent* with the set of true observation statements—because it implies a false prediction—then some appropriate subset would have to be specified, but I shall not consider here how this might be done). If B_1 is the empirical science accepted at *one* time and B_2 is the empirical

science accepted at a *different* time, then, according to this "quasi-Intuitionist" interpretation, the very *logical connectives* would refer to "provability in B_1" when used in B_1 and to "provability in B_2" when used in B_2. The *logical connectives* would change meaning in a systematic way as empirical knowledge changed.

> *A technical complication is that "provability in* B_1*" cannot be understood as formal (syntactic) provability, if we are to satisfy the axioms of Heyting's (Intuitionist) propositional calculus when we reinterpret the Intuitionist propositional calculus into which we are doing our conjunction-negation translation. Rather, we must take this notion in the sense of "informal" provability. But this same problem—the need for such an "informal" notion (satisfying the axioms of* S4, *with* □ *taken as denoting informal provability) arises in all Intuitionist mathematics.*

4. *Truth*

Suppose we formalize empirical science or some part of empirical science—that is, we formulate it in a formalized language L, with suitable logical rules and axioms, and with empirical postulates appropriate to the body of theory we are formalizing. Following standard present day logical practice, the predicate "true" (as applied to sentences of L) would not itself be a predicate of L, but would belong to a stronger "meta-language", ML. (Saul Kripke is currently exploring a method of avoiding this separation of object language and meta-language, but this would not affect the present discussion.) This predicate might be defined (using the logical resources of ML but no descriptive vocabulary except that of L) by methods due to Tarski; or it might be taken as a primitive (undefined) notion of ML. In either case, we would wish all sentences of the famous form:

(T) "Snow is white" is true if and only if snow is white

—all sentences asserting the equivalence of a sentence of L (pretend "snow is white" is a sentence of L) and the sentence of ML which says of that sentence that it is true—to be

theorems of *ML*. (Tarski called this "Criterium *W*" in his *Wahrheitsbegriff*—and this somehow got translated into English as "*Convention T*". I shall refer to the requirement that all sentences of the form (*T*) be theorems of *ML* as *Criterion T*.)

What happens to "true" if we reinterpret the logical connectives in the "quasi-Intuitionist" manner just described? *It is possible to define it exactly à la Tarski.* Only "truth" becomes *provability* (or, to be more precise, the double negation of provability. I shall ignore this last subtlety.) In short: the *formal* property of Truth: the Criterion of Adequacy (Criterion *T*)—only *fixes* the extension of "true" *if the logical connectives are classical.*

> *This means that we can extend the remark we made in section 3, (the first indented remark): even if the "natives" we are studying accept the Criterion* T *in addition to accepting all classical tautologies, it doesn't follow just from that that their "true" is the classical "true".*

"Truth" (defined in the standard recursive way, following Tarski) becomes *provability* if the logical connectives are suitably reinterpreted. What does "reference" become?

On the Tarski definition of *truth* and *reference*,

(a) "Electron" refers.

—is equivalent to

(b) There are electrons.

But if "there are" is interpreted Intuitionistically (b) asserts only

(c) There is a description *D* such that ⌜*D* is an electron⌝ is provable in B_1.

—and *this* could be true (for suitable B_1) even if there are no electrons! In short, the effect of reinterpreting the logical connectives Intuitionalistically is that "existence" becomes *intra-theoretic.* Actually, the effect is even more complicated than (c) if, in addition to understanding the connectives "quasi-intuitionistically" (*i.e.*, in the Intuitionist manner, but with "provability" relativized to B_1), we use the conjunction-

negation translation to interpret the "classical" connectives, as suggested here. But this complication does not change the point just made: if the quantifiers, like the other logical connectives, are interpreted in terms of the notion of *provability,* then existence becomes intra-theoretic.

5. *Correspondence Theory of Truth*

Now, what I want to suggest (the reader has probably been wondering what all this is leading up to!) is that the effect of abandoning realism—that is, abandoning the belief in any describable world of unobservable things, and accepting in its place the belief that all the "unobservable things" (and, possibly, the observable things as well) spoken of in any generation's scientific theories, including our own, are *mere* theoretical conveniences, destined to be replaced and supplanted by quite different and unrelated theoretical constructions in the future—would *not* be a total scrapping of the predicates *true* and *refers* in their *formal* aspects. We could, as the above discussion indicates, *keep* formal semantics (including "Tarski-type" truth-definitions); even keep classical logic; and yet *shift* our notion of "truth" over to something approximating "warranted assertibility". And I believe that this shift is what would in fact happen. (Of course, the formal details are only a rational reconstruction, and not the only possible one at that.)

Of course, there isn't any question of *proving* such a claim. It is a speculation about human cognitive nature, couched in the form of a prediction about an hypothetical situation. But what makes it plausible is that just such a subsitution—a subsitution of "truth within the theory" or "warranted assertibility" for the realist notion of truth—has *always* accompanied scepticism about the realist notion from Protagoras to Michael Dummett.

If this is right, then what is the answer to our original question: what is the relation between realist explanations of the scientific method, its success, its convergence, and the realist view of truth?

We remarked at the outset that realists claim to believe in something called a Correspondence Theory of Truth. But what is that?

If I am right, it isn't a different *definition* of truth. There

is only one way anyone knows how to *define* "true" and that is Tarski's way. (Actually, as we mentioned earlier, Saul Kripke has a *new* way—but the difference from Tarski is inessential in this context, although it is important for the treatment of the antinomies.) But is Tarski's way "realist"?

Well, it depends. If the logical connectives are understood realistically ("classically", as people say), then a Tarski-type truth-definition is "realist" to at least this degree: satisfaction (of which truth is a special case) is a relation beween words and things—more precisely, between formulas and finite sequences of things. ("Satisfies" is the technical term Tarski uses for what I have been calling *reference*. For example, instead of saying " 'Electron' refers to electrons", he would say "The sequence of length one consisting of just x satisfies the formula 'Electron (y)' if and only if x is an electron". "Satisfies" has the technical advantage of applying to n-place formulas. For example, one can say that the sequence *Abraham;Isaac* satisfies the formula 'x is the father of y'; but it is not customary to use "refers" in connexion with dyadic, *etc.*, formulas, *e.g.*, to say that "father of" *refers* to *Abraham;Isaac*.) This certainly conforms to an essential part of the idea of a Correspondence Theory.

Still, one tends to feel dissatisfied with the Tarski theory as a reconstruction of the "Correspondence Theory of Truth" *even if* the logical connectives are understood classically. I think that there are a number of sources of this dissatisfaction, which I have expressed myself in some of my writings, but it seems to me that Hartry Field[4] put his finger on the main one: the fact that primitive reference (*i.e.*, *satisfaction* in the case of primitive predicates of the language) is "explained" by a *list* is the big cause of distress.

But the list has a very special *structure*. Look at the following clauses from the definition of primitive reference:

(1) "Electron" refers to electrons.

(2) "Gene" refers to genes.

(3) "DNA molecule" refers to DNA molecules.

These are similar to the famous

(4) "Snow is white" is true if and only if snow is white.

—and the similarity is not coincidental: "true" is the O-adic case of satisfaction (a formula is true if it has no free variables and the null sequence satisfies it). The Criterion of Adequacy (Criterion T) can be generalized as follows:

(Call the result "Criterion S"—"S" for Satisfaction:)

*An adequate definition of satisfies-in-*L *must yield as theorems all instances of the following schema*:

$\ulcorner P(x_1, \ldots, x_n) \urcorner$ is satisfied by the sequence y_1, \ldots, y_n if and only if $P(y_1, \ldots, y_n)$.

Rewriting (1) above as

(1′) "Electron (x)" is satisfied by y_1 if and only if y_1 is an electron—which is how it would be written in the first place in Tarski-ese—we see that the structure of the list Field objects to is *determined* by Criterion S. But these criteria—T, or its natural generalization to formulas containing free variables, S—are determined by the formal properties we want the notion of truth to have (this is discussed at length in my John Locke Lectures), by the fact that we *need* for a variety of purposes to have a predicate in our meta-language that satisfies precisely the Criterion T. (This is why we would *keep* Criterion T even if we went over to an Intuitionist or quasi-Intuitionist meaning for the logical connectives.)

So I conclude (as I argue in the John Locke Lectures) that Field's objection fails, and that it is correct for the realist to define "true" à la Tarski. Even though the notion of truth is derived, so to speak, by a "transcendental deduction" (the argument, which I cannot give here, that we *need* a meta-linguistic notion satisfying Criterion T), and Criterion S is only justified as a "natural" generalization of T, satisfaction or reference is still, viewed from within our realist conceptual scheme, a relation between words and things—and one of explanatory value, as Boyd's argument shows.

Now that I have laid out this argument, let me give a shorter and sloppier argument to somewhat the same effect:

" 'Electron' refers to electrons"—*how else* should we say what "electron" refers to from *within* a conceptual system in which "electron" is a *primitive* term?

As soon as we *analyse electrons*—say, "electrons are particles with such-and-such mass and negative unit charge"—we can say " 'electron' refers to particles of such-and-such mass and negative unit charge"— but then "charge" (or whatever the primitive notions may be in our new theory) will be explained "trivially", that is, in accordance with Criterion *S*. Given the Quinian Predicament (Kantian Predicament?) that there is a real world *but* we can only describe it in the terms of our own conceptual system (Well? We should use *someone else's* conceptual system?) *is it surprising* that *primitive* reference has this character of apparent triviality?

I conclude, dear reader, that the Tarski theory is a "correspondence theory" in any sense one could reasonably ask for *if* the logical connectives are interpreted realistically.

6. *Truth and Knowledge*

What is it to interpret the logical connectives realistically? We have seen what it is *not*: the fact that one accepts classical logic does not show that one understands the logical connectives realistically. (Nor does the fact that one rejects it show that one understands them idealistically. *Cf.* my interpretation of quantum mechanics *via* a non-standard logic.) Nor is it just a question of accepting Criterion *T* or even Criterion *S*, or a question of accepting a Tarski-style truth-definition for one's language.

What does show that one understands the connectives realistically is one's acceptance of such statements as:

(A) Venus could have carbon dioxide in its atmosphere even if it didn't follow from our theory (or even from our theory plus the set of true "observation sentences") that Venus has carbon dioxide in its atmosphere.

—and

(B) A statement can be true even though it doesn't follow from our theory (or from our theory plus the set of true observation sentences).

Now (B) follows from any sentence of the general form (A). So why do we believe (A) (and many similar sentences)? The answer is that as realists we view *knowledge itself* as the

product of certain types of causal interactions, at least in such cases as "Venus has carbon dioxide in its atmosphere". And it *follows from our theory* of the interaction whereby we learned this fact—for example, the standard causal account of perception—that we might have, for any number of reasons, made up a theory from which it *didn't* follow that Venus has carbon dioxide in its atmosphere even though Venus *does* have carbon dioxide in its atmosphere. In short, (A) is itself a "scientific" (or even a *common sense*) *fact about the world* (albeit a *modal* fact about the world). But given the obviousness and centrality to our understanding of knowledge of facts like (A), how could anyone *not* understand the logical connectives realistically? How could anyone not be a realist?

Historically, one possible tack was to *accept* (A), *accept* the "realist" (classical) account of the logical connectives, but to give an idealist account of the meanings of the descriptive terms (*i.e.*, the predicates, or at least the "theoretical vocabulary"). But with the failure of the reduction programmes of phenomenalism and Logical Empiricism, that way was blocked. The more feasible tack, if one believes that scientific knowledge does not converge, would be to argue that the *phenomenon of scientific revolutions* shows that the realist notion of reference (and hence of truth) leads to disaster (*via* the meta-induction I discussed in section 2) and so we must fall back on an Intuitionist or quasi-Intuitionist reading of the logical connectives, which would save the bulk of extensional scientific theory, and save the formal part of our theories of reference and truth, at the cost of giving up (A) and (B).

The realist, in effect, argues that science should be taken at "face value"—without philosophical reinterpretation—in the light of the failure of all serious programmes of philosophical reinterpretation of science, and that science taken at "face value" *implies* realism. (Realism is, so to speak, "science's philosophy of science".) The opponent replies (assuming *no* convergence) that science itself—viewed *diachronically*—refutes realism. But the failure of convergence is crucial to this sort of anti-realist argument. If Boyd is right in claiming that the mature sciences do "converge" (in a very sophisticated sense), and that that convergence has great explanatory

value for the theory of science, then this sort of anti-realism, "cultural relativist" anti-realism, is bankrupt.

To sum up: Realism depends on a way of understanding the logical connectives (not just "truth", not just the rejection of reductionist analyses of the descriptive terms). This way of understanding the connectives depends on taking science at "face value" in a very strong sense—counting (B) as part of science. It also depends on blocking the disastrous meta-induction that concludes "no theoretical term ever refers". But blocking that meta-induction by a theory of science which stresses the "limiting case" relation between successor theories, and which employs a "causal" theory of reference, commits us to viewing the scientific method as not given *a priori*, but as dependent on our highest level empirical generalizations about knowledge itself, construed as an interaction with the world. Both our reasons for believing in a sophisticated version of convergence, such as Boyd's, and our reasons for accepting (B), have to do with our over-all view of *knowledge as part of the subject of our knowledge*.

Idealists have always maintained that our notion of truth depends on our understanding of our theory and of the activity of "discovering" it, *as a whole*. If I am right, then this is an insight of idealism that realists need to accept—though not in the way idealists meant it, of course.

NOTES

1 *Realism and Scientific Epistemology*, 1973 (privately circulated).

2 In "What Theories are Not", reprinted in my *Mathematics, Matter, and Method, Philosophical Papers*, Volume 1, Cambridge Univ. Press, 1975.

3 In "Language and Reality", in my *Mind, Language and Reality, Philosophical Papers*, Volume 2, Cambridge Univ. Press, 1975.

4 *Cf.* his "Tarski's Theory of Truth", *Journal of Philosophy*, vol. 69, no. 13, July 13, 1972, pp. 347–375.

XI*—*A PRIORI* AND *A POSTERIORI* KNOWLEDGE

by Colin McGinn

The paper† falls naturally into two parts. My intention in the first part is to propose an extensionally adequate and conceptually illuminating criterion (necessary and sufficient condition) for distinguishing *a priori* from *a posteriori* knowledge. In the second part I try to articulate some interrelations between this epistemic distinction and the (by tradition) collateral concepts of metaphysical modality, *viz.*, necessity and contingency. The parts are connected inasmuch as the criterion proposed in the first is trained upon issues raised in the second.

I

Before I give my account of the difference between *a priori* and *a posteriori knowledge*, something had better be said about the distinction in its application to *statements*. It is important to realise that, because the distinction is epistemic in character, what it originally partitions are propositional attitudes. The properties of apriority and aposteriority hold of a statement, therefore, only according as that statement comes to be known in this way or that. So if we are to classify statements as *a priori* or *a posteriori*, as the case may be, it will be because the propositional attitudes consisting in a recognition of their truth meet certain epistemic conditions. The following pair of definitions make this dependence explicit:

(1) It is *a priori* (true) that p iff \diamondsuit $(\exists x)$ (x knows that p *a priori*),

and

(2) It is *a posteriori* (true) that p iff \square $(\forall x)$ (x knows that $p \rightarrow x$ knows that p *a posteriori*).

* Meeting of the Aristotelian Society at 5/7, Tavistock Place, London, W.C.1, on Monday, 22nd March, 1976 at 7.30 p.m.

Some comments on these definitions. The reason (1) stipulates that an *a priori* statement is a statement know*able a priori* is that it seems clear that one can know an *a priori* truth *a posteriori*. A statement might be an instance of a derivable schema of first-order predicate logic, yet not recognized as such, but known to be true on ordinary empirical grounds; or we might come to know some mathematical truth on the basis of the outpourings of a reliable calculating device, or again because of the testimony of an authoritative mathematician.[1] Notice also that the possibility expressed in (1) has to be pretty liberal if it is to yield the intended results. For there might be some number-theoretic conjecture whose proof, though finite, required for its execution more time than a man's life permits, more even than is available to generations of men—it might indeed transcend the capacities of human beings *simpliciter*. So the scope of '\Diamond' has to be broader than that of '$\exists x$', and the quantifier should range over (possible) beings perhaps transcending our powers of ratiocination—or else there is the chance that not all mathematical truths will be reckoned *a priori* by (1).

Similar remarks go, *mutatis mutandis*, for (2). The necessitation of the conditional is required, not only to ensure exclusiveness of the partition of statements, but also to capture the idea that *a posteriori* statements are such as *only* to be knowable *a posteriori*—and not just must be known, if known at all, by *us a posteriori*, but by any being capable of knowledge. It seems that if we are exclusively and exhaustively to attribute apriority and aposteriority to statements, such extreme modal conditions are going to have to be countenanced.

My plan now is to state the criterion I have to offer, to explain it, and then to show how it handles specimen cases of *a priori* and *a posteriori* knowledge. The conditions are as follows:

(3) x knows that p *a posteriori* iff

 (i) x knows that p &

 (ii) ($\exists s$) (s is x's ground or reason for believing that p &

 (iii) the subject-matter of s causes x to believe that p),

and

(4) *x* knows that *p a priori* iff

 (i) *x* knows that *p* &

 (ii) (∃ *s*) (*s* is *x*'s ground or reason for believing that *p* &

 (iii) it is *not* the case that the subject-matter of *s* causes
 x to believe that *p*.)

First, some elucidatory comments on what (3) and (4) are meant to say, then some remarks by way of motivation for them.

(a) I do not intend (3) and (4) to commit me to the thesis that all knowledge is inferential. In cases where the knowledge that *p* is non-inferential, if such there be, the variable '*s*' should be instantiated by the statement that *p* itself. Then the causation will go immediately from the subject-matter of the statement that *p* to the corresponding knowledge-ranking belief that *p*. When the knowledge is inferential, on the other hand, the causal path will take a detour through a grounding belief in the truth of *s*, ultimately causing the belief that *p via* an inference from the reason-giving belief in *s*.

(b) By the 'subject-matter' of a statement I mean the entities the statement is about—denotations of singular terms, values of variables, and whatever else you think statements are about. (I take the liberty of letting feature-placing sentences possess a subject-matter in this sense.) Also my talk of entities causing beliefs is to be understood as elliptical: it is rather the events in which the entities comprising the subject-matter participate that are causally responsible, according to some correct causal explanation, for the belief in question.

(c) I assume for the sake of simplicity that *x*'s grounds for knowledge are unmixed. It seems appropriate where a person has both *a priori* and *a posteriori* grounds to let aposteriority be dominant with respect to apriority; replacing the existential by a universal quantifier in (4) seems to register this adequately enough. But I shall try to ignore this complication from now on.

Definitions (3) and (4) naturally prompt two queries: How do they relate to the traditional Kantian characterisation of the distinction?[2] and: How do they relate to the causal theory of knowledge (CTK)?[3] I shall address myself to these queries in turn.

Apart from extensional inadequacy in the Kantian criterion (which will emerge), and its reliance on a vague and unanalysed notion of 'experience', I prefer a causal condition partially out of a desire to see empiricism naturalized.[4] Fundamental to that project, as I conceive it, is a causal theory of perception (CTP)[5]: for empirical knowledge is, according to classical empiricism, ultimately founded on and traceable to perception of the external world. So, if CTP is conceptually necessary, and all *a posteriori* knowledge is ultimately and essentially justified perceptually, then the expectation is that a causal component will enter the analysis of what it is for a piece of knowledge to be *a posteriori*. Naturalized empiricism, now gone conceptual, then says that you cannot know about the external empirical world without causal interaction with it—for there is no perceiving the spatio-temporal world of particulars without causal commerce with it, and there is no knowing about it without perceiving it. In part, the causal requirement spells out what is involved in having experiences of, or beliefs about, the world of particulars.

My answer to the second query is not unconnected with my answer to the first, because CTP may be regarded as CTK's ancestor and model. Just as Gettier problems[6] for perceptual knowledge defined as true justified belief seemed soluble by introducing a causal clause into the analysis of perceptual knowledge, so a comparable tactic has recommended itself more generally. Thus it is required, in order that a man know that p, that his belief that p be caused by the fact that p, or by some fact 'suitably related' to the fact that p. Now I want to insist that in cases of *a priori* knowledge such a causal condition is unsatisfied: it won't in general be the case that the subject-matter of what you know *a priori* (or that of some statement 'suitably related' to what you know) causes you to know that thing (*vide infra*). But then if the concept of knowledge does not always require for its application the satisfaction of such a causal condition, it is hard to see how causality could be constitutively embedded in that concept. It is hard to see, that is, how causality could figure in its *analysis*. Since the verb 'to know' seems univocal, and since CTK seem inapplicable to *a priori* knowledge, I think that a causal condition cannot be part of the concept of knowledge. I suggest,

alternatively, that causality be expelled from the analysis of knowledge as such, and relocated, where naturalized empiricism indicates, in the account of what it takes for a given piece of knowledge to be *a posteriori*. If this advice is taken, the Gettier problems will have to be got round in some other way; but I think that CTK failed to fulfil that hope anyhow.

The acid test of the criterion, however, is its ability to handle cases—its ability appropriately to tag knowledge as *a priori* or *a posteriori*. It is easy to appreciate its operation in respect of *a posteriori* knowledge, because there one's ground is ultimately perceptual: the scattering of birds causes you, *via* the belief that birds have scattered, to infer, with the help of a number of other beliefs, that there is a cat in the vicinity; the deaths of individual men (*inter alia*) may cause you to form the belief that all men are mortal; and so on. Less trivial perhaps are examples of *a posteriori* knowledge of *a priori* truths, for in such cases the failure of an epistemic condition on the subject-matter of what is known to yield a criterion for apriority is most apparent; it is rather how we come to have our *reasons* that is decisive.[7] Thus suppose you come to know that the lines bisecting the interior angles of an equilateral triangle bisect the sides opposite by drawing many lines and noticing that they regularly display that geometrical property. Then, apparently, it is your causal contact, *via* perception, with those marks that is responsible (*inter alia*) for your inductively forming the belief in question. (The computer and testimony cases are parallel.) The subject-matter of your ground comprises particulars which are causally responsible, along with other things, for your coming to know.

A priori knowledge is the more challenging of the pair. I shall consider briefly: knowledge of logic, knowledge of mathematics, and knowledge of analytic truths.

Logic, it will be agreed, is concerned with deducibility relations among sentences—with the "laws of truth", as Frege says.[8] Our knowledge of logic is therefore concerned with such relations. That a set of (interpreted) sentences Γ implies a sentence A, *i.e.*, that the corresponding conditional is valid, can be known without any knowledge of the properties of the objects mentioned by Γ and A, since the implication holds no matter how the non-logical constants in those

sentences are (re-)interpreted. To know that a logically valid sentence is true, therefore, one needs no information about the specific properties of the entities making up the sentence's subject-matter, information one might acquire only by a *posteriori* inspection of those entities; knowledge of logical form is all that is required. Such knowledge, *i.e.*, that a sentence is logically true, is either primitive, as with the axioms, or derived, as with the theorems. But a logical proof (including one from the null set of axioms) does not mention entities that cause one's belief that the last line in the proof is valid, for the steps in a proof mention no entities at all. Logic is a purely deductive science, neutral as to topic. Thus a truth-table test for tautology is not the sort of ground whose subject-matter, if it has a subject-matter at all, is causally efficacious in producing knowledge of what is thereby proven. Even if stating the laws of logic requires semantic ascent,[9] so that sentence schemata become the subject-matter of logic, such entities cannot be said to cause one's logical knowledge. All this is evident from the fact, and I take it to be a fact, that one does not verify logical laws by perception. So logic is an *a priori* science by (4) and (1).

Mathematics cannot be treated so straightforwardly, because of the multiplicity of views as to what counts as a mathematical justification and what entities mathematics must be construed to speak of;[10] so the best I can do (here) is to assert conditionals. If strict logicism were correct, then the apriority of mathematics would fall out of the apriority of logic, as recently established, since the epistemology of mathematics would be that of logic, immensely prolongated. On the other hand, if mathematical discourse enjoys a distinctive subject-matter—so that, *e.g.*, arithmetical sentences speak of numbers, understood as abstract entities—then mathematical knowledge will come out *a priori* again. For, if mathematical grounds, *e.g.*, instances of mathematical induction, mention entities which are causally inert, as abstract objects surely are, then the subject-matter of a mathematical ground will not cause the knowledge had by a mathematician when such a ground is his reason for believing what he knows. If mathematics is reducible to logic and set theory, the same consequence is yielded, since logic is *a priori*, and sets are abstract

objects incapable, like numbers, of causal relations. On any view according to which the subject-matter of mathematical discourse, and of mathematical grounds, consists of abstract entities—on any Platonistic view, that is—(4) confers apriority upon mathematics and knowledge thereof.[11]

It is worth pausing to note that if mathematical knowledge can be acquired by so-called mathematical intuition,[12] where this epistemic relation is characterised in terms of quasi-perceptual acquaintance, then the Kantian independence-of-experience criterion, read literally, judges knowledge this way acquired to be *a posteriori*; for the kind of acquaintance involved in mathematical intuition is presented as a species of experience. Presumably, the availability of such a route to mathematical knowledge should not make knowledge so acquired *a posteriori*. The criterion I propose respects this intuition, because it is capable, in virtue of the causal condition, of distinguishing such intellectual perception from the common or garden variety. Maybe one can come to know mathematical truths by 'perceiving relations between universals', but universals cannot cause such perception, on account of their abstractness. So, if there is such a route to knowledge, (3) and (4) seem to handle it better, from an extensional point of view, than the traditional characterisation.

We must not neglect to mention those views according to which mathematical knowledge is *a posteriori*, as with Mill[13] and Quine[14]. Even if the ontology of mathematics is Platonistic, one's reasons for accepting a mathematical statement as true may be entirely empirical; for a mathematical statement may be accepted because of its relationship to perceptual reports, *i.e.*, observation statements. On such a view, the reason we accept and come to know mathematical statements is that there exists a complex and remote conformability relation between them and the observation statements which alone form the empirical content of any theory: for the utility of mathematics, like that of any other science, consists in its power to predict the course of experience. Clearly, if mathematical knowledge is thus verified and grounded, it is *a posteriori*; and it is *a posteriori* by (3) too, since observation statements speak of entities whose causal operation on our senses disposes us to hold them true. In unfathomable holistic ways

we come, by inference, to know classical mathematics, with
its abstract subject-matter: but we are prompted to do so *a
posteriori*. (Again, what is decisive in fixing the epistemic
status of a piece of knowledge are the properties of one's
reasons for belief.)

I have not tried to adjudicate between these various doc-
trines on how we come to know mathematics, only to argue
that the criterion proposed delivers the right verdicts with
respect to the *a priori*/*a posteriori* distinction given each doc-
trine as input.

Dummett[15] calls "compelling" the following principle: "if
someone knows the senses of two words, and the two words
have the same sense, he must know that they have the same
sense". When a sentence is formed from two synonymous ex-
pressions in such a way as to be analytically true, it follows
that a person who understands the sentence knows that it is,
since reference cannot diverge where sense does not. Thus
one's knowledge that oculists are eye-doctors is supervenient
upon one's grasp of the senses of the contained general terms;
it does not require any investigation of the objects in the ex-
tensions of those terms. However, instead of supposing know-
ledge of synonymies to follow inevitably from knowledge of
the senses of each of the synonymous expressions, I would pre-
fer to formulate Dummett's principle like this: that a person
apprised of the senses of two synonymous words is thereby in
a position to infer *a priori* that they have the same sense, and
hence to infer *a priori* that the corresponding analytic sen-
tence expresses a truth[16]—for there seems no clear limit to a
person's inability to draw out the consequences of what he
knows. But my main purpose is not to question Dummett's
formulation of his principle; it is rather to show how from it
and my test for apriority the *a priori* knowability of analytic
truths follows. One's sole and sufficient ground for such know-
ledge seems to be knowledge of synonymies (and related se-
mantic knowledge). Now whether synonymy is construed as
an equivalence relation between expressions, or as the iden-
tity relation between 'entified' senses, knowledge inferred from
such a basis comes out *a priori* by (4), since the subject-matter
of such a ground does not cause the knowledge in question.
To put it Frege's way, the mode of presentation associated

with an expression as its sense is not the sort of thing to enter into causal relations.

Lastly, what should we say of knowledge of one's own mental states? Here the Kantian criterion seems to run into trouble. For such knowledge—*e.g.*, that one intends to do such-and-such, that one has a certain belief, that one is in pain—does not seem either acquired or justified by experience or observation, still less by perception. Accordingly, it will get tagged *a priori* by the traditional test. But it is desirable, both intuitively and on account of its contingency, that it be rated *a posteriori*. And so it is by (3), since, as I should maintain on independent grounds, propositional attitudes directed on to one's own mental states are caused by those very states (this is not to say they are inferred from them.) That is, one's knowledge that one is in mental state ψ is caused by the subject-matter of the knowledge-ranking belief, *viz.*, state ψ. If this is right, (3) and (4) are more adequate extensionally than the traditional characterization, the reason being that they are more adequate *in*tensionally.

II

I turn now to the difficult but important question how apriority and aposteriority on the one hand, and necessity and contingency on the other, are connected—and here I am yet more diffident than hitherto. We are to enquire whether, and if so why, the following conditionals are valid or necessary:

(5) $\Box p \rightarrow$ it is *a priori* that p,

and

(6) It is *a priori* that $p \rightarrow \Box p$.

Or, contraposing, whether a truth's being *a posteriori* implies its contingency, and whether its contingency implies its aposteriority, respectively. How do the epistemic and metaphysical distinctions connect up, conceptually speaking?

As to (5) I am persuaded, with Kripke,[17] that it is invalid: some of its substitution-instances are false. Standard cases of *de re* necessity—necessity of identity, of constitution, of kind, of origin, *etc.*—seem counter-examples to it; none of these

necessities could be known *a priori*. What I am anxious to
insist, however, is that we must beware of an ambiguity in
attributing *a posteriori* necessity to statements. The ambi-
guity invites confusion between two quite distinct theses:
one true, the other false. To claim we have *a posteriori* know-
ledge of essence might be to claim *either* that there are neces-
sary truths whose *truth* we know *a posteriori* (there being no
other way), *or* that there are necessary truths whose *necessity*
we know *a posteriori*.[18] The latter thesis, but not the former,
collides with a famous dictum of Kant's: "Experience teaches
us that a thing is so and so, but not that it cannot be other-
wise."[19] The ambiguity can be removed by attending to mat-
ters of scope: the true statement 'we can know *a posteriori of*
a necessary truth that it is true' is different from and does not
imply the (I think) false statement 'we can know *a posteriori*
of a necessary truth that it is a *necessary* truth'. The intended
reading is got by bringing the attribution of necessity (or
contingency for that matter) out from under the scope of the
epistemic operator.

How, if not by perception, do we come by our knowledge of
modality? The phenomenology of acquiring modal know-
ledge seems to be something like this: we assess a statement's
modal status by constructing or surveying possible worlds; if
the result is that the statement is true at all worlds it is pre-
sumed necessary, if at some only then contingent. The exer-
cise consists in taking thought, perhaps primarily imaginative
thought, about how things might have been. The upshot of
such ratiocination is an ascription of this or that modality to
the statement in question; and it seems that a person could
not come to have such knowledge unless he (or someone he
heard it from) had conducted this kind of *Gedankenexperi-
ment*. (Perception tells us what is the case; reason what could
be.) If this is roughly how we acquire and justify our modal
knowledge, it seems *a priori* by (4) and by the Kantian crite-
rion. For one's knowledge of possible worlds, of how things
might be, is not derived from perception of, or causal contact
with, those *possibilia*. The possibilities to which imagination
relates us do not cause the beliefs thus formed; for only what
is actual can cause anything. So modal knowledge *as such* is
a priori, though we may have *a posteriori* knowledge of neces-
sary truths.

The converse implication, (6), seems in contrast, and as Kripke acknowledges,[20] to carry a lot of intuitive weight. But what account might we give of the intuition? Here is one way of articulating, if not quite proving the soundness of, the thought behind (6). Suppose it knowable *a priori* that *p*. Now since the knowledge that *p* is grounded upon reasons one has independently of observation of (causal contact with) the world, one's evidential state is not contingent upon the vicissitudes of the world. And if one's evidential state does not thus depend upon the ways of the actual world, then one could be, in Kripke's phrase,[21] in qualitatively the same epistemic situation in any world: *a priori* evidence is constant across worlds, because available without observation of the specific properties of each world. Now if, as seems plausible, *a priori* grounds, unlike *a posteriori* grounds, *entail* what they ground—*i.e.*, provide *conclusive* reasons for belief—then one could not be in possession of the very same evidence in a counter-factual situation and yet the statement thus evidentially supported be false. Putting these two thoughts together—independence of evidential state and epistemic necessity of *a priori* evidence—we derive the conclusion that what is known *a priori* is true in all worlds, which is to say it is necessary. Contraposition of (6) enables us to conclude also that what is contingent can only be known *a posteriori*. (Notice that *a posteriori* evidence exhibits neither of the properties I have attributed to *a priori* evidence.)

I anticipate at least two lines of objection to this argument. The first, which at least shows its non-triviality, is that there seem to be cases of epistemically contingent *a priori* knowledge, *i.e.*, cases in which a person seems entitled to claim to know some proposition *a priori* though his justification does not necessarily preclude its falsehood. I have in mind probabilistic or quasi-inductive mathematical arguments which fall short of proof, *e.g.*, Euler's solution to Bernoulli's problem of the sum of the reciprocals of the squares.[22] I do not know how to answer this objection.

The second objection, to which I think I do have an answer, is that there are actual counter-examples to (6), given by Kripke.[23] These instantiate the general pattern of coming to know a truth on the basis of reference-fixing stipulative definitions. Thus it is claimed that one can know *a priori*

that a certain rod is one metre long even though it is only contingently of that length. How might we, in hopes of preserving (6), try to dispose of such counter-examples? I don't doubt that the rod is accidentally a metre long, nor that a person can be said to know (relationally) of the rod that it satisfies that condition, nor even that there is a clear sense in which we have 'automatic' or 'prior' knowledge of the rod's length. But I think that attention to what grounds the knowledge in question brings its apriority into serious doubt.

Compare the case of naming a ship. As a result of instantiating certain general conventions about how the reference of a ship's name is determined, a ship comes to be (say) the QE2. So those present at the christening come to know the contingent fact that the ship struck at t by a certain champagne bottle is the QE2. But they only know this because they are antecendently apprised of the general conventions governing the naming of ships and because they have observed that these conventions have been instantiated in (among other acts) a certain speech act. And these things they know *a posteriori*. Since aposteriority transmits itself through inference, their inferred knowledge is *a posteriori* too—even though they enjoyed 'automatic' and 'prior' access to the ship's identity. I think the case is similar with the metre rod. One comes to know it is a metre long on the basis of knowledge concerning the general convention of stipulative definition and observation of (or testimony about) the event of utterance (*etc.*) instantiating the convention, these requiring causal commerce with empirical particulars. So I am inclined to say that the sort of knowledge Kripke has cottoned on to is not genuinely *a priori*. The example of the metre rod seemed to count against (6) only because it traded on an unacceptable conception of the *a priori*.

(6) recommends itself on a quite different front too. One feature of *a priori* knowledge claimed by tradition, and sustained by reflection, is that in knowing a truth *a priori* one comes—as it were in the very act—to recognise its necessity. I prefer to view the consequent modal knowledge as acquired by inference, on these lines. Suppose a man knows *a priori* that p. Given that he knows his knowledge to be *a priori*, and given knowledge of (6), he can infer that $\Box p$: so if a man

knows that p a *priori*, then he knows that $\Box p$ a *priori*. (No such inference is valid when a necessary truth is known *a posteriori*.)[24]

There is clearly much more to be said on these topics, but I hope I have succeeded in scratching the surface of a subject that deserves to be re-opened.

NOTES

† I was greatly helped in writing this paper by W. D. Hart, Jennifer Hornsby, Marie McGinn and Christopher Peacocke.

[1] *Cp.* S. Kripke, "Naming and Necessity", in D. Davidson and G. Harman, eds., *Semantics of Natural Language* (Dordrecht: Reidel, 1972), p. 261

[2] Thus Kant, "we shall understand by a *priori* knowledge, not knowledge independent of this or that experience, but knowledge absolutely independent of all experience. Opposed to it is empirical knowledge, which is knowledge possible only a *posteriori*, that is, through experience." *Critique of Pure Reason*, B3.

[3] See A. Goldman, "A Causal Theory of Knowing", *The Journal of Philosophy*, June 22, 1967.

[4] *Cp.* Quine, "Epistemology Naturalised", in *Ontological Relativity and Other Essays* (Columbia University Press, 1969).

[5] See H. P. Grice, "The Causal Theory of Perception", *P. A. S.*, *Supp. Vol.* 35 (1961). I see no internal evidence that Grice views CTP in this light.

[6] See G. Harman, *Thought* (Princeton University Press, 1973), pp. 174 ff for a discussion of such examples. He does not propose a causal condition to handle these cases.

[7] Neither can it be sufficient for apriority that the subject-matters of the ground and the known proposition be, in some intuitive sense, *disjoint*; for this condition is met in cases of a *posteriori* knowledge of a *priori* truths.

[8] In "The Thought", in Strawson, ed., *Philosophical Logic* (O.U.P., 1967).

[9] See Quine, *Philosophy of Logic* (Prentice-Hall, 1970), pp. 10 ff.

[10] See M. Steiner, *Mathematical Knowledge* (Cornell University Press, 1975) and Hart's review of it (forthcoming in *The Journal of Philosophy*).

[11] Since I am not proposing a causal condition as part of the analysis of knowledge, I can turn CTK's troubles over mathematical knowledge to my own advantage in suggesting a *differentia*. (I do not pretend that this solves the problem of *how* we get to know the properties of abstract objects. If anything, the question how a *priori* knowledge is possible is yet more acute on my criterion; the problem of reconciling Platonism in mathematics with a plausible epistemology is, I think, a special case of this general question.)

[12] See Russell, *Problems of Philosophy* (1912), chap.10; Gödel, "What is Cantor's Continuum Problem?" in Benacerraf and Putnam, eds., *Philosophy of Mathematics*, p.271; and Steiner, *op cit.*, pp. 130 ff. Note that Russell's characterisation of a *priori* knowledge as that which "deals exclusively with the relations of universals" (p.59), conforms closely to my own, though he defines the concept by reference to a special sort of subject-matter rather than in terms of what epistemic consequences fall out of having such a subject-matter.

[13] J. S. Mill, *A System of Logic*, chapter V and VI of Book II.

[14] See *e.g.*, *Philosophy of Logic*, pp.98 ff. Of course, the views of Mill and Quine on this matter are not to be identified.

[15] In *Frege* (Duckworth, 1973), p.95.

[16] This interpretation of the principle seems closer to Frege's intentions in "On Sense and Reference", where he speaks of identity statements whose truth "cannot always be established *a priori*", p.56 of Geach and Black, eds., *Translations from the Philosophical Writings of Gottlob Frege* (Basil Blackwell, 1966).

[17] "Naming and Necessity", *passim*.

[18] The following remarks from Kripke seem to me to encourage the confusion: "Whether science can discover empirically that certain properties are *necessary* of cows, or of tigers, is another question, which I answer affirmatively" (pp.322-3), and "whatever necessity it ['gold is a yellow metal'] has is established by scientific investigation" (p.353), *loc.cit.*

[19] *Critique of Pure Reason*, B3.

[20] At p.347, *loc.cit.*

[21] *Loc.cit.*, p.308.

[22] For details see Steiner, *op.cit.*, pp.162 ff.

[23] *Loc.cit.*, pp.274 ff.

[24] It is interesting to note that given (6), the principle that modal knowledge is *a priori*, and a few other standard modal principles, it is possible to derive the distinctive axioms of S4 and S5. This result will be reported in a paper by Hart and myself.

XII*—ANALYSING HOBBES'S CONTRACT

by M. T. Dalgarno[1]

The aim of this paper is to examine how Hobbes analyses contracts in general, and to use this analysis to clarify features of the particular contract, Hobbes's political contract, which have puzzled generations of commentators. I shall concentrate on the relatively recent statement of the puzzles by Howard Warrender in his admirable book *The Political Philosophy of Hobbes*, although discussions of these problems are to be found in Pufendorf's *De Jure Naturae et Gentium*, Bk. VII, ch. II, secs. ix-xii, as well as in the controversies among continental scholars of the last century about whether Hobbes was proposing a *pactum unionis* or *pactum subjectionis*.

A. The Warrender Problem

Warrender argues that by insisting on making the parties to the political contract in an instituted commonwealth every man with every man, Hobbes has created great difficulties for his theory.[2] If the prospective subjects are the contracting parties then the sovereign who is not a party to the contract must be merely a third-party beneficiary. If one of his subjects violated the obligation he undertook as a party to the political contract then the sovereign would not suffer injury. In Hobbes's technical use of these terms, he might be *damaged* but could not be *injured* since the obligation in question was one owed to fellow subjects.[3] Further, if the contracting parties were to engage in an orgy of mutual forgiveness, releasing each other from the obligations undertaken through their mutual covenants, then the subjects would cease even to have obligations to each other *with respect to* the sovereign. Warrender considers these conclusions fatal to Hobbes's enterprise of basing the rights of sovereignty on the contract to institute a commonwealth, and this prompts Warrender to

* Meeting of the Aristotelian Society at 5/7, Tavistock Place, London, W.C.1, on Monday, 26th April, 1976, at 7.30 p.m.

look beyond the political contract for the coherent account of political obligation he claims to find in the general obligation at natural law to seek peace. Warrender thinks Hobbes was fully aware of the difficulties and points to Hobbes's claim the "government is upheld by a double obligation from the citizens, first, that which is due to their fellow-citizens, next, that which they owe to their prince" (DE CIVE VI, 20). However, Warrender insists that it is very difficult to find the principle under which it is possible for Hobbes, in terms of his own theory, to introduce this additional obligation to the sovereign. More recently, David Gauthier has written that Hobbes has no argument to support his claim that subjects have an obligation to the sovereign, from which they may not release themselves.[4]

This problem of how the sovereign in Hobbes's instituted commonwealth has rights correlative to obligations which his subjects owe to him is what, for shortness, I refer to as the Warrender problem. It is clear that Hobbes intended his political contract to provide such rights. Is the design the failure Warrender argues it to be?

B. *Contract and Covenant*

Hobbes defines contract as the mutual transferring of right. Covenant is defined as a transferring of right where the party who covenants is trusted to perform his part. A contract where both parties bind themselves to perform their parts later would be a contract consisting of mutual covenants. A contract where one party performed his part immediately while the other party was to perform later, would include a single covenant. A contract where both parties performed immediately would not include any covenant. But in all three cases there would be mutual transferrings of right, since for Hobbes "all contract is mutual translation" (LEV XIV, 88 (194), EW III, 123).

It is important to emphasise that for Hobbes contract and covenant are not synonyms, and that while talk of a mutual contract between two parties is pleonastic, talk of mutual covenants is not. Covenant is not the name for a particular sort of contract, one involving trust; it is the name for a transaction which may be part of a contract. Thus Hobbes writes

that in all contracts where there is trust, "the promise of him that is trusted, is called a COVENANT" (EL I, XV, 9). And in *Leviathan* it is not the contract which is called covenant, but "the contract on his part" who is trusted (LEV XIV, 87 (193), EW III, 121). By attending to Hobbes's definitions whereby a contract consists of a mutual transferring of right while a covenant is a unilateral transfer of right, it is possible to give some precision to the dangerously ambiguous phrase of 'party to a covenant'. If *A* covenants with *B* to deliver goods to a third-party, this is *A*'s covenant. Since Hobbes insists that *B* must accept the translation of right involved for *A* to succeed in binding himself by his covenant, *B* has a part to play. However, it is confusing to call *B* 'a party' to *A*'s covenant; he is merely the covenantee, as Hobbes calls him, in virtue of his acceptance of *A*'s covenant.

Warrender who employs the term covenant where strictly speaking he should be talking of a contract or of mutual covenants, repeatedly asserts that Hobbes makes the sovereign a party to the covenant on which a commonwealth by acquisition is based.[5] Warrender moves quickly from the passage where Hobbes writes

> . . . seeing sovereignty by institution, is by covenant of every one to every one; and sovereignty by acquisition, by covenants of the vanquished to the victor, or child to parent; (LEV XXI, 142 (268), EW III, 204)

to the conclusion that Hobbes should have placed his sovereign by institution in the same position as the sovereign by acquisition. The former need only promise to sustain sufficient power to protect his subjects in return for their promise of obedience.[6] With apparent disregard for the problem of how the sovereign by institution could be a party to the act which creates the sovereign, Warrender maintains that Hobbes should have made the sovereign a covenanting party in the commonwealth by institution just as in the commonwealth by acquisition.

Hobbes, however, does not say that acquired sovereignty rests on mutual covenants between the victor and the vanquished. He is quite explicit as in his statement above that it rests on the covenant of the vanquished. Just as one can be

a promisee without being in turn a promisor, the victor is not made a covenanting party by accepting the covenant the vanquished makes to him. A's covenant with B is not equivalent to a contract between A and B. It is the error of taking these to be equivalent which leads to the denial of the truth that for Hobbes the sovereign is not a covenanting or contracting party in either acquired or instituted forms of commonwealth.

C. Transfer of Right

A covenant is a particular sort of transfer of right, and contracts consist in mutual transfers whether these are covenants or not. Hobbes then, makes transfer of right the basic element in his analysis of contract. However, what Hobbes means by a right in this context is not what is frequently understood by that expression in ordinary language. Secondly, the phrase 'transfer of right' is highly misleading since what one party gives up is not what the other party receives; and Hobbes as we shall see is forced to make some spectacular gyrations in order to deny the implications of his own terminology. It is scarcely surprising then that the political contract should prove puzzling when the basic element of Hobbes's analysis of even the simplest contract, covenant, or promise, is so liable to mislead.

A contemporary way of describing what A does in a contract with B whereby he is to do x and B to do y, would be to describe A as placing himself under the obligation to B to do x or as giving B the right that he, A, should do x. Of the various terms suggested for this conception of a right, 'right that', 'right of recipience', 'right *stricto sensu*' or 'right correlative to obligation', perhaps the last is the clearest. However, it might not immediately have been clear to Hobbes. As D. D. Raphael argued, since Hobbes had appropriated the expression 'a right' for a quite different conception he was left with the problem of how to describe the sort of position which arises for B from A's part in the contract.[7] Hobbes, in fact, would use circumlocutions, talking of B's *meriting* A's performance or having it as *due*.

The conception of a right which Hobbes fastens upon in talking of a transfer of right is that of a normative liberty:

what Hohfeld calls a privilege, Glanville Williams a liberty, and Hart a liberty-right. While a right correlative to obligation involves two parties where one party's right is correlative to an obligation on *another*, a liberty-right is a one-party relation. It asserts the relation between one party and a law or obligation relative to some performance or omission by that same agent. To say, for instance, that A has a liberty-right to omit doing x is to say that A is not under an obligation to do x. Hobbes describes this as a right in the sense of "blameless liberty".[8] For A to omit doing x is "lawful",[9] since A does so *juste et jure*.[10] If A did not have this liberty-right, if he had been under an obligation to B to do x, then he would have acted *sine jure* by not doing x, his omission constituting an injury to B.[11] The liberty-right which A enjoys is, in Hohfeld's expression, the opposite of A's having the obligation to do x; or as Hobbes puts it, "where liberty ceaseth, there beginneth obligation" (EL I, XV, 9).

If we follow Hobbes in making liberty-right the starting-point, then A's part in the contract with B (provided it was not redundant, as it would be if A were already under an obligation to B to do x, or repugnant, as it would be if he were under an antecedent obligation to omit doing x)[12] can be described in the following terms: Prior to the contract, A had the liberty-right to omit x which he extinguishes by imposing on himself the obligation to B to do x thereby giving B the right correlative to obligation that A should do x. B's part, given the same provisions, consists in B's giving up his liberty-right of not doing y in such a way as to impose on himself the obligation to A to do y, and A acquires the right correlative to obligation that B should do y. Hobbes's description of this is that A and B mutually transfer rights. Transfer of right, according to Hobbes, consists in divesting oneself of a right and this right is clearly a liberty-right. But it is not this liberty-right which the other party acquires. B for instance might already have had the liberty-right to omit x. He does not enter into contract in order to acquire that liberty-right. The consideration for B is A's doing x and the contract gives him the right correlative to A's obligation to do x.

Incidentally, when we talk of two men having the same

liberty-right, as we sometimes do, I think we must mean that each has the liberty-right to do, or omit corresponding acts. But when these acts are fully specified, it is clear that two distinct liberty-rights are involved. While A's liberty-right to omit x consists in his violating no obligation if he, A, omits x, B's liberty-right to omit x consists in his violating no obligation if he, B, omits x. Thus, if A had the liberty-right to commit suicide, the question is never strictly one of whether A can transfer to B that particular liberty-right to put an end to A's life unless one wants to enter a world of fiction where B's acting is allowed to be really A's. Rather the question should be whether A, who has the liberty-right to take his own life, has *in addition*, whether in virtue of possessing this liberty-right or not, the power to license B so that B is not subject to the obligation to forbear taking A's life. I would argue that while in certain cases A may be able to give B a liberty-right to do, or omit x, he cannot give *his own* liberty-right since the latter includes an essential reference to his own act or omission. If one is to insist on speaking strictly, one should not allow that liberty-rights can be transferred.[13]

At any rate, in a transfer of right Hobbes does not think that the right which one party gives up is the right which the other receives. But placing the transaction at the bridge between the state of nature and civil society he argues:

> For he that renounceth, or passeth away his right, giveth not to any other man a right which he had not before; because there is nothing to which every man had not right by nature: but only standeth out of his way, that he may enjoy his own original right, without hindrance from him; not without hindrance from another. So that the effect which redoundeth to one man, by another man's defect of right, is but so much diminution of impediments to the use of his own right original (LEV XIV, 85–86 (190–191), EW III, 118).

Here there can be no question of the other man's acquiring the liberty-right formerly enjoyed by the first man. The other man already enjoyed the corresponding liberty-right since in the state of nature he had all liberty-rights, the liberty-right to do or omit all things. But this is something of a red-herring

since Hobbes's subsequent explanation affords no grounds for thinking that the other would receive a corresponding liberty-right if he had not formerly possessed it.

Hobbes's story is that given a situation where all men have all liberty-rights, where both *A* and *B* have the liberty-rights to do *x* as well as to interfere with each other's attempts to do *x*, then, whether *A* gives up the liberty-right to do *x* or the liberty-right to hinder *B*'s attempts to do *x*, the effect in either case is "diminution of impediments" to *B*'s use of his own liberty-right to do *x*. Hobbes may have in mind the case of the liberty-right to hinder being given up but it is clear that "diminution of impediments" might occur if the liberty given up was, say, the taking or using of some scarce resource.[14]

But in wriggling out of the implications of his term 'transfer of right', Hobbes is rather untypically guilty of the slip of confusing non-normative effects which are merely probable and necessary normative effects. Diminution of impediments will follow only if *A* no longer does what he has given up the liberty-right to do. Indeed, this will not necessarily follow even if *A* is conscientious; no diminution of impediments will occur if *A* had never previously exercised the liberty-right which he later gave up. The necessary effect, as Hobbes almost immediately makes clear, is that *A* "*ought*, and it is his DUTY, not to make void that voluntary act of his own: and that such hindrance is INJUSTICE, and INJURY, as being *sine jure*; the right being renounced or transferred" (LEV XIV, 86 (191), EW III, 119).

It is interesting that Hobbes succeeds in avoiding the error in the passage at DE CIVE II, 4 where the gyrations required to deny the implications of 'transfer' result in quite contorted syntax:

> But that the conveyance of right consists merely in not resisting, is understood by this, that before it was conveyed, he [*B*] to whom he [*A*] conveyed it, had even then also a right to all, whence he [*A*] could not give any new right: but the resisting right he [*A*] had, before he [*A*] gave it, by reason thereof the other [*B*] could not freely enjoy his [*B*'s] rights, is utterly abolished. Whosoever therefore acquires some right in the natural state of men,

he only procures himself security, and freedom from just molestation in the enjoyment of his primitive right: [the annotation which I have supplied, is *A* for the *obliged*, and *B* for the *obliger*].

Lest anyone think the English of this argues for the thesis that the English text which we have of *De Cive* is not a translation by Hobbes's hand from the Latin original, it can be pointed out that the original which is written in a language rich in resources for distinguishing separate third-person singulars, has *alter* and *is* referring to the same person while the subject changes at *potuit* without the least indication.[15]

But where the *De Cive* passage is much superior to its *Leviathan* counterpart is in its insistence that the effect of the 'transfer of right' to the obliger is the latter's freedom from *just* molestation. The necessary effect is the normative one consisting in what we would describe as *B*'s right correlative to obligation that *A* should not do what *A* formerly had the liberty-right to do. What is given up is a liberty-right and what the other party acquires is a right correlative to obligation.

Why did Hobbes choose to describe this procedure as a 'transfer to' another party rather than simply talking of the 'divesting of right'? The latter way of talking would be perspicuous enough once one attended to his definitions which make it clear that the right in question is a liberty-right. The reason seems to be his wish to distinguish varieties of such divesting. Hobbes wished to distinguish the procedure he called renunciation from the procedure of transfer. In the former, *A* gives up his liberty-right using a form of words which makes it clear that he wills anyone who accepts to have it as his due that *A* should no longer do what he has renounced the liberty-right to do. In the case of 'transfer', *A* makes it clear that it is a designated party and only that designated party who is to have it as his due that *A* should act in a certain way. Just as a promise can be made to you and not to me, someone can make a 'transfer' to you and not to me. This is the force of 'to' in Hobbes's talk of 'transfer to'. Hobbes explains the situation particularly clearly in *The Elements of Law* I, XV, 4 where he explains that if I signify my will to make a 'transfer' to you and you do not accept it,

my liberty-right remains. It does not follow in such a case that I have divested myself of my liberty-right, and 'transferred' it to anyone who wishes this. My offer was to bind myself by an obligation owed to you; it was not my will to undertake the obligation to anyone else.

What exactly does B accept when A 'transfers a right' to him? Although Hobbes's 'transfer' conception leads him to write in a way which suggests that it is A's liberty-right which is accepted, this suggestion must be rejected. Despite the following sort of passage, Hobbes's insistence that the 'transfer of right' involved in promises, covenants and contracts requires acceptance is not the insistence that something be received:

> The way by which a man either simply renounceth, or transferreth his right, is a declaration, or signification, by some voluntary and sufficient sign, or signs, that he doth so renounce, or transfer; or hath so renounced, or transferred the same, to him that accepteth it (LEV XIV, 86 (191), EW III, 119).

Here, it is most natural to take the "it" which is accepted as being the liberty-right in question. But we have seen that Hobbes himself disallows that the accepting party receives this liberty-right. One gets better sense if one reads "it" as referring to the declaration or signification. Hobbes's sentences which have the "conveyance" or "translation" being accepted, may be slightly more helpful in indicating that we should understand Hobbes to be talking about accepting not in the sense of receiving but in the sense of agreeing or consenting.[16] Indeed, if we are to get behind not only the false implications of Hobbes's terminology but also the idea that 'liberty-right' in virtue of being a noun must name a thing, we should be prepared to think in terms of accepting *that* such-and-such is the case rather than of accepting an object or thing. Hobbes, I take it, would regard what we describe as B's accepting or rejecting a promise made to him by A, as precisely the accepting or rejecting of the special kind of the laying down of the liberty-right involved, the kind which determines that the obligation is undertaken to this particular designated party, B. According to Hobbes, the way for A to do this is for A to reveal his will to B as being the will to lay down his liberty-right so as to be under the obligation in

question to *B*. The will must be revealed to *B* and it must be made clear to *B* that it is an obligation to him and not to others which *A* is offering to impose on himself. The spoken or written word is the most likely medium but the essential point for Hobbes is that there should be a "sufficient signification" of *A*'s will. However, for this signification to have the intended normative consequences, there must be from *B* a "sufficient signification of his acceptance thereof" (EL I, XV, 4). As I understand this, *B* must show that he accepts that *A* has placed himself under this obligation to him. This, of course, may involve very little. As Hobbes argues: "Silence in them that think it will be so taken, is a sign of consent; for so little labour being required to say No, it is to be presumed, that in this case he that saith it not, consenteth" (EL I, XIII, 11).

The person to whom the 'transfer' is made need not of course be the person whose material interests are involved in the performance or violation of the obligation in question. It is the will of the person giving up the liberty-right which is crucial. Thus the servant who makes a covenant with his master to deliver a sum of money to a third-party is making the 'transfer' to his master. If the servant does not deliver the money, then this is the not infrequent case of injury and damage being disjoined. Since the 'transfer' was to the master and no other, he alone suffers the injury.[17] Hobbes confesses that he sees nothing reprehensible in the servant's replying "what art thou to me?" should the third-party complain to him. To discover why there would be something reprehensible in a subject in a Hobbesian commonwealth flouting the sovereign in just this way, it is necessary to take this basic idea of a 'transfer of right' which Hobbes uses to analyse contracts, covenants, promises and donations and apply it in the particular synthesis which is the political contract described in chapters XVII and XVIII of *Leviathan*.

D. *The Political Contract*

(i) *The Leviathan Chapter XVII Version*: Hobbes gives two descriptions in *Leviathan* of the procedure required to institute a commonwealth. The first description is the one which comes towards the end of chapter XVII where the commonwealth is made:

> . . . by covenant of every man with every man, in such manner, as if every man should say to every man, *I authorize and give up my right of governing myself, to this man, or to this assembly of men, on this condition, that thou give up thy right to him, and authorize all his actions in like manner.*

Of course, if *A* and *B* are actually to make this mutual covenant they would not say "to this man, or to this assembly of men". They are not attempting to authorise, at one and the same time, a monarch *and* an aristocratic or democratic assembly as sovereign. For the purposes of examination let it be "this man", *X*, whom they authorise.

Initially, let us consider *A*'s utterance as if it were not part of a contract with *B*. If we ignore for a moment the problem of validating conditions, the possibility of *A*'s authorisation being void because of the irrationality of his binding himself when others do not, what would be the effect of *A*'s saying "I authorise and give up my right of governing myself to this man, *X*"? Clearly, at least one 'transfer of right' is involved here, since if *X* consents, *A* has given up his liberty-right to govern himself in such a way as to impose on himself the obligation to *X* not to govern himself. In contemporary terms, *X* acquires the right correlative to obligation that *A* should forbear to govern himself; or, in Hobbes's language, *X* merits this or has it as his due. But while this is an analysis of *A*'s "I give up my right of governing myself to this man *X*", it leaves his "I authorise *X*" unaccounted for.

Attention to the text reveals that 'authorisation of the sovereign' is something of a portmanteau expression for the 'transfer' of a particular set of liberties, but the key one is the one which chapter XVI makes standard for all authorisations, namely, the liberty-right of forbearing to own or acknowledge the actor's acts as one's own. The artificial person, the *civitas*, is made what Hobbes calls a real unity by having all its actions owned. Thus *A*'s declaration of will, given *X*'s consent, has the effect of *X*'s having the rights correlative to obligation both that *A* own *X*'s actions and that *A* forbear governing himself. Hobbes proceeds to reveal that other liberty-rights have been included in the 'transfer'. The authorisation includes subjects giving up their freedom to

disobey the sovereign, to challenge his judgment of what is necessary for the common peace and safety, to refuse him the use of their strength and faculties, to defend another against the sovereign or to forbear to assist the sovereign in punishing another if required to do so. Hobbes's strategy is to decide which obligations subjects must owe to their sovereign if peace and stability are to be secured in the commonwealth from all except external violence. Since this is the aim or end of the parties to the authorisation, he builds the giving up of the relevant liberty-rights into the authorisation. When Hobbes discusses the liberties which remain to subjects in a commonwealth he begins by subtracting those which are inferred from the "the express words, *I authorize all his actions,* . . . or others equivalent; or else from the end of the institution of sovereignty" (LEV XXI, 141 (268), EW III, 203). But the business of giving an exhaustive list of these liberty-rights should not obscure the point that the authorisation of the sovereign consists in the 'transfer of rights' to the sovereign by the prospective subjects. Since these 'transfers', from *A* to *X* in our example, must not be confused with another set, it might be useful to follow one of Hobbes's suggestions in calling them the *donational* 'transfers'. They are unilateral 'transfers' to the sovereign and are of the covenant type since *A* has to be trusted to behave in certain ways in the future.

If *B* were, quite independently of *A*'s declaration, to utter the same form of words, then *B* would have made corresponding 'transfers' to *X*, binding himself by obligations owed to *X* to acknowledge from then on *X*'s acts as his own, and forbear governing himself. But as Hobbes presents the political contract, *A* and *B* do not make isolated declarations. The political contract consists in the series of mutual covenants *A* with *B*, *A* with *C*, *A* with *D*, and so on, to yield the "every man with every man" situation, where for example:

A says to *B*: "I (*A*) authorise and give up my liberty-right of governing myself to this man (*X*) on condition that you (*B*) give up your liberty-right to *X* and authorise him in like manner."

B replies: "I (*B*) authorise and give up my liberty-right of governing myself to this man (*X*)."

It is evident straightaway that if B did not make this reply, then A's declaration would not authorise X. But if B does make this reply authorising X, he fulfils the condition included in A's declaration so that A has authorised X as well. It is not the case that after B's reply, both A and B have then to set about authorising the sovereign. When linked in the ingenious way Hobbes proposes, the declarations of A and B have the effect of authorising X just as the isolated declarations envisaged earlier would have had this effect; but neither party risks the situation where one binds himself without the other doing so. The sovereign is authorised simultaneously by both parties at the moment B replies "I (B) authorise X".

Since A's declaration and B's reply consist of an offer and acceptance which amount to contract between them, 'transfers' of liberty-rights from A to B and B to A are involved. To distinguish these from A's and B's *donational* 'transfers' to X, let us call them the *contractual* transfers. In saying what he does, A makes clear to B that his will is to be under an obligation owed to B to acknowledge X's acts as his own, provided B will place himself under the corresponding obligation to A concerning acknowledging X's acts. In the case of this mutual 'transfer' between A and B, X is merely a designated third-party. And since the obligations A and B owe to each other cover future acts of acknowledgement, the 'transfers' are, as Hobbes describes them, mutual covenants one with another.

By using this form of words with this special link, both A and B reveal their wills whereby they each make the *donational* and *contractual* transfers. Thus if A subsequently refuses to acknowledge one of X's acts, he will injure X in virtue of his *donational* 'transfer' and injure B in virtue of his *contractual* 'transfer'.[18] Whether either or both suffer damage will depend on contingent circumstances.

This analysis, then, accounts for the double tie of obligation to prince and fellow-subject which Hobbes outlines at DE CIVE VI, 20 and repeats at LEV XVIII, 114 (229), EW III, 160. Further, it yields the solution to the Warrender problem by showing how the sovereign without being a covenanting party acquires rights correlative to the obligations to him which his subjects impose on themselves as parties to the political contract.

(ii) *The Leviathan Chapter XVIII Version*: Chapter XVIII of *Leviathan* opens with the following description of the act of instituting a commonwealth:

> A *commonwealth* is said to be *instituted*, when a *multitude* of men do agree, and *covenant, every one, with every one*, that to whatsoever *man*, or *assembly of men*, shall be given by the major part, the *right* to *present* the person of them all, that is to say, to be their *representative;* every one, as well he that *voted for it*, as he that *voted against it*, shall *authorize* all the actions and judgments, of that man, or assembly of men, in the same manner, as if they were his own, . . .

At least two recent commentators have described it as 'unfortunate' that Hobbes should give this second description since they believe it to be inconsistent with the chapter XVII version, and one of them, M. M. Goldsmith, has advanced the view that the chapter XVIII version contains 'a legacy by oversight' of Hobbes's doctrine presented in *The Elements of Law*, but abandoned in *Leviathan*, that a democratic commonwealth must be instituted before either of the other two forms can be instituted.[19] This is not the place for a detailed examination of what I take to be a mistaken interpretation. However, the existence of such an interpretation obliges anyone who offers an analysis of the political contract in *Leviathan* to show that the analysis fits both the versions Hobbes offers.

The essential difference between the two versions is that while the chapter XVII version requires prior consensus regarding the identity of the man or assembly to be made sovereign, the chapter XVIII version does not. Parties to the chapter XVII contract have to name "this man, or this assembly of men", while the chapter XVIII version is designed to do away with the need for this. It succeeds by being based on the 'propounding prizes' model which Hobbes explains in chapter XIV. If *A* undertakes to give a prize to the winner of a proposed race and the athletes agree to run, *A* has there and then given up his liberty-right to withhold that prize. The 'transfer' is made, "though it be not determined to whom, but by the event of the contention" (LEV XIV, 89

(195), EW III, 123). Before the race, no one is picked out by the expression "the winner of the race". But when X wins the race and is picked out by the description, he immediately has the right correlative to obligation that A give him the prize.

The description in the chapter XVIII contract which parallels "the winner of the race" is "whatsoever man, or assembly of men, shall be given by the major part, the right to bear the person of them all, that is to say, to be their representative". The following form of words would meet the requirements of parties contracting in the chapter XVIII manner:

A declares to B: "I (A) authorise whosoever receives the vote of the majority, upon condition that you do likewise"

B replies: "I (B) authorise whosoever receives the vote of the majority."

Here, A and B have actually authorised "whosoever receives the vote of the majority". Once "every one" has so covenanted with "every one", each has a vote. These votes, unless there is a tie, will produce a determinate man or assembly to fit the description in the covenants. If the majority vote for a democratic sovereign assembly, an assembly of a narrower composition, or a particular man, then that determinate assembly or man has been authorised by every party to the contract whether he abstained from the voting or voted for or against the determinate assembly or man who does receive the majority of the votes. Since Hobbes is at such pains to stress that the chapter XVIII version provides for the unanimous authorisation of the sovereign by every party to the contract, it is unwise to follow McNeilly in labelling the chapter XVII and chapter XVIII versions respectively as the *unanimity formula* and the *majority formula*.[20] The sovereign is authorised by the *donational* 'transfers' of each party. The voting is not the authorisation. Voting is simply the device to settle who or what is to satisfy the description "whatsoever man . . . *etc.*" which is the description each party to the contract employs in the *donational* and *contractual* transfers embodied in the chapter XVIII contract.

If this analysis is correct, we must reject Goldsmith's view

that the chapter XVIII version does away with the need for unanimous authorisation.[21] We should also reject his 'legacy by oversight' view, since the chapter XVIII contract is similar to the Chapter XVII version in providing for the immediate institution of any one of the three possible sovereigns, a democratic or aristocratic assembly, or a monarch.

(iii) *Sovereignty by Acquisition*: The commonwealth by acquisition does not rest on the mutual covenants of prospective subjects, one with another. The victor already has power in the sense of strength; what remains is that he should be given *right*. This is done "when men singly, or many together by plurality of voices, for fear of death, or bonds, do authorize all the actions of that man, or assembly, that hath their lives and liberty in his power" (LEV XX, 129 (251-252), EW III, 185). There is no suggestion in this of a contract between the vanquished pair, *A* and *B*. It seems that *A* and *B* independently authorise *X* whether they do so together or in turn. They make the *donational* 'transfers', each giving up his liberty-right to forbear acknowledging *X*'s acts as his own *etc.*, placing themselves under obligations owed to *X* who acquires the rights correlative to these obligations. However, there are no *contractual* transfers between *A* and *B*, nor between *A* and *X* since Hobbes explains that *X* does not covenant to spare *A*'s life upon condition of *A*'s authorising him.

Hobbes's claim that the "rights and consequences of sovereignty, are the same in both" instituted and acquired commonwealths is strictly correct in so far as the sovereign's rights in both sorts of commonwealth come from the same *donational* transfers from prospective subjects to their prospective sovereign. However, subjects in an acquired commonwealth do not have rights correlative to obligations they owe to each other *with respect to* the sovereign.

My conclusion is that Hobbes's express claim at LEV XVIII, 113 (229), EW III, 159 to the effect that it is from the contract to institute a commonwealth that all the sovereign's rights correlative to obligation are derived, is justified by an examination of the political contract in terms of Hobbes's own analysis of contracts in general. Whether they are embodied in a contract, as in an instituted commonwealth where

the contract serves both as a *pactum unionis* and a *pactum subjectionis*, or independent of any contract, the *donational* 'transfers' to the sovereign give him the rights of sovereignty which are correlative to obligations on his subjects from which they cannot release themselves since these are obligations owed to the sovereign. This is the solution to the Warrender problem of how the sovereign can acquire rights against his subjects without being a covenanting party or a party to a contract with them.

NOTES

Passages from Hobbes's works are taken from the following editions: *The Elements of Law Natural and Politic*, edited by F. Tönnies. 2nd edn., 1969 (cited as EL by part, chapter and section); *De Cive or The Citizen*, edited by S. P. Lamprecht (cited as DE CIVE by chapter and section); and *Leviathan*, edited by M. Oakeshott. Unfortunately, the last two editions are no longer in print. In view of this I have supplied additional references for passages in *Leviathan*. Thus, "LEV XIV, 86 (191), EW III, 118-119" cites a passage found on p. 86 of Oakeshott's edition, p. 191 of Macpherson's *Pelican* edition, and pp. 118-119 of vol. III of Molesworth's edition of Hobbes's English Works.

[1] I gratefully acknowledge the generous assistance I have had from A. G. Wernham and D. D. Raphael. Their suggestions and criticisms have been invaluable in helping me to clarify my ideas on this topic.

[2] H. Warrender, *The Political Philosophy of Hobbes* (Oxford, 1957), esp. pp. 125–140.

[3] *Cf.* LEV XV, 97–98 (207), EW III, 136.

[4] D. P. Gauthier, *The Logic of Leviathan* (Oxford, 1969), p. 159.

[5] Warrender, *op. cit.*, cf. pp. 133, 138, 177, 196 (that for Warrender 'a party to the covenant' = 'a covenanting party', see p. 155).

[6] *Id.*, p. 138.

[7] D. D. Raphael, "Human Rights", *The Aristotelian Society, Supp. Vol.* XXXIX (1965), p. 138.

[8] EL I, XIV, 6.

[9] DE CIVE I, 10.

[10] Latin Works II, 163.

[11] LEV XIV, 86 (191), EW III, 119.

[12] "Whosoever shall contract with one to do or omit somewhat, and shall after contract the contrary with another, he maketh not the former, but the latter contract unlawful. For he hath no longer right to do, or omit aught, who by former contracts hath conveyed it to another" (DE CIVE II, 17). The matter is explained in terms of the possession of the relevant liberty-right.

[13] For the view that while liberty-rights may conceptually admit of delegation, it is an empirical fact that courts tend not to recognise such delegation, see Peter Wallington, "Corporal Punishment in Schools", *Juridical Review* 1972, pp. 124–161.

[14] The liberty-rights in cases of 'transfer' cannot be invariably the liberty-right to hinder. Every contract is a case of mutual 'transfer' but few contracts have hindering as their terms.

[15] Cf. LW II, 171. The opinion held by A. G. Wernham on stylistic grounds that Hobbes did not, as tradition has it, translate DE CIVE into English, which can also be supported by striking instances of mistranslation, has recently received strong bibliographical support following the examination of different copies of the 1651 English edition, sparked off by H. J. H. Drummond's noticing differences between Aberdeen University Library's copy and a recently acquired second copy. The latter includes a dedicatory epistle to Lady Fane by the translator "C.C.". See H. J. H. Drummond's Bibliographical Note in *The Library* (*The Transactions of the Bibliographical Society*), Vol. XXVIII, pp. 54–56.

[16] Cf. DE CIVE II, 12.

[17] This doctrine of 'privity of contract' has been modified in English Law during recent years.

[18] Hobbes confirms this in DE CIVE VII, 14.

[19] Cf. F. S. McNeilly, *The Anatomy of Leviathan* (London, 1968), p. 219 and M. M. Goldsmith, *Hobbes's Science of Politics* (New York and London, 1966) p. 160 (Professor Goldsmith repeats his 'legacy by oversight' view in his new introduction to Tönnies' edition of EL).

[20] McNeilly, *op. cit.*, p. 219.

[21] Goldsmith, *op. cit.*, p. 161.

XIII*—DEMOCRACY, PARADOX AND THE REAL WORLD

by Keith Graham

In an article published in 1962, Richard Wollheim located a difficulty which, he thought, seemed to constitute "a paradox in the very heart of democratic theory" (Wollheim, p. 79). By the end of the same article he had offered a solution to his own difficulty, doubting as he did that anyone would be prepared to admit that democracy really is inconsistent (p. 84). There has been a steady trickle of papers on Wollheim's Paradox ever since it appeared (see bibliography), more or less all of which conform to certain conventions. The pattern is to précis and criticise all previous attempts at resolving the difficulty and then to offer one's own, acceptable and definitive, solution.

In the first two sections I conform to these conventions. In section I, I set out the paradox and discuss other people's attempts to dissolve it, and in section II I offer my own solution (or rather solutions: there are several to choose from). Thereafter, however, I attempt to depart from the established pattern. I believe that previous discussions of Wollheim's Paradox have proceeded on a network of assumptions, about people, philosophy and society, which ought not to go unchallenged. In section III, therefore, I try to dig deeper, and show that the difficulty which has been discussed for the last dozen years is an unreal one. Readers who are more interested in inspecting the destination than travelling hopefully might therefore turn straight to section III.

I

First, the paradox. In what will turn out to be a crucial over-simplification, let us say that a man is a democrat if he believes that the policy which a majority of people vote for

* Meeting of the Aristotelian Society at 5/7, Tavistock Place, London, W.C.1, on Monday, 10th May 1976, at 7.30 p.m.

ought to be enacted. Suppose that on a particular occasion such a man himself votes for policy A and that this is an expression of his belief that

(*1*) A ought to be enacted.

He also believes, as we said, that

(*2*) The policy chosen by the majority ought to be enacted.

But suppose that on this occasion

(*3*) The policy chosen by the majority is policy B.

Then from (*2*) and (*3*) it follows that our democrat believes that

(*4*) B ought to be enacted.

On the face of it, then, he seems to be landed with incompatible beliefs. By virtue of believing (*1*) and (*4*) he believes that two different (and, let us suppose, not jointly realisable) policies ought each to be enacted. It seems that subscription to the democratic principle may preclude holding any more particular views on what policy ought to be enacted, and conversely that anyone who does hold such particular views cannot afford to subscribe to the democratic principle.

How is this difficulty to be resolved? Broadly speaking, there are three possible strategies. The paradox consists in the democrat's holding (*1*) and (*4*). So the problem disappears if we can say *either* that he does not really hold (*1*) *or* that he does not really hold (*4*) *or* that, contrary to appearances, (*1*) and (*4*) are not incompatible. Before considering Wollheim's own solution I examine other people's, and argue that all of them either fall to objections which Wollheim makes or else suffer from some other defect.

The *first strategy*, that of denying that the democrat is committed to (*1*), is adopted by Barry (1965), Honderich and Barry (1973). Dubbing Wollheim's democrat a "majoritarian", Barry (1965) argues that though the majoritarian's position is unacceptable on other grounds, it can be defended against the claim that it involves a paradox. A distinction is drawn between primary wishes, which take no account of anyone else's views, and corrected wishes, which do. The assertion which the majoritarian makes in casting his vote for A is therefore a *qualified* one and not a straightforward wish

for A to be the result (p. 60). If a majority votes for B the majoritarian corrects his view of the desirability of A, relinquishes (I), and there is no paradox.

Honderich (p. 225) explicitly dissociates himself from the view which can fairly be ascribed to Barry, *viz.*, that (I) should be struck out and replaced by a conditional belief, that A ought to be enacted *if a majority is in favour*. Instead he replaces (I) with a more complex judgment, of which the relevant part is the belief that policy A's being enacted with majority support is preferable to policy B's being enacted with majority support (*ibid.*). This is clearly compatible with believing, once the vote is in, that B ought to be enacted, and once again there is no paradox.

Wollheim has a number of objections to the first strategy, at least some of which are valid. If a vote is interpreted as expressing an hypothetical choice, then it is not clear why any authority should be given to the aggregation of the votes as if they had been unconditional. The voter, after all, has merely said what he thinks should be done *under certain conditions*, which may not be fulfilled (p. 81). Worse still, it seems that our voter might now just as well have voted for B in the first place. If he corrects his judgment according to what the majority votes for, then he will believe of any policy—A, B or anything else—that it ought to be enacted if a majority votes for it (p. 82).

These are fair points to make against the first strategy, but the situation is even worse than Wollheim suggests. For a voting process to have any point, it must yield some determinate result; that is, it must result in the truth of some premiss like (3) in the argument set out at the beginning of this section. But if we generalise and construe everyone's vote in the way suggested, no such determinate result is obtained. Since no one expresses a categorical opinion that B (or any other policy) ought to be enacted, an aggregation of the votes will yield only the conclusion that the majority has chosen B-if-a-majority-chooses-it. But then *ex hypothesi* a majority has not chosen it, since no one sticks his neck out and chooses any policy *simpliciter*. We are caught in a vicious 'I-will-if-you-will-so-will-I' circle. This is what is at bottom wrong with these attempts to escape the paradox by way of the first strategy. To have a working democratic system at all, not only

must people's preferences have a certain constancy and not fluctuate merely according to other people's preferences, as Wollheim insists (p. 81); equally, people must express their categorical preferences and vote for a policy on its merits.

This objection applies as much to Honderich's solution as to Barry's, even if Honderich's replacement for (*1*) is not strictly conditional in form. If the voter only expresses a view on *A*-in-certain-circumstances as against *B*-in-certain-circumstances, then we shall never be able to say that a majority has voted for *A* or for *B*. They have simply failed to consider *A* on its own or *B* on its own.

Barry (1973) attempts to meet Wollheim's objections in a way which may be thought sufficient to escape the difficulty I have just raised. His amended suggestion is that we construe the voter as not merely saying "*A* should be enacted if a majority favour it" but rather "*A* should be enacted if a majority favour it, *taking account of my vote in favour of A*" (p. 320). This avoids the objection that he might just as well have voted for *B* if his vote is hypothetical, for he would not be prepared to add the italicised statement in relation to *B*. Equally, it seems that the italicised statement gives us an element we can detach and aggregate, so that we do after all obtain a determinate result. But this is no way out of the original paradox: it just pushes it a stage further back. *Why* does the voter vote for *A*? If he is a Wollheimian democrat, because he believes it ought to be enacted, whether or not it is that belief which is expressed in the act of voting. But that is to reinstate (*1*), and if the commitment to democracy also leads him to embrace (*4*) we are no nearer a solution.

It is time, therefore, to consider the *second strategy*, that of denying that the democrat is committed to (*4*). This is adopted by Barry (1965), Schiller and Pennock. Barry argues that although the majoritarian can escape the paradox by the first strategy his position is an unwelcome one, since it commits him to handing over to the majority decisions about what measures ought to be taken, without any escape clause (p. 61). The alternative position he recommends is to retain the kind of beliefs expressed in (*1*) and to commit oneself to majority voting rather than majoritarianism. The difference is that majority voting "is only an instrument, liable to be aban-

doned whenever it appears that your principles would have more chance of being implemented under a different system" (p. 65). The majority voter may *say* that B, the majority choice, ought to be enacted, but when he does so "he is merely announcing his continued adherence to the democratic decision-rule" (p. 66). If he could get A implemented without adverse effects, he would prefer that to happen (*ibid.*). It is fairly clear that Barry's suggestion relieves the voter of any moral commitment to the majority's choice and hence of the beliefs expressed in (2) and (4). So again the paradox disappears.

Schiller takes a similar line. The democrat, he suggests, is only committed to a decision-procedure (p. 49). He need not believe, as Wollheim's argument implies, that the majority's choice will be the right one, nor will he necessarily be under an obligation to abide by it (p. 51). Once again, then, it looks as though (2) is a mis-expression of the democrat's position. If so, (4) cannot be derived from (2) and (3), and the paradox is dissolved.

Pennock's approach is slightly different. At one point Wollheim had asked how the democrat can accept the majority choice, that B ought to be enacted, when he has already expressed his support for A. Pennock's reply is that he "need not accept it as right, as the best policy; and he presumably would not" (p. 91). But what he must accept is that B is now law, since the majority's voting in favour of it actually constitutes its enactment (p. 90). To put it another way, "The pro-A voter can go on believing that A ought to be enacted right up to the moment that B is enacted. After that he can still believe that A ought to be enacted, although now that belief entails the further belief that B ought to be repealed" (p. 92).

If the second strategy can succeed, it has not been shown that it can in these versions. For the three proponents fail to consider a point made by Wollheim, that the democrat is distinguished precisely by the fact that he accepts this particular decision-procedure *for moral reasons*, and in this he is distinguished for example from a man who merely goes along with majority decisions in order to increase his chances of attaining some other end in the long run (Wollheim, pp. 83–4). Indeed, I should want to strengthen this and say that

even if the man goes along with this procedure for some *moral* end he is not necessarily a democrat, and no more is the man who goes along with the procedure because he thinks that "its utilization will on the whole lead to more preferable consequences than would any alternative way of settling political disputes" (Schiller, p. 49). A democrat is a man who sees majority voting as morally important *in itself*. This is not the same as supposing that the majority will come to the morally right conclusion, or that what the majority decides has an overriding claim to enactment (a point which I enlarge upon in the next section). To the extent that the case for striking out (2) (and therefore (4)) from the argument rests on the assumption that these are the same, it is further weakened.

The *third strategy*, arguing that (1) and (4) are compatible, is adopted by Weiss, Harrison and Wollheim. With the air of believing that you can fight fire with fire and paradox with paradox, Weiss bases his argument on the assumption that the best way of furthering some moral end which I have may be to support states of affairs which are inferior judged by the moral standard embodied in that end (Weiss (a) pp. 164–5). Put less paradoxically, the point is that although the enactment of *A*, considered in itself, may seem to me the morally best course, this may alter when I take account of other people's views in the matter. Hence, I may "believe that policy *A* 'ought to be enacted' in the sense that it is clearly preferable to policy *B* but that under the circumstances—in particular, given the fact of disagreement on what is the best policy—the best possible state of affairs is achieved by having and following the democratic procedure" (p. 166). Weiss is insistent that the commitments expressed in (1) and (4) are both real and both apply to the same situation (Weiss (b) p. 325). But all the same it is difficult to resist the conclusion that his argument collapses into a version of the first strategy (*cf.* Barry 1973, p. 319). For he commits the democrat to the view that *A* ought to *have been* enacted *if* a majority had voted in favour (Weiss (a) p. 169). If this is correct, and Weiss is advocating the deletion of (1), he falls to the objections made earlier against the first strategy.

In contrast, Harrison does insist on retaining both (1) and (4). He argues that the alleged paradox "arises out of purely

general considerations involved in the commitment to moral principles as such" (p. 515). It is simply one of a much larger class of cases where two of my moral beliefs come into conflict because of some further, contingent feature of the world, as when I believe that I ought to save lives and that I ought to keep my promises but in a particular situation saving a life will involve not keeping a promise, and vice versa. Here, too, I may end up believing that I ought to keep my promise and that I ought not to keep my promise, but we do not find the ordinary case of moral conflict so puzzling as to label it a paradox, and our way of dealing with it will be equally available in the case of democracy (pp. 516–7).

There are two difficulties here. One is that it is much clearer that the ordinary moral case is due to the caprice of an unkind world. It just so happens that we occasionally encounter drowning men whilst on our way to keep promised appointments, and we can always do our best to ensure that we avoid such situations or hope that the world will be kinder. But in a system where decisions are recurrently taken on the basis of counting votes, every time the democrat turns out to be on the losing side (and someone has to be) he is faced with the dilemma: the problem is endemic. The second point is that Harrison does not say just how we are to deal with the problem in the ordinary moral case, and this invites the retort that for all that he has shown, it gives rise to the same difficulty and should be called paradoxical itself. He is doubtless right in saying that the practical problem will be overcome by allowing one of the *oughts* to override the other, but that does not show *why* there is nothing wrong in a man's believing that he ought keep his promise and that he ought not to keep his promise. Equally, then, it has not been shown why there is nothing wrong in a democrat's believing both (*1*) and (*4*).

This is the deficiency which Wollheim tries to make good in his own solution. He argues that (*1*) and (*4*) do not conflict because they derive from different types of principle. (*1*) derives from a direct principle, which picks out actions, *etc.*, by means of some general property they possess, (*2*) derives from an oblique principle which picks things out by means of some artificial property such as "what is commanded by the

sovereign"; and we should not regard two judgments as incompatible if they are derived from different types of principle in this way (p. 85). Some critics (*e.g.*, Barry 1965, p. 294, Harrison p. 515) have objected that a pair of judgments like (*1*) and (*4*) must surely be incompatible whatever their origin. But this is a response which Wollheim anticipates, and it depends on a misconstruction of his suggestion, which is effectively that (*1*) and (*4*) differ in meaning because of the different types of reason for espousing them (p. 86). As an example we are given the apparently single judgment "Jews ought to be given privileged treatment", which acquires a different meaning depending on whether it is derived from some principle to do with recompense for the persecuted or from an attitude of Jewish chauvinism (*ibid.*).

But though there could be a difference in meaning in the democrat case, Wollheim fails to show that there is. Indeed, he fails to show that there is in the Jewish example. If we suppose that the two people who make the judgments are claiming that Jews have a *moral right* to privileged treatment (and the example is of no interest in connexion with our own problem unless we do), then it seems on the face of it that their claims do have the same meaning. They are picking out the same object in the world and saying the same thing about it, whatever their reasons for saying it and independently of whether the reasons are good or bad. And nothing has been said to show that things are otherwise in the democrat's case. In the end, he believes the same thing about B as he does about A. The problem, therefore, remains.

II

Although none of the solutions considered so far is successful, almost all of them carry hints which can be used in offering acceptable solutions within the framework of assumptions which their proponents adopt. In the present section I furnish some such solutions.

What is Wollheim's Paradox about? As originally introduced, it concerns the possibility that a democrat is committed to incompatible beliefs (Wollheim pp. 78–9). It may be that that does not exhaust its interest, and that there are

further practical consequences which make the problem a pressing one. That is a question I return to. For the moment, what can we say about the charge that the democrat holds incompatible beliefs?

Consider again the postulated beliefs that

(*1*) *A* ought to be enacted

and

(*4*) *B* ought to be enacted.

Why should we agree that these are incompatible, *i.e.*, that they are reducible to the form '*p* and ~*p*'? Why not regard a man who believes (*1*) and (*4*) as akin to a man who believes that beer is good for you and that chocolate is good for you? The democrat, it might be said, is simply picking out two different policies and ascribing the same predicate to them. And what is wrong with that?

There are two possible answers. The first is to say that all we need add, for the sake of formal tidiness, are the premises

(*5*) *B* = ~*A*

and

(*6*) ~ *A* ought to be enacted.

The paradox then resides in the joint belief in (*1*) and (*6*), and their conjunction clearly does have the form '*p* and ~*p*'. The second reply is that (*1*) and (*4*) are themselves already incompatible. To say that something ought to be done, unlike saying it is good, is to imply that it is in a unique position: it is *the* course to be adopted. And you cannot say that of two different policies.

Both replies can be challenged in such a way as to resist the claim that the democrat holds inconsistent beliefs. It has often been held that belief is referentially opaque (*cf.*, Quine pp. 141*ff*.). I may believe that

(*A*) It would be nice to smoke a cigarette.

Suppose that

(*B*) Smoking a cigarette = Increasing one's chances of dying prematurely.

Then, so it is argued, it cannot be inferred from my belief in (*A*) and (*B*) that I believe that

(*C*) It would be nice to increase one's chances of dying prematurely.

Applying this to our present case, it could then be argued that (*6*) cannot be derived from (*4*) and (*5*): the democrat does not believe that policy *B* ought to be enacted *under the description '∼A'*. Indeed, on this principle it can also be argued that (*4*) cannot be derived, since the democrat does not believe that the majority-chosen policy ought to be enacted under the description '*B*' but only under the description 'majority-chosen policy'. In either case he no longer holds beliefs reducible to '*p* and ∼*p*', and the paradox disappears.

Doubts can be expressed, however, about the view that beliefs are referentially opaque, so it will be as well to look for further solutions. Suppose we allow that (*6*) can be derived. It still does not follow that a belief in (*1*) and (*6*) is a belief of the form '*p* and ∼*p*'. (*6*) is structurally ambiguous, and can be represented as either

(*6′*) ∼(*A* ought to be enacted)

or

(*6″*) (∼*A*) ought to be enacted.

In (*6′*) a policy is picked out by the expression '*A*', a predicate ascribed to it, and the whole of that thought is then negated. In (*6″*) a policy is picked out by the expression '∼*A*' and a predicate is ascribed to it. It is the latter which the democrat believes. He believes of ∼*A*, as he believes of *A*, that it ought to be enacted. And that is not to hold a belief of the form '*p* and ∼*p*'. Compare the case where the pound is in such a bad way that I believe policy *A* will lead to devaluation and also that ∼*A* will lead to devaluation.

This argument would be unsuccessful, however, if the second of the replies mentioned above were correct. If, in saying a policy ought to be enacted, you are saying something which can only be said of one policy, a problem will remain. But this idea itself can be challenged. I have argued elsewhere (Graham pp. 72–3) that moral terms like *right, wrong*

and *ought* can be and are used in two distinct ways. Certainly I can say that you ought not to perform an action where this expresses a decisive moral verdict on that action; but equally I can say that you ought not to perform an action where this is a general, non-conclusive thought, true in virtue of some general characteristic which your contemplated action would possess. Such 'general' and 'decisive' uses of *ought* can then be distinguished by means of subscripts. For example, suppose you are contemplating deceiving someone. This is something which, as an act of deception, you ought$_G$ not to do. Yet it may be that some immeasurably greater evil will result from your not acting in this way, and in that case deceiving someone is, finally, what you ought$_D$ to do.[1] This provides a way out of the paradox because clearly the first kind of *ought*, the general non-decisive one, can apply to more than one course of action in a given situation. It is not contradictory to say that there is something morally to be said for A and also something morally to be said for $\sim A$, and that is what we can represent the democrat as believing. It is therefore possible to agree with the conclusion reached by Harrison and Wollheim; but unlike Harrison I have given a reason for reaching it, and unlike Wollheim's it is a reason based not on an *ad hoc* distinction but on a distinction which there are independent grounds for making.

It might be objected that this is to seek a solution in "arcane doctrines about the language of morality" (Honderich p. 222). To meet such an objection I offer one further solution of a different kind. We saw in section I the argument that a genuine democrat must hold a specifically moral attitude towards the majority-chosen policy. The same is not true, however, of the attitude which is expressed in his own vote for A, *i.e.*, premiss (I). This may be an expression of what he *wants* without its casting him in a morally dubious light. One good reason for believing that the majority choice ought to be enacted is that it is only fair for each person's wants to be taken into account in making decisions of social policy. For anyone who believed this it would be inconsistent not to put his own want into the sum which is thus arrived at; his moral belief in democracy does not require him to make an exception in his own disfavour. If a genuine

democrat can think in this way, then (I) will be a misrepresentation of what is expressed in his vote. It must be replaced by

(I') I want A to be enacted

and once again we have lost any belief of the form 'p and $\sim p$'.

I have now offered four solutions to Wollheim's Paradox, which between them exemplify each of the three strategies distinguished in section I. We can adopt the first strategy, and argue that the democrat's vote is mis-expressed in (I), since he votes for what he wants. We can adopt the second strategy by arguing that the referential opacity of belief prevents the derivation of (4) from (2) and (3). And we can adopt the third strategy by arguing that (I) and (4) are not contradictories, a claim which we can support either by a theory about their structure or by a theory about the nature of the terms which provide their content.

Someone might now object that an air of unreality clings to my discussion, and suggest as the reason for this the narrow way of construing the paradox which has persisted throughout this section. Surely we feel it presents a problem in virtue of its practical consequences, because of the choices confronting the democrat in the real world when he comes to act? And the various formalistic devices offered by way of resolution do nothing to help us with that kind of problem.

I have some sympathy with an objection brought on the grounds of lack of practical applicability. But I suggest that we now train it not on my solutions but on the problem itself. It will prove to be an interesting case of *sauter pour mieux reculer*. In the next section I shall argue that, judged from the standpoint of practical application, Wollheim's Paradox sets an unreal problem. In this way I hope to undermine the idea that any importance attaches to the arguments of the present section or to any previous contribution to this debate. I now proceed with that immodestly modest aim.

III

Wollheim's democrat believes that the policy he votes for and also the policy the majority votes for ought to be enacted. If this is a dilemma at all, is it one with any practical conse-

quences? Does it give anyone a headache about what to do in a real political situation? There is room for doubt whether Wollheim himself thinks so. On the one hand he says, gnomically, that any justification of democracy will relate to some ideal construction.[2] On the other hand he and other contributors make assumptions about the real world in order to advance their argument, notably about the attitude which voters have towards their own voting. For example, Wollheim speculates that the votes of "the ordinary citizen" are more likely to reflect what he thinks ought to be done than what he himself wants to be done (p. 79). Why? Because he is more likely to know the first thing than the second (*ibid.*). Now I see no particular reason to agree that a man's knowledge of his moral convictions is more secure than his knowledge of his own wants, but even if that were so it would not support Wollheim's speculation about the voter's attitude. A citizen impressed by the last solution which I offered in section II might reason as follows: "I am sure about my moral evaluations, less sure about my wants. All the same, since it is so important for social policy to accord as far as possible with the majority's wants I shall vote for what I think I want." Of course, to say that the "the ordinary citizen" does reason in this way is merely to offer counter-speculation. The obvious way to settle the matter would be to ask the voters, but I know of no political sociologist who has done so.

Further assumptions are made about the things which people do or do not call "democratic". According to Wollheim, we call legislation democratic if it conforms to what the majority would like and is enacted for that reason (p. 74). Pennock objects to this that the British Parliament and U.S. Congress pass laws which the majority of the populace is known not to favour but "I doubt if in such instances most people would call the result 'undemocratic' " (p. 90). Does it matter which of them is right? Only if we make the further, philosophical assumption that we can decide what is democratic by seeing what people call democratic. And that is an assumption which should be rejected. What matters is not that people use the word 'democratic' in a certain way but what their reasons are and whether they are good reasons. What matters, in short, is how people *ought* to use the word. That

depends on what is bound up in the idea of democracy, and it should be uncovered by a philosophichal analysis of the concept. We need an explanation and a justification for the use of the concept, one which outlines the common features of the situations where it is proper to speak of democracy, and the point, purpose or interest we have in so speaking. That is, it will give the facts about the world and the facts about us which are reasons for our speaking of democratic procedures, *etc.* An analysis of this kind is not provided by informed guesses about where people call a procedure democratic or by picking out superficial recurrent features in those situations where they so speak. On the contrary, a successful analysis may itself imply criticism of the way people do as a matter of fact use some term.[3]

Bearing these points in mind, I think it can be seen by even a rudimentary analysis that if people call legislation democratic where it conforms to Wollheim's two conditions, they ought not to do so. Imagine a society where the majority's wish is enacted because it is the majority's wish, but where a cynical ruling group keeps the majority in ignorance about the total range of possibilities, or where the majority's wishes are manipulated by morally dubious techniques of persuasion. The presence of these countervailing conditions would make it wrong to speak of such legislation as democratic even though it met Wollheim's conditions. Why? Because, as Pennock points out (p. 89), democracy connects with the ideas of equality and liberty. The point of the concept of democracy is not merely to mark off decision-procedures of a given kind, but to mark them off because they realise certain values to do with human dignity and the idea of being master of one's own fate. Where a decision-procedure shares certain formal features of a democratic procedure, but in conditions which inhibit the realisation of these values, it is a misuse of the concept of democracy to call it democratic.

The fulfilment of Wollheim's conditions, then, is not sufficient for democracy to be in operation. Is it also, as Pennock in effect argues, not necessary? Consider those cases where a government acts against the known wishes of its electorate. In what way are they a realisation of the ideals of liberty and equality, and an example of our being masters of our own

fate? It might be answered that we are talking now of forms of social organisation which realise these values at an earlier stage, *viz.*, the election of representatives, and which for that reason deserve to be called democratic. All are on an equal footing at the stage of putting themselves forward as representatives and electing others to the office, and some exercise the liberty to relinquish any direct control over legislation thereafter. In that case we should have to see that certain other conditions were fulfilled, in much the same way as Wollheim's conditions needed supplementation. Imagine that a man's chances of being elected as a representative depend on his finding favour with one of a small number of large organised political parties or with the only legally permitted party; or that a man is unable to reach a significant number of electors without large reserves of personal wealth. In such circumstances it will not be true to say that all are on an equal footing at the stage of electing representatives. A famous judge once said that British justice is open to everyone—like the Ritz. For the election of representatives to be democratic, it must be genuinely open to anyone to become a representative, not just open in the formal, Ritzian sense (*cf.* Pateman p. 21). Already, then, a consideration of the idea of democracy has begun to sprout consequences. For a start, it looks as though inequalities of wealth and of access to the mass media are incompatible with its realisation.[4]

But this still leaves the main question unanswered. Suppose that social conditions were very different and that all citizens did have an equal chance of election as representatives. What if those elected then went against the known wishes of the majority? Here we should recall Wollheim's remarks that "to the modern mind Democracy is opposed to all forms of sectional government" (p. 72) and that democracy requires that the people should rule in the sense of choosing or controlling legislation (p. 73). In the situations of which Pennock speaks these conditions are not met, and we could conclude that they are only by a logical error—that of taking an intransitive relation to be a transitive one. If we (the entire populace) choose the legislators and the legislators choose the legislation, it by no means follows that we (the entire populace) choose the legislation. And it not only does not follow, it is not true that

we have chosen the legislation if our known wishes are
ignored.

What is beginning to emerge is a tension between the idea
of democracy and the idea of representation. Let us consider
it more directly. There is much morally to be said for a form
of social organisation in which everyone has an equal say in
matters affecting them. The most natural way of realising
this would be for each person to have one vote on any parti-
cular issue, for the governing body to be identical with the
citizen body, in Wollheim's phrase (p. 72). Why does this not
happen in any of the different countries called democratic?
Why do all such countries have a "government" composed of
a small, indeed tiny, proportion of the populace? Two consid-
erations mentioned by Wollheim are that the populace as a
whole is both too numerous and too diverse to rule effectively
(*ibid.*).

Both of these supposed obstacles to direct democracy should
be challenged. As regards number, direct democracy does not
require that everyone meet in assembly, only that everyone
be consulted on issues affecting them. With modern means of
mass communication and electronic techniques of data collec-
tion and processing, it is a mistake to suppose that such uni-
versal consultation of a large populace is impossible. Now it
might be said that such a procedure is not impossible, but is
prohibitively expensive. (People argue against the frequent
use of referenda on those grounds.) But this is a different and,
it seems to me, highly disreputable argument. If we have any
serious regard for the value of democracy then we ought to be
prepared to expend resources on it. A society which prefers
to allocate resources to the pomp of Government, and to
royalty, presidency or members of the inner caucus of the
Party, has failed to take democracy seriously enough.

As for diversity, it does not call for, and is unaffected by,
a switch from a direct to a representative method of legisla-
tion. Wollheim says that the people's ruling in the strong
sense of devising or initiating legislation requires that *every-
one* assent to the legislation (*ibid.*). But why should any more
than a majority be required? (We always decide collectively
which bar to drink in, and we do so democratically even
though I sometimes dissent from the choice, because we all

have an equal say.) In any case, if it were said that the whole people does not rule in the strong sense in the event of there being some dissenters, the same would be true of the whole people's ruling in the weakened sense in the event of there being some dissenters, whether amongst government or governed. If direct democracy is to be rejected, then, it must be for other reasons than these.[5]

IV

My conclusion is that Wollheim's Paradox is not a problem for political agents in the real world, because the social conditions in which it is imagined to arise do not exist. More briefly, there is no democracy. All contributors to the debate have assumed that there is. With the exception of Wollheim and Pennock, they have paid little attention to the idea of democracy, and even less to what is merely an aspect of the same thing, a consideration of the relation between the concept of democracy and existing political reality.[6] Had they done so, the results might have been different.

Now at this point it would be possible to raise a fresh complaint against me. Surely I am implicitly recommending the establishment of conditions in which Wollheim's democrat *would* face practical problems? And surely I have not met the criticism voiced at the end of section II, that my formal solutions do nothing to help with it?

This is true, of course. Let us be clear on what that practical problem would be in such a world. The democrat would not be caught in any kind of contradiction, but whichever of my solutions is adopted, he would be in the position of seeing that there are reasons (of some kind) for two conflicting courses of action and he would have to weigh those reasons against each other. The democratic choice would weigh heavily, because of the immense importance of people's controlling the conditions of their own existence; but it is possible for it to clash with some other project legitimately held to be important. The problem then is the general one of balancing competing considerations in a rational way (*cf.* Graham p. 78). To that problem I have no answer, and I suspect it is probably futile to consider it just in the abstract, in terms of A's and B's. But I suggest we should move with

haste to the situation where the luxury of its arising is a real possibility.

One final point. In my remarks I have adumbrated, in the most skeletal way, an ideal of direct democracy, where this means roughly a system of social organisation where all people have (in a substantial and not just a formal sense) a free and equal say in matters affecting them. That ideal is in dire need of elaboration and defence against many possible objections. But when I say that it is an ideal I mean only that it is a conception which we should develop and use to measure the acceptability of existing social arrangements. I should not agree that it is an ideal in the sense of being an unrealisable goal. We should not equate being unrealisable with being realisable only through a process of fundamental changes in all existing societies. Fundamental change may be the logical consequence of taking certain ideas seriously.

NOTES

[1] This is distinct from a theory of *prima facie* obligation in that statements containing *ought$_G$* are not eliminated from the picture. *Cf.* Williams pp. 113-115.

[2] Does that mean that it is not possible to justify what exists, but only what should exist?

[3] For a more detailed argument, *cf.* my *J. L. Austin*, chapter II (forthcoming).

[4] "It is easy for the uninvolved to sneer at or deplore forms which minorities' propaganda is forced to take—words painted on walls, fly-posting, the duplicated leaflets, the patient man on the corner with his papers for sale. The large organizations can buy (and accordingly are given) the dignified facilities. To a small one, a puny amount of publicity can be critically expensive, and the principal means for it are closed anyway; the rare chance of a minute with a television interviewer in an election is wildly exciting." Robert Barltrop, *The Monument*, Pluto Press, 1975.

[5] A thought often found lurking just below the surface is that the populace is too wicked or too silly to be trusted with decisions. (Two examples raised in a discussion of an earlier draft of this paper were where the majority votes (i) to kill all red-haired people and (ii) to ban circumcision.) It is perfectly possible, of course, for majority decisions to be bad ones. But why suppose that when taken in the circumstances outlined they would be any worse than those taken by a small group of people who have actively sought the power, authority and privilege which political office confers? And whom shall we allow to decide that the democratic choice is bad? Do we still believe in philosopher kings?

[6] This is revealed, for example, in the tacit acceptance that what a voter votes for is primarily a policy (rather than a man or a party). One can make that assumption only by taking election promises more seriously than any professional politician does.

[7] There is one misunderstanding which my argument invites and which I should like to forestall. It may seem that I think the strongest reason for advocating the establishment of democracy is that it is morally a good idea. That is not so. Important though that reason is, I believe that certain more basic changes in social existence are imperative (both for moral and for other reasons), and that these changes themselves require the concomitant establishment of direct democracy. But that is something I shall have to argue for elsewhere.

BIBLIOGRAPHY

Barry, B., *Political Argument*, Routledge and Kegan Paul, 1965.

Barry, B., "Comment on Weiss", *Political Theory*, 1973.

Graham, K., "Moral Notions and Moral Misconceptions", *Analysis*, 1975.

Harrison, R., "No Paradox in Democracy", *Political Studies*, 1970.

Honderich, T., "A Difficulty with Democracy", *Philosophy and Public Affairs*, 1974.

Pateman, T., *Language, Truth and Politics*, Stroud and Pateman, 1975.

Pennock, R., "Democracy is *Not* Paradoxical", *Political Theory*, 1974.

Quine, W., *From a Logical Point View*, Harper and Row, 1953.

Schiller, M., "On the Logic of Being a Democrat", *Philosophy*, 1969.

Weiss, D. (a), "Wollheim's Paradox", *Political Theory*, 1973.

Weiss, D. (b), "Rejoinder to Barry", *ibid*.

Williams, B., "Consistency In Ethics", *Proceedings of the Aristotelian Society, Supplementary Volume*, XXXIX, 1965.

Wollheim, R., "A Paradox in the Theory of Democracy", *Philosophy, Politics and Society*, Second Series, eds. P. Laslett and W. G. Runciman, Blackwell, 1962.

XIV*—THE POTENTIAL INFINITE

by W. D. Hart

I

Introduction

Less than a century ago, Richard Dedekind and Georg Cantor brought the actual infinite within the purview of rigorous scientific study. To be sure, for centuries before, mathematicians had studied objects, like natural numbers, of which there are infinitely many. And since the time of Archimedes at least, they had employed notions and principles whose very expression requires the concept of infinity. But Dedekind has priority as one who boldly predicated infinity of objects, now known as sets, and who articulated the distinction between finite and infinite sets: namely, a set is infinite if there exists a one-to-one function mapping the set onto one of its proper subsets, and otherwise it is finite. Thus Dedekind made possible a precise mathematical theory of infinite objects *per se* within the context of a pure and general theory of sets. Cantor discovered and proved many of the basic laws of this theory. In particular a theorem justly named after Cantor implies that for every infinite set, there exists a strictly larger infinite set. (Here "larger" means that while there is a one-to-one function mapping the first set into the second, there is no function mapping the first *onto* the second; this last means that every function mapping the first into the second fails to have some member of the second as a value.) Cantor's theorem thus assures us of the existence of a wealth of infinite sets, each different in its infinite size from all the rest. This result shows that the infinite sets are a rich field for study. That, and the beauty of their laws, explain why David Hilbert spoke of the transfinite objects as Cantor's Paradise. It is the actual infinite that makes set theory a paradise.

All his life Cantor insisted that his was a theory of the actual

*Meeting of the Aristotelian Society at 5/7 Tavistock Place, London, W.C.1, on Monday 24th May 1976, at 7.30 p.m.

infinite, not the potential infinite, and time and again he
urged that the two must not be conflated. The distinction be-
tween the two is of ancient lineage, but it had always been a
philosophical distinction confined by mathematicians to their
table talk and their invective. Even as great a path-breaker
as Gauss declared himself against any intrusion by the actual
infinite into mathematics, a declaration of prejudice that
posed a foolish but serious obstacle for Cantor since it came
from so authoritative a source. Cantor's achievement was to
bring the actual infinite out of the philosophical shadows into
the scientific light. Can we do for the potential infinite what
Dedekind and Cantor did for the actual infinite? That is my
topic.

I do not claim to have analysed the potential infinite ade-
quately. Instead, I shall explore two natural approaches to the
topic which have been mentioned in the literature. I reach no
decisive conclusion on the merits of either, but perhaps the
explorations turn up intuitions which are at least candidates
for the eventual material adequacy conditions in terms of
which a genuine analysis of the potential infinite should be
judged. Such, at any rate, is my hope.

But before entering into these two approaches, there is a
prior idea I should mention if only to get it out of the way.
For all I know, the best theory of the potential infinite identi-
fies it with a process in time conceived as a series of moments
isomorphic to the natural numbers. Such a process might (1)
have one input given at moment zero prior to any operation
of the process; (2) for any output the process has actually al-
ready yielded at a moment t, the process can take that and
only that output as an input at the next moment $t + 1$, and;
(3) the process never yields the same output at two different
moments and never destroys its inputs (so that what it once
yields exists ever after). For such a process, there is no mo-
ment at which it can have produced an infinity of outputs,
but no matter how many outputs it has yielded at any given
time, at some later time it can always yield more. Moreover,
if the process were in some radical sense unpredictably cre-
ative, then since except in the first moment it takes only its
own outputs as inputs, it might be reasonable to say that at
no moment could we survey in advance the totality of outputs

it might produce over all time. (This conception may somewhat resemble the intuitionist idea of a free choice sequence.) The trouble with this sketch is that we have no settled theory of processes in which to imbed it, so we have no sharp way to establish whether it satisfies reasonable desiderata for potential infinities. For example, does it presuppose a completed actual infinity of moments? This question is central to an issue raised by a thesis of Cantor's to be stated below. My present point is only that we are after a genuine *theory* of the potential infinite amenable to crisp formulation, rigorous development and decisive judgment. To that end it is highly desirable that any analysis of the potential infinite be posed within the context of some reasonably well established theory.

With an eye then toward theory construction, let us look for guiding intuitions. A crucial question for such intuition is raised by a passage in Cantor's philosophical letters. In May 1886 Cantor wrote:

> One can also demonstrate incontestably the occurrence of the actual infinite and its absolute necessity in analysis as well as in number theory and algebra from another point of view. For since there can be no doubt but what we cannot do without *variable* magnitudes in the sense of the potential infinite, then the necessity for the actual infinite can be proved as follows: In order for such variable magnitudes to be capable of evaluation in a mathematical investigation, the "range" of their variation must be precisely known by means of a prior definition; but this "range" cannot itself be in turn something variable, for otherwise every fixed support for the investigation would give way; hence, this "range" is a definite actually infinite set of values.
>
> Thus every potential infinity, if it is to be employable rigorously in mathematics, presupposes an actual infinity.

Do not be too quick to condemn Cantor with the wisdom of hindsight. He does give an argument in the first paragraph which appears to depend essentially on an analysis of the potential infinite, *viz.*, identifying potential infinities with infinitely variable magnitudes. We all learnt from Frege to treat the notion of a variable magnitude with contempt. Variables

are notations which are assigned varying denotations, often numbers; but numbers could not change into other numbers. The idea of a variable magnitude is a confusion of use and mention. But Cantor also states a thesis in the passage cited above. This thesis has two forms. The (apparently) stronger thesis is that for any predicate F of objects, it is true that

(1) If there are potentially infinitely many F's, then there is an actual infinity of F's.

The (apparently) weaker thesis, is that for every predicate F there is a predicate G such that it is true that

(2) If there are potentially infinitely many F's, then there is an actual infinity of G's.

(My reason for expressing these theses metalinguistically as first-order schemata rather than as closed second-order sentences will emerge later.) Cantor's argument seems to be an argument for the stronger thesis, but the thesis he states at the end of the passage seems to be a version of the weaker thesis. Even if Cantor's argument depends on a faulty analysis of the potential infinite, it still might be the case that his argument can be revised into a correct argument, and more importantly, that one of his theses is true.

The point is that those like Gauss who are subject to an *Horror Infiniti* believe both that there are (or could be) potential infinities but that there aren't (or couldn't be) actual infinities. This is a view of ancient and honourable lineage, but it is also incompatible with either of Cantor's theses. What is the verdict of intuition in this dispute? It seems to me that even if for some predicate F it is true that

(3) There are potentially infinitely many F's

it need not turn out that for some predicate G that it *follows* that

(4) There is an actual infinity of G's

even if for that G, (4) is a necessary truth. What I think I am trying to say is that there should be a way to analyse (3) and (4) such that there is a model (in the technical sense) in which an instance of (3) with a predicate from suitable language

comes out true, but all instances of (4) with such predicates come out false. Depending on how suitable the language is, this would dispose of Cantor's thesis even if the model does not contain all objects which exist necessarily and hence is not a (full) possible world.

But let us stop here to notice an oddity about an intuition of some with the *Horror Infiniti*. Surely something is possible only if it could be actual. There is a considerable temptation to view the potential as a species of the possible. Succumbing to this temptation apparently, one might think that there is a potential infinity of *F*'s only if there could be an actual infinity of *F*'s. But some who hold a version of the intuition I recently endorsed believe that

(5) There are potential infinities but there could not be actual infinities.

What I just now tempted you to think might lead you to hold that those who believe (5) are committed to the absurdity that there are possibilities which cannot be actualized. Now I have an intuition that it should be possible to believe (5) without being committed thereby to this absurdity. So I think that the potential infinite should be analysed in such a way that (5) does not *entail* the existence of unactualizable possibilities, even if that analysis shows that (5) is false. Such reflections lead us to our first approach to the potential infinite.

II

The Potential Infinite and Modality

Succumb again to the view that the potential is a species of the possible. But also start thinking of possibilities through the modish modern picture of possible worlds. If you also have in mind the potential infinite, it will not take too long for you to come to consider a model system for a modal logic containing S4 in which the possible worlds are all finite, but for each world there is one possible relative to it which contains at least one more member. At any rate, Charles Parsons mentions such a structure and it is a natural and beautiful idea. Can we use Parsons's idea to get a grasp on the potential (but not actual) infinite? Suppose Parsons' model structure

were used to interpret a language L in which we can express
(λn) (there are at least n things). More precisely, suppose that
for every natural number n, L has a name \tilde{n} which denotes
n; that L has a special variable "x" ranging over natural num-
bers; and that L also has a predicate "Φ" such that for any
natural number n and any possible world w in the universe
of Parsons' model system.

$\ulcorner\Phi(\tilde{n})\urcorner$ is true at w if and only if there are at least n things
in w. In Parsons' model system, for each world w and num-
ber n, there is a world w^* possible relative ($=$accessible) to w
such that $\ulcorner\Phi(\tilde{n})\urcorner$ is true at w^*. So for each w and n, $\ulcorner\Diamond\Phi(\tilde{n})\urcorner$
is true at w, and thus for each w, $\ulcorner(x)\Diamond\Phi(x)\urcorner$ is true at w. On
the other hand, for each world w and every world w^* accessi-
ble to w there is an n such that $\ulcorner\sim\Phi(\tilde{n})\urcorner$ is true at w^*. So for
each w and each w^* accessible to w, $\ulcorner(\exists x)\sim\Phi(x)\urcorner$ is true at
w^*. Hence for each w, $\ulcorner\Box(\exists x)\sim\Phi(x)\urcorner$ is true at w. Therefore
$\ulcorner\sim\Diamond(x)\Phi(x)\urcorner$ is true at every world w. Thus

(6) $(x)\Diamond\Phi(x)$ & $\sim\Diamond(x)\Phi(x)$

is true at all worlds. Generalizing (6) we might propose

(7) $(n)\Diamond$ (There are at least n F's)
& $\sim\Diamond(n)$ (There are at least n F's)

as an interpretation (in regimented English, not L) of (5).
How good is this proposal? In particular, does it permit us to
deny Cantor's Thesis and (since (7) is a version of (5) appar-
ently) does it commit us to unactualizable possibilities?

Whether it permits us to deny Cantor's Thesis depends in
part on how rich the expressive powers of L are. If in L it is
only possible to express properties P such that whether P
holds of something at a world w depends (intuitively) only on
what's going on in w, then I don't think we can make out
Cantor's Thesis for L. But this restriction is excessive and
contrary to the *raison d'être* of quantified modal logic. In
particular it would prevent us from expressing $(\lambda x)(\Diamond\Phi(x))$
thus blocking the foregoing argument for (6). Intuitively.
then, we have to be able to express properties whose holding
of something at a world w depends on what's going on in
other worlds. The usual explicit apparatus of quantified
modal logic is best suited for expressing properties whose

holding for something at a world depends on the character of single other worlds one by one, not on the character of arbitrary collections of other worlds. But this distinction should seem over-subtle. Why shouldn't L be able to express (λx) (There are at least x objects in all possible worlds together)? That is, suppose L has a predicate "Ψ" such that for all n and w

$\ulcorner \Psi(\tilde{n}) \urcorner$ is true at w

if and only if the total of things in worlds accessible to w is at least n. Then for every w, every w^* accessible to w and every n, $\ulcorner \Psi(\tilde{n}) \urcorner$ is true at w^*. So for each such w and w^*, $\ulcorner (x)\Psi(x) \urcorner$ is true at w^*, and thus $\ulcorner \Box(x)\Psi \urcorner$ is true at w. Or, more simply, why shouldn't we be able to express (λx) (There are at least x possible worlds)? That is, suppose L has a predicate "Ψ_1" such that for each w and n

$\ulcorner \Psi_1(\tilde{n}) \urcorner$ is true at w

precisely in case there are at least n worlds accessible to w. Then as before, for each w, each w^* accessible to w and each n, $\ulcorner \Psi_1(\tilde{n}) \urcorner$ is true at w^*, so $\ulcorner (x)\Psi_1(x) \urcorner$ is true at each w^* accessible to w, so $\ulcorner \Box(x)\Psi_1(x) \urcorner$ is true at every world w. And note too that (6) is true at every w in the universe of Parsons' model system only *because* $\ulcorner \Box(x)\Psi(x) \urcorner$ and $\ulcorner \Box(x)\Psi_1(x) \urcorner$ are true at each w. These considerations seem to support Cantor's Thesis. As it were, Parsons' construction allows for a potential infinity of objects eventually actual in some world or other only because it requires an infinity of possible objects and possible worlds. *If* one is a realist about possible objects or possible worlds (and the objectivity of possibility supports this), *then* Parsons's construction is evidence for the weak version of Cantor's Thesis.

I want to resist taking the potentiality of the potential infinite as the possibility of objects of which there are infinitely many; I do not identify the existence of a potential infinity with the existence of an infinity of possible objects. This does not have anything to do with infinity. I am equally unhappy about construing the possible existence of an object as the existence of a possible object. Now I know of no way to get

a sound and complete possible worlds semantics for a plausible quantified modal logic without interpreting possible existence as the existence of possibilia, so I want to avoid using quantified modal logic if I can. This means that I want to analyse the potential infinite without referring to possibilia. The point is that to treat the potential infinite as an infinity of possible objects seems to amount to affirming the existence of an infinity of possibles while denying that this infinity could be actual. True, in Parsons' model system, each object is eventually actual, but the infinity of them never is, so why isn't that infinity impossible rather than potential? This way of using possibilia is too close to unactualizable possibilities for my comfort. This leads us from possible worlds to our second approach to the potential infinite.

III

The Potential Infinite and Set Theory

But if "There are potentially infinitely many F's" is not of the form "There are infinitely many potential F's" then what is its form? Let us mimic Russell's and Frege's strategy for number and take

(8) There are potentially infinitely many F's

and

(9) There is an actual infinity of F's,

as the basic contexts to be analysed. I want to exploit the suggestive singular verb and indefinite article in (9), and the equally suggestive plural with no article in (8). That is, I want (9) to commit us to the existence of an *object* which is an actual infinity; I do not want (8) to make any such commitment. Nevertheless I also want to treat (8) and (9) along the lines Frege discovered for treating ordinary quantifiers. That is, roughly, both (8) and (9) are of subject-predicate form; both attribute a second-order property (concept) to a first-order property, viz. (λx) (Fx). I shall do this in a set theoretic context.

Since set theory is a well established discipline and since it includes the best going theory of the actual infinite, it is natural to inquire whether an adequate theory of the poten-

tial infinite can be constructed using set theory. Experience argues that among set theories, those intended to describe the cumulative hierarchy of sets are most fitted to survive. A rigorous description of the cumulative hierarchy requires a prior idea of the transfinite ordinals. Assume all the natural numbers, that is, 0, 1, 2 and so forth. Now suppose there is a least number greater than all these. Call it ω; it is the first infinite ordinal. Assume ω has an immediate successor, $\omega + 1$, followed by $\omega + 2$, and so on. After these, we get to $\omega + \omega$, as we first got to ω. After another infinity of successors, we get $\omega \times 3$. Eventually, we get to ω^2, and later to ω^w. There is no evident end to the process; the doctrine of these objects, called ordinal numbers, can be formalized rigorously, and, we hope, consistently. There are three sorts of ordinals. There is a unique ordinal with no predecessor, namely, zero. There are those ordinals, called successor ordinals, which have not only predecessors but also immediate predecessors. And there are those ordinals, like ω, which though they have predecessors, have no immediate predecessors; for example, any ordinal before ω is finite, and there is always a finite number between any given finite number and ω. Ordinals like ω are called limit ordinals. There is a good theory of ordinals to be had because they satisfy a generalization of the principle of mathematical induction for natural numbers. One version of this principle says that whenever the fact that all numbers less than a number k have a property P is sufficient for k to have P as well, then all numbers have P. The generalization of this principle to ordinals goes like this: Suppose P is a property and that for any ordinal α, if all predecessors of α have P, then so does α. Transfinite induction says that it follows that all ordinals have P. This principle should be evident on reflection. It is equivalent to two other principles. According to the first, if zero has a property P, if whenever an ordinal α has P, then so does the successor of α, and if whenever all predecessors of a limit ordinal λ have P, then λ has P too, then it follows that all ordinals have P. (This induction principle corresponds to a principle of definition which generalizes the idea of inductive definitions on natural numbers. We take it that whenever we can specify the value of a function at an ordinal α in terms of its values at predecessors of α,

then we have defined the function at all ordinals; this is called definition by transfinite induction.) The second equivalent of reasoning by transfinite induction can be put like this. Let f be a function from natural numbers to ordinals. Say that f is an infinite descending sequence of ordinals if and only if for any natural numbers n and m, when n is less than m, then the ordinal $f(m)$ precedes $f(n)$. A little scribbling should convince you that the principle of transfinite induction is equivalent to the claim that there are no infinitely descending sequences of ordinals.

The cumulative hierarchy is what you get if you start off with nothing and go on building up longer than for ever. More precisely, let us say that rank zero is the empty set. Suppose we have defined rank α; then let rank $\alpha+1$ be the set of all subsets of rank α, *i.e.*, the power set of rank α. Suppose λ is a limit ordinal and we have defined rank β for all ordinals β which precede λ; then let rank λ be the union of all the ranks β for all β which precede λ. We have now defined rank α for all ordinals α. It is natural to picture the ranks as stages in which we build up sets. It is intended that an object be a set if and only if for some ordinal α, that object is a member of rank α. All such sets constitute the cumulative hierarchy of sets—or at least *pure* sets since we started off with the empty set; there is no problem with starting with a set of non-sets.

By and large, the cumulative hierarchy (or perhaps some initial segment of it) is the subject matter intended by almost all contemporary professional practitioners of set theory. It has an intuitive, non-formal description; formal axiomatizations of set theory are judged by how well they describe the cumulative hierarchy. By this remark, I mean to oppose the view that after the paradoxes, only more or less arbitrary choices can be made between different axiomatizations of set theory. The received axiomatic descriptions of the cumulative hierarchy are, basically, one called Zermelo-Fränkel set theory (ZF) and another called von Neumann-Bernays-Gödel set theory (NBG). It was an important result that in ZF and NBG exactly the same theorems about just sets are provable. For just as the equivalence of quite differently motivated definitions of "effectively calculable function of natural numbers" was rightly taken as evidence that the recursive functions are

a natural class of objects and that Church's Thesis is true, so also the fact that ZF and NBG make just the same claims about sets alone can be viewed as evidence that the sets of the cumulative hierarchy are natural objects and that, as far as they go, ZF and NBG characterize them adequately. (There is another argument for the cumulative hierarchy due to Gödel. According to what is sometimes called the logical conception of sets, for every predicate there exists a set which is the extension of that predicate. Unless we make more or less *ad hoc* restrictions on predicates, this conception is known to issue in contradiction, *viz.*, the paradoxes of set theory. In contrast, the cumulative hierarchy is a natural conception which, in Gödel's words, "has never led to any antinomy whatsoever.")

We need not enter into formal developments of ZF or NBG. With our intuitive description of the cumulative hierarchy alone, we can prove certain basic properties of sets. For example, it is not difficult to show that no set in the cumulative hierarchy is ever a member of itself; this view is natural enough if you picture sets as built up out of their elements combinatorially in stages along the lines of the cumulative hierarchy. Actually, we can prove something stronger. Call a function from natural numbers to sets an infinitely descending ε-chain if and only if for any natural numbers n and m, if n is less than m, then $f(m)$ is an element of $f(n)$. Then we can show that there are no infinitely descending ε-chains. If there were a set x which is a member of itself, then the function whose value for any natural number is x would be an infinitely descending ε-chain; hence, no set is a member of itself.

It is quite natural, given the cumulative hierarchy, that certain predicates should fail to have sets as extensions. For example, consider the predicate "is a set". Suppose there were a set, call it V, of all sets. Being a set, V would have to be a member of rank α for some α. Consider rank α; being a subset of itself, it is an element of rank $\alpha + 1$ and therefore it is a set. Since V is the set of all sets, it follows that rank α is a member of V. It is not hard to show by transfinite induction that the ranks are transitive in the sense that if x is a member of y, and y is a member of rank α, then x is also a member of

rank α. Then since rank α is a member of V, and V is a member of rank α, it follows that rank α is a member of itself; and by the preceding paragraph, that is impossible. Hence, "is a set" has no set as extension. (This argument can be viewed as a version of a more intuitive argument: sets are built up in stages and there is no end of stages at which new sets are built. A set of all sets could only be built at a stage after which no new sets are built. Since there is no such stage, there is no set of all sets.) Lets us now assume a new principle: let x be a set and let P be a property. Then there is a set comprising all and only those things in x which have property P. I take it that this principle, called *aussonderung* or separation, recommends itself to reflective intuition. Given *aussonderung*, it follows that the universe does not exist; that is, there is no set of which everything is a member. For if the universe existed, then since all sets are things, it would follow by *aussonderung* that there is a set of all sets. Since there is not, the universe does not exist. From this it follows that no set has a complement; that is, for no set x is there a set of all and only those objects not in x. For if some set had a complement, their union would be the universe. Now, since we can always build unions in the hierarchy, they always exist. So since the universe does not exist, no set has a complement. This is also intuitive: given that we build x at some stage, then since at each later stage we always build at least one new thing, we are always building non-members of x, and so at no stage could we have built all members of the complement of x. An application of this may interest philosophers. We showed above that no set is a member of itself. Hence, a set is a self-member just in case it is an element of the empty set. The empty set is in the hierarchy, so by extensionality, there is a set of self-members in the hierarchy. It follows that its complement, the set of all non-self-members which is otherways known as the villain in Russell's Paradox, does not exist. This illustrates a general strategy used in some theories of the cumulative hierarchy (ZF) to avoid paradox; and it all flows from an intuitive conception unadorned by *ad hoc* artifice.

All this is quite standard and well-known. My suggestion is that we investigate whether properties of the cumulative hierarchy of sets yield an adequate account of the potential

infinite. Our basic contexts are

(9) There is an actual infinity of F's

and

(8) There are potentially infinitely many F's

where I wish to construe the letter *"F" not* as an objectual variable but rather as a schematic letter for which predicates may be substituted. For the first context, the obvious set theoretic stratagem is to require that there exist (in the cumulative hierarchy) a set which is the extension of F, so that the singular term "the set of all F's" denotes, and that the set of all F's is infinite in that sense of "infinite" due to Dedekind which I mentioned at the outset. Then actual infinities are plain, old objects which are actual and infinite—a result which seems simple-minded enough to recommend itself to reflective intuition. My suggestion for the potential infinite is much less realistic. It is simply that we take (8) as true precisely when the predicate F has no set as extension, in which case, of course, the term "the set of all F's" does not denote.

In order to state the advantages of this apparently nutty suggestion, I want to state some of the motivation behind the description of the cumulative hierarchy implicit in NBG. Let us talk about classes rather than sets. Classes are not built up in stages; instead they are roughly extensions of predicates, but only certain predicates. Assume a language with variables (intended to range over classes), predicates for membership and identity, and the usual connectives and quantifiers. We assume a number of evident axioms. The crucial move consists in saying that a class is a set just in case it is a member of some class or other. We can then show that every formula in which the bound variables range only over sets has a class as extension. (Of course Cantor's Theorem shows that no converse is to be hoped for.) A proper class is any class which is not a set; all the paradoxical collections turn out to be proper classes. As it were, proper classes cannot be collected together into completed totalities; or in Parsons' terms, one is not allowed to quantify into the positions of predicates used to describe proper classes. Now consider two new axioms. The

first, due to Thoralf Skolem, is the axiom of replacement. It says that if x is a set and R is a class which is functional on x (that is, R is a two-place relation and for each y in x there is exactly one set z such that yRz), then there is a *set* of all those things to which some member of x bears R. This is quite strong, but on reflection I think it seems more likely than not. The second axiom, quite old but first stated explicitly by Ernst Zermelo, is the axiom of choice. It says that for any set x of non-empty sets, there is a set with just one member of each element of x. I have never understood how anyone could doubt the axiom of choice. Suppose we add replacement and choice to NBG; (versions of them are also reasonable for ZF). There then follows a striking result first proved by von Neumann. In NBG, there is a class V of all sets, but it is a proper class, not a set. If we allow ourselves a notation which for the moment is abusive, then we can express von Neumann's result by saying that a class is proper (not a set) just in case there is a one-to-one correspondence between it and V. So if we adopt the set-theoretic analysis of sameness of size, all proper classes are of the same size, namely, they are the same size as V, and this is as big as a class of sets could possibly be. All sets are strictly smaller than V, and any subset of V smaller than V is a set and a member of V. Such results are already striking to those who share the intuition that the source of the paradoxes lies in supposing to be sets collections too big to be sets. But such results are even more interesting when we use the cumulative hierarchy to interpret NBG. For we may suppose that the sets of NBG are all and only the sets of the cumulative hierarchy. Proper classes can then be thought of as properties (co-extensive ones being identified) of sets in the hierarchy. And a predicate fails to have a set in the hierarchy as extension just in case its extension is a proper class.

I will use these results to state some equivalents, consequences and background of my suggestion for the potential infinite. Let x be a set and let F be a predicate. Say that x is a set of F's if and only if the predicate F is true of every member of x. Then we can show (1) there are potentially infinitely many F's if and only if for every set x of F's there is another set of F's larger than x. This seems a desirable result. We can

also show that (2) if there are potentially infinitely many F's, then there does not exist an actual infinity of (all) F's. (If this is thought too strong, it is easy enough to soften it by using "potential infinity" to cover all infinities and replacing our notion of potential infinity by "strictly potential infinity".) This second result refutes Cantor's strong thesis (but see below). His weak thesis needs revision before it is worth considering in any set theory committed to the existence of an infinite set. An obvious revision is

(10) If there are potentially infinitely many F's, then there is an actual infinity of G's where all F's are G's;

on the obvious reading of its last clause. Thesis (10) is refutable. For were there an actual infinity of G's where all F's are G's then by *aussonderung* there would be an actual infinity of F's, and that is impossible by our second result. Hence (3), if there are potentially infinitely many F's and all F's are G's, then there are potentially infinitely many G's. It also follows from *aussonderung* that if all F's are members of a set x, and x is an actual infinity, then if there are infinitely many F's there is an actual infinity of F's. Both these results seem desirable. Also (4) it is trivial that if there is an actual infinity of F's, then there are potentially infinitely many G's such that all F's are G's; the predicate "is a set" will suffice uniformly in place of "G" for any predicate of sets in place of "F". We can also prove by replacement that if there are potentially infinitely many F's then there is an actually infinite set of F's (though of course it cannot include all F's). We can also establish sharper relations between potential and actual infinities. Say that when x is an infinite set of F's and there are potentially many F's, then x is an approximation to all F's. We can show that there are potentially infinitely many approximations to all F's such that each F belongs to some approximation or other. Moreover, these approximations can be ordered using ordinals so that each is a subset of all later ones. (We know that there is an actually infinite set of F's. Suppose it is of rank α. For each ordinal β greater or equal to α, the union of all sets of F's of rank β is a set, is infinite, and earlier ones are subsets of later ones. Let H be the predicate "is the union of all sets of F's of some rank greater or equal to α". Then

every H is an approximation to all F's, there are potentially infinitely many H's, and each F is a member of some H or other. The ordering of the H's by rank induces an ordering of H's by inclusion.) I suppose this result could be taken as suggesting that potential infinities are somehow built up out of or are limits of potential infinities of actual infinities—but this should *not* suggest an ontological reduction, any more than the picture of actual infinities as small selections from the potential infinity of sets. Next, (5) since the predicate "is an infinite set" has no set in the hierarchy as extension, there are potentially infinitely many actual infinities. If we allow ourselves a mix of substitutional and objectual quantification and if we agree with the thesis received in much philosophy of language that no language has more than denumerably many predicates, then we can say (for each language) there is an actual infinity of (predicates) F for which there are potentially infinitely many F's, or for short, there is an actual infinity of potential infinities. Finally I should mention that (6), while my proposal is metalinguistic and shares some of the disadvantages of other metalinguistic analyses in philosophy, it also has a certain advantage. We said that the truth condition of a sentence of the form "There are potentially infinitely many F's" for any predicate F is that the predicate does not have a set in the hierarchy as extension. One of our desiderata of an analysis of the potential infinite was that truths of this form should not commit us to the existence of an *object* which is a potential infinity. (This is a relatively crude approximation, offered in the absence of modality, to the mere potentiality of the potential infinite.) As far as the cumulative hierarchy of sets is concerned my proposal seems sufficient to satisfy this desideratum. (I should also mention that my proposal has very strong affinities with a suggestion Cantor made to Dedekind in a letter dated 28 July 1899.)

Each of these results holds for the cumulative hierarchy as originally described. If we allow ourselves to modify the hierarchy, we can get other results. For example, if we only construct the hierarchy through the natural numbers, then we can find predicates F such that it is true that there are potentially infinitely many F's, but since there are now no infinite sets in the hierarchy, it will be false for all predicates G that

there is an actual infinity of G's. We could take this as evidence that the existence of an actual infinity is not *implied* by there being potentially infinitely many F's. This is a strong rebuttal of Cantor's thesis. What about the converse; that is, Does the existence of an actual infinity imply that there are potentially infinitely many F's, for some predicate in place of "F"? This is a delicate question. Some relevant facts are these. Once proper classes are introduced over and above sets in the cumulative hierarchy, there seems no objection in principle to repeating for proper classes the construction which yielded sets in the first place. That is, we could construct a cumulative hierarchy of classes with that of sets as a tiny initial segment. Of course on this construction the predicate "is a set" now has a class as extension and the classes can be assumed to obey just about all the old laws sets did before. On the other hand "is a class" will now fail to have a class as extension for the reasons that "is a set" failed to have a set as extension before. But we could then introduce 'super-classes' on analogy with the old proper classes and then build yet another cumulative hierarchy. And, apparently, so forth. For each iteration of the hierarchy, some predicate seems to fail to have an extension which is a member of the latest iterate of the hierarchy. That fact allows the hierarchy to be reiterated which makes an extension available for the previously extensionless predicate. Now, *if* the only "possible words", relevant to whether "There is an actual infinity" *entails* "There are potentially infinitely many F's", are iterates of the hierarchy, and *if* for each iterate, some predicate has no extension, it would seem that the entailment holds. But, for all anybody knows, there may be some reasonable structure of which all iterates (and so forth) are members *and* in which somehow all predicates used to describe the construction of the structure have extensions; if so, it would seem reasonable to hold that the entailment in question fails. I think that probably we are not yet in a position to decide the issue satisfactorily. Part of the problem is that we have now come full circle: we have returned to the intuitive picture of processes we rejected at the outset as not sufficiently theoretical to yield an account of the potential infinite adequate to decide basic questions in a decisive way.

IV

End

It is frustrating to end on so indecisive a note. I can hope to stimulate someone more creative than I to make a more telling contribution to the problem. But I also hope that some of my comments along the way are worth considering as adequacy conditions on an eventual genuine theory of the potential infinite.

BIBLIOGRAPHY

George Boolos, "The Iterative Conception of Set", *The Journal of Philosophy*, LXVIII (22 April 1971), 215-231.

Georg Cantor, Letter to Dedekind, in *From Frege to Gödel*, Jean van Heijenoort, ed., Harvard University Press, Cambridge, Massachusetts, 1967, pp. 113-117.

———— *Gesammelte Abhandlungen mathematischen und philosophischen Inhalts*, Ernst Zermelo ed., Olms, Hildesheim, 1962.

Kurt Gödel, "What is Cantor's Continuum Problem?", reprinted in *Philosophy of Mathematics*, Benacerraf and Putnam, eds., Prentice Hall, Englewood Cliffs, 1964, pp. 258-273.

Charles Parsons, "Ontology and Mathematics", *The Philosophical Review*, LXXX (April, 1971), 151-176.

———— "Sets and Classes", *Noûs*, VIII (March, 1974), 1-12.

XV*—NATURE, ARTIFICE AND MORAL APPROBATION

by Christopher Cherry

I

In Book III of *A Treatise on Human Nature*,[1] Hume puts two questions which he says are distinct. The first concerns "the manner in which the rules of justice are established by the artifice of men" (Book III, Part II, Section II; p. 190.) The second concerns "the reasons which determine us to attribute to the observance or neglect of these rules a moral beauty and deformity." (*Ibid.*) Whatever his sympathies, the reader is bound to be struck by the sustained ingenuity of Hume's answer to the first question. He is likely to be less impressed by the way in which Hume copes with the second. I shall be concerned with certain difficulties in Hume's treatment in the *Treatise* of this second question—difficulties which are of far more than exegetical interest. However, because the two questions are by no means as distinct as Hume declares—something which is rapidly made evident even by Hume's own discussion—I cannot exclude all reference to the first. What I shall avoid is any attempt to assess what is commonly received as Hume's answer to that question, although it seems to me very much in need of reassessment.[2] Furthermore, I say next to nothing about what Hume takes just and unjust behaviour to *consist in*: about that remarkably confined area of human affairs which for Hume defines the limits within which people may be said to behave justly (and unjustly)—and, of course, to display other parasitic artificial virtues (and vices). My concern is rather with Hume's efforts to explain how there can be as well as natural, artificial *virtues*; how certain practices, whatever their detailed anatomies and inter-connexions, can be found *morally estimable*. And my conclusion is that his efforts are bound to fail.

*Meeting of the Aristotelian Society at 5/7 Tavistock Place, London, W.C.1, on Monday, 7th June, 1976, at 7.30 p.m.

II

I can best begin by quoting two short passages: the opening words of Hume's discussion of justice and injustice, and almost the concluding words of the *Treatise*. (In no other sense, however, are they to be taken as Hume's first and last thoughts):

"I have already hinted, that our sense of every kind of virtue is not natural; but that there are some virtues that produce pleasure and approbation by means of an artifice or contrivance, which arises from the circumstances and necessity of mankind. Of this kind I assert *justice* to be; . . ." (III, II, I; p. 184. Hume's italics).

"Though justice be artificial, the sense of its morality is natural. It is the combination of men in a system of conduct, which renders any act of justice beneficial to society. But when once it has that tendency, we *naturally* approve of it; and if we did not so, it is impossible any combination or convention could ever produce that sentiment." (III, III, VI; p. 311. Hume's italics).

Even when allowance is made for Hume's infuriating looseness of expression, the passages seem, if not contradictory, hard to reconcile. It is true that common to both is the assumption, which I believe is radically mistaken, that there are two essentially different topics: the historical topic of the processes whereby men become able to characterize conduct as just and unjust, and the distinct and subsequent moral-cum-phenomenological one of the attachment to such conduct of approval and disapproval. But it is the antagonism between the two passages which immediately concerns us. In the first, Hume seems to say that what is contrived is the *means of producing* the "pleasure and approbation" which constitute the virtuous aspect of just acts: that a moral sentiment is generated by artifice. He appears to say that the fact alone that an act is just is insufficient to excite moral approval of that act. In some manner it must be further contrived that just and unjust conduct excite approbation and disapprobation respectively. And so the sentiments in question are artificial in the respect that, were it not for that further contrivance, they could not attach themselves to conduct so described.

Not only does the second passage not prompt this—somewhat obscure—account of the matter: it positively excludes it. Indeed, it goes further. Hume there appears to deny that there is any proper sense in which a moral sentiment may be termed "artificial", and *a fortiori* in respect of its aetiology. And this denial accords with which is commonly received as his general doctrine of a necessarily direct, unmediated causal connexion between our observing particular acts of certain kinds and our experiencing moral sentiments of praise or blame—a doctrine which can in turn be brought under a more comprehensive one still of the rôles of reason and passion: if nature had not already established such a connexion, the contrivances of reason could not furnish one.[3]

It is, of course, the second rather than the first account that Hume repeatedly affirms—which makes neither the accounts, nor the contrast between them, a lot clearer. What are, in the nicest sense of that expression, artificially created are rule-constituted, or institutional, practices. (The anachronism is intended, and I shall stay with it). Once certain of these practices are established, they without further ado become morally vested. From an embarrassment of possibilities, I choose two short passages:

> "It is the voluntary convention and artifice of men which makes the first interest [*sc.*, man's need to live in a stable society] take place; and therefore those laws of justice are so far to be considered as *artificial*. After that interest is once established and acknowledged, the sense of morality in the observance of these rules follows *naturally*, and of itself . . ." (III, II, VI; p. 234. Hume's italics);

and:

> "After it [*sc.*, the "whole scheme of law and justice"] is once established by these conventions, it is *naturally* attended with a strong sentiment of morals, which can proceed from nothing but our sympathy with the interests of society" (III, III, I; p. 276. Hume's italics).

If it is like this, we should expect to find the territory of artifice exhaustively charted in the first of the two undertakings Hume sets himself. What we in fact find is a notably inventive attempt to explain the possibility of certain institutions which are artificial in the respect that they cannot arise

solely from, although they must necessarily be based upon, "the natural and inartificial passions of men". According to what is most aptly styled an "aggregative egoist" account, individual self-interest is the original motive for the establishment of the institutions of justice and property, but their "natural tendency" is the *public* interest, the good of *mankind*. A great part of Hume's ingenuity is accordingly devoted to showing how, against expectation, such an unpromising-looking input yields such a profitable output. Thus, while the origins of justice cannot be explained in terms of a regard to the public good, its end-product happens to be precisely that good;[4] and, Hume tells us on many occasions, what is in the public good naturally excites moral approbation: "When any quality or character has a tendency to the good of mankind, we are pleased with it, and approve of it . . ." (III, III, I; p. 277); and justice is a moral virtue "merely because it has that tendency to the good of mankind" (*Ibid*; p. 274).

Hume means, then, to invoke the contrivances of man to account not for the fact that we approve of actions already characterized as "just", and of the system which they instantiate, but for the prior possibility of such a characterization, of such a system. The artifice of man explains the possibility of certain institutional descriptions, which is to say the possibility of certain institutions. We create new forms of behaviour and moral approbation naturally ensues.

The trouble with this conclusion is not its banality but its opacity. It could, I suppose, be said to allow—or at least not to forbid—our giving *a* sense to the suggestion that our moral response to certain forms of behaviour is artificially and not naturally generated. But it is the feeble and misleading sense of a transferred epithet, registering no more than that without a kind of artifice certain behavioural possibilities would not have been available to *be* approved (or indeed disapproved) of. Happily, there is much more to be said—for a start, about the notion of an institutional description. Consider the following passage:

> "The only difference betwixt the natural virtues and justice lies in this, that the good which results from the former rises from every single act, and is the object of some

natural passion; whereas a single act of justice, considered in itself, may often be contrary to the public good; and it is only the concurrence of mankind, in a general scheme or system of action, which is advantageous. When I relieve persons in distress, my natural humanity is my motive; and so far as my succour extends, so far have I promoted the happiness of my fellow-creatures. But if we examine all the questions that come before any tribunal of justice, we shall find that, considering each case apart, it would often be an instance of humanity to decide contrary to the laws of justice as conformable to them. Judges take from a poor man to give to a rich; they bestow on the dissolute the labour of the industrious; and put into the hands of the vicious the means of harming both themselves and others" (III, III, I; pp. 275-6).

Setting aside for a moment the complicated issue raised in the opening sentence, I want to examine a feature to which Hume draws attention in the later part of the passage. In addition to its relatively determinate, non-institutional characterization—"taking from a poor man to give to a rich", "bestowing on the dissolute the labour of the industrous"— an action, a, may have an institutional characterization such as "just", or "fair", or "legally binding", etc. In the present case, a under a non-institutional characterization excites a moral sentiment diametrically opposed to that which it excites under an institutional. To the extent that we treat a as the same action in both cases,[5] we have a contrast which it is tempting to describe in some such terms as the following: in the first case, the moral sentiment (disapprobation) is natural in the respect that it is *naturally produced*; in the second, it (approbation) is artificial in the respect that it is *artificially produced*. This idea of artificial production goes deeper than the one dismissed just above. Unlike that, it takes its force from a contrast between descriptions both of which apply to the same situation. The pair of descriptions, institutional and non-institutional, is a contrasting one precisely because both members apply to one and the same situation. It thus becomes possible for a range of cases at least to view the artificial

as an institutionalized *version* of the natural and "inartificial", and hence the moral sentiment excited by conduct described in institutional terms as artificial by contrast with that excited by the same conduct described non-institutionally.

At the beginning, I quoted a passage in which Hume implies that in the case of the artificial virtues the production of the moral sentiment is artificial in the respect that there exists a gap between act and approbation—a gap plugged with certain contrivances. That account, and that notion of artificiality, is belied by much that Hume says elsewhere. The present notion of artificiality does not hint at any such gap. It does not suggest that between an action institutionally described and the moral response which it elicits there exists any more of a gap than between an act non-institutionally described and the response which *it* elicits. I must now try to say something more positive about what it does suggest. I shall from now on refer to non-institutional descriptions as *N-descriptions*, and to the moral responses elicited by actions so described as *N-responses*; and to institutional descriptions and the responses which they elicit as *I-descriptions* and *I-responses* respectively.

It is hard to deny that there is something inalienably primary about *N*-descriptions and hence *N*-responses, and something secondary and non-fundamental about *I*-descriptions and hence *I*-responses. This alone inclines us to speak of "natural" *versus* "artificial" responses. This inclination merges with another: to declare that *I*-responses, by contrast with their *N*-counterparts, are artificial in the respect not merely that they are non-fundamental but that they are fabricated, in some way spurious. The application to a situation of an *I*-description appears to usurp its *N*-description, to interpose itself between situation and "natural" response—the response which would have occurred but for the *I*-description—thereby frustrating, deforming, or replacing it. To view an action simply as one which "puts into the hands of the vicious the means of harming both themselves and others" prompts one response; to contrive to view it as an act of justice prompts quite another. I am not suggesting that it is a matter of choice whether or not the further description be applied, although the matter is far more complicated than

Hume's politics allow him to suppose. I am suggesting that the availability of further descriptions of this kind both gives a sense to and, at the same time, plays havoc with the idea of what is naturally virtuous. For Rousseau, all morality is such generalized havoc, and is viewed by him with very mixed feelings. For Hume, a good part is; and that part deserves to be acclaimed as an achievement of the highest order.

III

Hume does not experience, and so is not disturbed by, any sense that *I*-responses are spurious. However, he is uneasily aware of the fact that there are special—and, I shall argue, insurmountable—difficulties for him in showing that an apparently fatal discontinuity between what he deems the natural and the artificial *is* only apparent. Of course, a continuity problem is in one form or another faced by any philosopher who makes use of a distinction between what is and what is not natural to man, for he must satisfy the formal requirement that no conceptual hiatus be left between what, plausibly or otherwise, he accounts natural and what artificial. Otherwise, there is not even the suggestion of an *explanation*. Now, the way in which the requirement is (or is not) satisfied will vary from thinker to thinker, depending as it must upon what he deems natural and what artificial.[6] And Hume's peculiar embarrassment is that his general epistemology, and in particular his concept of moral approbation, will not allow him to satisfy the continuity requirement and at the same time remain true to the notion of artificial virtue which he wishes to develop. His philosophy cannot accommodate his own notion of institutional virtue, and induces him to violate that notion very seriously.

He does so by talking as if the artificial virtues were a subclass of the "social virtues". Now the social virtues are a subclass of the *natural* virtues, and so the artificial virtues are made to appear natural virtues all the time. The move is as follows: "Meekness, beneficence, charity, generosity, clemency, moderation, equity . . . are commonly denominated the *social* virtues, to mark their tendency to the good of society" (III, III, I; p. 275, Hume's italics); justice, we already know, is approved of for no other reason that that it has a tendency

to the good of society; therefore justice is just like those *natural* virtues which have a like tendency to the good of society.

Of course, Hume is perfectly well equipped to discriminate certain natural virtues as "social". They are, so to speak, the more outgoing of the natural virtues. But like the less outgoing they are immediately and directly agreeable. They differ from these only in respect of the extent to which they may be said to tend to the good of society; and this must mean something like: in respect of the quantity of *immediately appreciative individuals* constituting, so to speak, their respective catchment areas. But this cannot possibly be the sense in which the artificial virtues are said by Hume to have a tendency to the public good. Nor, indeed, can the public goods be of the same kind. This is made clear by that part of an earlier quoted passage which I deliberately ignored:

> "The only difference betwixt the natural virtues and justice lies in this, that the good which results from the former rises from every single act, and is the object of some natural passion; whereas a single act of justice, considered in itself, may often be contrary to the public good; and it is only the concurrence of mankind, in a general scheme or system of action, which is advantageous."

What Hume calls "the only difference" between the natural and the artificial virtues is a difference of the first magnitude. It cannot be the case, as we have seen Hume to imply, that the public good which is the hidden end of the artificial virtues is simply more of the same commodity secured by the more social of the natural virtues but produced in a less *ad hoc* and more efficient way. Its means of production, and the kind of thing it is, are very different. The public good produced by the system of justice is that good accruing from the existence of the system: it depends upon "the concurrence of mankind in a general scheme or system of action". As Hume says elsewhere, the direct consequences of particular acts of justice are irrelevant to *this* notion of the public good:

> ". . . whatever may be the consequence of any single act of justice, performed by a single person, yet the whole

system of actions concurred in by the whole society, is infinitely advantageous to the whole, and to every part . . . Taking any single act, my justice may be pernicious in every respect; and it is only upon the supposition that others are to imitate my example, that I can be induced to embrace that virtue; since nothing but this combination can render justice advantageous, or afford me any motives to conform myself to its rules" (III, II, II; pp. 202-3).

By contrast, the goods of, for instance, generosity and charity are emphatically not dependent for their production upon "the concurrence of mankind in a general scheme or system". As Hume himself condescendingly observes: ". . . every particular act of generosity, or relief of the industrious and indigent, is beneficial, and is beneficial to a particular person . . ." (III, III, I; p. 276).

Hume, then, repeatedly talks as if the artificial virtues are really the less parochial and more expansive of the natural virtues, and yet simultaneously distinguishes them in terms of features which make a nonsense of such talk. By way of illustration and elaboration, consider the following passage:

"A single act of justice is frequently contrary to *public interest*; and were it to stand alone, without being followed by other acts, may, in itself, be very prejudicial to society . . . Nor is every single act of justice, considered apart, more conducive to private interest than to public . . ." (III, II, II; pp. 201-2, Hume's italics).

Of course there are problems about what it is to consider an act "apart", or "in itself", or "alone" as contrasted with considering it as "followed by other acts". But the contrast Hume intends ought to be fairly clear. It is one between considering an act in respect of the consequences which as a particular, historic instance of a kind it may be said to have, and considering it in respect of the consequences produced by a universal performance of acts of the kind of which it is an instance. But if so, "public interest" in the passage above cannot be taken in its *institutional* sense. An act of *justice*, unlike a naturally virtuous act, cannot conceivably be contrary to the public interest in that sense of the expression. For,

according to Hume, to call a particular act "just" is precisely to consider that act in respect of features whereby it conduces to that interest, *i.e.*, as an instance of a practice in terms of which that interest has to be understood. This is what considering a just act "apart" must *mean*. Hume, however, decides at this point that to consider a just act "apart" means to consider it with respect to the effect which, taken as a particular case, it produces, that is, to consider it with respect to its direct consequences. It is this confusion which makes him say that a single act of justice may frequently be "contrary to" or "prejudicial to" public interest. But this is nonsense. What he really describes is what it is to consider not a given just act in isolation but a given act from a point of view *other than* that of justice. He describes what it is to consider an act with respect to precisely these features which he has ruled to be irrelevant to the matter of justice.

In the jargon of *N*- and *I*-responses: *N*-responses, whether favourable or unfavourable, have nothing to do with the public good in its institutional acceptation, with "the whole system of actions concurred in by the whole society". To the extent that we concern ourselves with the *N*-response excited by an act we fail to concern ourselves with it as an act of justice, or injustice. We can share Hume's revulsion at the spectacle of "a man of merit, of a beneficial disposition, [restoring] a great fortune to a miser, or a seditious bigot". But the revulsion does not constitute an *I*-response of disapprobation. If, as Hume says, the man has acted "justly and laudably", then the *I*-response is one of approbation. Our revulsion is our *N*-response to the situation; that is to say, our response to the situation under an aspect other than that of justice. If, like Hume, we insist upon describing the situation as one which makes "the public" suffer, we must be operating with a "natural", non-institutional notion of public good. In short, we are regressing: we are talking not of artificial but of natural morality, of what is moralised by nature rather than by artifice.

Matters of some interest and importance emerge from the foregoing: the matter of conflicting demands of justice and generosity transcribed into terms of the commensurability and relative stringency of *N*- and *I*-responses; that of a pos-

sible, if not inescapable, contrast between the concepts of natural and institutional "public goods": the related issue of aggregative and non-aggregative goods; and others. But I cannot pursue these here, for I have still to make good my claim that Hume's moral epistemology is too narrow to accommodate his idea of artificial virtue. All I have so far shown is that he *does* violate what he has declared to be the distinguishing mark of artificial virtue, that when he supposes himself to be talking of institutional responses to an institutional good he is *in fact* talking of their counterparts in nature (or else talking nonsense). What I have now to show is that he cannot help doing so: that he cannot but fail to provide "the reasons which determine us to attribute . . . a moral beauty and deformity to the observance or neglect of the rules of justice". If I am right, Hume is in the uncomfortable, though scarcely uncommon, position of embracing a doctrine which he is debarred by his own first principles from even entertaining.

I argued above that Hume misrepresents the logic of what look like problem cases. He should not have said that taken severally such cases go counter to both private and public interests, since he is already committed to the view that they are conceptually, if unobviously, tied to the latter. Instead, he should have said that to evaluate an act as just or unjust *is* to evaluate it in respect of its contribution to the public good; that to such an evaluation an *N*-response—the response pertaining to and in a sense constituting the private dimension— is strictly irrelevant; and that it is a matter of total indifference whether the *N*-response is one of disapprobation, as in his alleged problem case, or one of approbation, as in some readily amended version. (Of course, *N*-responses are far from irrelevant to the different question whether there is anything in Hume's notion of public good, and if so whether it is anything *good*. But although I end with a few words on this very different issue, it is no part of this paper to provide one more critique of Rule Utilitarianism.) Now, since *N*-approbation and *N*-disapprobation are alike irrelevant to the evaluation as just or unjust of a particular act, *a*, approbation of *a* as just cannot be approbation excited by features of *a* considered apart and in isolation. But it does not follow from this, and it is not the case, that *a*, in isolation and apart, cannot be

the object of approbation; indeed, to characterize it as "just and laudable" is to treat it as exactly that. To suppose otherwise, as Hume appears to, is to confuse grounds of approval with object of approval. What does follow is that approbation of *a* is possible only by virtue of a logically prior approbation of a system of which *a* is a part and to which it contributes. That is to say, the difference between *I*-approbation of *a* and *N*-approbation of *a* lies in the fact that the former, unlike the latter, is approbation elicited by *a* because *a* is an instance of a kind which is already approved of. *A moral interest in the particular case is parasitic upon, logically posterior to, a moral interest in the kind.*

Now, Intuitionism, and no doubt certain forms of religious ethics, can accommodate this kind of conceptual arrangement —indeed, this is one reason why they are suspect. But it is far from clear than any ethics with a consequentialist flavour can coherently do so; and I think it certain that Hume's theory of moral approval—his "Approbationism"—cannot. It cannot because of its insistence upon the particular case. For Hume's—and presumably any approbationist's—account of the right and the good is such as to demand that approval be excited, if at all, by *particular* actions affecting *particular* individuals, or groups of individuals; and this is tantamount to ruling out any but *N*-responses. Hume, then, cannot accommodate the idea of artificial *virtue* because his moral epistemology is too narrow to accommodate the idea of an *I*-response. He is in the end unable to distinguish between natural and artificial *virtue* because he is unable to give a sense to the distinction between *N*- and *I*-responses upon which this first distinction rests—indeed, of which it is in a sense constituted.

It is important to appreciate the nature and extent of my claim. It is not that Hume is logically precluded from accounting for a moral interest in kinds of action in the sense that actions of certain kinds may invariably excite approval (or disapproval) in some people. Hume can here, as he frequently does elsewhere, invoke with some plausibility the force of custom or unreflective habit. Such an interest is, however, very different from the sort demanded; and rules to the effect that actions of kind *A* ought always to be performed have a correspondingly different rationale. For the moral in-

terest which after a fashion he can encompass is an approval or disapproval attaching to a kind only by virtue of the fact that it is excited by every particular case of that kind. As such, it is posterior to and derivative from an approval or disapproval attaching to the particular case. And this is the converse of what Hume requires. It is at this point, of course, that the present issue engages with more familiar ones in the convoluted philosophy of rule and act. However, I shall not embark upon those eminently resistible issues because they are incidental to what remains to be said on the present matter.

Hume has a doctrine of sympathy which I have so far ignored. He prescribes it as a cure for, among others, the problem of the artificial virtues. But in reality the prescription is interesting because it so perfectly discloses and illustrates his particularist ills. While there may be something (apart from its unflagging ingenuity) to be said for the doctrine in certain of its aspects, it cannot cope with his present embarrassment. Hume, we have seen, is in the impossible position of having to account for a moral interest in certain kinds of act which is not derived from one in particular instances of those kinds. But the most that sympathy can do is to expand a moral interest which is *already* directed towards a particular case. It can at best increase, and arguably adjust, the range and extent of an approbation already excited by some particular act. And not only does it fail to account for the required priority, it suggests that no account is available. Sympathy battens upon a natural approbation excited by particular cases severally pleasing or satisfying to some individual or individuals and—the intention is—expands the catchment area of that approbation. But it is precisely these several and particular satisfactions that are irrelevant to Hume's notion of the public, institutional good. From the point of view of that notion, sympathy can get expansive only about irrelevancies, and is likely for that reason to be counter-productive. Consider typical words of Hume on the matter:

". . . [sympathy] is that principle which takes us so far out of ourselves as to give us the same pleasure or uneasiness in the characters of others, as if they had a tendency to our own advantage or loss" (III, III, I; p. 275).

And again:

> "The sentiments of others can never affect us, but by
> becoming in some measure our own; in which case they
> operate upon us, by opposing and increasing our passions,
> in the very same manner as if they had been originally
> derived from our own temper and disposition" (III, III,
> II; p. 288).

The doctrine of sympathy, then, is supposed to provide an
answer to the question: How is it possible that a situation
which excites *N*-approbation in another because it is agree-
able or advantageous to him should excite it *in me* also? I
think that this question should not have been asked and,
once asked, answered in this way. But that is not the point.
What is is that the sympathetic machinery is necessarily
geared to *N*-responses. But Hume will not acknowledge this
self-imposed necessity. Running together the artificial and the
natural virtues in ways we noticed earlier, he describes the
operations of sympathy not as socialising what unquestion-
ably remain natural virtues but as transforming these into
artificial virtues. Sympathy cannot, as Hume claims, be "the
source of the esteem which we pay to all the artificial virtues".
The claim is plausible only because Hume busily dismantles
his own crucial distinctions:

> "Justice is certainly approved of, for no other reason
> than because it has a tendency to the public good; and
> the public good is indifferent to us, except so far as sym-
> pathy interests us in it. We may presume the like with
> regard to all the other [*sc.* natural] virtues, which have
> a like tendency to the public good. They must derive all
> their merit from our sympathy with those who reap any
> advantage from them; as the virtues, which have a ten-
> dency to the good of the person possessed of them, derive
> their merit from our sympathy with him" (III, III, VI;
> p. 310).

Now, it may be conceded that sympathy cannot be the
source of our approbation of the artificial virtues since if it
were they would be not artificial but natural, but still argued
that once approbation gets a toe-hold the expansive powers of
sympathy are able to operate. This is a very much weaker
claim (though Hume does not recognise it as such),[7] and

smacks of answering a cry for help once the victim has perished. Nonetheless it is interesting since it reinforces earlier objections. Recall for the last time the sort of situation exemplified by the fortune restored to a miser. By attention to what estimable feature or features of the affair might sympathy in responsive observers serve to increase the number of gratified, public-spirited persons? The only features upon which sympathy might focus are ones which have been declared strictly irrelevant: namely, those having to do with N-responses. Of course, the N-response in the present case is likely to be one of disapprobation; but even if it were one of approbation, it would necessarily be an approbation (perversely) excited by, and directed towards, the good fortune of the miser which was made general by the operations of sympathy. So sympathy remains inalienably on the side of nature.

But might there not be a further possibility? Might not sympathy make general the response of approbation excited by and directed towards *the tendency of the act in question to the good of society*? Such a "tendency" might seem to be the one feature available and capable of exciting the I-response which is required. Unfortunately, this will not do either, for it demands an incoherent additive notion of the public good. It is true that if a particular act is of a kind the universal performance of which tends or conduces to the public good then the particular performance of that act may itself be described as tending or conducing to that good. However, it would be wrong to conclude that therefore the act in question—in common with every other particular case of the same kind—produces a tiny portion of the public good. For the good produced by the practice is not distributable among the elements which constitute that practice: it is not the sum of many small goods severally and separately realized. If, for example, a person's overall demeanour makes me suspicious of him it is perfectly proper to say of any given item of his behaviour that it tends to make me suspicious, but not to conclude that my resultant suspicions can be parcelled out among those items. It is not until the second *Enquiry* (to which I now refer for the first and last time) that Hume appreciates the essentially non-aggregative nature of what he deems artificial public as contrasted with natural social good. He marvellously captures the difference in a majestic simile:

"The happiness and prosperity of mankind arising from the social virtue of benevolence and its subdivisions may be compared to a wall built by many hands—which still rises by each stone that is heaped upon it and receives increase proportional to the diligence and care of each workman. The same happiness, raised by the social virtue of justice and its subdivisions, may be compared to the building of a vault where each individual stone would, of itself, fall to the ground; nor is the whole fabric supported but by the mutual assistance and combination of its corresponding parts."

(*An Enquiry Concerning the Principles of Morals,*
Appendix III).

I conclude, then, that the stronger and weaker claims on behalf of sympathy both fail. I do not deny that as a matter of fact the moral concerns of many begin, and in some cases end, with a conception of an artificial public good very like Hume's. I do deny that sympathy either originates or lubricates that concern—and, more generally, that Hume is capable of accounting for it.

IV

I have been concerned not with the merits or demerits of Hume's conception of the public good but to argue that he must fail to make provision for the distinction between natural and artificial virtue which such a conception demands. Our capacity to attribute a "moral beauty" to certain artificial practices must remain for Hume a complete mystery. Now, a moral and political evaluation of the conception will, I think, yield a moral counterpart of sorts to the epistemological particularism which incapacitates Hume. Hume's public good is simply not *public,* which suggests, perhaps, that it is not much *good.* It is the good not of all, or even of most, persons, but of a small body of individuals. To speak as Hume does of interests, advantages, common to all is to speak dishonestly. We must be clear that this is a very different, and in some respects more urgent, criticism. The objection has changed from the conceptual one that Hume's philosophy

cannot encompass the Rule Utilitarianism which he invents to the moral and political one that his invention is unacceptable. To break away from *moral* particularism we must seek to provide a radically different analysis of interest; and to understand afresh the relationship between interests which are particular and interests which, because they are no one's in particular, transcend that particularity. Rousseau's, rather than Hume's or Mr. Wilson's, social contract is one such attempt.

Why did Hume not see that his conception of the public good, which in the end amounts to little more than the degree of stability necessary for the assured possession, preservation and transmission of property, is a—supremely clever—comic fiction? It would be facile, not to say ridiculous, to answer that his economic and political interests determined his philosophy. If anything, it is the other way round: for Hume, explaining a phenomenon can come very close to exhibiting its inevitability; and it is more sensible to welcome than submit with resignation to the inevitable.

NOTES

[1] Page references are to volume 2 of the Everyman edition, 1949.

[2] A reappraisal of Hume's view of the origins of justice would need to show the extent to which Hume sees social rules as creative, enabling instruments and not merely as inhibiting and restraining ones. It would have to promote features, commonly overlooked, which Hume's account shares with, for instance, Rousseau's second *Discourse* and play down those, commonly exaggerated, which it shares with *Leviathan*. On this matter, Hume is his own worst enemy; and we must not take too seriously his own summary statements of his position, where more often than not he suggests that the *raison d'être* of society is *simply* that "we can better satisfy our appetites in an oblique and artificial manner, than by their headlong and impetuous motion" (III, II, V; p. 223).

[3] Of course, certain ancillary features of Hume's ethics seem to breach, or at least co-exist uneasily with, the doctrine of the direct connexion. A feature with massive implications is Sympathy, with the elaborate adjustments and rectifications of the moral sentiment for which it is made responsible. Later I have something to say about Hume's misplaced confidence in this concoction. It is worth disposing immediately of a different feature which might be thought troublesome in a more limited way. It might be argued that what Hume calls the "artifice of politicians", and the influences of education, are required to *create* the moral approbation which makes the artificial virtues virtuous. Hume anticipates this sort of argument: the efforts of politicians and educators can do no more than "augment . . . by artifice" a sentiment "which follows naturally, and of itself".

4 ". . . the laws of justice arise from natural principles, in a manner . . . oblique and artificial. It is self-love which is their real origin; and as the self-love of one person is naturally contrary to that of another, these several interested passions are obliged to adjust themselves after such a manner as to concur in some system of conduct and behaviour. This system, therefore, comprehending the interest of each individual, is of course advantageous to the public, though it be not intended for that purpose by the inventors". (III, II, VI; p. 229).

5 An earlier paper ("Two views of moral practices", *Analysis*, 33.4) con-nects with this and related issues, and explores them in ways I cannot here.

6 The requirement does not, for instance, dictate that any coherent ex-planation of man must show that he is *at bottom* the same sort of creature as "natural" man. But it does mean that the two conditions of man, how-ever dissimilar they are taken to be, must be situated on a conceptual con-tinuum. Now, the trouble with Hume is not that he fails to recognise this. On the contrary, his refusal to stay with his own distinction between the natural and the artificial is in part the consequence of that recognition as he interprets it. Nor is it that he exaggerates the differences between non-institutional and institutional man, and hence between non-institutional and institutional goods. On the contrary, unlike Rousseau, or even Mill, he grossly understates them. In Rousseau, we find no suggestion that understand-ing social institutions is understanding the complicated machinery whereby we (or those of us who are sufficiently fortunate) are able to satisfy certain pre-existing and basically unchanged appetites in "an oblique and artificial manner". Hume's trouble is that, because of his moral epistemology, he simply cannot make his concept of artificial virtue continuous with his con-cept of natural virtue, and in his efforts to do so ends by reducing the former to the latter. The reduction is widespread, but most pronounced in III, III, VI and III, III, I. The latter section in particular, with its fascinating sinu-osities, witnesses to Hume's need to have his cake and eat it. He distinguishes the artificial virtues in terms of features which must make them (for him) an unaccountably different kind of animal from the natural, and at the same time insists that they *are* natural social virtues.

7 See especially III, II, II, pp. 203-4: ". . . when the injustice is so distant from us as no way to affect our interest, it still displeases us . . . by *sym-pathy*". (Hume's italics).

286

HONORARY MEMBERS

Mr. R. J. BARTLETT, 51 Warrington Road, Harrow, Middx.
Prof. GILBERT RYLE, *Vice-President*, Magdalen College, Oxford, OX1 4UA.
Prof. H. H. PRICE, *Vice-President*, Hillside, 69 Jack Straws Lane, Oxford OX3 oDW.
Prof. R. B. BRAITHWAITE, *Vice-President*, King's College, Cambridge, CB2 1ST.
Mrs. M. MACE, 105 Roebuck House, Stag Place, London, S.W.1.
The Rev. M. C. D'ARCY, S. J., 114 Mount Street, London, W.1.
Prof. L. A. REID, 50 Rotherwick Road, London, N.W.11.
Mrs. B. ACTON, 5 Abbotsford Park, Edinburgh, 10.
*Prof. B. BLANSHARD, 4 St. Ronan Terrace, New Haven, 11. Conn., USA.

MEMBERS

Elected

‡1932 Prof. R. I. AARON, *Vice-President*, Garth Celyn, St. David's Road, Aberystwyth, Wales.

1975 C. ABRAHAM, 12 Helvedon Road, London, SW6 5BW.

§1948 Prof. J. L. ACKRILL, Brasenose College, Oxford.

1964 W. L. ACROMAN.

Ω1935 Prof. ELOF AKESSON, Skolradsvägen, 9, S-223 67 Lund, Sweden.

1959 Prof. V. C. ALDRICH, Dept. of Philosophy, University of North Carolina, Chapel Hill, North Carolina 27514, U.S.A.

§1945 P. ALEXANDER, Dept. of Philosophy, The University, Bristol 8.

*1966 Prof. D. J. ALLAN, 83 Bainton Road, Oxford.

*1966 HAROLD J. ALLEN, Dept. Phil., Adelphi Univ., Garden City L.I., New York 11830, U.S.A.

*†1975 Prof. W. P. ALSTON, Dept. of Philosophy, University of Illinois, Urbana, Ill. 81801, U.S.A.

1972 J. E. J. ALTHAM, Gonville and Caius College, Cambridge, CB2 1TA.

‡1969 D. J. C. ANGLUIN, Dept. of Sociology, The Polytechnic of North London, Ladbroke House, Highbury Grove, London, N5 2AD.

*†1971 Miss J. ANNAS, St. Hugh's College, Oxford.

‡1956 Prof. G. E. M. ANSCOMBE, 3 Richmond Road, Cambridge.

*†1969 SANSANDRO ARCOLEO, Via F. Sivori 1/18, 16134 Genova, Italy.

*†1960 Prof. PALL S. ARDAL, Department of Philosophy, Queen's University, Kingston, Ontario, Canada.

*†1969 Prof. D. M. ARMSTRONG, Dept. of Philosophy, Sydney University, Sydney, N.S.W. 2006, Australia.

1955 R. ASHBY, 14 Knoll Court, Farquhar Road, London, S.E.19.

†1957 Prof. R. F. ATKINSON, Dept. of Philosophy, University of York, Heslington, York.

1967 Mrs. J. AUSTIN, St. Hilda's College, Oxford.

1976 S. AXINN, 84 Greenhill, Prince Arthur Road, London, NW3.

1933 Prof. Sir ALFRED AYER, *Vice-President*, New College, Oxford.

1964 M. R. AYERS, Wadham College, Oxford.

1949 Prof. K. E. BAIER, University of Pittsburg, Faculty of Arts & Sciences, Dept. of Philosophy, Pittsburg, PA15260 USA.

1969 GEOFFREY BAILEY.

*1966 E. BAKER, "The Bays", Kings Road, Southminster, Essex.

*1974 T. R. BALDWIN, Dept. of Philosophy, University of York, Heslington, York, YO1 5DD.

1972 G. B. BALLESTER, Linacre College, Oxford.

‡1960 J. R. BAMBROUGH, St. John's College, Cambridge.

1966 Prof. F. RIVETTI-BARBO, Via Pietro Mascagni, No. 2, 20122 Milan, Italy.

‡1960 M. J. W. BARKER, Danby Lodge, 239 West Ella Road, W. Ella, East Yorkshire.

Elected

‡1969 J. BARNES, Oriel College, Oxford.

1944 Prof. W. H. F. BARNES, 7, Great Stuart Street, Edinburgh, EH3 7TP.

*1962 Father CYRIL BARRETT, S. J., University of Warwick, Coventry.

1969 Mrs. E. J. C. BAXENDALE, 114 Petersburg Road, Edgeley, Stockport, Cheshire.

‡1975 A. BAXTER, Many Trees, Packhorse Road, Bessels Green, Sevenoaks, Kent, TN13 2QP.

1968 R. W. BEARDSMORE, Bryn Awel, Star, Gaerwen, Isle of Anglesey, Gwynedd.

1961 R. A. BECHER, 6 Weech Road, London, N.W.6.

1956 E. BEDFORD, Dept. of Philosophy, University of Edinburgh, David Hume Tower, George Square, Edinburgh 8.

1955 W. BEDNAROWSKI, 31 College Bounds, Old Aberdeen.

§1974 MARTIN BELL, Dept. of Philosophy, University of York, Heslington, York.

†1975 ANDREW BELSEY, Dept. of Philosophy, University College, Cardiff, CF1 1XL.

§1959 S. J. BENN, Inst. of Advanced Studies, Australian National University, P.O. Box. 4, Canberra A.C.T. 2600, Australia.

1941 J. G. BENNETT, The Institute for the Comparative Study of History, Philosophy of The Sciences Ltd., Sherbourne House, Sherbourne, Cheltenham, Glos.

*†1957 Prof. J. F. BENNETT, Dept. of Philosophy, University of British Columbia, Vancouver 8, B.C., Canada.

‡1963 Prof. J. H. BENSON, Dept. of Philosophy, Bowland College, Bailrigg, Lancaster.

§1970 Mrs. F. BERENSONG, 13 Lansdowne, 9/10 Carlton Drive, Putney, London S.W.15.

1937 Prof. Sir ISAIAH BERLIN, *Vice-President*, Wolfson College, Oxford.

1945 U. R. BHATTACHARYYA, 103 Rash Behari Avenue, Calcutta 20, India.

1956 PETER BINDLEY, 11 Leinster Road, Muswell Hill N.10.

‡1955 Prof. G. H. BIRD, Dept. of Philosophy, The University of Stirling, Stirling.

1935 Prof. MAX BLACK, 408 Highland Road, Ithaca, New York, U.S.A.

1971 ROBERT K. BLACK, Dept. of Philosophy, The University of Nottingham, University Park, Nottingham NG7 2RD.

‡1974 S. BLACKBURN, Pembroke College, Oxford.

*1961 Miss MARGARET A. BODEN, The University of Sussex, School of Social Studies, Brighton BN1 9QN.

‡1974 Mrs. A. V. BOFF (24/3/75).

1975 D. E. BOLTON, 3 Kenley Close, Bexley, Kent.

*†1970 E. J. BOND, 4226 Bath Road, Kingston, Ontario, Canada.

*1965 W. L. BONNEY, Dept. of Philosophy, University of Sydney, Australia.

‡1974 C. V. BORST, Dept. of Philosophy, University of Keele, Newcastle, Staffs, ST5 5BG.

1972 DAVID BOSTOCK, Merton College, Oxford.

1969 Miss SOPHIE BOTROS (14/4/74).

1956 Prof. T. B. BOTTIMORE, Office of the Arts Deans, Arts Building, University of Sussex, Falmer, Brighton, Sussex.

§1972 K. BOUDOURIS, 57 Solonos Street, The University, Athens.

§1975 JOHN BOUSFIELD, 2 Lingfield House, Park Court, Lawrie Park Road, London, S.E.26.

1972 M. HARRISON BOYLE, 6 Wyneham Road, London S.E.24.

‡1967 D. D. C. BRAINE, Dept. of Logic, King's College, Old Aberdeen, Scotland.

1933 Mrs. M. M. BRAITHWAITE, 11 Millington Road, Cambridge.

*†1970 E. P. BRANDON, St. Mary's College, The Park, Cheltenham, GL50 2RH.

Elected

1975 T. BRISTOL, London House, Mecklenburgh Square, London WC1.

‡1937 Prof K. W. BRITTON, Horthope, Millfield Road, Riding Mill, Northumberland.

1969 A. BROADIE, Dept. of Moral Philosophy, The University, Glasgow W.2.

*1971 F. BROADIE, Dept. of Philosophy, The University of Edinburgh, David Hume Tower, George Square, Edinburgh 8.

1952 D. G. BROWN, Dept. of Philosophy, University of British Columbia, Vancouver, Canada.

*†1949 N. J. BROWN, Dept. of Philosophy, Queen's University, Kingston, Ontario, Canada.

§1954 ROBERT BROWN, Dept. of Social Philosophy, Australian National University, Canberra, A.C.T., Australia.

1962 S. C. BROWN, 42 Park Road, New Barnet, Herts.

1967 Prof. J. E. BROWLES (14/4/74).

1963 Miss NADINE BRUMMER (14/4/74).

†1974 P. D. BRUNNING, 38 Elsworthy Road, London N.W.3.

§1948 J. A. BRUNTON, University College, Cathays Park, Cardiff.

*†1974 CHRISTOPHER BRYANT, Dept. of Moral Philosophy, The University, St. Andrews, Fife.

1966 GERD BUCHDAHL, 11 Brookside, Cambridge.

1948 ROGER BUCK (14/4/74).

1962 T. E. BURKE, Dept. of Philosophy, The University, Reading.

‡1964 M. F. BURNYEAT, 203 Highbury Quadrant, London N5 2TE.

§1975 P. A. BYRNE, Dept. of Philosophy of Religion, University of London, Kings College, Strand, London WC2R 2LS.

*1969 Mrs. EVA H. CADWALLADER, Department of Philosophy, Westminster College, New Wilmington, Pa. 16142, U.S.A.

1952 Prof. GUIDO CALOGERO (14/4/74).

1951 Prof. J. M. CAMERON, St. Michael's College, University of Toronto, Toronto 5, Ontario, Canada.

*†1974 Dr. RICHARD CAMPBELL, Dept. of Philosophy, S.G.S., Australian National University, Box 4, P.O., Canberra, A.C.T., Australia 2600.

1964 T. D. CAMPBELL, Dept. of Philosophy, University of Stirling, Stirling FK9 4LA, Scotland.

*†1974 STEWART CANDLISH, Dept. of Philosophy, University of Western Australia, Nedlands 6009, Western Australia.

†1975 A. D. CARSTAIRS, 12 Blenheim Road, London W4 1UA.

1975 T. CARVER, Dept. of Political Theory and Institutions, Roxby Buildings, P.O. Box 147, The University, Liverpool, L69 3BX.

‡1957 Miss EVA CASSIRER, 1 Berlin 33, Wildpfad 28, West Germany.

*†1967 Prof. HECTOR-NERI CASTANEDA, Dept. of Philosophy, Indiana University, Bloomington, Indiana 47401.

§1971 Mrs. S. C. DE CASTELL-JUNGHERTZ, 49 Craven Walk, Stamford Hill, London, N.16.

*1957 Prof. STANLEY CAVELL (14/4/74).

1946 Prof. A. P. CAVENDISH, Dept. of Philosophy, St. David's College, Lampeter, Cards., Wales.

*1970 J. H. CHANDLER, Philosophy Dept., University of Adelaide, Adelaide, South Australia, 5001.

1973 S. CHANDRA (6/11/73).

1976 Mrs. L. M. CHANEY, 24 Wilmar Close, Uxbridge, Mx. (U2).

*†1959 Prof. V. C. CHAPPELL, Dept. of Philosophy, University of Massachusetts, Amherst, Mass. 01002, U.S.A.

§1966 Mrs. A. CHARLTON, Lee Hall Wark, Hexham, Northumberland.

1963 Prof. E. L. CHERBONNIER, 72, Eaton Place, London, S.W.1.

1974 C. M. CHERRY, Eliot College, The University, Canterbury, Kent.

1958 Prof. N. CHOMSKY, Massachusetts Institute of Technology, Cambridge 39, Mass., U.S.A.

Elected

1956 Y. N. CHOPRA, (22/10/75).

1958 Prof. W. A. CHRISTIAN, 1567 Timothy Dwight College, Yale University, New Haven, Conn., U.S.A.

1974 Prof. F. CIOFFI, Dept of Philosophy, University of Essex, Colchester. CO3 3SQ.

§1975 A. W. CLARE, 105 Monks Orchard Road, Beckenham, Kent BR3 3BX.

§1963 M. CLARK, Dept. of Philosophy, The University, Nottingham NG7 2RD.

§1975 STEPHEN R. L. CLARK, 9 Clarence Drive, Glasgow G12 9QL.

1976 P. COATES, 15a Pembridge Crescent, London, W11 3DX (P5).

*1970 Prof. A. B. CODY, Dept. of Philosophy, San Jose State College, San Jose, California, 95114, U.S.A.

1975 J. COFMAN-NICORESTI, 18 Lord Roberts Avenue, Leigh-on-Sea, Essex.

1961 Mrs. B. M. COHEN, Dept. of Philosophy, The University of Surrey, Guildford, Surrey.

1976 Mrs. CYNTHIA B. COHEN, 3935 Penberton, Ann Arbor, Michigan, 48105, U.S.A.

1963 G. A. COHEN, Dept. of Philosophy, University College, Gower Street, W.C.1.

†1969 JERALD M. COHEN, (14/4/74).

*1959 JOSEPH J. COHEN, 150 West End Avenue, Apt. 25F, New York 10023, U.S.A.

§1948 L. JONATHAN COHEN, The Queen's College, Oxford.

‡1968 M. COHEN, Dept. of Philosophy, University College of North Wales. Bangor.

*†1972 SHELDON M. COHEN, Department of Philosophy, University of Tennessee, Knoxville, Tenn. 37916. U.S.A.

§1975 A. R. COLCLOUGH, 65 Winchendon Road, Teddington, Middx.

1971 Mrs. DIANE J. COLLINSON, Peekmill, Ivybridge, Devon, PL21 0LA.

§1976 Prof. JOHN CRONQUIST, Dept. of Philosophy, California State University Fullerton, Fullerton, California 92634, U.S.A.

1975 D. E. COOPER, School of Humanities and Social Sciences, Dept. of Philosophy, Guildford, Surrey.

1959 N. COOPER, 2 Minto Place, Dundee, Scotland, DD2 1BR.

1946 Prof. F. C. COPLESTON, S.J., 11 Cavendish Square, London, W1M 0AN.

1972 Prof. STEVEN CORD, 580 N. 6 Street, Indiana, Pa. 15701, U.S.A.

1976 M. CORRADO, Dept. of Philosophy, Ohio University, Athens, Ohio.

1961 S. COVAL, Dept. of Philosophy, University of British Columbia, Vancouver 8, B.E. Columbia.

*1946 SYBIL M. CRANE, 2 Britannia Square, Worcester.

§1973 Prof. J. M. B. CRAWFORD, Common Room, Middle Temple Lane, Middle Temple, E.C.4.

1953 CAMPBELL CROCKET, The Spyglass, Apt. 520, 1600 Thomson Hghts. Dr., Cincinnati, Ohio 45223, U.S.A.

1948 I. M. CROMBIE, Wadham College, Oxford.

‡1941 Prof. R. C. CROSS, The University, Aberdeen.

‡1963 C. R. A. CUNLIFFE, 29 Riverdale Gardens, Twickenham.

1954 Mrs. F. K. CUTLER, Bramley College, Sandy Lane, Bearsted, Kent.

§1975 Dr. MELVIN T. DALGARNO, 16 College Bounds, Aberdeen.

§1975 J. P. DANCY, Dept. of Philosophy, University of Keele, Keele, Staffs. ST5 5BG.

1948 J. P. DE C. DAY, Dept. of Philosophy, University of Keele, Keele, Staffordshire.

‡1965 R. F. DEARDEN, 49, Wattleton Road, Beaconsfield, Bucks, HP9 1RY.

*1969 Prof. CORNELIUS DE DEUGD, "Ravesteyn", Bourmalsen, Holland.

§1971 M. A. B. DEGENHARDT, Stockwell College, Rochester Avenue, Bromley, Kent.

Elected

†1973 COUNT LYSANDER DE GRANDY, Glen Eyre Hall, Bassett, Southampton, SO9 2QN.

1964 D. DENEAU (14/4/74).

†1975 N. J. H. DENT, Dept. of Philosophy, University of York, Heslington, York YO1 5DD.

1947 Prof. PHILIP DEVAUX, 88 Avenue Messidor, Brussels, Belgium.

*†1957 Prof. P. DIAMONDOPOULOS, Brandeis University, Waltham, Mass. 02154, U.S.A.

1962 Miss CORA DIAMOND, Dept. of Philosophy, The University of Virginia, 1512, Jefferson Park Avenue, Charlottesville, Virginia 22901, U.S.A.

1970 MALCOLM L. DIAMOND (18/10/71).

1975 R. DIETZ, 8 Fieldend, Waldergrave Park, Twickenham, Middx. TW1 4TF.

1974 K. J. DILLON, 6 Summit Close, Colindale, London, N.W.9.

1955 ILHAM DILMAN, Dept. of Philosophy, University College of Swansea, South Wales.

*†1970 M. A. DIXEY (4/12/74).

‖¶1965 K. DIXON, Dept. of Sociology, Simon Fraser University, Burnaby B.C., Canada, V5A 1S6.

‡1952 A. H. DONAGAN, 1453 East Park Place, Chicago, Illinois 60637, U.S.A.

§1952 WILLIS DONEY, Dept. of Philosophy, Dartmouth College, Hanover, New Hampshire, U.S.A.

1961 Prof. K. S. DONNELLAN (14/4/74).

1968 NIGEL DOWER, Dept. of Logic and Moral Philosophy, Univ. of Aberdeen, King's College, Old Aberdeen.

§1961 Prof. R. S. DOWNIE, Dept. of Moral Philosophy, The University, Glasgow W.2.

1955 P. DOWNING, c/o Messrs. Turner, Peacock, 1 Raymond Buildings, Gray's Inn, London WC1R 5RJ.

†1969 B. S. DRASAR, Bacterial Metabolism Laboratory, Central Public Health Laboratories, Colindale Avenue, Colindale, NW9 5EQ.

†1952 W. H. DRAY, Dept. of Philosophy, Trent University, Peterborough, Ontario, Canada.

1967 Prof. D. P. DRYER, Room 819, 215 Huron Street, University of Toronto, Toronto 5, Canada.

1951 M. DUMMETT, All Souls College, Oxford.

*†1967 Prof. ELMER H. DUNCAN, Baylor University, Dept. of Philosophy, Waco, Texas 76703, U.S.A.

‡1938 Prof. ALISTAIR R. C. DUNCAN, Queen's University, Kingston, Ontario, Canada.

§1945 Sir GEORGE DUNNETT, K.B.E., C.B., Hon. Treasurer, Basings Cottage, Cowden, Kent.

1972 A. P. DURHAM, Philosophy Department, UCLA Los Angeles, Calif. 90024, U.S.A.

*1950 R. G. DURRANT, Dept. of Philosophy, University of Otago, Dunedin, New Zealand.

1964 D. J. DUTHIE, 35 Holmesdale Road, London N.6.

*1970 JOHN L. DWYER, Owen-Dixon Chambers, 205 William St., Melborne, Vic. 3000, Australia.

†1970 J. C. DYBIKOWSKI, Dept. of Philosophy, University of British Columbia, Vancouver 8, B.C., Canada.

1971 Prof. W. EASTMAN, Dept. of Philosophy, Univ. of Alberta, Edmonton 7, Canada.

1969 Mrs. D. M. D. EDGINGTON, Dept. of Philosophy, Birkbeck College, Malet Street, London, W.C.1.

‡1958 Prof. R. EDGLEY, The University of Sussex, Arts Building, Falmer, Brighton, Sussex BN1 9QN.

Elected

§1974 MICHAEL EDWARDS, 134 Colney Hatch Lane, Muswell Hill, London, N10 1ER.

1962 Prof. PAUL EDWARDS (14/4/74).

1956 Miss D. H. ELDERTON, 15 Wren Street, W.C.1.

1966 Prof. R. K. ELLIOTT, 12 Coppice Road, Moseley, Birmingham B13 9DD.

1934 Prof. DOROTHY EMMET, Vice-President, 11 Millington Road, Cambridge.

1966 GALE W. ENGLE (14/4/74).

1956 ELLIS C. EVANS, 102 Woodhead Road, Holmbridge, Huddersfield.

1971 GARETH EVANS, University College, Oxford.

§1974 J. D. G. EVANS, Sidney Sussex College, Cambridge CB2 3HU.

*†1946 Prof. J. L. EVANS, The Dingle, Danybryn Avenue, Radyr, nr. Cardiff.

1958 H. S. EVELING, Dept. of Philosophy, David Hume Tower, George Square, Edinburgh 8.

§1953 J. EVENDEN, "Milton", 8 St. John's Avenue, Burgess Hill, Sussex.

*1968 NICHOLAS EVERITT, University of East Anglia School of Social Studies, University Plain, Norwich NOR 88C.

1968 Dr. GERTRUDE EZORSKY (14/4/74).

*1974 B. FALK, Dept. of Philosophy, University of Birmingham, Birmingham 15.

‡1971 E. J. FARGE, 12 Tanza Road, Hampstead, London, N.W.3.

1947 B. A. FARRELL, Corpus Christi College, Oxford.

*†1976 JOEL FEINBERG, The Rockefeller University, 1230 York Avenue, New York, N.Y. 10021, U.S.A.

1974 L. FIELDS, Department of Philosophy, The University, Dundee, Scotland.

*1948 Prof. J. N. FINDLAY, Vice-President, Department of Philosophy, Boston University, 232 Bay State Road, Boston, Mass. 02215 U.S.A.

1963 Miss M. FINNEGAN, Dept. of Politics, Alfred Marshall Buildings, 40 Berkeley Square, Bristol 8.

1975 D. R. FISHER, 23 Twining Avenue, Twickenham, Middx.

*1976 Prof. JOSEPH FLANAGAN, S.J., Chairman, Dept. of Philosophy, Boston College, Chestnut Hill, Mass. 02167, U.S.A.

†1952 Prof. A. G. N. FLEW, Dept. of Philosophy, The University, Reading, RG6 2AA.

1948 Mrs. P. R. FOOT, 15 Walton Street, Oxford.

1954 P. FOULKES, 24 Granville Park, London, S.E.13.

*1968 D. L. FOWLER, Dept. of Philosophy, The University of Trondheim, College of Arts & Sciences, 7000 Trondheim, Norway.

*†1970 WILLIAM H. FREIDMAN, V.C.U. Philosophy Dept., Richmond, Va. 23220, U.S.A.

†1967 Prof. PIERRE C. FRUCHON, Les Cjenets, Residence du Poutet, 33 Pessac, France.

1936 Prof. E. J. FURLONG, 9 Trinity College, Dublin, Eire.

1973 Miss SUZI GABLIK, 5 Westmoreland Street, London W.1.

§1966 J. W. GALBRAITH, 5 Sanda Street, Glasgow N.W.

1968 ROGER D. GALLIE, Dept. of Philosophy, The University, Leicester.

1937 Prof. W. B. GALLIE, Vice-President, Peterhouse, Cambridge.

1950 P. L. GARDINER, Magdalen College, Oxford.

1963 J. GARLAND, 30 Moore Street, S.W.3.

§1968 R. T. GARNER, Dept. of Philosophy, Ohio State University, 216 North Oval Drive, Columbus, Ohio 43210, U.S.A.

1972 Mrs. G. D. V. GARTHWAITE, 40 Sandy Bank Avenue, Rothwell, Leeds LS26 0ER.

292

Elected
§1971 P. GASCOIGNE, 5 Hartington Villas, Hove, Sussex BN3 6HF.
1968 Mrs. NANCY GAYER, 1 Durham Terrace, London W.2.
*1948 QUENTIN B. GIBSON, Dept. of Philosophy, S.G.S., Australian National Univ., Canberra A.C.T., Australia.
§1975 A. J. GILMOUR, 316 Alexander Park Road, London, N.22.
‡1959 P. GOCHET, 78 Boulevard Louis Schmict, 1040 Brussels, Belgium.
1969 P. A. GOLDSBURY, 104 Livingstone Road, Hove, Sussex, BN3 3WL.
1970 J. GONLEY, 12 Gardenia Avenue, Luton, Beds.
1962 PHILIP GORDIS, 1 West 81st Street, Apartment 4DB, New York City New York 10024, U.S.A.
1951 D. R. GORDON, Dept. of Philosophy, University of Strathclyde, Livingstone Tower, 26 Richmond Street, Glasgow, G1 1XH.
1956 J. C. B. GOSLING, St. Edmund Hall, Oxford.
1975 KEITH GRAHAM, Dept. of Philosophy, The University of Bristol, Wills Memorial Building, Queens Road, Bristol, BS8 1RJ.
*1946 Prof C. K. GRANT, Philosophy Dept., The University, Durham.
1964 E. P. C. GREENE, 63F High Street, Oxford.
*†1969 Prof. HAROLD GREENSTEIN, 71 West Avenue, Brockport, New York 14420, U.S.A.
1967 Prof. W. H. GREENLEAF (14/4/74).
1956 Miss M. GREENWOOD, 66 Cliff Road, Leeds 6.
§1969 T. GREENWOOD, Dept. of Logic, University of Glasgow, Glasgow W.2.
1957 H. GREVILLE, "Walden", Bury Road, Stanningfield, Bury St. Edmunds, Suffolk.
1956 Prof. A. P. GRIFFITHS, Dept. of Philosophy, The University of Warwick, Coventry, Warwickshire.
†1975 J. L. GRIFFITHS, 1a Derby Road, Tolworth, Surbiton, Surrey, KT5 9AY. (P1)
*1968 B. GROSS (14/4/74).
*1964 H. R. J. GRUNER, Dept. of Philosophy, Sheffield University, Sheffield.
1969 C. E. GUNTON, 33 South Drive, Brentwood, Essex.
*1957 M. D. SUMAN GUPTA (14/4/74).

§1974 Miss SUSAN HAACK, Dept. of Philosophy, University of Warwick, Coventry, Warcs, CV4 7AL.
1946 Prof. W. HAAS, The University, Manchester 13.
1963 Prof. I. M. HACKING (14/4/74).
§1975 Miss A. HADJIPATERAS, 22 Abbey Lodge, Park Road, London N.W.8.
1965 V. HAKSAR, University of Edinburgh, Dept. of Philosophy, David Hume Tower, George Square, Edinburgh, EN8 9JK.
1962 J. C. HALL, 25 Hepburn Gardens, St. Andrews, Fife, Scotland, KY16 9DG.
*†1972 Miss JANET HALL (1/8/75).
§1957 ROLAND HALL, Dept. of Philosophy, University of York, Heslington, Yorks.
1959 Prof. R. HALLER, Karl-Franzens-Universitat, Graz, Philosophischas. Institut, Heinrichstrasse 26/VI, A-8010 Graz, Austria.
‡1951 Prof. D. W. HAMLYN, 7 Burland Road, Brentwood, Essex.
1961 Miss A. HAMMOND, Flat 3, 33 Hampstead Hill Gardens, London N.W.3.
1937 STUART HAMPSHIRE, The Warden's Lodgings, Wadham College, Oxford.
1970 O. HANFLING, Linnets, Terry's Lane, Cookham, Maidenhead, Berks.
1959 R. ALISTAIR HANNAY, Institute of Philosophy, Niels Henrik Abels Vei 12, Blindern, Oslo 3, Norway.
*1945 J. B. HANSON-LOWE, c/o Mailing Section, Shell Sekiyu K.K., C.P.O. Box 1239, Tokyo, Japan.

Elected

§1947 Prof. R. M. HARE, *Vice-President*, Corpus Christi College, Oxford.

*1972 Prof. B. HARRIS, Eastern Kentucky University, College of Arts & Sciences Dept. of Philosophy, Richmond, Kentucky 40475, U.S.A.

1952 Prof. ERROL E. HARRIS, Dept. of Philosophy, North Western University, Evanston, Illinois, U.S.A.

‡1975 J. M. HARRIS, 62 Princes Street, St. Clements, Oxford.

1976 L. D. HARRIS, 75 Reading Road., Northolt, Mx. UB5 4PJ.

1962 ANDREW HARRISON, Dept. of Philosophy, The University, Bristol 8.

‡1962 Prof. B. J. HARRISON, School of English and American Studies, University of Sussex, Arts and Building, Falmer, Brighton, Sussex.

‡1947 Prof. J. HARRISON, Dept. of Philosophy, The University, Nottingham NG7 2RD.

‡1971 T. R. HARRISON, King's College, Cambridge CB2 1ST.

†1946 Prof. H. L. A. HART, *Vice-President*, The Principal, Brasenose College, Oxford.

*†1975 W. D. HART, Dept. of Philosophy, University College London, Gower Street, London, WC1E 6BT.

1959 Miss L. C. HARVARD, The Old Rectory, Stock, Ingatestone, Essex.

†1973 H. H. HARVEY, Seafields, Blackgang, Ventnor, Isle of Wight.

1965 LAWRENCE HAWORTH, University of Waterloo, Dept. of Philosophy, Waterloo, Ontario, Canada.

1946 W. H. HAY, 39 Bagley Court, Madison, Wisconsin 53705, U.S.A.

*1946 Prof. P. L. HEATH, Dept. of Philosophy, University of Virginia, Charlottesville, U.S.A.

*1962 Prof. J. HEINTZ, Dept. of Philosophy, Faculty of Arts & Science, University of Calgary, Alberta, Canada T2N TN4.

*1967 PAUL HELM (14/4/74).

1968 M. HEMPOLINSKI (14/4/74).

*1958 Prof. G. P. HENDERSON, Dept. of Philosophy, The University, Dundee, Scotland.

1975 Miss P. A. HENDRA, 52 Glenloch Road, Hampstead, London, NW3.

†1969 Prof. D. HENRICH, Philosophisches Seminar, Der Universitat, 69 Heidelberg 1, Marsiliusplatz 1, West Germany.

1955 Prof. R. W. HEPBURN, Dept. of Philosophy, University of Edinburgh, David Hume Tower, George Square, Edinburgh 8.

1956 Miss M. B. HESSE, Whipple Museum, Free School Lane, Cambridge.

1949 T. J. O. HICKEY, 23 Lloyd Square, London, W.C.1.

‡1965 Prof. DAVID C. HICKS, Dept. of Theology, King's College, Old Aberdeen, Scotland, AB9 2UB.

‡1972 R. C. HICKS, Walcot, North Walls, Chichester, Sussex, PO19 1DB.

‡1974 GEOFFREY J. C. HIGGS, 78 New Kings Road, Fulham, London, S.W.6.

‡1966 Mrs. CORINNE HILL, 47 High Street, Hinxton, Saffron Walden, Essex.

‡1968 Mrs. RUTH HILLYER, Prior's Field, Godalming, Surrey GU7 2RH.

†1949 JOHN R. HILTON, Hope Cottage, Nash Hill, Lacock, Wilts.

*†1959 Prof. J. HINTIKKA, Mantypaadentie 13 as 3, 00830 Helsinki, Finland.

*1958 J. M. HINTON, Worcester College, Oxford.

‡1972 R. T. HINTON, 38 Regency Square, Brighton BN 2FT.

1964 E. HIRSCHMANN, 9 Limes Avenue N.12.

*†1961 Prof. P. H. HIRST, University of Cambridge, Department of Education, 17 Brookside, Cambridge CB2 1JG.

1954 Prof. R. J. HIRST, 179 Maxwell Drive, Glasgow, G41 5AE.

*1960 Prof. R. HOCKING, Madison, New Hampshire 03849, U.S.A.

1934 Prof. H. A. HODGES, 3 Grahame Avenue, Pangbourne, Berks, RH8 7LF.

*†1960 ROBERT HOFFMAN, 9, Wycomb Place, Coram, New York, 11727, U.S.A.

Elected

*1964 Prof. L. C. HOLBOROW, Dept. of Philosophy, University of Queensland, St. Lucia, 4067, Queensland, Australia.

§1950 Prof. R. F. HOLLAND, Dept. of Philosophy, The University of Leeds, Leeds 2.

§1968 L. A. HOLLINGS, Flat 1, 123, Ditchling Rise, Brighton, BN1 4QP.

1967 MARTIN HOLLIS, School of Social Studies, Dept. of Philosophy, University of East Anglia, Norwich.

*†1944 E. R. HOLMES, 84 Commercial Road, Bulwell, Nottingham.

†1962 T. HONDERICH, Dept. of Philosophy, University College, Gower Street, London, W.C.1.

1974 JAMES HOPKINS, King's College, Strand, London, W.C.2.

1954 Prof. JOHN HOSPERS (14/4/74).

1975 Miss JANE M. HOWARTH, Dept. of Philosophy, University of Lancaster, Lancaster, Lancs.

*1968 W. D. HUDSON, Dept. of Philosophy, The University, Exeter.

1946 Prof. G. E. HUGHES, Dept. of Philosophy, Victoria University of Wellington, P.O. Box 196, Wellington, New Zealand.

1970 G. J. HUGHES, Heythrop College, 11 Cavendish Square, London, W1M 0AN.

1964 W. H. HUGHES, Wellington College, University of Guelph, Ontario, Canada.

1959 P. HUGHESDEN, 107 Corringham Road, London, N.W.11.

1959 I. HUNT, University of Sussex, Falmer, Sussex.

1952 G. B. B. HUNTER, Dept. of Logic and Metaphysics, The University, St. Andrews, Fife, Scotland.

¶1968 D. E. IDONIBOYE, School of Humanities, Dept. of Philosophy, University of Lagos, Lagos, Nigeria.

*1963 M. P. IRELAND, Dept. of Philosophy, School of Social Studies, University of Sussex. Brighton BN1 9QN.

1960 Miss HIDE ISHIGURO, Dept. of Philosophy, University College, Gower Street, London, W.C.1.

§1975 TARIQ ISMAIL, 103 South Hill Park, London N.W.3.

†1972 Prof. NANDINI R. IYER, Dept. of Philosophy, University of California, Santa Barbara, California, 93106, U.S.A.

*†1967 Mrs. J. M. JACK, Somerville College, Oxford OX2 6HD.

1958 A. C. JACKSON, Monash University, Victoria, Australia.

§1955 R. B. JACKSON, The Cottage, 9c, The Grove, London, N6 6JU.

1975 N. JARDINE, Whipple Museum of the History of Science, Dept. of History & Philosophy of Science, Free School Lane, Cambridge CB2 3RH.

1965 J. J. JENKINS, Dept. of Moral Philosophy, David Hume Tower, George Square, Edinburgh 8.

1936 Prof. T. E. JESSOP, The University, Hull.

‡1970 H. JOHANNESSEN, Department of Philosophy, University of Trondheim, Trondheim, Norway.

*†1957 Prof. A. H. JOHNSON, Dept. of Philosophy, The University of Western Ontario, London, Ontario, Canada.

1966 Miss S. E. JOHNSON (14/4/74).

1964 Mrs. K. JONES (14/4/74).

§1958 O. R. JONES, Dept. of Philosophy, University College of Wales, Aberystwyth.

‡1964 P. H. JONES, Dept. of Philosophy, University of Edinburgh, David Hume Tower, George Square, Edinburgh 8.

1964 R. T. JONES, 3 Tungate Crescent, Cringleford, Norwich.

‡1955 Z. A. JORDAN, Dept. of Sociology and Anthropology, Carleton, University, Ottawa 1, Canada.

Elected

*†1967 W. D. JOSKE, Dept. of Philosophy, University of Tasmania, G.P.O. Box 252, Hobart 7001, Tasmania, Australia.

1969 N. S. JUNANKAR, 25 Welldon Crescent, Harrow, Middlesex.

1959 Miss S. E. KAHN (14/4/74).

1973 H. KAMP, Dept. of Philosophy, Bedford College, Regents Park, London NW1.

1954 A. A. KASSMAN, *Hon. Secretary & Editor*, 31 West Heath Drive, London, NW11 7QG.

*1970 B. P. P. KEANEY, Dept. of Philosophy, University of Cape Town, Private Bag, Rondebosche, Cape Province, Republic of South Africa.

†1969 Mrs. GILLIAN KEENE, 38 Kidbrooke Gardens, London S.E.3.

*†1963 Prof. C. W. KEGLEY, 7115 Mensa Verdi Way, Bakersfield, California, 93369, U.S.A.

1963 Prof. J. KEMP, Dept. of Moral Philosophy, The University, Leicester.

1956 LIONEL KENNER (14/4/74).

§1975 G. B. KESSLER, Flat 24, Ridgmount Gardens, London, W.C.1.

‡1971 Miss S. KHIN ZAW, 4 Devereux Road, London, S.W.11.

*1966 Prof. HOWARD E. KIEFER, State University College at Brockport, Brockport, New York, 14420, U.S.A.

*†1968 Prof. W. J. KILGORE, Dept. of Philosophy, Baylor University, Waco, Texas 76709, U.S.A.

1966 Miss E. F. KINGDOM, Institute of Extension Studies, 1 Abercromby Square, P.O. Box 147, Liverpool, L69 3BX.

*1969 Rev. Dr. F. T. KINGSTON, Canterbury College, University of Windsor, Windsor, Ontario, Canada.

†1967 ROBERT KIRK, Dept. of Philosophy, The University, Nottingham, NG7 2RD.

1960 C. A. KIRWAN, Exeter College, Oxford.

*†1963 M. KITELEY (14/4/74).

 Miss ASTRID KJARGAARD, Universitetslektor Ternevej 43, 5000 Odense, Denmark.

‡1968 STANLEY S. KLEINBERG, Dept. of Philosophy, The University, Stirling, Scotland.

*†1937 Mrs. M. KNEALE, *Vice-President*, 4 Bridge End, Grassington, Nr. Skipton, N. Yorks,. BD23 5NH.

*1933 Prof. W. KNEALE, *Vice-President*, 4 Bridge End, Grassington, Nr. Skipton, N. Yorks., BD23 5NH.

1946 G. KNEEBONE, Bedford College, Regent's Park, N.W.1.

*†1973 Prof. K. KOLENDA, *North American Representative*, Dept. of Philosophy, Rice University, Houston, Texas, 77001, U.S.A.

¶1946 Prof. S. KORNER, Vice-President, Philosophy Dept., The University, Bristol 8.

1970 Miss ANASTASIA KUCHARSKI, 209 Spring Avenue, Arlington, Mass., 02174, U.S.A.

1966 D. KUMAR (14/4/74).

1963 P. W. KURTZ (14/4/74).

1962 D. KUSHNER (14/4/74).

1969 GERHARD H. KUSOLITSCH, 27 Highlands Heath, Portsmouth Road, London, S.W.15.

§1954 A. R. LACEY, Bedford College, London, N.W.1.

1965 Prof. JOHN LACEY (1972).

1975 L. LAGDEN, 12 Rutland Gardens, Harringay, London N4.

‡1976 A. C. LAMBERT, 2 Shaw Court, Ninehams Road, Caterham, Surrey CR3 5LL.

1974 Mrs. J. F. LAMBERT, 31 Finchams Close, Linton, Cambridge, CB1 6ND.

Elected

1968 S. G. LANGFORD, Dept. of Philosophy, Queen's Buildings, The University, Exeter.

‡1936 Prof. J. A. LAUWERYS, 167 Perry Vale, Forest Hill, London SE23.

*1967 REYNOLD J. LAWRIE, 14 Chalcot Crescent, London N.W.1.

†1968 J. G. M. LAWS, 81 Alderney Street, London, S.W.1.

1948 Prof. M. LAZEROWITZ, Newhall Road, Conway, Mass. 01341, U.S.A.

1955 Prof. C. LEJEWSKI, Dept. of Philosophy, University of Manchester, Manchester 13.

*1956 RAMON M. LEMOS, Dept. of Philosophy, University of Miami, Coral Gables, Florida, U.S.A.

*1960 Miss V. F. LESLIE (14/4/74).

*1964 H. A. LEWIS, Philosophy Dept., University of Leeds, Leeds 2.

§1938 Prof. H. D. LEWIS, Vice-President, 1 Normandy Park, Normandy, nr. Guildford, Surrey.

*1967 Mrs. J. H. LEWIS, 2 Lanark Court, Glen Waverley, Melbourne, Victoria 3150, Australia.

1973 P. B. LEWIS, Dept. of Philosophy, University of Edinburgh, David Hume Tower, George Square, Edinburgh.

1937 CASIMIR LEWY, 49 De Freville Avenue, Cambridge.

*1947 W. VON LEYDEN, 5 Pimlico, Durham.

*1961 A. T. W. LIDDELL, The Warden's Lodging, Whiteknights Hall, Upper Redlands Road, Reading RG1 5JN.

§1971 Prof. DAVID LIEBER, 305 El Camino, Beverly Hills, California 90212, U.S.A.

*1972 J. LIPNER, The Divinity School, St. John's Street, Cambridge, CB2 1TW.

§1965 J. E. LLEWELYN, Dept. of Philosophy, David Hume Tower, George Square, Edinburgh 8.

‡1954 Prof. A. C. LLOYD, The University, Liverpool 3.

1964 D. I. LLOYD, Stockwell College of Education, The Old Palace, Rochester Avenue, Bromley, Kent, BR1 3DH.

1959 V. G. LOKARE, Dept. of Clinical Psychology, West Park Hospital, Epsom, Surrey.

†1969 Prof. ANTHONY A. LONG, School of Classics, Abercromby Square, P.O. Box 147, Liverpool, L69 3BX.

*1973 J. ALLEN LONG III, 1 Fossfield Road, Midsomer Norton, Bath, BA3 4AS.

1956 P. LONG, Dept. of Philosophy, The University, Leeds 2.

1967 D. LOY (14/4/74).

1955 J. LUCAS, Merton College, Oxford.

1968 DAVID LUDLOW, 4 Torrington Court, Westwood Hill, Sydenham, London, S.E.26.

§1970 A. J. LYON, The City University, St. John Street, London, E.C.1.

*1970 Prof. DAVID LYONS, Cornell University, The Sage School of Philosophy, Goldwin Smith Hall, Ithaca, New York 14850.

1973 W. E. LYONS, Dept. of Moral Philosophy, The University, Glasgow, W.2.

1969 D. A. LLOYD-THOMAS, Dept. of Philosophy, Bedford College, Regent's Park, N.W.1.

*1956 J. MACADAMS, Trent University, Peterborough, Ontario, Canada.

§1975 A. MURRAY MACBEATH, Dept. of Philosophy, University of Stirling, Stirling FK9 4LA.

†1973 Prof. D. N. MACCORMICK, Dept. of Public Law, The Univ. of Edinburgh, Old College, Edinburgh EH8 97L.

1964 Miss O. A. MACDONALD, Dept, of Theology, The University, Bristol 8.

*1970 J. J. MACINTOSH, Dept. of Philosophy, University of Calgary, Calgary, Alta, Canada.

1955 Prof. A. MACINTYRE, Dean's Office, College of Liberal Arts, Boston University, Boston, Mass., 02215, U.S.A.

Elected

‡1971 J. L. Mackie, University College, Oxford.
1945 Prof. D. M. Mackinnon, *President*, Corpus Christi College, Cambridge.
*†1967 Prof. P. T. Mackenzie, R.R.5 Saskatoon, Saskatchewan, Canada.
1965 A. M. Macleod, Cartwright Point, Kingston, Ontario, Canada.
1937 D. G. Macnabb, Worpleway, Tompsets Bank, Forest Row, E. Sussex.
1951 Mrs. Jean M. Macpherson, Clunebeg, Drumnadrochit, Invernesshire.
§1972 B. Magee, 12 Falkland House, Marloes Road, London, W8 5LF.
§1973 W. J. Maginnis, 178 Finaghy Road South, Belfast, BT10 0DH.
†1976 T. A. Magnell, New College, Oxford OX1 3BN. (P.1)
*†1975 G. A. Malines, Dept. of Philosophy, Queensland University, Brisbane, Australia.
1975 P. D. Mannick, "Byways", Boarhills by St. Andrews, Fife, Scotland (P2).
‡1951 Prof. A. R. Manser, The University, Southampton.
1968 Miss P. Marcus, 60 Pilgrim's Lane, London, N.W.3.
1961 Miss R. H. Marcus, Dept. of Philosophy, Yale University, New Haven, Connecticut, 06520.
1967 K. A. Markham, Dept. of Applied Psychology, UWIST, Llwyn-y-Grant Road, Penlan, Cardiff CF3 7JX.
§1975 Roger Marples, 4 St. Margarets, Beckenham Place Park, Beckenham, Kent, BR3 2BT.
§1967 G. D. Marshall, Dept. of Philosophy, University of Melbourne, Parkville, 3052, Australia.
†1969 Miss S. E. Marshall, Dept. of Philosophy, University of Stirling, Scotland.
1957 R. P. Martin, British Council, 10 Spring Gardens, London, SW1A 2BN.
1949 B. M. Masani, 120 Simrole Road, MHOW, M.P. India.
1975 R. V. Mason, Brewery Cottage, Southstoke, Nr. Bath.
1953 Prof. Wallace I. Matson, Dept. of Philosophy, University of California, Berkeley, California 94720, U.S.A.
*1975 E. Matthews, Dept. of Logic, University of Aberdeen, King's College, Old Aberdeen, AB9 2UB.
§1954 Miss G. M. Matthews, St. Anne's College, Oxford.
‡1933 Mrs. C. Maund, Springs Farm, Fittleworth, Sussex.
*1969 Prof. T. C. Mayberry, Dept. of Philosophy, University of Toledo, Toledo, Ohio 43606, U.S.A.
1971 D. G. Mayers, University College, Durham.
1963 Miss S. Maylett, 5 Clyro Court, 93 Tollington Park, Finsbury Park, London, N.4.
§1952 Prof. B. Mayo, Dept. of Philosophy, The University, St. Andrews, Scotland.
‡1947 W. Mays, Dept. of Philosophy, The University, Manchester 13.
§1975 Miss P. McAuliffe, Dept. of Philosophy, University of Stirling, Stirling, FK9 4LA.
1974 David J. McCann, 42 Victoria Road, Swindon SN1 3AY.
*†1965 Prof. H. J. McCloskey, Philosophy Department, School of Humanities, La Trobe University, Bundoora, Victoria, Australia, 3083.
*1976 S. McCready, University of Nigeria, Nsukka, Nigeria.
1967 J. H. McDowell, University College, Oxford.
§1973 Graham James McFee, Chelsea College of Physical Education, Denton Road, Eastbourne, Sussex, BN20 7SR.
1975 I. G. McFetridge, Dept. of Philosophy, Birkbeck College, Malet Street, London, C1E 7HX.
1975 C. McGinn, Dept. of Philosophy, University College of London, Gower Street, London, WC1E 6BT.
1968 R. S. McGowan, Dept. of Philosophy, The University, Leicester.

298

Elected
1966 C. J. McKnight, Dept. of Philosophy, The Queen's University, Belfast, N. Ireland.
*†1967 R. M. McLaughlin, Macquarie University, Dept. of Philosophy, North Ryde, N.S.W., Australia, 2113.
*1969 Prof. J. B. McMinn, Department of Philosophy, P.O. Box 6287, University of Alabama, College of Arts and Sciences, Alabama 35486.
*1973 David A. McNaughton, Dept. of Philosophy, Keele, University, Staffs, ST5 5BG.
‡1952 T. H. McPherson, Dept. of Philosophy, University College, P.O. Box 78, Cardiff, CF1 1XL.
§1967 Donald A. McQueen, Dept. of Philosophy, The University, Nottingham.
§1955 Miss R. Meager, Birkbeck College, Dept. of Philosophy, Malet Street, London, W.C.1.
1970 S. Meikle (3/2/75).
§1951 Prof. Abraham Melden, Dept. of Philosophy, University of California, Irvine, California, 92664, U.S.A.
1958 George Melhuish, 29/1/73.
‡1966 D. H. Mellor, University of Cambridge, Faculty of Philosophy, Sidgwick Avenue, Cambridge CB3 9DA.
1958 Prof. J. Meloe, Institutt for Samfunnsvitenskap, Roald Amundsens Plass, 1, 9000 Tromso, Norge.
§1965 J. Melzack, 32 Addisland Court, Holland Villas Road, London, W.14.
*1972 M. A. Menlowe, Dept. of Moral Philosophy, King's College, University of Aberdeen, Aberdeen AB9 2UB.
§1975 Peter Mew, Dept. of Philosophy, Trinity College, Dublin 2.
*1976 B. E. Meyer, John Burnet Hall, St. Andrews University, Fife (P4).
1963 Prof. R. Meyer (14/4/74).
1966 H. A. Meynell, Dept. of Philosophy & Theology, The University, Leeds.
*†1967 Mrs. J. Meynell, Dept. of Philosophy, The University, Leeds, LS2 9JT.
1975 Mrs. A. Michaelson, 75 Furscroft, George Street, London, W.1.
1949 G. C. J. Midgley, Dept. of Philosophy, The University, Newcastle-upon-Tyne.
1972 Mrs. M. Midgley, Dept. of Philosophy, The University, Newcastle-upon-Tyne.
‡1976 A. Millar, Dept. of Philosophy, University of Stirling, Stirling FK9 4LA.
1948 Mrs. S. Millar (14/4/74).
§1959 D. E. Milligan, 11 Trelawney Road, Bristol 6.
1973 Keith W. Mills, 5, Hawthorn Crescent, Gilesgate Moor, Durham, DH1 1ED.
‡1969 E. P. Millstone, First Floor Flat, 31, St. Michaels Place, Brighton, BN1 3FU.
§1949 Prof. Basil Mitchell, Oriel College, Oxford.
1954 D. Mitchell, Worcester College, Oxford.
1953 J. S. Mitchell, "South View", Potter's Heath Road, Welwyn, Herts.
1975 Miss Sarah Mitchell, Dept. of Philosophy, Bedford College, Regents Park, London, N.W.1 (P2)..
1963 P. J. Mitchell (2/10/73).
1966 K. Mitchells, 1 Turner Close, London, N.W.11.
*1970 Miss J. Mitra (14/4/74).
1970 Rev. R. Moloney, Heythrop College, 11/13 Cavendish Square, London W.1.
‡1962 J. A. Moncaster, 3 York House, Kelvedon Road, Tiptree, Essex.
*1951 D. H. Monro, Dept. of Philosophy, Monash University, Victoria, Australia.

Elected
‡1959 R. D. L. MONTAGUE, Dept. of Philosophy, The University, Leicester, LE1 7RH.
‡1952 ALAN MONTEFIORE, Balliol College, Oxford.
1972 LAWRENCE MOONAN, 44 Knowsley House, Carslake Avenue, Bolton.
*1974 F. C. T. MOORE, Dept. of Philosophy, University of Birmingham, P.O. Box 363, Birmingham B15 2TT.
1961 M. MORAN.
*1964 A. MORENO, Azcuénaga, 1877-1E, Buenos Aires, R. Argentina.
‡1960 G. MORICE, 46 Queen Street, Edinburgh 2, Scotland.
1967 ALASTAIR MORRISON, Dept. of Politics, The University, Bristol.
1961 J. M. B. MOSS, 14 Northern Grove, Manchester M20 8WL.
*1965 Miss MARY MOTHERSILL, Dept. of Philosophy, Barnard College, Columbia University, New York, U.S.A.
1964 H. O. MOUNCE, Dept. of Philosophy, University College of Swansea, Singleton Park, Swansea, Wales.
*†1962 PHILIP MULLOCK, The School of Law, University of Pittsburgh. Pittsburgh, Pennsylvania 15213, U.S.A.
1948 Prof. C. W. K. MUNDLE, Dept. of Philosophy, University College of N. Wales, Bangor, Wales.
1958 Prof. M. K. MUNITZ, Marlborough Road, Scarborough, New York. 10510, U.S.A.
1969 DAVID MURRAY, Birkbeck College, 14 Gower Street, London W.C.1.

*1935 Prof. ERNEST NAGEL, Dept. of Philosophy, Columbia University, Broadway, New York, U.S.A.
*1969 MICHAEL NAISH, School of Education, Abercromby Square, The University, Liverpool 7.
†1967 Prof. H. NAKAMURA, Dept. of Philosophy, Chiba University, 33 I-Chome ya yoi-cho, Chiba, Japan.
‡1965 N. M. L. NATHAN, School of Social Studies, University of East Anglia, Univ. Plain, Norwich NOR 88C.
§1976 J. A. NAZARRO, 51 Beda Rd., Ganton, Cardiff, Glam., Wales (P.2).
*†1966 Miss M. NESSER, Dept. of Philosophy, University of Natal, P.O. Box 1525, Durban, South Africa.
1961 K. NEUBERG, New College, Ivy House, North End Road, London N.W.11.
‡1956 J. G. H. NEWFIELD, School of Social Sciences, The Hatfield Polytechnic, P.O. Box 109, Hatfield, Herts.
‡1975 Rev. KENNETH NEWTON, The Parsonage, Chapel-of-Ease Road, St. David's, Bermuda.
1959 Prof. P. H. NIDDITCH, Dept. of Philosophy, The University, Sheffield.
1952 Prof. S. GOMEZ NOGALES (14/4/74).
1964 Prof. G. NUCHELMANS, Aert van Neslaan 421 Oegstgest, Holland.
1957 Mrs. M. NUNAM (14/4/74).

‡1943 Prof. D. J. O'CONNOR, Vice-President, Dept. of Philosophy, The University, Exeter.
1966 H. R. ODLUM, Burgh Cottage, Nr. Woodbridge, Suffolk.
1975 A. O'HEAR, Dept. of Philosophy, Univ. of Surrey, Guildford, Surrey, GU2 5XH.
*†1974 Prof. MASAHIRO OKA, Hiroshima Shirdo University, Japan.
*†1966 PATRICK G. O'KEEFE, 23 Liverpool Road, St. Albans, Herts.
1962 HAROLD OSBOURNE, 90A St. John's Wood High Street, London N.W.8.
*1966 C. OLSEN, Dept. of History & Philosophy, Ontario, Institute for Studies in Education, 252 Bloor Street West, Toronto, Ontario M5S 1V6.

300

Elected

§1962 LADY HELEN OPPENHEIMER, L'Aiguillon, Grouville, Jersey C.I.

‡1961 C. P. ORMELL, 19 Kenton Road, Reading R96 2LQ.

1968 JACK ORNSTEIN, Department of Philosophy, Sir George Williams University, 1455 de Maisonnevve Blvd West, Montreal 107, Canada.

1956 BRIAN O'SHAUGHNESSY, 6 Oakhill Avenue, Hampstead, London N.W.3.

1952 Prof. G. E. L. OWEN, The Beeches, Lower Heyford, Oxford.

1962 H. P. OWEN, King's College, Strand, W.C.2.

†1969 I. C. ORR, 3 St. Giles Road, Camberwell, London SE5 FRL.

1970 DAVID E. OVER, Sunderland Polytechnic, Forster Building, Chester Road, Sunderland, SR1 3SD.

*1969 EDGAR PAGE, Pembroke Lodge, 43 Chapmangate, Pocklington, York.

‡1974 F. G. PALMER, 12 Buckingham Close, Hampton, Middlesex, TW12 3JU.

‡1962 HUMPHREY PALMER, 82 Plymouth Road, Penarth, S. Glamorgan.

1955 Rev. H. P. F. PANDITARATNE (23/4/72).

*†1972 DOMENICO PARISI, Via Iside, 12, Rome, Italy.

*1967 A. R. PARRY (14/4/74).

§1975 S. J. PARRY, 10 Barnsley Road, Thorpe Hesley, Rotherham, S. Yorks.

1961 M. F. PARTRIDGE, Dept. of Logic, King's College, Aberdeen.

‡1975 Prof. ALAN PASCH, 6910 Wake Forest Drive, College Park, Maryland 20740, U.S.A.

1971 B. PASKINS, King's College London, Strand, London W.C.2.

*1968 NEIL G. PASSAGE (14/4/74).

*1948 Prof. J. A. PASSMORE, Australian National University, Canberra, A.C.T.

1960 Miss MARGARET PATON, Dept. of Philosophy, David Hume Tower, George Square, Edinburgh 8.

1954 Prof. BERNARD PEACH, Dept. of Philosophy, Duke University, Durham N.C., U.S.A.

*†1970 The Rev. T. E. PEACOCK, Chemistry Dept., University of Queensland, St. Lucia, Queensland 4067, Australia.

1974 C. A. B. PEACOCKE, The Queen's College, Oxford.

*†1948 D. PEARS, Christchurch, Oxford.

1958 DIETRICH PEETZ, Dept. of Philosophy, The University, Nottingham.

1974 C. W. P. PEHRSON, Hamels Lodge, Hamels Park, Buntingford, Herts.

1961 Prof. T. M. PENELHUM, Dept. of Philosophy, The University of Calgary, Alberta, Canada.

‡1967 Prof. L. R. PERRY, University of London, King's College, Faculty of Education, Strand, London W.C.2.

§1946 Prof. R. S. PETERS, University of London, Institute of Education, Malet Street, London W.C.1.

1975 M. PETHERAM, 18 Spencer Walk, Rickmansworth, Herts.

1975 Miss A. PHILLIPS, Dept. of Philosophy, University College, Gower Street, London W.C.1 (P2).

§1962 Prof. D. Z. PHILLIPS, Dept. of Philosophy, University College of Swansea, Singleton Park, Swansea.

*1961 S. PLOWDEN, 69 Albert Street, London N.W.1.

1957 MICHAEL PODRO, 1 Provost Road, London N.W.3.

1949 DAVID POLE, King's College, Strand, London W.C.2.

1962 LEONARDO POMPA, Dept. of Philosophy, David Hume Tower, George Square, Edinburgh EH8 9JX.

*1946 Prof. Sir KARL POPPER, Vice-President, Fallowfield, Manor Road, Penn, Bucks.

§1935 Prof. A. J. D. PORTEOUS, 8 Osmanston Road, Prenton, Birkenhead, Cheshire.

Elected

§1967 T. POTTS, Dept. of Philosophy, Leeds University, Leeds 2, Yorkshire.

‡1957 Miss BETTY POWELL, Dept. of Philosophy, The University, Exeter.

1968 W. K. PRESA (14/4/74).

1968 A. E. PRESTON, University of Exeter, Guild of Students, Devonshire House, Stocker Road, Exeter, Devon, EX4 4PZ.

§1976 A. W. PRICE, Dept. of Philosophy, Univ. of York, Heslington, York, YD1 5DD.

†1953 Prof. KINGSLEY PRICE, Dept. of Philosophy, The John Hopkins University, Baltimore 18, Maryland, U.S.A.

1973 A. C. PURTON, 22 Auderley Drive, Eaton, Norwich, NOR 98P.

1973 Miss E. M. PYBUS, Dept. of Moral Philosophy, The University, Glasgow, W.2.

1975 Mrs. T. M. PYBUS, 4 Harvey Gardens, Addison Road, Guildford, Surrey (U2).

‡1950 A. M. QUINTON, Vice-President, New College, Oxford.

*1968 J. DOUGLAS RABB, Dept. of Philosophy, Lakehead University, Thunder Bay, Ontario, Canada.

†1975 Professor R. D. RAMSDELL, c/o A. J. P. Taylor, 13 Mark's Crescent, London NW1.

*†1957 K. W. RANKIN, Dept. of Philosophy, University of Victoria, Victoria, B.C., Canada.

§1945 Prof. D. D. RAPHAEL, Vice-President, Imperial College of Science & Technology, Kensington, London, SW7 2AZ.

1971 M. SALMAN RASCHID, 96 Caledonian Road, London N.1.

1955 Prof. JOHN RAWLS, (14/4/74).

‡1968 Prof. A. J. RECK, Dept. of Philosophy, Tulane University, New Orleans, La 70118, U.S.A.

1938 R. T. H. REDPATH, 49 Madingley Road, Cambridge.

§1947 D. A. REES, Jesus College, Oxford.

§1954 JOHN C. REES, Dept. of Politics, University College, Swansea.

1957 W. J. REES, 20 Bracken Edge, Leeds 8.

*1973 JOHN REEVE, 20 Raleigh Road, Richmond, Surrey.

‡1960 A. D. REID, Newbattle Abbey College, Dalkeith, Midlothian.

1972 Mrs. E. M. REID, Dept. of Philosophy, The University, Glasgow, W2.

*1966 Prof. NICHOLAS RESCHER, Dept. of Philosophy, University of Pittsburgh, Pittsburgh, Pennsylvania 15213, U.S.A.

†1959 R. RHEES, 5A Greville Place, London N.W.6.

1954 JOSEPH RHYMER, Notre Dame College of Education, Mount Pleasant, Liverpool L3 55P.

1972 A. RHYS-WILLIAMS, 35 Dorset Road, Forest Gate, London E7.

1961 H. P. RICKMAN, 4 Nancy Downs, Oxhey, Herts, WD1 4NF.

*1951 Prof. A. M. RITCHIE, Dept. of Arts, Newcastle University College, Tighe's Hill, 2N, N.S.W., Australia.

*1970 C. W. ROBBINS, Dept. of Philosophy, University of York, Heslington, York.

1968 Prof. GEORGE W. ROBERTS, Dept. of Philosophy, Duke University, Durham, North Carolina, U.S.A.

‡1963 T. A. ROBERTS, Dept. of Philosophy, University College of Wales, Aberystwyth.

*†1967 PETER ROBERTSON (14/4/74).

*1948 Prof. C. D. ROLLINS, Philosophy Dept., The University of Connecticut, Storrs, Connecticut, 06268, U.S.A.

1971 SERGE RONDINONE, 2265 Grand Avenue, New York, N.Y. 10453, U.S.A.

†1971 Miss A. RORTY, 7-K Hibben Apartments, Faculty Road, Princeton, N.J. 08540.

Elected
§1976 C. J. ROSE, Flat 2, 78, Arthur Road, London S.W.19.
1969 R. ROSE (14/4/74).
1968 F. ROSEN, 40 Priory Gardens, Highgate, London N.6.
‡1966 G. ROSS, 66, Whitney Drive, Stevenage, Herts.
1972 R. H. ROWSON, 52, Tonteg Close, Tonteg, Pontypridd, Glamorgan.
§1959 J. W. ROXBEE COX, 1 Rectory Barn, Halton, Lancaster, LA2 6LT.
*1971 DAVID-HILLEL RUBEN, Dept. of Philosophy, University of Essex, Wivenhoe Park, Colchester CO4 35Q.
§1968 Prof. W. M. RUDDICK, 110 Bleecker Street, New York, N.Y. 10012.
§1967 BEDE RUNDLE, Trinity College, Oxford.
*†1969 M. JACQUES RUYTINX, 5 Rue des Taxandres, Bruxelles, Belgium.

1968 DAVID H. SANFORD, Dept. of Philosophy, Duke University, Durham, N. Carolina, 27708, U.S.A.
1968 A. B. SAVILE, Dept. of Philosophy, Bedford College, Regent's Park, London N.W.1.
1962 Prof. R. L. SAW, *Vice-President*, 72 Grosvenor Avenue, Carshalton, Surrey.
§1967 EVA SCHAPER, Logic Dept., The University, Glasgow, W.2.
*1958 Prof. I. SCHEFFLER, Larsen Hall, Harvard University, Cambridge, Mass. 02138, U.S.A.
*1971 FREDERIC SCHICK, Dept. of Philosophy, Rutgers University, New Brunswick, N.J. 08903, U.S.A.
1947 W. E. SCHLARETZKI, Dept. of Philosophy, University of Maryland, College Park, Maryland 20902, U.S.A.
*†1972 Prof. DANA S. SCOTT, Merton College, Oxford.
1966 Miss M. SCOTFORD-MORTON, Dept. of Sociology, University of Reading, Berks.
1970 R. V. SCRUTON, Dept. of Philosophy, Birkbeck College, Malet Street, London, W.C.1.
1959 J. R. SEARLE, Dept. of Philosophy, University of California, Berkeley 4, California, U.S.A.
‡1945 Prof. PAUL SELIGMAN, Dept. of Philosophy, University of Waterloo, Waterloo, Ontario, Canada.
1968 Miss ANNE SELLAR, Keynes College, The University of Kent, Canterbury, Kent.
‡1976 J. SERTIC, Dept. of Philosophy, American River College, Sacramento, California 95821, U.S.A.
*1956 A. SHALOM, McMaster University (Dept. of Philosophy), Hamilton, Ontario, Canada.
1975 Prof. F. A. SHAMSI, Islamic Research Institute, P.O. Box 1035, Islamabad, Pakistan.
‡1971 R. A. SHARPE, St. David's College, Lampeter, Cards.
1972 RABBI DANIEL MARK SHERBOK, University College, Cambridge.
1975 Prof. R. A. SHINER, Dept. of Philosophy, 4-108 Humanities Centre, University of Alberta, Edmonton, Alberta, Canada, T6G 2E9.
§1970 J. M. SHORTER, Lincoln College, Oxford.
§1972 PETER J. SHOTT, 55 Frederick Avenue, Penkhull, Stoke-on-Trent, Staffordshire, ST4 7DY.
‡1951 Prof. F. N. SIBLEY, Dept. of Philosophy, University of Lancaster, Bowland College, Bailrigg, Lancaster.
§1969 Mrs. B. A. SICHEL, 61 Duncan Road, Hemstead, New York 11550.
‡1962 J. W. SIM, Pine Cottage, Harfield Road, Sunbury-on-Thames, Middlesex.
1963 Prof. J. SILBER, Boston University, 147 Bay State Road, Boston, Mass. 02215, U.S.A.
1952 J. C. SIMOPOULOS, c/o The Librarian, St. Catherine's College, Oxford OX1 3UJ.
1970 R. W. SIMPSON, Dept. of Moral Philosophy, Kings College, Old Aberdeen, Aberdeen.

Elected
*†1952 Prof. MARCUS G. SINGER, 5185 Helen C. White Hall, University of
 Wisconsin, Madison, Wis 53706, U.S.A.
*1957 I. P. SINGH (14/4/74).
§1972 Miss D. J. D. SISSON, Dept. of Moral Philosophy, The University
 Glasgow, Glasgow G12 8QG.
‡1969 R. A. SKILLICORN, Tan y Weirglodd, Clwt y Bont, Caernarfon,
 Glwynedd, LL55 3DE.
‡1975 J. M. ŠKORUPSKI, Dept. of Philosophy, University College of
 Swansea, Singleton Park, Swansea, Glam., SA2 8PP.
1966 B. J. SMART, Dept. of Philosophy, University of Keele, Keele,
 Staffordshire, ST5 5BG.
1948 Prof. J. J. C. SMART, Dept. of Philosophy, La Trobe University,
 Bundoora, Victoria 3083, Australia.
§1969 Miss PATRICIA SMART, University of Surrey, Guildford, Surrey.
1956 Prof. R. N. SMART, Dept. of Religious Studies, Cartmel College,
 University of Lancaster, Bailrigg, Lancaster.
‡1958 COLIN SMITH, Dept. of French Studies, Faculty of Letters, University
 of Reading, Whiteknights Park, Reading, Berks.
1949 Prof. F. V. SMITH, University of Durham, Dept. of Psychology,
 Science Laboratories, South Road, Durham.
§1971 PETER SMITH, Dept. of Philosophy, University College of Wales,
 Aberystwyth.
‡1964 JAMES W. F. SOMERVILLE, Dept. of Philosophy, The University,
 Hull.
1967 R. SORABJI, 2 Dorlcote Road, Wandsworth Common, London
 S.W.18.
*†1972 A. W. SPARKES, Dept. of Philosophy, The University of Newcastle,
 N.S.W. 2308, Australia.
*1951 F. E. SPARSHOTT, Victoria College, Toronto 5, Ontario, Canada.
*†1970 Prof. S. F. SPICKER, 17, Longdane Road, West Hartford,
 Connecticut, 06117, U.S.A.
*1958 T. L. SPRIGGE, The University of Sussex, School of English &
 American Studies, Arts Building, Falmer, Brighton, Sussex
 BN1 9QN.
§1972 J. E. R. SQUIRES, 5 Drumcarrow Road, St. Andrews, Fife, Scotland.
1958 Mrs. I. H. STADLER (14/4/74).
1974 Miss H. S. STANILAND, Dept. of Philosophy & Classics, University of
 Nigeria Nsukka, Nigeria.
1968 ZENON STAVRINIDES, (4/4/76).
1966 M. STCHEDROFF, The Philosophy Dept., The Queen's University of
 Belfast 7, Northern Ireland.
1976 Mrs. B. L. STEELE, c/o Miss H. Williams, Stone Cottage, Chilgrove,
 Nr. Chichester, W. Sussex, PO18 9HU.
*1958 Mrs. DOROTHY C. MACEDO DE STEFFENS, Rondeau, 669 Bahia
 Blanca, R. Argentina.
§1974 H. I. STEINER, Dept. of Government, University of Manchester,
 Manchester 13.
1964 AXEL STERN, Dept. of Philosophy, The University, Hull.
*1964 Prof. L. STERN, Dept. of Philosophy, Rutgers, The State University,
 New Brunswick, New Jersey, 08903, U.S.A.
*1965 G. G. L. STOCK, Dept. of Logic, King's College, Old Aberdeen,
 Aberdeen.
1953 S. J. STOLJAR, Institute of Advanced Studies, Australian National
 University, Canberra, Australia.
§1955 The Hon. COLIN STRANG, Dept. of Philosophy, The University,
 Newcastle-upon-Tyne NE1 7RU.
‡1947 Prof. P. F. STRAWSON, Vice-President, Magdalen College, Oxford.
1961 Prof. A. STROLL, Dept. of Philosophy, University of California, San
 Diego, U.S.A.
1959 Prof. W. STRZALWOWSKI, 207 Fulham Court, SW6 5PQ.

304

Elected

‡1950 OLIVER STUTCHBURY, Gayles, Friston, Nr. Eastbourne, Sussex.
‡1966 S. R. SUTHERLAND, Dept. of Philosophy, University of Stirling, Stirling, Scotland.
‡1969 Mrs. A. M. SUTTON, 247 Avenue Albert 1st, B-1320, Genval, Belgium.
‡1961 Prof. R. G. SWINBURNE, Dept. of Philosophy, University of Keele, Keele, Staffs. ST5 5BG.

1958 E. TALMOR (14/4/74).
1963 M. K. TANNER, Corpus Christi College, Cambridge.
§1968 C. C. W. TAYLOR, Corpus Christi College, Oxford.
§1948 Prof. D. TAYLOR, Dept. of Philosophy, University of Otago, Box 56, Dunedin, New Zealand.
1976 D. M. TAYLOR, Master Eliot College, Univ. of Kent at Canterbury, Kent, CT2 7NS.
1975 Mrs. E. G. TAYLOR, St. Annes College, Oxford.
*1975 E. H. TAYLOR, 2 Lowery Drive, Atherton, California 94025 U.S.A.
§1972 DAVID REX-TAYLOR, 1A Whitton Waye, Hounslow, Middlesex.
1970 Mrs. JENNY TEICHMANN, New Hall, Cambridge.
‡1968 Miss ELIZABETH TELFER, Dept. of Philosophy, University of Glasgow, Glasgow W.2.
§1969 Mrs. RACHEL TERRY, 74 Brook Drive, London SE11 4TS.
§1972 Prof. S. C. THAKUR, Department of Philosophy, The University of Surrey, Guildford, Surrey.
§1972 H. J. THIBAULT, Allen Hall, 28 Beaufort Street, London SW3 5AA.
1960 D. O. THOMAS, Dept. of Philosophy, University College, Aberystwyth, Wales.
1968 H. J. THOMAS.
1966 H. W. THOMAS (14/4/74).
*†1966 Rev. J. C. THOMAS, Dept. of the Study of Religions, P.O. Box 66, The University, Legon, Accra, Ghana.
1975 Mrs. JANICE L. THOMAS, 4A Provost Road, London, NW3 3ST.
1945 L. E. THOMAS, Bodalwen, Merion Road, Bangor, Caerns. LL57 2BY.
1970 F. W. THOMPSON (14/4/74).
1961 MANLEY THOMPSON, University of Chicago, Chicago 37, Illinois, U.S.A.
1968 N. S. THORNTON (14/4/74).
1975 H. THORPE, 2B Manor Park Road, London, N2 0SL.
1956 H. TINT, 57 Pilgrim's Way, Kemsing, Kent.
1973 T. T. TOMINAGA, Dept. of Philosophy, University of Nevada, 4505 Maryland Parkway, Las Vegas, Nevada 89154, U.S.A.
1938 E. W. F. TOMLIN, Tall Trees, Morwenstow, Cornwall.
‡1972 ERIC TOMS, 9, Campsie Drive, Milngavie, Glasgow, G62 8HX.
1975 IAN M. TONOTHY, 20 Clarendon Gardens, London W9 1A2.
1965 Mrs. M. H. F. TOOMEY, Bard College, Annandale-on-Hudson, New York, U.S.A.
*1969 S. B. TORRANCE, Corpus Christi College, Oxford.
1948 STEPHEN TOULMIN, University of California, Crown College, Santa Cruz, California 95060, U.S.A.
1965 R. H. TRIGG, School of Philosophy, University of Warwick, Coventry, Warwickshire.
§1975 Mr. JUN'ICHI TSUCHIYA, Dept. of Philosophy, Kanazawa University, 1-1 Morunouchi, Kanazawa, 920, Japan.
1964 Prof. R. TSUESITA, (106) 1-5-22, Moto-Azabu, Minato-Ku, Tokyo. Japan.
1952 Prof. JOHN TUCKER (14/4/74).
1969 Mrs. DANIEL M. TUMAN (13/6/72).

1975 WILLIAM UNGLESS, 73 Holden Road, London, N12.

Elected

1939 J. O. URMSON, Corpus Christi College, Oxford.

1970 J. J. VALBERG, Dept. of Philosophy, University College London, Gower Street, London W.C.1.

1966 Prof. G. L. VANDER VEER (14/4/74).

‡1974 Miss G. VAUGHAN, 44 Woodland Gardens, London N10 3UA.

1964 Prof. MICHALINA VAUGHAN, Dept. of Sociology, Cartmell College, Bailrigg, Lancs.

1952 Prof G. N. A. VESEY, Faculty of Arts, The Open University, Walton Hall, Milton Keynes, Bucks.

*1976 Professor GERALD VISION, Temple University, Philosophy Dept., Philadelphia, PA 19122, U.S.A.

1975 Professor GREGORY VLASTOS, Dept. of Philosophy, Princeton University, 1879 Hall, Princeton, New Jersey 08540, U.S.A.

†1975 G. I. WALL, 73 Ridge Road, London, N8 9NP.

1953 The Rev. Dr. N. E. WALLBANK, St. Peter's House, Oakley Crescent, City Road, E.C.1.

1965 J. D. B. WALKER, Dept. of Philosophy, McGill University, Montreal 2, Canada.

‡1950 Prof. W. H. WALSH, *Vice-President*, 19 Great Stuart Street, Edinburgh 3.

1964 R. S. WALTERS, School of Philosophy, University of New South Wales, P.O. Box 1 Kensington, N.S.W., Australia.

1972 Prof. G. N. WALTON, Department of Chemical Engineering, Imperial College, South Kensington, London S.W.7.

1971 K. A. WALTON, 940, Westbrook, Apt. 2, Perrysburg, Ohio, 43551, U.S.A.

1971 Revd. J. S. K. WARD, Trinity Hall, Cambridge.

*†1964 R. X. WARE, Dept. of Philosophy, University of Calgary, Calgary, Alberta, Canada.

§1969 MARTIN M. WARNER, School of Philosophy, University of Warwick, Coventry.

1949 G. J. WARNOCK, Hertford College, Oxford.

1971 Miss SARAH WATERLOW, Dept. of Philosophy, The University of Edinburgh, David Hume Tower, George Square, Edinburgh.

§1954 J. WATLING, Dept. of Philosophy, University College, Gower Street, W.C.1.

1971 D. W. WATSON, Dept. of Moral Philosophy, The University, Glasgow, W.2.

*1967 SIK-YING WAUNG, 19A Repulse Bay Road, 10th Floor, Hong Kong.

1973 Miss GERALDINE WEBSTER, Dufferin House, 24 Dalrymple Crescent, Edinburgh 9.

*1973 Mrs. M. E. WEDDEN, 155 Ash Grove, Heston, Hounslow, Middlesex TW5 9DX.

1951 Prof. M. WEITZ, Dept. of Philosophy, Brandeis University, Waltham, Mass., U.S.A.

§1951 PAUL WELSH, Box 6846, College Station, Durham, N. Carolina, 27708, U.S.A.

*1969 D. J. WEST, Dept. of Philosophy, Acadia University, Wolfville, Nova Scotia, Canada.

1960 J. J. WHEATLEY, Dean of Graduate Studies, Simon Fraser University, Burnaby 2, British Columbia, Canada.

*1973 D. A. WHEWELL, Dept. of Philosophy, University of Durham, 50 Old Elvet, Durham.

§1962 Prof. A. R. WHITE, The University Hull.

*†1976 D. M. WHITE, Dept. of Politics, Monash University, Clayton 3168, Victoria, W. Australia.

1975 ROGER M. WHITE, Dept. of Philosophy, University of Leeds, Leeds.

Elected

1966 J. P. WHITE, Dept. of Philosophy, Inst. of Education, Malet Street, London W.C.1.

*1951 Prof. MORTON WHITE, The Institute for Advanced Study, Princeton, New Jersey, 08540, U.S.A.

‡1936 Prof. C. H. WHITELEY, *Vice-President*, Department of Philosophy, The University of Birmingham.

‡1962 Prof. D. WIGGINS, Dept. of Philosophy, Bedford College, Regent's Park, London N.W.1.

‡1960 GEORGE WIGHTMAN, 11 Bramham Gardens, London S.W.5.

1969 Y. WILKS, Dept. of Artificial Intelligence, University of Edinburgh, Edinburgh, Scotland.

1953 Prof BERNARD WILLIAMS, King's College, Cambridge.

‡1961 C. J. F. WILLIAMS, Cluthaville, 1 Fossefield Road, Midsomer Norton, Bath, BA3 4AS.

1960 JOHN WILLIAMSON, Dept. of Philosophy, The University of Liverpool.

1973 H. R. WILLS, Thomas Huxley College, Woodlands Avenue, Acton, London, W3 9DP.

1963 Mrs. S. WILSMORE, Willow House, Conduit Head Road, Cambridge.

*†1974 B. G. WILSON, 26661, Pepita Drive, Mission Viejo, California 92675, U.S.A.

1966 I. R. WILSON, Department of Philosophy, University of Stirling, Stirling, Scotland.

*1972 ROBERT D. WILSON, 86, Bramhall Lane South, Bramhall, Stockport, SK7 2EA, Cheshire.

‡1958 Prof. P. G. WINCH, Dept. of Philosophy, King's College, The Strand, London W.C.2.

1933 Prof. J. WISDOM, *Vice-President*, Colorado State University, Dept. of Philosophy, Fort Collins, Colorado, U.S.A.

*1932 Prof. J. O. WISDOM, Dept. of Philosophy, York University, Toronto, Ontario, Canada.

1951 Mrs. I. WISDOM, Flat 25 Hornton Court, London W.8.

1949 LORD WOLFENDEN, The White House, Westcott, Guildford Road, Nr. Dorking, Surrey.

1950 Prof. R. A. WOLLHEIM, *Vice-President*, Dept. of Philosophy, University College, Gower Street, London W.C.1.

1975 D. A. R. WOOD, University of W. Australia, Dept. of Philosophy, Nedlands, 6009, Australia.

 J. W. WOOD, Oriel College, Oxford.

§1948 OSCAR P. WOOD, Christ Church, Oxford.

§1958 M. WOODS, Brasenose College, Oxford.

1936 Prof. A. D. WOOZLEY, Dept. of Philosophy, University of Virginia, Charlottesville, Va. 22903, U.S.A.

*1939 Mrs. L. E. G. WORSLEY, 167 Long Ashton Road, Nr. Bristol.

1970 A. C. H. WRIGHT, 108 Derby Lodge, Wicklow Street, London W.C.1.

1969 C. B. WRIGHT, Dept. of Philosophy, The University of Exeter, Queen's Building, The Queen's Drive, Exeter.

†1975 C. J. G. WRIGHT, All Souls College, Oxford.

‡1975 P. N. WRIGHT, 29 Leaf Close, Northwood, Middlesex, HA6 2YY. (P.2)

*1964 Rev. MICHAEL YANASE, S.J., Faculty of Science and Technology, Sophia University, 7 Kioi-Cho, Chiyoda, Tokyo-KU, Japan.

1960 M. F. ZEIDAN, Faculty of Arts, Shatby, Alexandria, U.A.R.

*1968 ROBERT L. ZIMMERMAN, Sarah Lawrence College, c/o Dept. of Philosophy, Bronxville, New York, 10708, U.S.A.